MAKING

MODERNISM

□

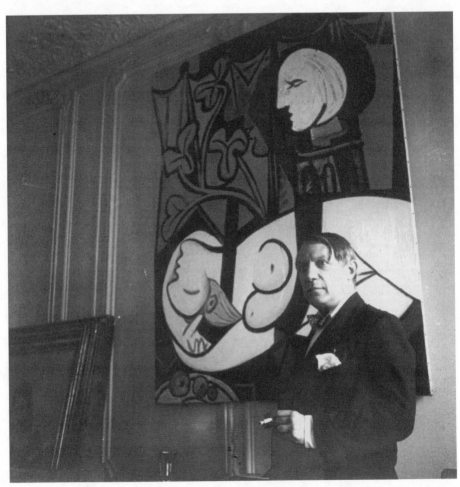

Picasso at 23 rue La Boétie, 1931. Photograph by Cecil Beaton
(Courtesy of Sotheby's, London)

MAKING MODERNISM

□

PICASSO AND THE CREATION OF THE MARKET FOR TWENTIETH-CENTURY ART

□

MICHAEL C. FITZGERALD

FARRAR, STRAUS AND GIROUX · NEW YORK

LIBRARY OF CONGRESS CATALOGING-IN-PUBLICATION DATA
FitzGerald, Michael C.
Making modernism: Picasso and the creation of the market for
twentieth-century art / Michael C. FitzGerald. — 1st ed.
p. cm.
Includes index.
1. Picasso, Pablo, 1881–1973—Psychology. 2. Picasso, Pablo,
1881–1973—Influence. 3. Modernism (Art) 4. Avant-garde
(Aesthetics)—History—20th century. 5. Art—Marketing. 6. Artists
and patrons. I. Title.
ND553.P5F58 1994
759.4—dc20 94-14062 CIP

For my father
James Lawrence FitzGerald

A C K N O W L E D G M E N T S

This book owes its greatest debt to the abysmal state of the profession of art history.

Were it not for the dearth of gainful employment that young art historians face upon completion of the usual near-decade of apprenticeship, I probably would not have sought the experiences that have enriched my life during the past ten years and contributed so much to this book. Acquiring an M.B.A. while finishing a doctorate in art history challenged me to look at the history of art as an integral part of modern life rather than as an arcane academic discipline. Employment at an auction house tested my perceptions and taught me the difference between disinterested speculation and the realities of the bottom line. Finally, a return to academia has offered the opportunity to write. I can only hope that this book conveys the fascination I have felt observing the web of complexities, contradictions, and confabulations that maps the broad territory called the art world.

The foundation of this book is the voluminous correspondence between Picasso and the dealers, curators, collectors, and critics who surrounded him during most of his life. Thanks to Picasso's superstitious hoarding and his consciousness of his place in the history of art, a remarkable number of these documents have survived. The French government and the artist's heirs have generously made many of them

accessible through the Picasso Archive in the Musée Picasso in Paris.

It has been my great pleasure and privilege to work in the Musée Picasso for thirteen years, beginning when the collection was temporarily housed on the heights of the Trocadéro in the Palais Chaillot and continuing through the inauguration of the grand museum in the Hôtel Salé. Throughout this time, the staff has been unfailingly kind and helpful to me. Even during my initial visits as a graduate student, Michèle Richet went out of her way to facilitate my research, and Laurence Marceillac, now Laurence Berthon, immediately extended the generosity of spirit that has continued to characterize my interactions with her over the years. During her time at the Musée Picasso, Marie-Laure Bernadac aided me greatly through her willingness to share her knowledge of the slowly evolving archive. More recently, Hélène Seckel has proved both a considerate colleague and an inspiring scholar.

Without the assistance of these individuals and access to the Picasso Archive, it would have been impossible to write this book. I especially thank the artist's heirs for granting me permission to read many files that had previously been restricted. I would particularly like to thank Claude Picasso for his devotion to the study of his father's art and his unfailing kindness to scholars, both young and old. I also very much appreciate the access granted me by the heirs of Picasso's correspondents.

In the scholarly community, I have received crucial support and assistance from art historians on whose publications my work greatly depends. Despite the overwhelming task of writing his magisterial multivolume biography, John Richardson frequently offered his time and suggested one or another individual or document that turned out to illuminate a crucial question. Similarly, Pierre Daix, over the course of many years, served as a sounding board and freely shared his extensive knowledge of the artist. Time and again, Judith Cousins dipped into her cornucopia of sources to revive an avenue of research that had seemed dead. I owe her a particular debt of gratitude for reading chapter 5 of the manuscript and offering many useful suggestions.

Among the greatest pleasures of writing this book have been the friendships I have made with the descendants of my subjects. Brigitte Level shared not only essential documents on the activities of André Level and La Peau de l'Ours but also, as the president of the Société

des Poètes Français, her knowledge of and enthusiasm for French art. Ariane Lopez-Huici likewise encouraged my study of her great-aunt Eugenia Errazuriz. I am grateful to Daniel Wildenstein for granting me an interview to discuss his family's little-known involvement with Picasso in the years between the world wars.

Most of all, I have benefited from long discussions with Elaine Rosenberg, the daughter-in-law of Paul Rosenberg and widow of his son, Alexandre. Not only did Mrs. Rosenberg and Micheline Sinclair, Paul Rosenberg's daughter, give me permission to use the Rosenberg correspondence, but they shared with me the family's history from the twenties and thirties. Over many lingering lunches atop the old Paul Rosenberg Gallery in New York, Mrs. Rosenberg searched her remarkable memory and hunted up documents to revivify the period. Despite her abiding interest in the history of the family's business, she never made any attempt to control the contents of this book. Such discretion is extremely rare today. I can only wish that I had met her long ago and that I had had the opportunity to converse with her husband.

I have profited from the advice of many curators who took time from their exhibition programs to read stages of the manuscript. Charles S. Moffett and Kirk Varnedoe kindly evaluated parts of the text in conjunction with my tenure procedure at Trinity College. Charles Stuckey devoted a considerable amount of his apparently boundless energy to reviewing much of the manuscript for a publisher and for academic promotion. His scrupulous comments are especially appreciated.

For my practical training in the art market, I thank Michael Findlay and John Steinert. During the two years I spent as a principal in the Department of Impressionist and Modern Art at Christie's (1986–88), Michael Findlay directed the department and passed on to me some of his infectious, knowing enthusiasm for a very worldly profession. John Steinert's constant metaphysical searches kept me sane.

My goal of addressing the formation of Picasso's public reputation —one of the questions I hope to have shed some light on in this book—stems from a dissertation I wrote at Columbia University during the 1980s on Picasso's projects for a tomb monument to honor Guillaume Apollinaire. Although the contents of that text figure only briefly here, the research that underpinned it was crucial. I wish to

thank Michel Décaudin, Leroy C. Breunig, and William Rubin for the long-term support that enabled me to grow from a novice graduate student to a more seasoned professor. My oldest debt, however, is to Theodore Reff, who oversaw my graduate career from the boot camp of the introductory seminar to the defense of my thesis. Through all the transformations of those years (and beyond), he has remained a most considerate adviser.

Many professionals have facilitated my research in archives and libraries in France and the United States. Among them are François Chapon, Anne Distel, Colette Giraudon, Clive Philpot, and Rona Roob. To them and to the many others who have aided me over the years, I offer hearty thanks.

I have enjoyed the attention of several fine editors. At *Art in America*, where parts of chapters 1–3 first appeared, I had the pleasure of working with Elizabeth Baker and Ted Mooney. Their thoughtful attention to my drafts not only improved the resulting articles but taught me a great deal about the craft of writing. Sarah King performed a significant service by securing photographs for both the articles and this book.

At Farrar, Straus and Giroux, it has been my privilege to work with Jonathan Galassi. He has always been ready with encouragement and with insightful criticisms that have improved the clarity and focus of the book. Without his attention, it would have been far inferior. Paul Elie has been a highly efficient and resourceful coordinator of the project. For any remaining errors, omissions, or confusions, only I am to blame.

I offer warmest thanks to my agent, Gloria Loomis, for her sensitive reading of the manuscript and her belief in the project.

With much appreciation, I acknowledge the institutions whose financial contributions helped fund my research: the National Endowment for the Humanities, Trinity College, and Columbia University.

Many friends have lent essential support. My colleagues in the Department of Fine Arts at Trinity College—Jean Cadogan, Kathleen Curran, Alden Gordon, and Michael Mahoney—have been unfailingly generous with both their advice on scholarly matters and their encouragement as the book slowly came together. In academia, it is highly unusual to find a group of scholars who still honor individual freedom and truly enjoy cultivating the mind. I thank them for giving

me such a convivial place to work and, in recent years, such a gracious
roof over my head. It has been a great pleasure to teach the students
at Trinity; their enthusiasm and their belief in my efforts, even if few
of them will ever read this book, were a frequent and vital source of
strength.

In a fine tradition of friendship, Nicholas Olsberg listened patiently
and offered sage advice during many stages of my work. Others, par-
ticularly Nan Richardson, helped me revise the text.

Like most other projects that absorb many years and cross funda-
mental divides in their authors' lives, this one involved far too deep a
debt to my family for me to express here. The absolutely unswerving
personal devotion and financial assistance of my parents, Doris Cowan
FitzGerald and James Lawrence FitzGerald, have grounded not only
this book but my intellectual life. My wife, May Castleberry, has con-
tributed to every aspect of this project. Her critical eye and unvar-
nished evaluations have honed the text, while her encouragement to
look beyond an academic audience has enlivened its style.

This book is dedicated to my father, who lived long enough to know
it would be published but not long enough to hold it in his hands.

New York City
August 1994

CONTENTS

MAKING

MODERNISM

□

INTRODUCTION

I n the fall of 1918, as the First World War ended, Picasso lashed
out at his sometime dealer Léonce Rosenberg with militaristic
fervor: "Le marchand—voilà l'ennemi."[1] Far more than merely reflect-
ing the spirit of that violent time, this hostile characterization of the
relationship between artist and dealer has helped shape our conception
of artistic stature and the development of modernism across the twen-
tieth century.

Despite the popular attention that has been lavished on the daily
lives of Picasso, Matisse, and their contemporaries, as well as the schol-
arly analysis that has been devoted to their masterpieces and minor
productions, artists have generally been studied in isolation from the
dealers who represented them and the marketplace that judged their
work. Not all writers have echoed Picasso's accusation that dealers are
the enemy of artists, yet most have disregarded the relevance of com-
merce in the history of twentieth-century art. Dealers may be com-
mended for their willingness to lend financial support by purchasing
artists' work or encouragement through exhibitions and publications,
but artists themselves are rarely portrayed as actively allied with dealers
in promoting their careers.

Only two years before Picasso issued his denunciation of the trade,
Léonce Rosenberg had offered just such a collaboration: "*Together*, we

will be *invincible.* You will be the *creator,* I will be the *action!*"[2] And Daniel-Henry Kahnweiler, the dealer of Picasso's youth and old age, openly acknowledged the artist's desire to reap the benefits of commercial success: "A long time ago Picasso told me, 'I'd like to live like a poor man with a lot of money.' This is really the secret. Picasso wanted to live like a poor man, to continue to live like a poor man, but not to have to worry about tomorrow. That is really what he meant—to be free of financial worry."[3] To most readers, this goal is probably not much of a secret, since many people follow the same dream—to be financially secure but unrestricted by social expectations. But it does appear to be a secret in regard to the history of avant-garde art, because of the widespread assumption that these artists' rejection of established conventions (aesthetic and otherwise) must involve an opposition to the systems of consumption that generate wealth and fame in our culture.

Perhaps the photographer Cecil Beaton best captured the surprise some still feel upon realizing how far modern artists could diverge from this image. As he approached Picasso's studio for the first time in the early 1930s, Beaton recounted, "I conjured up mental pictures of some extremely *farouche* Bohemian living in a disordered studio, and expected to find the maestro in a chaos of tubes of paint and plaster. Instead of this, Picasso welcomed me to his flat in the rue La Boétie looking as neat as a new pin in an extremely smart navy-blue suit, white shirt which showed a lot of cuff, and a satin tie [frontispiece]. He showed me around an apartment which contained many exquisite pieces of Regency furniture with the manner of a *Grand Seigneur.*"[4] Clearly, Picasso did not always choose to live like a poor man. Despite the expectations that Beaton harbored, a number of leaders of the avant-garde were in fact very worldly figures.

Many of them were deeply immersed in the wide-ranging business of the marketplace. Moreover, the market was not peripheral to the development of modernism but central to it. It was the crucible in which individual artists' reputations were forged as critics, collectors, and curators joined with artists and dealers to define and confer artistic standing.

The topic of this book is not merely the relationship of artist and dealer in selling the work. It begins in the studio with the question of how artists' ambitions for public success may shape their art and ex-

pands to encompass the broad array of promotional activities maker and merchant pursued to enhance the standing of individual artists and to establish the varied movement called modernism.[5]

I explore this fundamental process by charting the formation of a market for the art of the twentieth-century avant-garde from its origins in Paris at the turn of the century to its transfer to New York at the beginning of the Second World War. By revealing the intricate network that often intertwines commercial success and critical acclaim to create artistic stature, this book presents an approach to the development of modern art that places the artist at the center of a promotional enterprise, thereby directly joining the artist's studio with the dealer's marketplace and the world beyond.

In this expansive program, museums become both an integral part of the venture and the ultimate forum for accreditation. As the campaigns of artists and dealers became increasingly successful, the number of institutions receptive to modern art expanded in Europe and especially in America. With considerable sophistication, dealers extended their activities to join with directors and curators in developing audiences around the world. Generally working behind the scenes, dealers and their artists orchestrated museum exhibitions that raised the leading twentieth-century artists to the rank of modern masters.

My account focuses primarily on Picasso and the growth of his reputation from his first, difficult years in Paris through his lionization at the Museum of Modern Art's retrospective of his work in 1939–40, when he was fifty-nine years old. I believe this emphasis on a single artist is well justified. Whatever one's opinion of Picasso's achievement may be, there is little doubt that during the first half of this century he quickly became the most famous artist of his time and a model for success—with critics and curators as well as dealers and collectors—that other artists sought to emulate. Moreover, the remarkably rich resource of his correspondence with leading figures in the art world offers an exceptional opportunity to look behind the artist's many masks and attempt to see how his public reputation was constructed within the network of professionals who gathered around him.

I do not mean to give the impression that this phenomenon is unique to the modern era. In the 1720s, the historian Filippo Baldinucci reported that Rembrandt had bid up the prices of paintings and drawings at auction "in order to emphasize the prestige of his profes-

sion," and in recent years Francis Haskell has concluded that the large sums received by artists such as Bernini in the seventeenth century served a similar purpose: "These high prices, besides making life more comfortable for the artist, had an important symbolic function. They raised the whole status of art in the eyes of the world."[6] In the twentieth century, this role of the market has certainly been revived, if not elevated to new heights of influence and honed to a sharp edge.

During most of the intervening years, however, the conception of the artist as an entrepreneur lost its charm. The official academies of art and agencies of state patronage that arose in the later seventeenth and eighteenth centuries promulgated an opposing model. Seeking to centralize artistic theory and practice, these new institutions viewed the independence and worldliness of some preceding artists as detrimental to the standing of the profession. Instead of applauding commercial success, the French Academy went so far as to dismiss it as harmful to the intellectual stature of art. The academy's founding statutes specifically forbade members to publicly engage in the sale of their work or "to do anything to permit the confounding of two such different things as a mercenary profession and the status of Academician."[7] Until the middle of the nineteenth century, the power of the academy to create reputations and influence commissions subsumed self-promotion under the guise of institutional advancement. Competition for a Prix de Rome—the highly coveted fellowship to study at the French Academy in Rome—seamlessly melded the various threads of this enterprise because success could mean not only aesthetic commendation but lucrative contracts as well.

Despite the academy's original goal of isolating artists from commerce, its patronage rarely sufficed, and its members refused, however discreetly, to refrain from promoting their work. Although these activities are yet to be reconstructed in all their variety (perhaps the artists' desire not to offend officialdom explains why it is difficult to locate documentation of their practices), it is clear that members of the academy and other prominent artists aggressively cultivated private markets, often by selling directly from their studios. Moreover, a scattering of dealers arose (frequently paint suppliers, antique sellers, or failed artists) who represented painters and sculptors apart from their official activities.

By the middle of the nineteenth century, acclaim in the commercial arena rivaled the importance of institutional honors in making an artist's reputation, and the academy's prestige began to be usurped by artists who built their careers in the open marketplace. Whether one chooses to begin with Courbet's presentation of his own work in his Pavilion of Realism across from the Universal Exposition of 1855 or with the furor surrounding the Salon des Réfusés in 1863, it is apparent that artists were searching for ways to establish themselves outside the purview of the academy and official patronage. The growing network of dealers began to respond.

It was, of course, the Impressionists who achieved this breakthrough. As Cynthia and Harrison White suggested nearly thirty years ago, the Impressionists did not simply create an art that repudiated the aesthetic norms of the academy. If they had done only that, they might well have remained as obscure as they were in the 1870s. The success of the Impressionists was based on a more remarkable—and more complex—achievement. By coupling their new aesthetic with the establishment of a commercial and critical system to support their art, they not only created the movement of Impressionism but also laid the foundation for the succession of modern movements that would dominate art through the twentieth century.

Such a fundamental reorientation was not easy to accomplish, and its realization consumed many years. It is not surprising that the Impressionists enjoyed relatively little critical acclaim and lacked financial security until the late nineteenth century. It would be mistaken to conclude, however, that many of the Impressionists did not seek wealth and the broad commendation of their art that frequently accompanies high prices. Renoir, for example, claimed: "There's only one indicator for telling the value of paintings, and that is the sale room";[8] both he and Monet, in particular, astutely developed their markets in tandem with their reputations.

By the 1890s, the concerted efforts of the Impressionists and their primary dealer, Paul Durand-Ruel, had firmly established an international network of collectors and critics that in the following years delivered substantial wealth and acclaim to the Impressionists. This success enabled Monet to cultivate the private world of his extensive gardens at Giverny, which in turn served as the subject of many of

his late paintings. And Renoir settled in the South of France in a house, Les Collettes, surrounded by acres of orchards. So situated, Monet and Renoir received admirers in almost stately grandeur.

Yet the Impressionists' greatest acclaim came in the first decades of the twentieth century, when the much younger artists of the Fauve and Cubist movements were already becoming established. By the 1920s, the aged Monet had nearly been eclipsed by Picasso and Matisse in their rapid rise to prominence. This overlap of generations reflects the maturation of the market for modern art and the increasing sophistication of artists and dealers in the twentieth century. Although the basic model for an entrepreneurial avant-garde was created by the Impressionists, it was the artists of the next century who truly reaped the benefits. Not only did they achieve critical acclaim and financial independence far earlier in their careers but several enjoyed the ultimate accolade—a museum retrospective—before the Impressionists were so honored.

During those years, one of Renoir's frequent guests was Ambroise Vollard, who took advantage of his visits to Les Collettes to buy many works directly from the artist. By the turn of the century, Vollard had become not only a dealer in Impressionist paintings but also the chief representative of Cézanne and Gauguin, among other Post-Impressionists. Vollard was a crucial figure in the development of the market for modern art because he served as a bridge from the Impressionists to the Post-Impressionists and on to the new generation of twentieth-century artists.

Even more than the reputations of the Impressionist generation, those of the Post-Impressionists have seemed to demonstrate the notion that avant-garde artists are opposed to involvement in the commercial world. Van Gogh and Gauguin, in particular, are eulogized for their adherence to their artistic beliefs in the face of financial and critical rejection. Without doubting their sacrifices or commitment, one can fairly say that their attitude toward the marketplace was both considerably more complex and much less dismissive than might be assumed. For all its suggestiveness, Gauguin's choice to pursue a bohemian life in the South Seas did not prevent him from applying the craft he had learned in his earlier career as a stockbroker in promoting his reputation through critics and dealers back in France. One might even wonder whether the growing success of the Impressionists in the

1880s did not underpin Gauguin's decision to follow his contrary course.

Among the Post-Impressionists, van Gogh has had the most powerful effect on our conception of the modern artist. His persistence in the face of an almost complete failure to sell his work has enthralled many, especially since his paintings have become the most consistently valuable of those produced by modern artists. Ironically, the willingness of buyers to pay record prices may owe something to their sentimental response to his lifelong poverty. Yet, not only was Vincent van Gogh the brother of an art dealer, he himself spent seven years in the profession. From 1869 to 1876, Vincent worked as a dealer, including a stint in Paris with the mainstream firm of Goupil-Boussod & Valadon, before beginning his career as a painter. His brother, Theo, joined the same establishment in 1879 and remained there until his own mental collapse in October 1890, a few months after Vincent's suicide.

Perhaps more than any other of the Impressionists or Post-Impressionists, Vincent understood the market, and he freely acknowledged the crucial role a dealer could play in both materially and critically supporting artists. He urged his brother to leave Goupil, where Theo nurtured a small market in the work of Gauguin and other contemporaries, to found an association devoted to his confreres in the avant-garde that would parallel his long-sought "academy" for like-minded artists. Vincent repeatedly admonished his brother that artist and dealer were linked in a communal pursuit. In one of his last letters to Theo, he returned to this theme and suggested that the dealer might even contribute to the creation of art: "I tell you again that I shall always consider you to be something more than a simple dealer in Corots, that through my mediation you have your part in the actual production of some canvases . . ."[9] Despite his failure to win public support, Vincent continued to believe in a collaboration between dealer and artist that reached from the easel to the marketplace and to the broad public.

If he and the other leading Post-Impressionists had been as long-lived as most of the prominent Impressionists, they almost certainly would have enjoyed the acclaim they sought during their lifetimes. With the Impressionists established by the end of the nineteenth century, the Post-Impressionists followed in the first decade of the twen-

tieth. Yet, for most of them, recognition came at the very end or posthumously. In contrast to Degas, who died in 1917 at the age of eighty-three, Renoir, who died in 1919 at seventy-eight, and Monet, who survived until 1926 to the age of eighty-six, many of the Post-Impressionists died relatively young: van Gogh in 1890 (thirty-seven), Seurat in 1891 (thirty-one), Lautrec in 1901 (thirty-six), Gauguin in 1903 (fifty-four), and Cézanne in 1906 (sixty-seven).[10] During their short careers, the Post-Impressionists were lost in the wake of the Impressionists. This limited span of time and the artists' secondary position in the development of the market are crucial in any evaluation of their reception. Given lives of normal length, the Post-Impressionists might be remembered very differently today.

Vollard quickly grasped this generational trend, and he enlarged his activities during the early years of the century to include some of the young artists who were just appearing on the scene—giving Picasso his first show in 1901 and Matisse his first solo exhibition in 1904. Although Vollard never chose to represent either artist, he taught them both the realities of the marketplace. Having learned those lessons, Matisse soon became known as a very hard bargainer. His business acumen was apparent in 1909, when he entered into his first contract with a gallery, the Galerie Bernheim-Jeune, which acknowledged his substantial role in the sale of his work and his speculation on future profits. More than forty years after exhibiting at Vollard's gallery, Picasso told his companion, Françoise Gilot, that he still "based his own maneuvers on Vollard's tactics."[11] This experience informed Picasso's relationship with Kahnweiler, as their initial contacts grew into an alliance that lasted from approximately 1910 until the First World War.

It is at this point, when the market for contemporary avant-garde art in France was only starting to be established, that this book begins, with the early careers of Matisse, Picasso, and their contemporaries. It continues through the beginning of the Second World War, by which time they had achieved worldwide acclaim. After a slow beginning in the first decade of the twentieth century, the market for contemporary art boomed in the years just before the First World War and reached a peak of public attention in the spring of 1914. The following four years of war, however, quickly dissipated this new audience, and it did not revive until the early 1920s. The twenties wit-

nessed a maturation of the market that in many ways created the network of relationships we call the art world today. Its range and sophistication led to a great series of museum exhibitions during the 1930s that celebrated the foremost artists of the twentieth-century avant-garde and the achievements of modernism.

During the decade before the First World War, the remarkably wide-ranging activities of a group of collectors called La Peau de l'Ours (The Skin of the Bear), after a fable by La Fontaine enable us to map the burgeoning market for contemporary art. The group's direct involvement with young artists demonstrates the role that collectors often played in helping them secure their first gallery affiliations and begin to gain public reputations.

With the wartime collapse of the market and the closing of the Galerie Kahnweiler, among other galleries, Picasso becomes the primary focus of this book, as his private correspondence reveals his struggle to further his career by securing new aesthetic and financial support. After a brief association with Léonce Rosenberg, who sought to promote a school of Cubism under his banner of "Effort Moderne," Picasso shifted course. His efforts to move beyond Cubism by opening his art to Neoclassical styles attracted the patronage of aristocratic circles he encountered through his friendships with two impresarios, the poet Jean Cocteau and Eugenia Errazuriz, a woman of great taste and social prestige. His condemnation of dealers as "enemies" in 1918— the rebuke with which we began—signifies Picasso's increasing confidence in achieving a transformation of his art and public reputation, not his isolation from the trade.

The core of this book is devoted to the alliance that Picasso formed in 1918 with two of the most prominent dealers in France, Paul Rosenberg (Léonce's brother and sometime competitor) and Georges Wildenstein, a world-renowned dealer in Old Masters. With Wildenstein as a largely silent partner (he withdrew entirely in 1932), Rosenberg became Picasso's public representative and brought the artist into a gallery that had established its reputation in the market for nineteenth-century French painting—not contemporary art. The association endured for twenty-one years.

The relationship between Picasso and Paul Rosenberg was based on far more than a simple commercial contract to buy and exhibit the artist's work. From the outset, it was an intense collaboration that both

stimulated Picasso's art and contributed greatly to his growing reputation. Living next door to the building that housed Paul's residence and gallery on the elegant rue La Boétie, Picasso was surrounded by the Impressionist and Post-Impressionist paintings that had long been Rosenberg's specialty; they became inspirations for Picasso's art and measures of his stature among the modern masters.

During the 1920s and 1930s, Paul Rosenberg organized a series of exhibitions that stretched from his gallery in Paris across Europe to the United States. As he orchestrated these shows, Rosenberg constantly consulted with Picasso, and his correspondence explicitly records their concerted efforts to promote Picasso's work around the world. Moreover, Rosenberg's accounts of his trips to America provide rare views of how the country responded to modern art in those pioneering years.

The apogee of their partnership was a series of retrospectives in some of the world's leading institutions: in 1932 at the Galeries Petit in Paris and the Zurich Kunsthaus, in 1934 at the Wadsworth Atheneum in Hartford, and in 1939–40 at the Museum of Modern Art in New York and the Art Institute of Chicago. Paul Rosenberg's correspondence with curators, directors, and dealers documents the essential role he and Picasso played in shaping these grand displays. The exhibitions present a remarkably varied set of relationships between artist, dealer, and curator—ranging from the Petit exhibition, which was arranged by a trade consortium, to the Atheneum's first American retrospective of Picasso's work, which Paul Rosenberg largely organized behind the scenes, to the MoMA/AIC blockbuster.

In this sequence, the Modern and its director, Alfred Barr, play a crucial part. Beginning in 1930, Barr fought to assert his authority over artist and dealer in organizing exhibitions at the museum. While still deeply dependent on Picasso and Rosenberg, the retrospective of 1939–40 marked Barr's establishment of new curatorial prerogatives in the exhibition of contemporary art. In so doing, Barr's landmark exhibition both validated Rosenberg's campaign to initiate museum exhibitions of Picasso's work and transformed the dealer's influence over the resulting shows. Underlying these early presentations of twentieth-century modernism in museums is an intimate intermingling of functions between artists, dealers, and curators, which, although widely

decried during the boom years of the 1980s, has long characterized the promotion of modern art.

Just before the German Army swept over France in the summer of 1940, Paul Rosenberg successfully established both Picasso's paramount status and his own prominence as a dealer in America, to which he transferred his gallery during the Second World War. Yet, as the First World War had prompted his alliance with Picasso, the Second War ended it. Rosenberg's flight from France to escape the Nazis forced him to limit severely his purchases of Picasso's work and opened the door to Picasso's renewed association with Daniel-Henry Kahnweiler. From 1918 to 1939, however, Picasso and Rosenberg pursued a collaboration in artistic promotion that substantially created the image of Picasso and the modern movement that is still widely affirmed.

CHAPTER I

THE SKIN OF THE BEAR

□

O n March 2, 1914, the art world celebrated a major achievement in the history of twentieth-century art. On both sides of the Atlantic, artists, critics, dealers, collectors, and curators alike cheered an event that took place in Paris at the dowdy municipal auction house, the Hôtel Drouot. The occasion was the sale of a collection called La Peau de l'Ours, and the cause for celebration was the auction's phenomenal financial success. It was the first time that the art of the Fauves and the Cubists had really been tested in the public marketplace, and among the 145 lots in the auction the vast majority were works by twentieth-century artists. Beginning with paintings by Gauguin, van Gogh, and other Post-Impressionists, the collection presented a panorama of twentieth-century art centered on the early work of Picasso and Matisse. The ten paintings by Matisse extended from his earliest essays in the style of seventeenth-century Dutch masters, such as *Still Life with Eggs* (1896), to his pointillist masterpiece *Still Life with a Purro, II* (1904). Picasso was represented by twelve paintings and drawings, ranging from the Blue period *Man in a Cloak* (1900) to the Cubist *Bowl of Fruit* (1908), but there was no doubt in anyone's mind that the star of the sale was his greatest painting of the Rose period, *The Family of Saltimbanques* (1905; fig. 1), which received its first public exhibition on this occasion. Still, it was only an auction.[1]

The thirteen men who had assembled this collection over the pre-
ceding ten years, under the leadership of a businessman named André
Level, had always intended to sell it at the end of a decade.[2] They had
never hidden the fact that they were speculators. As they searched
makeshift galleries, amateurs' apartments, and artists' studios for prom-
ising investments, the men of La Peau de l'Ours had charted the nas-
cent trade in the art of the twentieth-century avant-garde and had
contributed greatly to its development into a thriving market. The
scale of their purchases rivaled that of better-known patrons like the
Americans Leo and Gertrude Stein and the Russian Sergei Shchukin,
but in the diversity of its interests, La Peau de l'Ours surpassed these
collectors. Probably more than the involvement of any of the group's
contemporaries, the activities of La Peau de l'Ours enable us to obtain
a near-comprehensive overview of the rapidly developing market dur-
ing the heady years before the First World War. Moreover, the group's
frequent practice of buying directly from artists reveals not only the
broad pattern of collecting but also the effect of individual exchanges
on these artists' work and careers.

The openly speculative purpose of La Peau de l'Ours focused atten-
tion on the relationship of commercial and aesthetic judgments. Al-
though the relatively low prices fetched by contemporary art might
suggest otherwise, many people were already concerned about the fair-
ness of profiting from investment in the work of emerging artists. The
Berne Convention of 1886 had codified rights of authorship, but until
1920, French law did not specify a visual artist's right to share in the
profits from the resale of his work.[3] (Such a right still does not exist in
U.S. law.) Yet this resale principle, known as the *droit de suite*, was
much discussed in 1914, because the organizers of La Peau de l'Ours
decided to institute it voluntarily six years before it became law.
Clearly, the awareness that artists might be exploited financially by
speculators did not begin with Robert Rauschenberg's famous com-
plaint to Robert Scull after the sale of Scull's collection at Sotheby's
in 1973. It was foreseen and addressed by the organizers of La Peau
de l'Ours when they decided to return twenty percent of their profits
to the artists involved, an act that the leading avant-garde critic Guil-
laume Apollinaire and his colleagues acclaimed.[4]

Yet their enthusiasm for the successful auction was a measure of
more than their gratitude for the checks they expected their friends

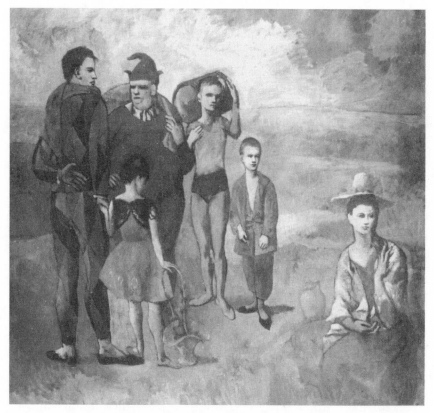

1. Picasso, *The Family of Saltimbanques*, 1905
(National Gallery of Art, Washington, D.C.)

to receive. The critics perceived the auction as a confirmation of the art's importance that their own aesthetic evaluations could not confer. In retrospect, Picasso's good friend André Salmon even characterized the sale as the "*Hernani* of painting,"[5] equating the auction with the premiere of the play by Victor Hugo that in 1830 became a symbol of the public triumph of avant-garde art and its role in the overthrow of the French monarchy in the July Revolution.[6] Even if exaggerated, Salmon's allusion instills the Peau de l'Ours auction with a broad cultural—and even political—significance by defining it as a crowning example of the direct engagement of avant-garde art with popular opinion.

While the creation of the Peau de l'Ours collection maps the de-velopment of the budding Parisian market for the art of the twentieth-

century avant-garde, the great public attention accorded its auction marks the aesthetic and financial confluence of the avant-garde and the mainstream that had begun by the First World War. The history of the Peau de l'Ours collection casts the issue of the interdependence between critical and commercial acclaim in a historical light and enlarges our understanding of the role of commercial success in the development of artistic reputation.

Even the collection's name—La Peau de l'Ours—identified the investors' awareness that their venture was subordinate to the careers of the artists they collected. The La Fontaine fable from which it derives, the tale of "The Bear and the Two Companions" (Book 5, number x), is, in fact, a stiff admonition against speculation. Two friends in need of money sell the skin of a great bear to a furrier before they have gone to the trouble of trapping the creature. The "future contract" goes unfulfilled because the bear not only proves indomitable but even subdues one of the hunters, only to whisper slyly into his ear, "Don't sell the bear's skin before you've downed him." By adopting the title La Peau de l'Ours, this group of buyers cast themselves in the role of La Fontaine's inept hunters in search of profit, only from a different type of skin—a painted one.[7]

A visit to the first Salon d'Automne in 1903 inspired André Level to organize the group, but his pursuit of a speculative venture in contemporary art sprang from the transformation in the market for modern art that he had witnessed during the preceding decade.[8] Level acknowledged that his education as a collector began in 1895, when he met several of the young dealers who were supporting avant-garde artists. Like many other collectors, Level developed his interest through a social encounter: during his summer holiday at the resort of Bain de Mer he met the Bernheim brothers, Gaston and Josse. When he followed up the acquaintance by visiting their Galerie Bernheim-Jeune in Paris, he saw for the first time the work of Nabis artists, whom the gallery had recently begun to show.

Although only thirty-two, Level was sufficiently comfortable in his career in the shipping industry that he could devote the late afternoons to cultivating other interests (fig. 2). He chose art and never doubted that its rewards might be both aesthetic and economic. After becoming a regular at the Bernheims' gallery, he soon expanded his contacts to include several of the other dealers handling the work of avant-garde

artists. The most important of these was Ambroise Vollard, who was building a career as a dealer in Impressionist and Post-Impressionist art. Vollard's pioneering show of Cézanne's work in 1895 was probably the crucial event in Level's early education. Yet, despite his romantic

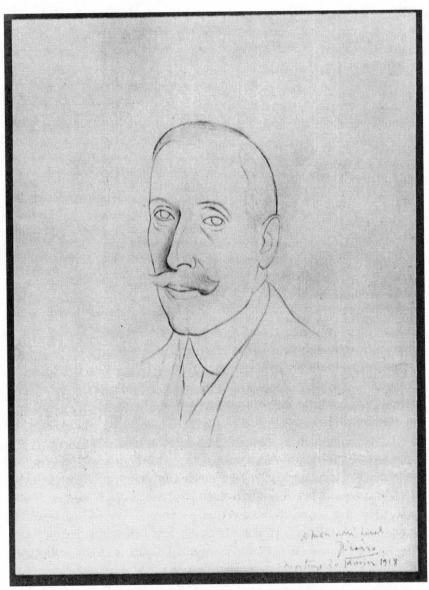

2. Picasso, *Portrait of André Level*, 1918
(Private collection, Paris)

fascination with "unique works in which the hand of the artist still resonates," Level refused to pay the five hundred francs Vollard demanded for a landscape by Cézanne. Instead, he purchased a painting from Vuillard for the modest sum of one hundred francs.[9]

As is well known, the artists of the Impressionist generation struggled for approximately twenty years to achieve the substantial prices for their works that became common by the mid-1890s.[10] Nonetheless, the appreciation in the market for Impressionist and Post-Impressionist art that Level observed during the last years of the nineteenth century and the first years of the twentieth soon justified Vollard's price. With this demonstration of a thriving market for art outside the system of academy and state patronage, the work of following generations began to be reconsidered.

Three events are illustrative. In 1895, at the estate sale of the art-supply dealer Père Tanguy (who had often swapped materials for finished pictures), Vollard had been able to scoop up paintings by Cézanne for a hundred or two hundred francs. Auctions held in 1900 and 1906 by Eugène Blot, an amateur dealer, charted a rapid appreciation in the market for Post-Impressionist art. Since many of the paintings by Cézanne, Gauguin, van Gogh, and Toulouse-Lautrec that Blot presented in 1900 were less desirable than his Impressionist pictures and remained unsold, he waited six years before offering them again. This time, they proved more sought-after than Impressionist works. As he recounted: "The times had changed. Previously, I said that the pure Impressionists were less in fashion than six years earlier. In contrast, the great unknowns that I had been forced to buy back [in 1900] attained the highest prices, and Cézanne, Renoir, Gauguin, van Gogh and Toulouse-Lautrec, as well as some of the new school called Neoimpressionist, like Bonnard and Vuillard, were far more highly prized."[11]

If these events suggested a trend in the prices of contemporary art that led some astute collectors to turn their attention to artists emerging in the first years of the twentieth century, the fact that works by the Impressionists brought extremely low prices for decades and that the Post-Impressionists saw substantial prices for their works only at the end of their lives caused many of the dealers and collectors interested in contemporary art to judge the potential market for young artists' work skeptically. The late, indeed sometimes posthumous, es-

tablishment of a market for the art of the Post-Impressionists initially worked to the disadvantage of twentieth-century artists. At Vollard's gallery, for example, Picasso and Matisse found themselves in competition with their revered predecessors Cézanne and Gauguin. This situation did not change until 1904, when Gauguin's recent death and Cézanne's failing health forced Vollard to look for new sources of merchandise.

The Salon d'Automne was created in 1903 to ameliorate this problem by establishing a venue that would present to the public the art that a panel of distinguished jurors had selected as the best in contemporary art; although the Salon des Indépendants, too, was outside the academic system of the Salon des Beaux-Arts, its exhibitions were vast unjuried shows. That the Salon d'Automne indeed focused public attention on contemporary art is evident not only from the *succès de scandale* of the Fauve room in 1905 but also from the fact that future leading amateurs and dealers, including Leo and Gertrude Stein, Wilhelm Uhde, and Daniel-Henry Kahnweiler, began collecting twentieth-century art on the inspiration of what they saw in these annual exhibitions. Certainly for Level, who was not unfamiliar with the contemporary scene, the first Salon d'Automne achieved its goal: "For me it was a revelation. There was a boldness and youthfulness in contrast to the monotony and lack of inspiration in the big annual *salons* . . . I saw there paintings which appeared to me, not without a moment's doubt, to be the authentic art of our epoch and the near future."[12] Since he did not personally have the means to act on this perception, Level resolved to form a consortium with sufficient resources to do so. This became La Peau de l'Ours, which gave Level the responsibility for spending 2,750 francs a year on contemporary art.[13]

To a large extent, La Peau de l'Ours was a family affair. André convinced his three brothers, Emile, Jacques, and Maurice, to join, as well as a cousin, Georges Ancey, the Baron Curnieu. Although Ancey was already an accomplished playwright and poet, André was the only member of his family knowledgeable about the art market. So, as André's brothers pursued careers that led to prominent success—Emile in banking, Jacques in the utilities industry, and Maurice as a lawyer —they generally left acquisitions to him. Moreover, André crafted the consortium's charter to reinforce his authority. As the permanent director, who could only be removed for gross malfeasance, he had the

right to propose works for purchase, though acquisitions had to be approved by both the director and another member appointed by the group. As we shall see, this requirement that André's decisions be seconded sometimes resulted in serious disagreements.[14]

Unlike the Steins, Uhde, and Kahnweiler, Level did not make his first choices from the works presented for sale in the independent salons. Beginning a year before the Steins and several years before Uhde and Kahnweiler, Level operated in the uncharted world of artists' studios and nascent dealers that the Salon d'Automne was designed to circumvent. His activities during the first years of the century not only reveal the vestigial but increasingly viable commercial network on which Matisse, Picasso, and their contemporaries depended but also enable us to investigate the importance of commercial success to their immediate survival and future reputations. This link is particularly evident in the artists' frequent reliance on galleries, where their critical reception was directly dependent on their commercial desirability, since the exhibitions necessary to publicize their work would not occur unless the dealers foresaw a chance for a profit.

From the beginning of La Peau de l'Ours in 1904, Level sought to assemble a collection devoted to art of the *début* rather than the *fin de siècle* in France. Although it included a few works by Post-Impressionist artists, most of the eighty-eight paintings and fifty-six drawings that constituted La Peau de l'Ours were the work of twentieth-century artists, and the largest concentrations were among the Fauves and Picasso. The first purchases included a painting by Vuillard, *Woman in Blue* (which Level convinced the artist to recall from Bernheim and sell directly to him); a Gauguin, *Portrait of Upaupa Schneklud* (1894; fig. 3), for which Level "outbid a big gallery," paying three hundred francs; and three paintings by Matisse. While Level's emphasis on the Fauves (a year before they made headlines) probably reflects both his response to their paintings in the 1903 Salon d'Automne and his long-standing friendship with one of their minor associates, René Piot, his interest in Picasso's art could only have come from the rare gallery exhibitions that included it.

On weekly tours of Montmartre, Level exercised his skills as an astute *dénicheur* by assiduously cultivating the meager network of secondhand dealers, particularly Père Soulier, Clovis Sagot, and Lucien

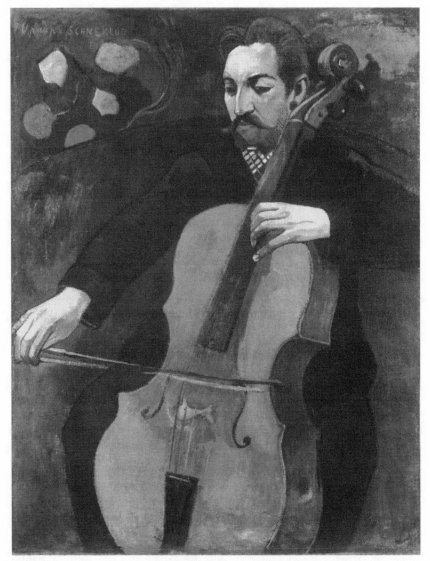

3. Gauguin, *Portrait of Upaupa Schneklud,* 1894
(Baltimore Museum of Art)

Moline, as well as the galleries, such as they were. In contrast to the plethora of outlets we know today, there were just two galleries in Paris that dealt in the work of artists of the new century. For Ambroise Vollard, Matisse and Picasso were experiments outside his primary focus on the Impressionists and Post-Impressionists. In the first years

of the century, only one gallery truly specialized in twentieth-century art—the Galerie Berthe Weill.

Level's influential position in this budding commercial network is evident from the relationship with Matisse that he began in 1904, the year that Matisse received his first one-man show in one of Vollard's few ventures into twentieth-century art. Soon after Level developed the plan for La Peau de l'Ours, he told René Piot about the scheme, and Piot introduced him to Matisse, with a strong recommendation to buy his paintings.[15] By March 19, Level had agreed to purchase several of his canvases for a total of 550 francs: *Still Life with Eggs* (1896), *Snow Scene* (c. 1899), and *Studio under the Eaves* (1902; fig. 4).[16] One of these paintings, *Studio*, is often said to reflect, in its striking contrast between the cramped, gloomy interior and the brilliantly illuminated view of nature, Matisse's own sense of entrapment as he struggled to earn enough money from his art to feed his family.[17] Presumably, Level's purchases helped alleviate this need, and Level's selection, ranging across Matisse's work from his early study after the Dutch masters to his current engagement with the Fauvist exploration of nature, records Level's commitment to the emerging twentieth-century avant-garde.

When Vollard finally agreed to hold a one-man show of Matisse's work in June 1904, the artist immediately requested permission from Level to include *Still Life with Eggs* in the exhibition, where it appeared as number 3 in the catalogue.[18] But Matisse's hope that the show would convince Vollard to stock his work (as Vollard did that of the Fauvist painter Henri Manguin in 1905 and Picasso in 1906) was dashed by the show's poor financial results. Once again, Matisse was forced to rely primarily on his own ability to cultivate the small group of private collectors who bought directly from his studio. In the summer of 1903, Matisse had already attempted to overcome his lack of a dealer by substituting a collector's consortium, which would have guaranteed him 2,400 francs a year in return for twenty-four paintings. Although the project may well have contributed to Level's ideas for La Peau de l'Ours a few months later, it failed to attract enough subscribers.[19] No doubt its failure made Matisse appreciate Level's purchases of an additional seven paintings for La Peau de l'Ours before 1914 and his efforts to help Matisse sell his pictures to other collectors in the years before his first contract with the Galerie Bernheim-Jeune in 1909.[20]

While Vollard refused to support the work of Matisse and his contemporaries with profits from the sale of their predecessors' art and to build the young artists' reputations by this association, Berthe Weill was exclusively committed to contemporary art.[21] Having served her apprenticeship in the bric-a-brac shop of a Monsieur Mayer, Weill had come to know most of the small cadre of adventurous collectors who sometimes bought paintings by unknown young artists. She had also

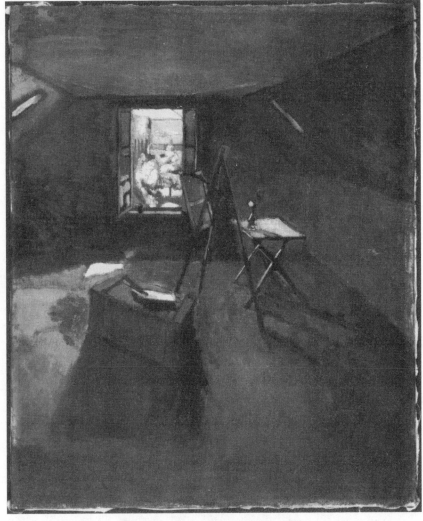

4. Matisse, *Studio under the Eaves*, 1902
(Fitzwilliam Museum, Cambridge)

met Vollard, who, according to Weill, had frequented Mayer's shop to learn the trade.

By 1900, Weill had opened her own antique shop, but her specialization in contemporary art began when she inaugurated the Galerie Berthe Weill on December 1, 1901. Her business card proclaimed that her gallery was a "place for youth." And as a sign of her dedication, and limited means, her working capital consisted of her dowry—four thousand francs. From the beginning, this independent woman presented the paintings of the French Fauves and Catalonian *modernistes* in group exhibitions that alternated with displays of more conventional prints. Weill may have been the first French dealer to sell works by Picasso—specifically, three bullfight scenes, which she bought for a total of a hundred francs and immediately resold for 150. She was also the first dealer to exhibit Matisse's work (in a group show of February 1902) and the first to sell one of his paintings (the following April, for 130 francs, of which Matisse received all but twenty). Weill's consistent adherence to very low commissions (whether or not for altruistic reasons) prevented her from ever providing the long-term support her artists sought, so, as their reputations grew, they left for better-capitalized galleries. Yet she relished her gallery's position as an initial showcase of new talent, and she persisted through the 1920s, when Picasso drew a stately portrait of her (fig. 5).[22] As the only woman who showed the work of twentieth-century artists and as the dealer who gave many of them their first shows, she deserves far more recognition than she has received.

Picasso's alien status as a Spanish citizen and his poor grasp of French, as well as his distrust of organizations, probably dissuaded him from exhibiting in the salons.[23] This left him particularly dependent on dealers to sell his work. His early reliance on Weill is recorded in a drawing he inscribed to her in 1901,[24] and it appears that Level's fascination with Picasso's work began at Berthe Weill's gallery that same year. In her autobiography, Weill recorded the surprise that each sale generated in those early days: "I sold to M. André Level two paintings by Picasso for which he paid me two hundred francs!! A rare event in that epoch, which is good to recall."[25] A list of her first dozen clients includes two collectors who would be the leading members of La Peau de l'Ours—Level and Ellissen. Moreover, Weill claimed that three-quarters of the items in the collection were purchased from her gallery.

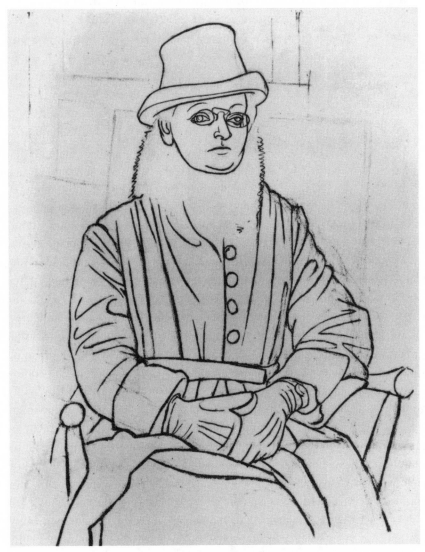

5. Picasso, *Portrait of Berthe Weill*, 1920
(Private collection, Paris)

Even if she exaggerated, there is no doubt that Level bought from her on a regular basis.[26]

Along with the Post-Impressionist works and three paintings by Matisse that Level acquired in the first year of La Peau de l'Ours, he bought *Intimacy* (1902–03) from Weill's second Picasso show, the first

of the twelve Picassos that would form the core of the collection.[27] This choice of a sentimental scene of women and children in a domestic setting reflects not only Level's taste for Vuillard's interiors but also a cautious approach to the market for twentieth-century art. Level was exactly the type of buyer Picasso had in mind, admitting that he had made the work to sell: "I was living on the rue Champollion. I wanted to do something to make some money. I'm a little ashamed to admit it, but that's how it was. So I did this pastel. I rolled it up and carried it to Berthe Weill. She lived in Montmartre, at the other end of Paris. It was snowing. And me with my pastel under my arm . . . She had no money . . . So I went away . . . and left the pastel."[28] A year passed before she hung it in a show and sold it to Level.

Picasso's frank acknowledgment of his commercial goal may shock those who were trained to believe that, at least among the avant-garde, art was created without concern for financial gain, but such idealism clearly does not correspond to Picasso's motivations. (Nor does it reflect the judgment of many critics at the later auction of La Peau de l'Ours that commercial success could substantiate the importance of art.) To Daniel-Henry Kahnweiler, after all, he said that he had always wanted to be rich, "to live like a poor man with a lot of money."[29] Picasso's enthusiasm for making money appears to have been moderated only by his desire to reject the social conventions that the bourgeoisie attached to wealth: his aim was to employ money to create freedom of action in his life and art. It is hard, therefore, to credit the claims of some recent scholars that Picasso was deeply sympathetic to radical politics in his early years. Instead, his acceptance of art as a commercial instrument places the avant-garde artist solidly within the tradition of entrepreneurship.[30]

Indeed, from the beginning of his career in France, Picasso applied his art and his social talents to the cultivation of those who might develop his reputation and make his fortune. Picasso's first show at Vollard's gallery in 1901 demonstrates the degree to which he consciously promoted his career in these early years. If Picasso chose Parisian scenes as his subjects and painted in broadly brushed, vivid colors to present himself as the successor of the Post-Impressionists, particularly Toulouse-Lautrec (see, for example, At the Moulin Rouge, 1901), he also painted three pictures that curried favor more directly. These were portraits of the three backers of the exhibition: Pedro Mañach

(his agent, who convinced Vollard to hold the show), Gustave Coquiot (the critic and collector who wrote the laudatory preface to the catalogue), and Vollard himself (fig. 6). Picasso gave two other works to critics who wrote complimentary reviews (Felicien Fagus and Pere Coll).[31] Thus, even in the desperate poverty he suffered at the beginning of his career, Picasso's actions reveal his understanding of the relationship between commercial success and critical commendation. His work, particularly the portraits, reflected this worldly approach for many years to come. So when his work began to command thousands of francs and receive public validation at events such as the auction of La Peau de l'Ours, Picasso may have viewed his success as at least in part the result of diligent cultivation over the previous years.

By 1906, Picasso's reputation and finances were becoming more secure as he attracted a group of collectors whose interest would eventually (about 1910) convince Kahnweiler to become his dealer and, apparently, end his financial worries. Late in 1905, Leo and Gertrude Stein had begun to collect his art, and probably in 1906 Sergei Shchukin made the first of his many purchases. Level convinced his col-

6. Picasso, *Portrait of Ambroise Vollard*, 1901
(Bührle Collection, Zurich)

leagues in La Peau de l'Ours to make a special commitment: the majority of their budget for 1906 was to be spent on the work of a single artist, Picasso. Culling Weill's stock and sending Clovis Sagot as his agent, Level purchased six paintings and watercolors for the collection. The works were primarily confined to the first years of the century; at least one of them, *The Blue House* (1902), seems to have been in Weill's back room since 1902, when she exhibited it in her first show of Picasso's work.[32]

About this time, Vollard finally decided to buy a substantial amount of Picasso's art. Even though he had presented a Picasso exhibition in 1901, Vollard did not make a major purchase until April 1906, when he acquired twenty canvases for two thousand francs. Level's activities may shed light on Vollard's newfound confidence in Picasso. Quite uncharacteristically, Level emphasized his priority over Vollard in collecting Picasso's work, and it appears likely that the clever dealer was responding to the purchases by Level, the Steins, and others when he made this substantial investment.[33] As Vollard surmised, he could now count on a market for Picassos.

The financial security these sales afforded may also have contributed to his manifest self-confidence in creating *Les Demoiselles d'Avignon* (1907), a painting that signaled to his contemporaries a fundamental, and disturbing, shift in contemporary art. Yet, by the end of 1907, he was once again in serious need of funds—and he found the necessary support in André Level. La Peau de l'Ours had expended its 1907 budget filling out its holdings of the Fauves (Albert Marquet, Henri Manguin, and Jean Puy) and Nabis (Maurice Denis and Ker-Xavier Roussel), but by the next year it was prepared to make a commitment to Picasso that exceeded in importance, if not in value, that of 1906. Although Level chuckled over buying a still life by van Gogh (*Flowers in a Vase*, 1890) from Vollard at a bargain price of five hundred francs, the major purchase of the year was a single painting by Picasso, *The Family of Saltimbanques*.[34] The picture had remained in Picasso's possession since it was finished in the fall of 1905, and it appears to have been one of the few to have escaped Vollard's sweeps of his studio in 1906 and 1907, either because Picasso refused to sell it or because Vollard would not meet his price. There is little doubt that on this huge canvas Picasso created a composition that synthesized his themes of the previous years and presented them on a scale

that fit the tradition of a salon masterpiece. It is not surprising, therefore, that Picasso had not parted with the painting two years after he completed it, and his decision to sell it then would seem to demonstrate the severity of his financial need. The timing may also reflect the negative reception that the *Demoiselles* was receiving from his small group of buyers. Even as Vollard accused Picasso of going mad in his current work, the dealer sought to find a buyer for the earlier painting.[35]

The negotiations over the sale of *The Family of Saltimbanques* clearly reveal the network that linked Picasso with his dealers and collectors. Level does not appear to have been a regular visitor to Picasso's studio, since he heard from Sagot (with whom he had recently begun working because Picasso often entrusted Sagot with his better paintings) that the picture was being offered to Russian and German collectors. Presumably, Vollard would have been involved, since he often sold to Shchukin (probably the Russian in question).

Level quickly entered the negotiations. To cut off other potential buyers, he made an offer of a thousand francs through Lucien Moline. Hoping for a higher price, Picasso did not initially accept. He did, however, welcome the suggestion that Level's group relieve his immediate distress by lending him three hundred francs for a month. Thus, both Picasso and Level kept their options open until the foreigners replied. Although this sounds like high finance, the conclusion was more mundane. In less than two weeks, Picasso accepted Level's original offer. Whether Picasso distrusted the dealers or had heard that their clients had refused to buy the painting, he walked from his studio on Montmartre to Level's office in the center of Paris and closed the deal. Even if the artist did not exactly come hat in hand, the meeting must have been a remarkable one for Level's staff to witness.[36]

By January 24, 1908, Level had arranged to have the huge painting framed, but not without considerable resistance from his group.[37] Everyone who attended the acquisition meetings of La Peau de l'Ours was free to speak, and the gathering early that year exploded. For Level, the purchase of *The Family of Saltimbanques* was his greatest achievement. Not only was the painting already acknowledged as one of Picasso's most important works, but Level had been forced to compete against foreign collectors and had nonetheless secured it at a bargain price. For several of the consortium's subscribers, however, it

forced the question of whether the group should be supporting Picas-
so's art, particularly since the one painting consumed more than a
third of the annual budget.

Level's successful championing of the *Saltimbanques* to the mem-
bers of La Peau de l'Ours answered these doubts when the painting
returned a phenomenal profit six years later at the auction of the col-
lection; it also marked the beginning of his long friendship with Pi-
casso. Perhaps to commemorate the ten-year anniversary of the
purchase, Picasso drew Level's portrait on January 20, 1918, and the
two men remained good friends until Level's death in 1946.[38] Level's
appreciation of the painting's significance and its public address is re-
flected in his desire to exhibit it in the Salon des Beaux-Arts. Level's
awareness that the final painting overlay two earlier versions must re-
flect discussions with Picasso, and he rightly judged it a culminating
work of the already historic Blue and Rose periods.[39] Indeed, Level
shared this sense of closure, since few of the works in La Peau de
l'Ours were created after 1905.

One reflection of the new friendship between Picasso and Level is
the group's decision in 1908 to buy *Bowl of Fruit,* an example of
the artist's most recent work and one of the rare Cubist pieces in the
collection.[40] Level also took Picasso's advice the next year when the
group bought five contemporary paintings by André Derain.

By 1909, the market for contemporary art was developing rapidly.
The activities of Level and other adventurous collectors finally con-
vinced prominent galleries and dealers with considerable capital to
make commitments to the leading artists of the twentieth-century
avant-garde. Nearly a decade after their first exhibitions, Matisse and
Picasso, as well as some of their contemporaries, began to be offered
the substantial commercial support that Berthe Weill could not afford
and that Vollard refused to extend. Matisse was the first to achieve
the security afforded by a contract when he signed with Bernheim-
Jeune on September 18, 1909. The gallery was obliged to purchase all
the paintings he produced during the next three years, at specified
prices (ranging from 450 francs for the smallest canvas to 1,875 francs
for the largest). Moreover, Matisse retained a twenty-five percent in-
terest in the profits from all sales and the right to accept orders for
portraits and decorations without compensating Bernheim-Jeune.[41]

These generous terms reflect both Matisse's business acumen and the gallery's confidence in his market.

The same month that Matisse signed his contract with Bernheim, Picasso used his new financial stability to move from the tenement Bateau Lavoir to a spacious apartment with a separate studio on the boulevard de Clichy; he also hired a maid to keep house and serve meals.[42] Yet Picasso still lacked a regular dealer. His search for a steady backer appears to be registered in the portraits he painted at this time, much as it was during other transitional periods in his career—such as his show with Vollard in 1901 and his cultivation of the Steins in 1905.[43] During 1909–10, Picasso painted five portraits—the last ones he executed until 1915. One represents his old friend Manuel Pallarès, whom he painted during a visit to Barcelona in the spring of 1909.[44] The other four depict dealers, not the poets or critics one might expect the artist to portray. Instead of Apollinaire, Salmon, and Max Jacob, for instance, Picasso labored for months over portraits of Clovis Sagot, Ambroise Vollard, Wilhelm Uhde, and Daniel-Henry Kahnweiler (figs. 7, 8, 9).

Appropriately, since Sagot had been the artist's most consistent dealer over the past few years, the first in this great series of Cubist paintings is a portrait of him that Picasso executed in the spring of 1909 before departing for Barcelona. Following his return to Paris and the move to new quarters, he embarked during the winter of 1909–10 on a closely matched set of portraits: Vollard, Uhde, and Kahnweiler.[45] While Sagot's small operation could not offer hope of long-term security, these three better-capitalized businessmen did. But although Vollard had made substantial purchases and continued to buy paintings from time to time, Picasso had been unsuccessful in obtaining a commitment from him. (True to form, Vollard sold his portrait a few years later to the Russian collector Ivan Morozov for three thousand francs.) Uhde had also been a regular customer since 1905, when he began to develop a collection that actually constituted stock for his private dealing. It is probably not a coincidence that Picasso's portrait of him preceded by only a few months an exhibition of the artist's work that Uhde organized in May 1910 at the Galerie Notre Dame des Champs.[46]

The overlapping Uhde and Vollard portraits of the winter and spring

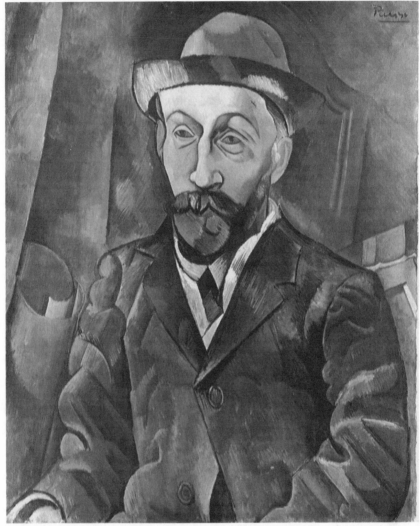

7. Picasso, *Portrait of Clovis Sagot*, 1909
(Kunsthalle, Hamburg)

of 1909–10 were followed in the autumn by the final picture in the
series, the portrait of Kahnweiler. Unlike the other three sitters, he
was relatively new on the scene, having opened his gallery in 1907 and
met Picasso through Uhde during that summer.[47] His purchases began
to escalate during 1909 and reached sixty canvases in 1910. Although
Kahnweiler and Picasso did not sign a formal contract until December
1912, they had clearly begun working together several years before.

8. Picasso, *Portrait of Ambroise Vollard*, 1910
(Pushkin State Museum of Fine Arts, Moscow)

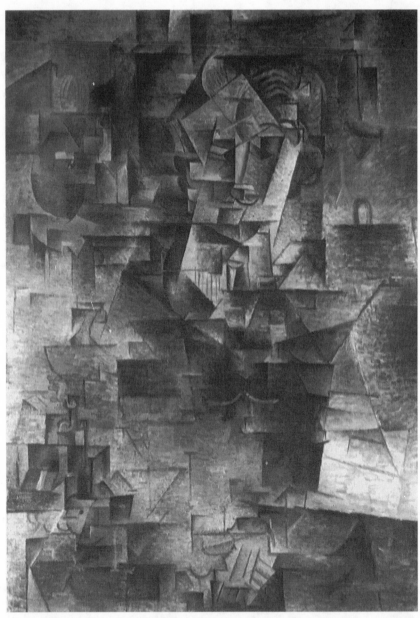

9. Picasso, *Portrait of Daniel-Henry Kahnweiler*, 1910
(The Art Institute of Chicago)

The portrait of Kahnweiler, following those of Sagot, Vollard, and Uhde, suggests that Picasso may have used the sittings to interview, woo, and select a dealer who would guarantee him the security Matisse had gained from his contract with Bernheim. We will probably never know whether Kahnweiler was his first choice, but he certainly proved a strong acquirer and promoter of Picasso's work until the beginning of the First World War. The history of their relationship has been extensively discussed by Pierre Assouline in his well-known biography of Kahnweiler; it is too familiar to justify repetition here.[48]

For La Peau de l'Ours, the period from 1910 through its final year of existence in 1913 was primarily a time of consolidation. Although the group acquired a few works by artists not yet present in the collection, such as Roger de La Fresnaye and Marie Laurencin, most of the purchases during these years were works by the artists Level had followed from the beginning, particularly Matisse and Picasso. Indeed, the greater part of the 2,750 francs for 1911 was expended on two paintings by Picasso—a gouache from his 1905 trip to Holland, *Three Dutch Girls* (fig. 10), and an oil from the circus series, *Harlequin on Horseback* (1905).[49] Since these were older works, Level purchased them on the secondary market rather than from Kahnweiler. Instead of going to Vollard's cache, he bought the two paintings from Louis Libaude, a semiprofessional dealer of unsavory reputation whom Picasso disliked. As Level suggested, Libaude probably bought them from Sagot, who dealt directly with Picasso. This expanding network of secondary dealers confirms the commercial desirability of Picasso's work, particularly of the Blue and Rose periods.

Although both pictures are of fine quality and considerable size, the fact that each cost more than Level paid for *The Family of Saltimbanques* three years earlier demonstrates the abrupt rise in prices for works by Picasso and other members of the avant-garde.[50] In the contract that Picasso signed with Kahnweiler in late 1912, the dealer agreed to pay 1,000 to 1,500 francs for paintings the size of the *Dutch Girls* and *Harlequin*, with the intention of doubling those figures for the retail market. Apparently, the price of Picasso's contemporary work now rivaled the sums commanded by his popular Blue and Rose pictures.

By the final two years of the club, Level could afford to buy only the work of less-established artists, such as de La Fresnaye and Hervier,

and even then he often bought drawings rather than paintings. Thus, the lifespan of La Peau de l'Ours was perfectly timed. Its budget of 2,750 francs, which had enabled it to be a major buyer in the years before 1910, relegated it to minor status afterwards. The group's support of avant-garde art had contributed to the establishment of the reputations and markets it patronized, but that success drove prices beyond the group's means.

When the appointed time came for the members of La Peau de l'Ours to test their mettle against La Fontaine's hunters, Level orchestrated a publicity campaign that turned the auction into a forum for the aesthetic, political, and economic estimation of the paintings and drawings in the collection. As the enthusiasm of Apollinaire and Salmon demonstrates, many observers saw the auction at the Hôtel Drouot as a vindication of Fauvism and Cubism. Economic success stood as a powerful demonstration of the aesthetic quality that many had doubted. This public achievement also placed avant-garde art in a broad social context that made it a focus of the political debate that would dominate the discussion of art during the First World War. For the artists, critics, collectors, and dealers involved in the sale of the Peau de l'Ours collection, there was no doubt about the link between commercial success and artistic recognition, particularly since the artists stood to benefit directly.

Level's showmanship in organizing the auction resulted in a social event remarkably similar to the evening sales that are a matter of course at Christie's or Sotheby's. Because of the auction's potential profitability, Level obtained the right to use two exhibition rooms that opened off the building's grand staircase, instead of cramped chambers like those that still serve the Drouot today.[51] He hung the pictures to emphasize the artists who were represented in depth; Picasso and Matisse were the focus of discrete groupings. *The Family of Saltimbanques* received its first public display surrounded by works of the Blue and Rose periods. And Level made sure that there were plenty of flowers to enhance the festive mood. To solicit visitors for the long preview, he convinced many newspapers to print advance announcements. Finally, he produced a lavish catalogue that began with his own essay on the development of the collection.

According to newspaper accounts, Level's strategy worked extremely well. The room was filled with a crowd that ranged from the usual

dealers (Vollard, Alfred Flechtheim, and Heinrich Thannhauser) and collectors (Coquiot, Joachim Gasquet) to theatrical flaneurs (for example, the poet Alfred Lombard, "d'un élégance de dandy"), besides a large press corps. Artists and critics (Albert Gleizes, Jean Metzinger, Salmon, and Jacob) rubbed elbows with royalty (Prince Bibesco and the Countess de La Rochefoucauld).[52] This conjunction suggests an early stage in the union of the avant-garde and the haut monde that

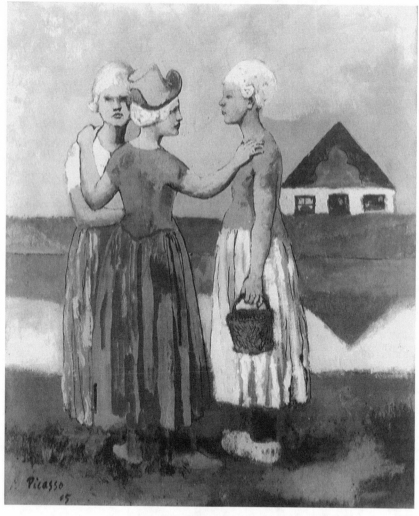

10. Picasso, *Three Dutch Girls*, 1905
(Musée National d'Art Moderne, Paris)

would become apparent after World War I. But the sale also generated great popular interest. For example, the *Herald* announced the results to its readers in New York on a day when the worst blizzard since 1888 dominated the headlines.

The sale total of 116,545 francs more than quadrupled the group's investment of 27,500 francs over the ten-year period, and it signaled the desirability of twentieth-century art as on a par with that of Post-Impressionism. Although the paintings by Gauguin and van Gogh commanded the high prices (4,400 and 4,620 francs, respectively) that one would expect, given these artists' firmly established reputations in 1914, paintings by Matisse and Picasso brought the highest bids. Matisse's 1899 *Still Life with Oranges, I* rose to 5,500 francs, and Level's brother Emile bought Picasso's 1905 gouache *Three Dutch Girls* for 5,720 francs. Without question, the prize of the sale was *The Family of Saltimbanques*. It sold for 12,650 francs (over twelve times what Level had paid Picasso for it in 1908). After all expenses were deducted, the total profit for the investors was 63,207 francs; of this, 12,641—one-fifth—were distributed to the artists.[53]

Although it is unlikely that Picasso or Matisse was present to witness his triumph, the Louvre was well represented. Its prominent curators Paul Jamot and Léon-Jacques Blocq attended the sale amid rumors that they would buy *The Family of Saltimbanques* for the state. Whatever their intentions, their mere presence confirmed the degree to which Picasso and his contemporaries were now recognized by the French artistic establishment. Perhaps Salmon's characterization of the sale as the *"Hernani* of painting" was not exaggerated after all.[54]

As it turned out, the *Saltimbanques* went to Thannhauser, and he shocked a number of reporters by stating that he would happily have paid twice the price. While this apparent prodigality may be taken as a dealer's sales pitch, it could also evince his knowledge of the prices that Kahnweiler had recently obtained for comparable paintings on the private market. The fact that a German bought the star lot of the sale inspired at least one vociferous critic to see political implications in the act.[55]

The public recognition generated by the financial success of the auction resulted in more than a confirmation of the aesthetic qualities of the work. The publicity placed the event in the spotlight of contemporary politics in the months before the declaration of war, when

some commentators believed that a German assault on French culture was already under way. For these critics, the avant-garde was a weapon in this campaign by virtue of its opposition to the academic tradition in France and its inclusion of foreigners, even though many members of the avant-garde, such as Georges Braque, Fernand Léger, and Guillaume Apollinaire (an Italian national), joined the French Army when war was declared.[56]

The extent of this hysteria and its focus on La Peau de l'Ours are evident in an article that Maurice Delcourt, a journalist unsympathetic to avant-garde art, wrote about the auction under the title "Avant l'invasion." As a preface to his remarks about the sale itself, he called attention to the belief that French culture had already been subverted by German influence before the onset of military action: "It appears to superficial observers and the half-informed that the Germans have, in art, already succeeded among us in their task of disorganization, which affects all aspects of our activity."[57]

While refusing to accept this as a fait accompli, Delcourt found specific confirmation of the threat: "A new proof of this German meddling is striking. It is this sale, called La Peau de l'Ours, which took place amid a great deal of attention and which has received a gratuitous level of publicity in, oddly enough, the most French newspapers . . . The 'great prices' were attained there by the grotesque and crude works of undesirable foreigners, *and it was the Germans who paid or pushed up these prices*." Shocked that prominent papers commended the sale, Delcourt asserted that the German dealers (he later identified Thannhauser by name) had driven up prices to promote art that undermined the "measure and order of our national art." Apparently, in Delcourt's view, buying art could constitute an act of espionage. Still, the exaggeration in Delcourt's claim does not mean that the auction was without political significance in the months of bitter prewar debate. This recontextualization of avant-garde art is another confirmation of its assimilation into mainstream French culture that the public reception of La Peau de l'Ours furthered.

The degree to which the sale became a public event is reflected in a cartoon by Hermann-Paul entitled *La Peau de l'Ours* that appeared a week later (March 9) in the newspaper *Gil Blas* (fig. 11). There is no mistaking the illustrator's intention to highlight the newly established

11. Hermann-Paul, *Cartoon of "La Peau de l'Ours,"* 1914

financial value of avant-garde art. The drawing depicts a meeting be-
tween a suitor and the mother of the bride-to-be, as her daughter
stands passively in the background. When the mother tells the gentle-
man that her daughter's only dowry is "a pretty futurist collection,"
the young woman swoons in anxiety, but we know that she needn't
worry. After the Peau de l'Ours sale, avant-garde art appeared to be
as good as gold.

Certainly, Kahnweiler considered the success of the auction impor-
tant to his campaign to establish Picasso and the other artists he han-
dled. On February 20, he had written to urge two of his best clients,
Shchukin and Morozov, to bid on *The Family of Saltimbanques.*[58] As
collectors of Picasso's Blue and Rose periods, they were likely to be
interested, but Kahnweiler also solicited their bids in order to support

the price of Picasso's masterpiece on the open market. He knew a public triumph would greatly enhance the artist's reputation.

Although the Russians decided against bidding on the *Saltimbanques*, its buyer, Thannhauser, was a business partner of Kahnweiler's. Indeed, as part of Kahnweiler's continuing effort to spread the reputations of his artists, the two dealers had organized the largest exhibition of Picasso's work yet held—in Thannhauser's Munich gallery in 1913.[59] Beginning in 1910, Kahnweiler had initiated a policy of loaning his stock to exhibitions held outside France by galleries or other organizations. He assiduously exploited his connections with dealers in Germany, Switzerland, and Eastern Europe to blanket the region with his artists' work, which soon were regular attractions in Frankfurt, Cologne, Breslau, Budapest, and St. Petersburg. As the program gained momentum, he sent Picasso's pictures to one show in 1910, three in 1911, eight in 1912, and seven in 1913 (including thirty-two works in Thannhauser's exhibition).[60]

The comprehensiveness of this assault on the east was not matched by strong activity elsewhere. He lent Picasso's work to only one exhibition in Great Britain, albeit an important one—the Grafton Gallery show of 1912, which included thirteen Picassos. Across the Atlantic, Kahnweiler's only contribution was the four Picassos on view in the Armory Show of 1913. Nonetheless, by February 1914 he had signed a contract with Michael Brenner of the Washington Square Gallery to organize regular exhibitions of his artists in New York and to give Brenner the exclusive right to sell their work in the United States.[61] Unfortunately, the First World War severed Kahnweiler's bridgehead to the New World before any shows could be mounted.

His firmly established base in the east enabled Kahnweiler to initiate this worldwide expansion, and he no doubt expected it to produce new sales. Yet, during the years before the war, Kahnweiler seems to have sold only about forty percent of the Picassos he acquired.[62] Following Vollard's example, Kahnweiler focused on building an inventory of his artists' work with the goal of holding it until the artists' reputations were sufficiently established for their paintings to command high prices. He rarely organized exhibitions in France, preferring instead to encourage critics and other dealers to spread his artists' acclaim. The record prices at the Peau de l'Ours auction must have fired his hopes, even though the sale included very little of the Cubist work he stocked.

Despite his probably lackluster financial results, Kahnweiler maintained the loyalty of his artists by paying them well. The degree to which financial security encouraged Picasso and Braque to pursue the radical experiments of hermetic Cubism and collage remains an unanswered question, and no available documents specify the extent of Picasso's involvement in his dealer's business. But it is fairly certain that during 1913, the last full year before the war, Picasso earned his top salary so far. In March, Kahnweiler paid him 27,250 francs for twenty-three recent paintings, three old ones, twenty-two gouaches, and fifty drawings.[63] By December, he had handed over an additional 24,150 francs, for a grand total of 51,400 francs (approximately $10,280) that year. Picasso was already on his way to becoming a wealthy man.

Thus, it is not surprising that after the Peau de l'Ours auction Kahnweiler raced from the Hôtel Drouot to congratulate Picasso, and the artist's notebooks reveal the importance Picasso attached to the sale and his profits from its success. In one of his sketchbooks are inscribed the catalogue numbers of six of his works and the prices they fetched.[64] Although not in Picasso's hand, this record demonstrates not only his awareness of the event but also his desire to know the results.

Moreover, Picasso carefully noted his earnings from La Peau de l'Ours in his own handwritten accounts (fig. 12). Covering the period from October 15, 1913, though January 1916, his informal list includes an entry from 1914 of "Level—4 Avril—3,978.85."[65] Measured to the centime, this sum is the twenty-percent share of the overall profits from the sale of his work that Picasso earned by virtue of the decision by La Peau de l'Ours to institute the *droit de suite*. Picasso's receipt of this substantial windfall may well be commemorated in a collage (usually dated early 1914) that includes André Level's dog-eared visiting card—*Bottle of Bass, Wine Glass, Packet of Tobacco, and Calling Card* (fig. 13).[66] Many artists wrote letters of thanks to Level for the often quite small checks they received from the sale proceeds, but Picasso's and Matisse's earnings were far from insignificant.[67] Picasso's would turn out to constitute nearly one-fifth of his recorded income for 1914. The sum came to mean a great deal to him as the year unfolded.

The widespread conception that avant-garde art could be a profitable investment came to an abrupt halt only a few months later, when the real possibility of war swept across Europe in the summer of 1914. Ironically, the recognition that the Peau de l'Ours auction brought to

12. Handlist of Picasso's accounts, 1913–15
(Courtesy of Jan Krugier Gallery, Geneva)

13. Picasso, *Bottle of Bass, Wine Glass, Packet of Tobacco, and Calling Card*, 1914
(Musée National d'Art Moderne, Paris)

avant-garde art of the twentieth century occurred at the end of an era,
as the market for art, along with nearly everything else, was radically
transformed by the four years of the war. For Picasso and his contem-
poraries, the war shattered the tentative union of aesthetic commen-
dation and commercial success that had contributed so significantly to
the establishment of their reputations. The outbreak of war forced
these artists to switch from celebrating their new fame to salvaging
what remained of their careers. Many sought to survive by pursuing
the integration of the avant-garde with mainstream society that the
Peau de l'Ours auction had broached.

CHAPTER 2

TOGETHER, WE WILL BE INVINCIBLE

□

I n the months following the Peau de l'Ours auction, Guillaume
Apollinaire went so far as to chastise the French nation for not
owning any works by Picasso and Matisse. Noting that these artists
now enjoyed worldwide reputations, he urged the acquisition of their
work for the Luxembourg Museum, where they would hang with Ma-
net's *Olympia* and other masterpieces by the Impressionists and Post-
Impressionists.[1] Besides this public praise, Picasso found professional
security in Kahnweiler's continuing development of the market. In
April 1914, Kahnweiler expanded the contract he had negotiated only
two months before with the Washington Square Gallery to present his
gallery's artists in New York. Even the growing rumors of impending
war seem not to have caused Picasso and his dealer serious doubts
about their plans. After collecting a fat payment of 12,400 francs from
Kahnweiler on June 8, Picasso departed for his accustomed summer
sojourn in the south of France. By the end of July, Kahnweiler had
also left Paris, for a holiday in Italy.

Like many other Europeans, these members of the French avant-
garde felt far too secure to allow the possibility of a world war to
interrupt their vacations. Yet, with startling suddenness, the declara-
tions of August 1914 would splinter the Parisian art world that had so
recently appeared poised for expansion and radically alter the lives of

most of its participants. Kahnweiler would not see Paris again for over five years, and when he finally did return to the city, he would not be the representative of Picasso. The war created a division between the two men that did not heal until another world war threw them together once more. Suddenly cut adrift, Picasso would struggle to save his career. And with the help of André Level he would find a new supporter, one who welcomed the role of artistic promoter without grasping the business of art—Léonce Rosenberg. As the self-proclaimed champion of Cubism, he sought to place Picasso at the head of a Cubist army. Picasso, however, soon broke ranks and joined the opposition. In the midst of the wartime chaos, Picasso pursued an eclectic transformation of his art that would lead to friendship with Jean Cocteau and participation in Sergei Diaghilev's Ballets Russes, and would result by the end of the war in an aesthetic armistice that joined him with a dealer to the beau monde, Léonce's brother, Paul Rosenberg.

Yet, during the spring and early summer of 1914, as Picasso basked in the afterglow of the Peau de l'Ours sale, he took the first step toward an artistic metamorphosis that in the view of many critics and fellow artists would fundamentally change the conception of modernism and point toward the worldly eclecticism of the postwar years. Without masking his dislike for this shift, Kahnweiler recollected that in the spring of 1914, before their fateful separation in June, Picasso showed him "two drawings that were not cubist, but classicist, two drawings of a seated man."[2] Although this departure from Cubism might appear to be only a passing fancy, Picasso soon elaborated these initial sketches into a small painting, *The Artist and His Model,* that marks a full-blown return to classicism (figs. 14, 15).[3] With Cubism only just achieving widespread recognition, this painting would have shocked the avant-garde if it had been seen on his return to Paris in the fall, because its style would have been received as a repudiation of Cubism by one of its inventors—a capitulation to the academy that would devastate the avant-garde's claim to independence. Perhaps because he realized the implications of this new work, Picasso not only kept the picture secret but stopped work on it when the composition was little more than a design, and he hid the canvas for the rest of his life.[4]

Despite his choice to keep his experiment private, we now know that Picasso opened a new direction in his art during the months be-

tween the Peau de l'Ours auction and the beginning of the war. The character and timing of this departure may well reflect these two very different events. As Pierre Daix has shown, throughout the second half of 1913 and the early months of 1914, Picasso had begun to salt his Cubist compositions with realistic passages in a way that suggests an effort to reintroduce the classical styles of art that Cubism had apparently banished from the avant-garde repertoire. These appearances in works such as *Woman in an Armchair* and its related studies are mere snippets of anatomy within a Cubist framework, yet they signal Picasso's uneasiness with Cubism.[5]

The reasons for Picasso's apparent dissatisfaction with Cubism and the departure from it in the spring and summer of 1914 that led to

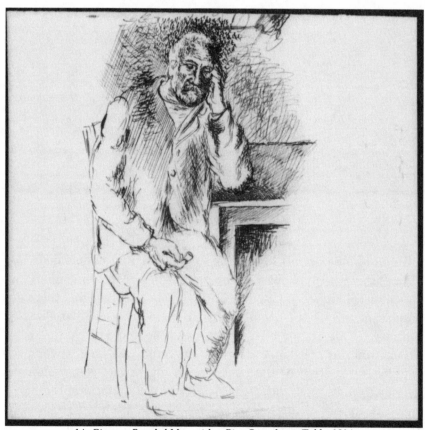

14. Picasso, *Bearded Man with a Pipe Seated at a Table*, 1914
(Musée Picasso, Paris)

15. Picasso, *The Artist and His Model*, 1914
(Musée Picasso, Paris)

the end of a modernist hegemony are still far from understood.[6] Perhaps they were simply part of the process that seems to lend an evolutionary coherence to Cubism. But there are also signs that there was trouble in the Cubist camp. Gertrude Stein reported that Picasso's "intimacy with Braque was waning," and his frequent physical separation from his collaborator in Cubism could well have encouraged him to shift course.[7] At the same time as this private partnership was breaking up, outside critics and politicians were attacking the movement as downright unpatriotic. Moreover, the attention received by Cubist work exhibited by Gleizes, Metzinger, and others in the salons

of 1911–13 and the spring of 1914 may well have prompted Picasso to distance himself from his unwanted acolytes.[8]

Given these pressures, the Peau de l'Ours sale may have suggested to Picasso a welcome alternative. Having had the opportunity to see his major early work, which, like Cubist work, was rarely exhibited, critics suggested that Picasso would do well to revisit his Blue and Rose periods.[9] Whether or not Picasso was specifically prompted by the largely laudatory public attention to these pictures in the spring of 1914, he did what the critics urged.

Kahnweiler recalled that, after showing him the two classical drawings of a seated man, Picasso asked, "They're better than before, aren't they?" When Kahnweiler was asked by an interviewer to clarify whether by saying "better than before" Picasso meant "They're better than what I did before Cubism," Kahnweiler affirmed, "Precisely: Better than the classicist, or, if you will, the naturalistic drawings I did before."[10] If Kahnweiler's recollection can be trusted, and I see no reason to doubt its accuracy, Picasso had in mind his pre-Cubist work—that is, the Blue and Rose work—when he resurrected a classical style in the spring of 1914. Moreover, at least one art historian describes the resulting painting, *The Artist and His Model*, as exhibiting characteristics that are "typical of Picasso's most ambitious pictures prior to 1908—*La Vie, The Family of Saltimbanques, Les Demoiselles d'Avignon*"—and concludes that the painting "reiterates one of his key compositional types of the Blue Period: the two figures facing off (if not looking at each other) at the center."[11]

Kahnweiler's recollection and scholars' recent examination of the work make it seem likely that Picasso's turn away from Cubism was not merely based on his dissatisfaction with it or on the public's prewar antipathy and suspicion but also involved a return to his pre-Cubist roots. Among the prominently displayed works of that period was one demonstrating "his key compositional type." This 1904 watercolor depicts a couple in an interior, and its alternative titles, *Contemplation* or *Meditation*, reflect uncertainty over whether the man is directly observing the sleeping woman or is lost in thought as he looks toward her (fig. 16). This pairing of a man and a woman in a room, and the woman's presence as an object of the man's attention, corresponds closely to the later painting. Even his thoughtful pose, seated at a table

with one hand supporting his head, matches both *The Artist and His Model* and the drawings Picasso showed Kahnweiler in the spring of 1914.

The similarities are not only formal. They extend to the subjects and issues of the two works as well. Although the watercolor does not depict an artist's studio, as does the painting, it is a self-portrait, as André Level confirmed. Moreover, the sleeping woman is Fernande Olivier, who had recently entered Picasso's life. If one accepts that the painting's "model" is based on Eva Gouel, Picasso's current lover, the connections between the two works extend to a shared theme of alienation, both personal and aesthetic.[12]

Believing that his 1914 sketches were "better than before," Picasso adopted an eclectic style that retains references to Cézanne and Courbet, among others. Yet the fundamental sources of these works seem to lie in Picasso's own oeuvre—pictures from the Blue and Rose periods like those exhibited and sold to such acclaim at the auction of the Peau de l'Ours collection.

Whether the works of this classical interlude stem from Picasso's disenchantment with Cubism, his engagement with his public reception at the Peau de l'Ours auction, or his prescience that a war would come and wipe out the social and economic stability that underpinned the banquet years of the avant-garde, most of his work during the summer of 1914 continued to be Cubist, a particularly exuberant form of Cubism flashing with brilliant hues and confetti-like dots. All of it seems to have lapsed quite abruptly, however, soon after war was declared in August.

Picasso's Spanish citizenship exempted him from service in the military and he did not suffer the physical wounds that many of his confreres, including Apollinaire and Braque, endured.[13] But he did not escape the criticism of those who felt that every able-bodied man in Paris should be fighting; moreover, his isolation extended to his artistic environment. Not only did Braque and Apollinaire go off to war in August 1914, but many of Picasso's other supporters also disappeared—particularly his buyers. If the news that Matisse passed to Gris is correct, Picasso immediately grasped the economic implications of war, because he withdrew his savings from a Paris bank.[14]

Kahnweiler was caught by surprise outside the country. But, worst of all, his German citizenship, which Picasso had counseled him to

16. Picasso, *Meditation*, 1904
(Mrs. Bertram Smith, Promised Gift to Museum of
Modern Art, New York)

change, caused his entire inventory to be swept up by French laws that required the sequestration of all German property in France.[15] Unfortunately, he had refused Michael Brenner's offer to house his stock in New York, where he could have continued to do business. Yet, even if Kahnweiler had saved some pictures from the French police, he probably would have had little success selling them, since the market for Cubism was in Europe, not the United States. Although there were a few French collectors, Kahnweiler's strategy of developing the market in Germany, Switzerland, and Eastern Europe, where his family was well connected, meant that he was severed from most of his contacts, including the important Russian collectors, and the few remaining potential buyers held on to their money. Even in Paris, the noncombatants Gertrude and Leo Stein vastly decreased their purchases, having split their collection the previous winter.[16]

Faced with the collapse of his business and the loss of his stock, Kahnweiler reneged on his contract with Picasso. The 12,400 francs that Picasso collected in June was his last recorded payment from Kahnweiler for nearly ten years. By the end of 1914, the approximately 20,000 francs due Picasso for his recent production had not been paid. Whether fairly or not, Picasso then cut his ties with the dealer and refused to do any substantial business with him until the debt was honored—in 1923. Even then, the rift was slow to heal.[17]

Picasso's income for 1914 was only fifty percent of the previous year's total. In this state of financial decline and personal isolation, he turned to his few remaining friends in Paris. In January 1915, he resurrected his realist experiments of the previous summer to sketch the first of several portraits he would use that year to fix his limited community. The first is a portrait of Max Jacob, his comrade from the Bateau Lavoir days. Now the seated man bears Jacob's intensely observed features, and the drawing's retrospective style suggests the reverie that may lie at its origin. Not surprisingly, Picasso's second portrait drawing depicts another associate from the years before Cubism, Ambroise Vollard (fig. 17).[18] Undertaken in August 1915, when the full impact of the art market's collapse had become apparent, it recalls the circumstances of Picasso's other portrayals of dealers: his 1901 portrait of Vollard, which was linked with his concurrent show, and his set of portraits of Sagot, Vollard, Uhde, and Kahnweiler, which marked the tepid early response to Cubism and his search for a dealer in 1909–10.

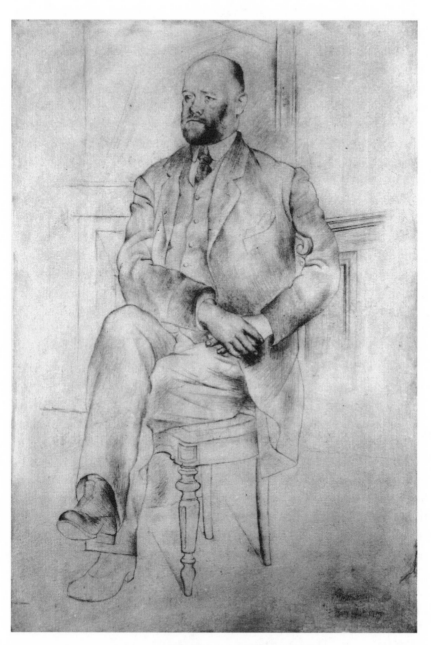

17. Picasso, *Portrait of Ambroise Vollard*, 1915
(Metropolitan Museum of Art, New York)

Once again, Vollard did not take the opportunity to sign Picasso, but André Level used his influence to help. Artists continued to be grateful to Level for enforcing the decision of La Peau de l'Ours to return profits to them. By the fall of 1914 the deprivations of the war prompted several of them to seek assistance from the man who had been their benefactor. For example, André Derain, another of Kahnweiler's artists, sent Level a note of thanks in October for the seventy-five francs he had received from the sale, and he asked Level's help in selling his current work, offering him the pick of his studio and later admitting his willingness "to sell at any price."[19]

Although Level did buy a small painting from Derain, he put his chief effort into supporting Picasso. In his monograph on the artist, Level conveyed the deprivation and uncertainty of those times: "He returned from Avignon to Paris, at the beginning of hostilities. Days of waiting, dark nights. His friends were in the army, his dealer immobilized on the other side of the frontier. A time of testing when he suffered in his affections and his interests. One must live and create life around oneself."[20] As Picasso sought to escape this isolation by constructing a new intellectual environment to nurture his creativity and a new market for his work, Level became a crucial link with the outside world. At the age of fifty-one, Level was too old for military service, but the friendships with artists that he had developed while assembling La Peau de l'Ours, and the camaraderie with Apollinaire that grew from its aftermath, made him a *chef de communication* between Paris and those at the front. It is easy to surmise that, in the face of Kahnweiler's withdrawal and Level's largesse, Picasso turned to the organizer of La Peau de l'Ours for financial advice as well as friendship. Even though the dissolution of the consortium prevented Level from being a significant buyer, its success made him an effective negotiator on Picasso's behalf.

It was Léonce Rosenberg who stepped into the breach opened by Kahnweiler's absence. And as Level recounts, the next portrait that Picasso drew after Vollard's depicted this young man. The son of a successful dealer in Impressionist paintings, Rosenberg had in the years before the war developed a taste for the contemporary avant-garde.[21] Having centered his collecting and dealing interests on Cubism, he moved quickly to cultivate its artists when the war severed them from their earlier gallery affiliations. By the end of the war, he

had founded the Galerie de l'Effort Moderne, and he remained dedicated to the modernist imperative throughout the 1920s and 1930s.

The sense of Rosenberg as a pioneering supporter of Cubism is captured in an account of a visit to Rosenberg's new gallery by a fellow dealer, René Gimpel, in 1919:

> At Léonce Rosenberg's, rue de la Baume. A quiet little house harbors the revelation. An unobtrusive plate on the door: L'EFFORT MODERNE. I rang the bell and was let into a low-pitched entrance way, tiled very simply in black and white. I was shown upstairs to a large, long room forming a gallery. Here he has displayed cubes of canvases, canvases of cubes, marble cubes, cubic marbles, cubes of color, cubic colorings, incomprehensible cubes and the incomprehensible divided cubically. What is on these canvases? Puzzles composed of patches of flat colors, interwoven and yet sharply differentiated. Léonce Rosenberg—tall, blond, and elegant like a pink shrimp—does splendidly: he keeps his gravity. I can take a lesson from him . . . he must be an admirable salesman.[22]

Although a specialist in established masters, Gimpel was well informed and not unsympathetic to the avant-garde, so his apparent astonishment at Rosenberg's singlemindedness is somewhat disingenuous. Nonetheless, his bemusement contains a considerable degree of skepticism about Cubism's artistic stature and shows that the movement was still far from accepted by many in the art world.

Gimpel's response suggests how important Rosenberg's support was for Picasso and the Cubists, especially during the war. Level's account of Picasso's life introduces Rosenberg immediately after a description of the difficulties the artist faced: "L. Rosenberg, who would be mobilized a little bit later, acquired his work, as he would also do for Braque, Léger, Juan Gris and other adherents to Cubism. He followed thereafter, on each leave, to make his purchases."[23] Indeed, during 1915 and 1916, Rosenberg was almost the only person who bought from Picasso and the other Cubists. According to his own account, Level and Picasso asked him to take up this role: "One day Picasso and a mutual friend, a 'cubisant,' M. Level, solicited me to take practically in my own hands the destiny of the cubist movement. Thus I created l'Effort Moderne."[24] Although Rosenberg may have exagger-

ated the tone of the conversation to inflate his own importance, the bleak early months of the war probably did cause some desperation on Picasso's part, and there is evidence of a mutual courtship.

Before the war, Rosenberg's devotion to Cubism had made him one of Kahnweiler's few French clients, yet he seems not even to have met Picasso until the summer of 1914. Writing in October 1914, Rosenberg introduced himself to Picasso, saying he owned "about fifteen of your works, all from the last period," and asking if the artist remembered the visit he and Kahnweiler had paid to Picasso's studio that June.[25] He wondered whether Picasso had abandoned his plan to enlist as a foreigner (a plan Picasso probably never considered seriously). Rosenberg declared the idealistic devotion to art that he would maintain throughout his career, averring that the Picassos he owned "sometimes make me forget the horrors of the moment . . . art is a religion that raises the soul above human contingencies to console all misfortunes."

Whether or not Picasso ever shared Rosenberg's sentiments, he did reciprocate the invitation, and by December he had taken Rosenberg to visit Gertrude Stein.[26] Picasso's handwritten accounts record that Rosenberg soon resumed his buying: two small paintings and six drawings, for a total of 4,200 francs in January 1915, presumably his first direct purchases from the artist. It was probably soon afterwards that Rosenberg made his commitment to support Picasso and other Cubists. In a more detailed recounting, he laid out the dire straits of Kahnweiler's artists in particular:

> In 1915, while I was in Paris on a day of leave, Picasso and a mutual friend revealed to me the deprivation that many Cubists found themselves in—abandoned by their dealer, a German—and the hostility and general indifference amid which they lived, and they fired my interest in taking in hand the destinies of a school of painting that deserved all of my efforts. I promised to found, immediately after my demobilization, "l'Effort Moderne." In the meantime, during the entire duration of the war and even while mobilized, I subsidized, by continuous purchases, the entire Cubist movement.[27]

In 1915, Rosenberg made a formal agreement with Juan Gris, and during 1916–17 he expanded his commercial net to include approxi-

mately twelve Cubists, but Picasso was not among them. After the collapse of Kahnweiler's commitment, Picasso knew that cash, not words, mattered. By the fall of 1915, however, it appeared that Rosenberg was becoming a serious financial backer. In a letter of November 3, he agreed to purchase two of Picasso's recent paintings for a total of 8,000 francs. One of them was *Harlequin*, which Picasso told Gertrude Stein was—in his and others' opinion—the best thing he had ever done (fig. 18).[28] Art historians have also acclaimed the picture, both for its formal inventiveness and because it compellingly sums up Picasso's response to the hardships of war. William Rubin writes: "That Picasso should have chosen to paint a commedia-dell'arte figure at a time of deep personal and general social distress might seem merely a confirmation of the customary hermeticism of his imagery. But a hostile spirit that may well reflect the tenor of the times has slipped into this *Harlequin*." And Theodore Reff characterizes the painting as a "haunting image inspired by Eva's illness and imminent death and no doubt by feelings of wartime loneliness and privation."[29]

Picasso suffered a grievous personal loss when Eva Gouel died in December 1915. Rubin suggests that "Harlequin's toothy smile seems almost sinister"; and one might even surmise an analogy between the painting's black background and the black border of mourning announcements. But Eva did not enter the hospital until November, and Rosenberg agreed to buy the painting on November 3, almost six weeks before her death, so one should not overemphasize the role that her failing health played in the tone of the painting.[30] The war alone was depressing enough.

The most surprising thing about the painting may not be its somber mood but the return of Harlequin. Having become Picasso's familiar alter ego in the Rose period, he almost disappeared during Cubism. According to Reff: "After an absence of six years—there had been a painting of 1913 where he was barely recognizable—he resurfaced in [*Harlequin*]."[31] This revival evokes the pre-Cubist work that Picasso had recalled in *The Artist and His Model* of the year before, and it even more closely suggests the relevance of works in La Peau de l'Ours, particularly *The Family of Saltimbanques*. In 1915, the acclaim this painting had received at its first public exhibition only a year earlier must have struck Picasso as quite hollow. What better way to probe

the disparity between that moment of fame for his masterpiece of the Rose period and the remarkably disruptive circumstances that had arisen since than by returning to his old alter ego?

Certainly Picasso associated *Harlequin* with Level, since he later contributed a print depicting a commedia-like circus scene as the frontispiece for Level's autobiography. Picasso also inscribed a related watercolor "to his friend André Level," and Rosenberg's correspondence records that Level was involved in the sale of the painting.[32]

Rosenberg's letters identify another party who praised *Harlequin* in the fall of 1915. As Rosenberg sifted through the rubble of the art market, he found that the other star of La Peau de l'Ours, Henri Matisse, was no longer securely attached to the Galerie Bernheim-Jeune, which had represented his work since 1909, when he was one of the first of the twentieth-century avant-garde to secure a gallery affiliation. Rosenberg moved fast to cultivate a relationship with Matisse, and one of his ploys was to show the artist the most recent work of his rival, Picasso. Somewhat indiscreetly, Rosenberg then reported Matisse's response to Picasso in a manner that inflated Picasso's achievements.

In a letter of November 25, 1915, Rosenberg wrote that, like himself, "the master of the 'goldfish,'" as he referred to Matisse, was at first disconcerted by *Harlequin*, because it seemed such a departure from Picasso's previous work. After studying the painting repeatedly, however, both Matisse and Rosenberg overcame their astonishment, and Matisse admitted that, not only was it better than anything Picasso had ever done, but he personally admired it the most. Further fueling these two artists' competitive relations, Rosenberg related that Matisse qualified his admiration by concluding that the picture showed the influence of his own recent paintings of goldfish—but then Rosenberg reversed the charge. "To summarize, although surprised, he could not help but be obliged to admire it. My feeling is that this work will influence his next painting." Perhaps this commendation lay behind Picasso's boast to Gertrude Stein that "several people" besides himself thought *Harlequin* was the best thing he had ever done.

The long-standing rivalry between Picasso and Matisse for aesthetic recognition and patronage appears to have reached a peak in the early years of the war.[33] It has been suggested that the bold coloring of Picasso's paintings during the summer of 1914 owes its intensity to Matisse's explorations of brilliant hues, and during 1915–16 Matisse

18. Picasso, *Harlequin*, 1915
(Museum of Modern Art, New York)

took the surprising step of finally opening his art to Cubism. As Jack Flam notes, "If, as was often remarked at the time, Matisse and Picasso were searching for the same thing through different means, Matisse's confrontation with cubism helped him to define the nature and parameters of his own art."

No doubt, Matisse's engagement with Cubism was facilitated by his friendship with Juan Gris, but one should not minimize the effects of his association with Rosenberg and his direct confrontation with Picasso's new work in the fall of 1915.[34] Although Rosenberg, even more than Kahnweiler, restricted his support to Cubism, that autumn he took a big step forward in his relationship with Matisse by purchasing the just completed *Variation on a Still Life after de Heem*. His decision to buy this major painting, which clearly manifests Matisse's engagement with Cubism, was probably not coincidental, and the artist's increasing assimilation of that style over the next year was certainly encouraged by Rosenberg's presence as a buyer and a potential promoter. For the first time since the early piecemeal shows of Berthe Weill, the two leaders of the French avant-garde were being supported by the same dealer and stood a chance of being exhibited under the same roof. The sense of competition must have been intense when Rosenberg showed Matisse Picasso's latest achievement.

Rosenberg's reference to Matisse as "the master of the 'goldfish'" is probably an allusion to another painting that emerged from Matisse's dialogue with Cubism, *Artist and Goldfish*, which Picasso apparently knew (fig. 19). Matisse's grudging acclaim for *Harlequin*, at least as reported by Rosenberg, shows how seriously the artist took Cubism, and Rosenberg was correct to predict that Matisse's forthcoming work would show the influence of Picasso's painting. Possibly beginning with the small *Gourds*, Matisse experimented with *Harlequin*'s reduction of the figure and objects to flat, heavily outlined shapes that appear as silhouettes floating on a dark ground. This significant stylistic shift in Matisse's work continued through major paintings of 1916, including *The Yellow Curtain*, *The Moroccans*, and *Bathers by a Stream*. In 1917, his direct engagement with Picasso's work faded, as did both of the artists' relations with Rosenberg. Matisse signed a new contract with Bernheim-Jeune, while Picasso turned to a different Parisian milieu in his continuing search for sponsorship.[35]

The close business relationship between Picasso and Rosenberg that

19. Matisse, *Artist and Goldfish*, 1914
(Museum of Modern Art, New York)

was cemented by Rosenberg's acquisition of *Harlequin* in the fall of 1915 is confirmed by the portrait that Picasso drew of him at the time (fig. 20). As if he had just arrived from the front (as indeed he may have), Rosenberg stands in full military uniform and greatcoat, holding

his cap and gloves; seen in three-quarter view, he strikes a pose of studied casualness, his right hand resting in his coat pocket as he gazes straight ahead. Yet his surroundings tell us more about the occasion. The setting is apparently Picasso's studio, and *Harlequin* stands discreetly in the background, on an easel. Thus, Rosenberg's self-satisfied expression is explained by the great picture he has just acquired, and Picasso's willingness to document the event confirms Rosenberg's position as Picasso's primary patron by the end of 1915. According to Picasso's personal accounts, his income for the year remained low (20,500 francs), and approximately fifty percent of it is clearly derived from Rosenberg's purchases. When his other known purchases are added, there is no doubt that Picasso depended on Rosenberg for economic survival.

Yet by the first months of the new year the relationship was beginning to fall apart. Rosenberg did not deliver the final payment for his November purchases by the January 31 deadline, although he pressed Picasso to officially accept an affiliation with a gallery that he planned to devote to the broad Cubist movement.[36] Like a military commander, he admonished Picasso, in a letter of March 6, to recognize who were "allies, neutrals, and enemies." He then offered his analysis of the artist's business opportunities: Picasso could remain independent, but most artists were poor managers. He could affiliate with an established gallery—and here Rosenberg considered Durand-Ruel, Bernheim-Jeune, and Vollard before rejecting them all as unlikely to support Picasso's work enthusiastically. Having concluded that Picasso must be represented by a young dealer, Rosenberg dismissed Kahnweiler and his German colleagues with chauvinistic vigor: "Well . . . a boche dealer? . . . I don't think it would be a very good idea for Picasso to be handled from Berlin or Frankfurt! The Picassos would arrive here with a vague odor of sausage and sauerkraut!" In concluding that he could best represent Picasso, Rosenberg overlooked two other "young dealers" who would vie with him—Paul Guillaume and Paul Rosenberg.

Later in the month, he renewed the pressure, saying that he needed Picasso's agreement so that he could go ahead with grand plans once the war ended. "I intend to undertake an *extremely energetic and vast* action in all of Europe and America and it would be ridiculous if I were distracted from my work by . . . petty games behind my back."

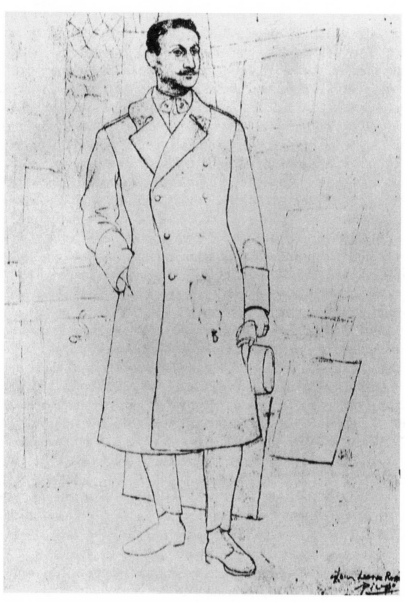

20. Picasso, *Portrait of Léonce Rosenberg*, 1915
(Private collection, Paris)

Finally he declared: *"Together,* we will be *invincible.* You will be the *creator,* I will be the *action!"*[37] Rosenberg was deadly earnest. He saw his role as a patron and promoter of Cubism in the great campaign against the enemies of the avant-garde—his "Effort Moderne" was a collective struggle for modernism. Picasso, however, not only retained his accustomed skepticism of groups but rejected Rosenberg's belief in a Cubist school. He had already begun experimenting with classicizing styles that many thought antithetical to Cubism. Furthermore, he did not wish to associate with most of Rosenberg's Cubists, because he thought they were mediocre artists who had merely stolen from him.

Picasso also had serious doubts about Rosenberg as a reliable patron. In May 1916, Jean Cocteau relayed them to his friend Valentine Hugo: "In brief, a man, a Jew who buys paintings for high prices and isn't a fashion designer or a dilettante. It's the kind of folly one likes. Picasso wonders whether the man may be putting on an act, pretending to be an utter idiot. But he is a shy man, a lover of Chinese and Japanese art, and I think rather that he must have a homing pigeon's (and the dealer's!) unfailing sense of direction."[38] While these aspersions on Rosenberg's honesty and dedication were entirely undeserved, the doubts about his ability to maintain his buying were well founded. Throughout the war, he bought pictures without any hope of selling them before hostilities ceased, and by 1916 he was running out of cash. By the end of the year, he admitted that he could not pay for the painting he had bought with *Harlequin* in November 1915. Even in 1918, Rosenberg tried to lower the prices he had recently negotiated with Léger.[39] And in December 1918 he wrote to Picasso that he had not bought very much from him for nearly two years, so it appears that at least by early 1917 Picasso was once again without a financial backer and still lacking an intellectual community.[40]

Although Picasso's professional relationship with Rosenberg would continue through a 1919 exhibition of his work at the Galerie de l'Effort Moderne, their increasing distance beginning in 1916 enabled Jean Cocteau to enter Picasso's life and guide his career in an entirely different direction. Cocteau's rather catty remarks about Rosenberg in May 1916 illustrate their differences. As Cocteau said, Rosenberg was no dilettante, but many people, including Rosenberg, thought Cocteau was. Whereas Rosenberg was earnest in his idealistic dedication to

perpetuating the prewar idea of an avant-garde separate from main-stream society, Cocteau was able, by virtue of his eclecticism and com-fortable position in the haute bourgeoisie, to join the two worlds, seeking acceptance for modernists among the established cultural cir-cles that had begun to pay attention to contemporary art at the time of the Peau de l'Ours auction but had lost interest with the beginning of the war. Pierre Daix has even suggested that Cocteau's idea for Picasso to participate in a ballet based on circus characters, which became *Parade*, was prompted by the reception for *The Family of Sal-timbanques* at the auction.[41]

Certainly, by the summer of 1915, Cocteau was eagerly cultivating Picasso, and he used Harlequin as one of his chief means of ingrati-ating himself. His notes to Picasso shifted from the formal address of "Cher Monsieur Picasso" to "Mon cher Picasso," and he tried to cajole Picasso into painting his portrait by saying it had to be done soon—before he died at the front (he was in an ambulance corps)—and by sending him two ration coupons for tobacco in payment for "a military canvas."[42] But Cocteau's greatest ploy was to appear in Picasso's studio wearing a harlequin costume under his greatcoat, in the hope that he would inspire Picasso to portray him as one of the family of saltim-banques. For all his mercurialness, Cocteau could be remarkably per-sistent, and in February 1916 he asked if there was truth to the rumors that "my portrait as harlequin *exists*."[43] Although he later claimed that Rosenberg's *Harlequin* was actually a portrait of him, all Cocteau got was a rather quick bust-length sketch, which Picasso drew on May 1, 1916.[44]

By then, Picasso was coming to believe that the young poet's solic-itation to collaborate on a ballet for Diaghilev was not just loose talk. Throughout the winter, Picasso had begun to meet other members of the ballet world. He had exhibited at the shop of the couturier Ger-maine Bongard and was becoming acquainted with a longtime patron of the ballet, Eugenia Errazuriz (fig. 21). Picasso probably met Erra-zuriz through Cocteau, but their friendship soon became a separate affair. Although apparently never lovers, they formed a bond far closer than Picasso had with any other member of this world.[45] By fall, Coc-teau was jealously criticizing Errazuriz's intimacy with the artist, but he soon changed his tune when she championed *Parade* to Sergei Dia-ghilev during its difficult months of production.[46] Even after the pre-

miere, she played a crucial role in Picasso's life, the ending of the war having enabled him to set a new course. Perhaps because she was a woman, her remarkable life and fundamental contribution to Picasso's career have received little attention.

Prominent in Chilean society by birth and marriage, "l'adorable Eugenia" spent most of her adult life in Europe, where she became a patron of the arts during the Belle Epoque.[47] Sargent, Helleu, and Boldini portrayed her, and she became a supporter of the Ballets Russes during the war. Her closeness to Picasso, which grew from their shared Spanish heritage, was in evidence at the Soirée Babel hosted by Count Etienne de Beaumont in October 1916. The balletomane count took pleasure in nurturing the theatrical spirit both inside and outside the performance hall, so he regularly invited the dancers, painters, and patrons of the ballet to evenings at his palatial eighteenth-century *hôtel* (when he was not at the front, managing the ambulance corps in which Cocteau served). On this particular occasion, the contribution of Picasso and Errazuriz to the cacophony of voices was particularly noted. Cocteau wrote to his friend Misia Sert: "I am sure [Diaghilev] will tell you about the Soirée Babel, where Madame Errazuriz shouted in Spanish with Picasso, Serge in Russian with Massine, and Satie in Sauterne with me." One might even say that a new epoch in Picasso's life was framed between two of the count's parties—the Soirée Babel and his ball for the ballet *Mercure* in June 1924.

It was Errazuriz's comfortable position among these patrons that had enabled her to induce Diaghilev to visit Picasso's studio and had helped convince the haughty Russian that this fellow who was all but unknown in high society and who had never worked in the theater might design a successful ballet.[48] Although Picasso did not formally accept the commission for *Parade* until August 1916 and did not sign a contract with Diaghilev until the following January, his life became dominated by plans for the production and by the entertainments of ballet society. With Léonce Rosenberg becoming unreliable and with the rest of the art world dug in for the duration, there wasn't any other game in town. But to succeed in this new world, Picasso needed a guide. As John Richardson notes: "Eugenia it was who transformed Picasso from a scruffy Montparnasse bohemian into the elegant lion of what Max Jacob called his 'duchess period.' "[49]

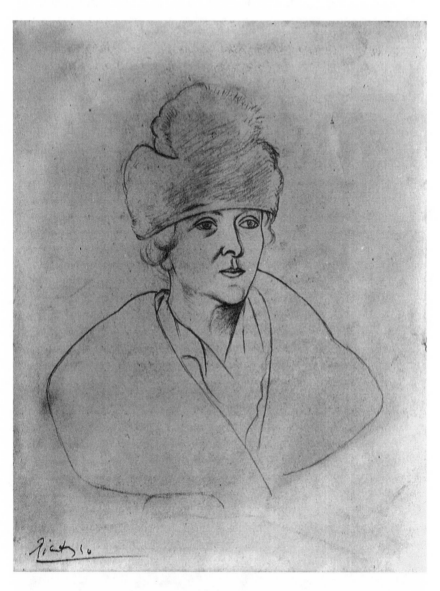

21. Picasso, *Portrait of Eugenia Errazuriz*, 1921
(Art Institute of Chicago)

Besides counseling him on dress and behavior, Errazuriz paid many of Picasso's expenses during the remaining years of the war, just as she did Stravinsky's (at the rate of a thousand francs a month). In thanks, Picasso seems to have given her two of his finest paintings from that period, *Man Leaning on a Table* and *Portrait of a Young Girl*.[50] Besides the *Parade* fee of six thousand francs and a few sales to Diaghilev and his supporters, among them Etienne de Beaumont, Picasso appears to have lived largely on Errazuriz's generosity and his travel allowance as a temporary member of Diaghilev's troop during 1917, when he spent much of the year with them in Italy and Spain.[51]

No event since the Peau de l'Ours exhibition called as much attention to Picasso's work as did the premiere of *Parade* on May 16, 1917. And he capitalized on the occasion to introduce his new art. Although the combination of Picasso's Cubist sets and costumes with Erik Satie's music and Léonide Massine's choreography provoked scandal and taunts of "sales boches," Picasso addressed the audience before the ballet began. In contrast to the mise-en-scène, Picasso's drop curtain presented a vision calculated to soothe the audience and heighten the shock of what followed (fig. 22). The curtain showcased for the first

22. Picasso, *Curtain for* Parade, 1917
(Musée National d'Art Moderne, Paris)

time the classical style that Picasso had experimented with during the previous three years, and its subject strongly recalls the Rose period pictures on which that revival was partially based. Several critics and art historians have noted a resemblance between the *Parade* curtain and *The Family of Saltimbanques*.[52] As one of his largest works (second only to *Les Demoiselles d'Avignon*), the 1905 painting might in some sense be considered a precedent for the vast curtain. Certainly its palette shares a foundation in red, blue, and white, and Cubism seems to be largely banished.

Beyond these formal elements, the paintings' complementary subjects may well reflect a link that Picasso made as he prepared for the debut of his new classicism. Not only do both compositions contain similar figures, such as a woman wearing a broad-brimmed hat, a harlequin, and other costumed performers; they depict a community of those individuals. The near-absence of physical or psychological bonds among the characters in *The Family of Saltimbanques* as (except for the seated woman) they stand together in an empty landscape contrasts sharply with the conviviality of the *Parade* crew. In both compositions the characters are thought to draw on Picasso's circle of friends—Apollinaire, Salmon, Jacob, and Fernande Olivier in the *Saltimbanques* versus Cocteau, Massine, and Picasso's future wife, Olga Koklova, in *Parade*. Yet this private level of meaning rests side by side with the public function of the curtain. If the camaraderie portrayed in the curtain contrasts with the alienation evident in the *Saltimbanques* and reflects Picasso's pleasure in once again belonging to a community after the disruptions caused by the war, its presentation in public may well hark back to the success of that painting at the Peau de l'Ours auction and suggest the hope of repeating that acclaim.

Picasso's work for *Parade*, and the controversy over it in the press, did grab the attention of dealers, among many others. On June 4, Léonce Rosenberg, who still thought he represented all the Cubists, wrote to Picasso: "I've heard that a syndicate (??) of dealers, excluding me, have offered you a contract saying that *I am working with them!!!* (What cheek!) *I am not with them and never will be.*" But his offer to present a show of Picasso's work the following year did not include any substantial purchases.[53]

Although we do not know the members of this syndicate or how serious they were, we do know that another young dealer, Paul Guil-

laume, had recently begun showing Picasso's pictures. Guillaume would later become rich as the pipeline to Albert Barnes's foundation in Merion, Pennsylvania, but he had begun modestly in the years before the war as a dealer in African objects and in pictures by minor members of the avant-garde.[54] Through his friendship with Apollinaire, he met Picasso, and when the war exiled Kahnweiler, Guillaume briefly hoped to replace him as Picasso's representative. He sought the help of Apollinaire, who advised him to work through André Level if he was willing to guarantee Picasso 50,000 francs a year.[55] This figure suggests that Apollinaire knew how much Picasso had earned during his last year with Kahnweiler, though the artist's income had rapidly declined from its prewar heights. Rosenberg won, yet Guillaume kept Picasso abreast of his activities, and in May 1917 he convinced the artist to loan him a painting to show a client who he was confident would buy it. Unfortunately, Guillaume had to report that the man found Picasso's *Harlequin* (which one is uncertain) too expensive. Still, Guillaume's profuse apologies on the failure of this first effort seem to have encouraged Picasso to give him another chance.[56]

Rosenberg was certainly not working out. Not only was he acting proprietary without providing the necessary financial backing, but he was spreading criticism of the artist's collaboration with the ballet. As Cocteau reported, the avant-garde generally frowned on such events: "A dictatorship hung over Montmartre and Montparnasse. Cubism was going through its austere phase. Objects that could be placed on a café table, and Spanish guitars, were the only pleasures allowed. To paint a stage set for a Russian Ballet (the dedicated young painters knew nothing of Stravinsky) was a crime."[57] Even if Cocteau overdramatized the situation, the division between the worlds of the theater and the visual arts did exist. Writing to Rosenberg about *Parade*, Juan Gris even included Picasso among those who doubted the seriousness of theatrical enterprises. He said Picasso "thinks as I do that this milieu of the ballet is a bit depressing for us. Too many beautiful women, too many jewels. All that is somewhat detrimental to the austerity of painting." Still, Gris admitted that *Parade*, while "no big deal," was "much finer and truer than the other ballets because the ones I have seen seem to me spectacles that are rather *gross* for us."[58]

Apparently Rosenberg, who was not in Paris during the performances of the ballet, did not accept Gris's opinion. In early September,

he fired off one of his bulletins to his stable of artists, cautioning them henceforth to abstain from involvement with the Ballets Russes. Having obtained a copy, Cocteau adroitly parried Léonce's portrayal of him as a "traveler toward the right" by suggesting that "I arrive in beautiful solitude not as a Rothschild, in slippers but shod in shoes that pinch—I escape . . . to other Ballets Russes."⁵⁹ One can imagine the tone he used in discussing with Picasso this blatant attempt at censorship. Even if Rosenberg had offered financial security, it seems unlikely that Picasso would have stayed with him after this intrusion into his new activities. Rosenberg's conception of himself as the general of a Cubist avant-garde probably never fit Picasso's independent nature, and it certainly offered no possibility of embracing Picasso's increasing openness to established society.

Thus, it is not surprising that Picasso's exhibition in 1918 was held not at the Galerie de l'Effort Moderne but at the Galerie Paul Guillaume. In organizing this show that paired the two leaders of French contemporary art, Matisse and Picasso, Guillaume had drawn on his friendship with Apollinaire, who, having been exempted from active service because of a head wound, was once again busily promoting his friends in the avant-garde. Besides writing the preface to the catalogue, Apollinaire no doubt convinced both artists to give the young dealer a chance when the prominent galleries remained moribund. Almost evenly split between the two artists, the exhibition included a dozen pictures by Matisse, with many of them from his Moroccan period. Picasso edged him out with thirteen works, which appear to have ranged from Blue period watercolors to recent paintings.

These probably included *Harlequin and Woman with Necklace* (fig. 23), one of the two major paintings he made while in Rome during the spring of 1917 to prepare *Parade*.⁶⁰ But the show was arranged at the last minute. Two weeks before the opening on January 23, Guillaume wrote to Picasso soliciting loans from his collection and inquiring whether it would be appropriate to approach Rosenberg and Madame Errazuriz.⁶¹ It is not clear if he was so untactful as to ask the former, but Errazuriz probably did lend her great painting of 1914, *Portrait of a Young Girl*. Nothing suggests that Guillaume was any more successful at selling Picasso's paintings on this occasion than he had been the year before. Certainly Picasso still had *Harlequin and Woman with Necklace* in January 1925, when he sold it to Paul Rosen-

berg for fifty thousand francs—perhaps ten times what he would have received in 1918.[62]

Even though Apollinaire's essay alludes to Picasso's recent departures into classicism by praising the variety of his art, the press presented the show as a contrast between the beauty of his early work and the aridity of recent Cubism. Lauding the considerable number of works from the Blue and Rose periods, Louis Vauxcelles lamented the "final works of a redoubtable Cubism." The young painter Roger Bissière sadly concluded that both Picasso and Matisse were becoming trapped as "chefs d'école."[63] These views reflected not just the long-standing rejection of Cubism by critics such as Vauxcelles but also a growing sense among many young artists and critics that Cubism was becoming stale.[64] In any event, Picasso had no desire to be a figurehead. He made this point in a joke recorded by René Gimpel in November 1918: "He was burglarized this summer. A friend ran into him at Léonce Rosenberg's, where some of his imitators were being exhibited. The dealer said to him: 'You've been robbed.' 'Ransacked,' replied Picasso, pointing to the pictures all around him."[65]

Nevertheless, Picasso finally gave in to Rosenberg's importuning and contributed to an exhibition at the Galerie de l'Effort Moderne in June 1919. In the fall of the previous year, the grievances that had accumulated during the four years of their association, the incompatibility of their temperaments, the deprivations of the war, and the hopes for change that arose with the armistice in November had caused a public rift. On December 2, Rosenberg sent Picasso a letter justifying his lack of purchases since 1916 and reiterating his long dedication to Picasso's work, beginning with his first purchase from Clovis Sagot in 1906.[66] It seems Picasso had not only spread word of his dissatisfaction with Léonce's stable, but he had also accused him, and dealers in general, of exploiting artists. As Rosenberg recounted it, Picasso saw the relations of artist and dealer as a "class struggle": "Le marchand—voilà l'ennemi." Perhaps by invoking Durand-Ruel's support for the Impressionists, Rosenberg convinced Picasso to give him another chance. The setbacks of the war years had certainly taught Picasso the value of a dealer who cultivated an artist's reputation and provided financial support in difficult times, but Kahnweiler's exile and Rosenberg's unreliability had also demonstrated how hard it was to find someone he could trust.

23. Picasso, *Harlequin and Woman with Necklace*, 1917
(Musée National d'Art Moderne, Paris)

The 1919 show was rightly seen as a celebration of Cubism. The press affirmed Picasso as one of the movement's inventors and acknowledged the exhibition as an important display of the Cubist work he had done before and during the war. Although the show's size and exact content are not known, those works that can be identified include some of the most important paintings Rosenberg had purchased from Kahnweiler and Picasso. Critics singled out two as particularly important: *Harlequin* of 1915—Rosenberg's great pride—and another monumental canvas, which he had purchased from Kahnweiler, *Woman in an Armchair* of 1913.[67] Rosenberg recalled Picasso's surprise that he had bought so many of the canvases Kahnweiler had managed to sell before the war, and *Woman in an Armchair* must have been one

of the most important.[68] Hung in Rosenberg's gallery with *Harlequin* amid contemporary Cubist works, it was part of a fine display of Picasso's Cubism, just as the artist was shifting into new styles derived from classicism. Probably at Picasso's insistence, the exhibition included at least a few classicizing drawings that disrupted its otherwise consistent devotion to Cubism.[69]

Some critics condemned the entire movement, as they had for years, but others used the opportunity to isolate Picasso. Rosenberg had hoped for exactly the opposite, having surrounded the Picassos with paintings by other Cubists. André Salmon wrote that it had become impossibly embarrassing to defend the display "of Picasso's great Harlequin among the Braques." In private, Jean Cocteau delivered an even more cutting judgment. Writing to Picasso, he dismissed the show because the mixed hanging made the Picassos appear to be "in jail," or at least "trapped in school behind obsequious pupils."[70]

The fact that Picasso must already have decided that this would be his only show with Léonce Rosenberg may well have sharpened his friends' criticism, but their desire to attack the dealer also reflected the widespread belief that Cubism was now quite academic. Picasso had not even bothered to attend the show, staying in London to design another ballet that, like *Parade*, Rosenberg would not have encouraged had he still had any influence. The previous winter, Picasso had linked his career to the fortunes of Léonce's brother, Paul. Picasso's acquiescence to the Effort Moderne exhibition softened the blow of Léonce's loss of the artist he had always intended to be the point man of his modernist charge. Since Paul was Léonce's brother, some accommodation had to be reached.

As Léonce himself acknowledged, the facts of the situation substantially lessened the initial impression of fratricide. He knew that he had lost Picasso's confidence over the previous three years because of his financial unreliability and their continually diverging aesthetic interests. It was only a matter of time before another dealer took over. Since Paul and Léonce worked together on many transactions—Paul frequently underwrote his brother's speculation in emerging artists—the new arrangement was probably the only way Léonce could maintain contact with Picasso.[71] His letters to the artist do not contain any of the accusations he marshaled against the rumors of a syndicate in 1917. He also refused to criticize Paul in public.

In an interview published in the magazine *Montparnasse* in June 1926, Léonce rejected the suggestion that his brother had acted improperly. Responding to a leading question by the interviewer Georges Charles—"Is it true that an important gallery 'swiped' Picasso, wanting to decapitate your effort?"—he said:

> I don't think his intentions were so machiavellian. In 1919, the market for Picasso was entirely created; his paintings therefore became eminently "saleable" for a dealer. That is why a dealer would not have hesitated, would have sensed the need to rejuvenate his stable and thereby procure an excellent way to publicize his business through the production of an already famous artist with powerful friends. Naturally a new intervention, the fifth to date, on behalf of Picasso's work could not fail to produce a substantial elevation of his prices.

Quite unlike conventional art historical divisions of Picasso's career, which are generally based on style, Léonce's demarcations unsentimentally affirm the importance of financial backing in making the artist's name. It would be interesting to know how Léonce would have identified the previous four "interventions" in the Picasso market; presumably, his own purchases counted for one, and one might reasonably claim Vollard and Kahnweiler as two other agents. Was the remaining "intervention" that of the Steins or of Level's Peau de l'Ours? Whatever the case, as Léonce said, the fifth was the most important.

Since Paul was not only his brother but also his informal business partner, Léonce was certainly the right person to judge how overwhelming the most recent intervention was. In 1906, the two brothers had inherited from their father, Alexandre, a gallery he had started twenty years earlier when five cargoes of grain he had purchased rotted in transit from Argentina to France, bankrupting his import firm. With his art collection his only negotiable asset, he became a dealer, and by the turn of the century he had successfully shifted from eighteenth-century decorative arts to the newly established market for Impressionist paintings. In 1910, Léonce and Paul decided to split the business so that Léonce could relinquish the modern masters and pursue his interest in the twentieth-century avant-garde without dis-

traction, while Paul continued to cultivate the market for nineteenth-century French art. As Léonce concentrated on Cubism and laid plans for the Galerie de l'Effort Moderne, Paul maintained his base in Impressionism but also anticipated a move into the twentieth-century market.

The contrasting styles of their respective galleries immediately announced their differing approaches. If Léonce's quarters struck René Gimpel as "very simply" appointed, Paul's building caused the elder academician Jacques-Emile Blanche to exclaim that it was a Ritz-Palace: "I paid a visit to Rosenberg . . . rue La Boétie, a facade entirely of marble, a vestibule of marble, a staircase of onyx . . . vast rooms hung with watered silk receiving torrents of light thanks to ingenious lozenge-shaped ceiling fixtures in which a dozen bulbs cluster like grapes on the vine."[72] In January 1914, Paul had opened his gallery at 21 rue La Boétie to much acclaim and had promptly filled it with a series of exhibitions that complemented the luxurious surroundings. One of his most prestigious early events was an exhibition of nineteenth-century French art that he held in 1917 to benefit wounded veterans (fig. 24).[73] This patriotic display included seventy-eight paintings ranging from Mary Cassatt to Vincent van Gogh (clearly, French taste, not citizenship, was the necessary qualification) and drew from prominent private collections, as well as from all the major galleries, including Durand-Ruel, Bernheim, Vollard, and Georges Petit.

Yet Blanche also noted during his visit in January 1917 that Paul's gallery included works by more recent artists, particularly "a vast panel by Matisse . . . the figure of an Algerian chieftain very richly colored and singularly decorative." Paul was already using his position as one of the most successful purveyors of modern art in Paris to expand his range to include the leaders of the contemporary avant-garde. When Paul solicited Picasso, Léonce simply knew he was outclassed.

Léonce would suggest to Georges Charles that Paul was not truly responsible for the postwar rise in Picasso's prices, saying that "the market for Picasso was entirely created" in 1919—that is, before Paul joined forces with the artist. In fact, the surge resulted from the alliance Picasso and Paul Rosenberg had formed the previous year. After all, Kahnweiler's efforts had been halted by the war, and Léonce's had waned before hostilities ceased. André Level's effectiveness had dwindled soon after the Peau de l'Ours was sold, even though his friendship

24. Galerie Paul Rosenberg, *Exposition d'art français du
XIX siècle au profit de l'Association Générale des
Mutilés de la Guerre*, June–July 1917

with Picasso endured and Picasso drew his portrait on a quiet Sunday
afternoon in January 1918. But the Armistice in November of that year
initiated a twenty-year period that would be free of major wars and
would witness some of the most prosperous, and economically devas-
tating, times in modern history. In comparison with what followed, the
burgeoning activity of the Peau de l'Ours years and the precipitous
decline during the war constituted only the overture for the main per-
formance. For Picasso, this renaissance had actually begun a few
months before hostilities ceased, when he accepted an invitation to
summer with the haut monde at the resort of Biarritz.

CHAPTER 3

THE ULTRA CHIC

□

During the last summer of the war, Eugenia Errazuriz once again did Picasso a great favor. Even more than when she brought Diaghilev to his studio in 1916, she now set the stage for a transformation of Picasso's career that would shape his reputation over the next two decades. After Picasso's marriage to Olga Koklova on July 12, 1918, Errazuriz invited the couple to spend their honeymoon at her villa, La Mimoseraie, near Biarritz. This escape from the war zone to the distant Atlantic coast of the Franco–Spanish border may appear to be a romantic idyll, but it turned out to be a working vacation at the height of the social season. Not only did Picasso accommodate his hostess by decorating a room in the villa with drawings of bathers and verses from Apollinaire's poetry, he also used his pencils and brushes to cultivate a set of patrons whom Errazuriz presented to him. In preparation for this debut, Picasso even shipped a crate of pictures to La Mimoseraie.[1]

A graceful blend of rustic materials and refined *objets*, Errazuriz's decor set the tone for life at the villa. As another visitor, Cecil Beaton, recalled, the walls were whitewashed and the floors tiled as in a peasant house. "A long wooden shelf, scrupulously scrubbed, ran the length of the wall; and on it for decoration as well as practicality, she placed a still life of hams, huge cheeses and loaves of bread under large bell jars. Her table was always set very informally, though napkins were of

the heaviest linen and knives and forks of the best quality of French eighteenth-century silver."[2] Writing to Apollinaire not long after his arrival, Picasso transformed the villa into the "château of a Russian. Each tower bears the name of one of the women he loved."[3] Besides prompting such rakish fantasies, the house provided the setting for Picasso to realize his dreams of wealth and acclaim.

Picasso and Koklova shared the company of Errazuriz's aristocratic friends, and he flattered them by sketching pencil portraits of several of the women, including the daughter of the Marquise de Villaurrutia.[4] Executed in the Ingresque style that he had adopted in his 1915 portrait of Max Jacob, these exquisitely rendered drawings reinforce their sitters' social status. The sketchbook that Picasso gave his hostess in thanks is filled with drawings in similarly retrospective styles, including one that lightheartedly acknowledges his apparently anachronistic position as courtier to his patrons. In what might as well be a visit to Bouguereau's studio, a woman dressed in flowing skirts and a plumed hat raises her lorgnette to examine a painting displayed on an easel, while a paunchy man in a top hat and tailcoat stands at her side.[5] Picasso confirmed the reality of this stately luxury by confiding to Cocteau that he was living "a very worldly life."[6]

In a slightly more subdued tone, Picasso told Apollinaire that he was "seeing the beau monde." But he also noted the presence of a pack that often trailed these social lions: "I saw Rosenberg, who has sold all his Rousseaus. Hessel is here with all the *antiquaires* of Paris."[7] In the midst of this busy season, Picasso did not neglect to pay particular attention to those members of the art trade who mixed smoothly with Errazuriz's guests. It was at this time of apparent relief from professional matters that Picasso became acquainted with the dealers who would soon guide his career: the Nabis specialist Jos. Hessel and, more important, Paul Rosenberg and Georges Wildenstein—two of the most prominent art dealers in France, or anywhere. Rosenberg and Wildenstein had rented villas just down the road from La Mimoseraie, and in the course of her social menu Errazuriz brought Picasso together with them. Unlike most of the dealers Picasso had known, these two men based their reputations not on their cultivation of the twentieth-century avant-garde, which they generally dismissed, but on their dominance of the market for acknowledged masters. Although they frequently shared investments, they operated separate galleries, with

Wildenstein's devoted to Old Masters and Rosenberg's to nineteenth-century French art. Besides financial resources and social entrée far exceeding anything Kahnweiler or even the Bernheims could offer, these dealers provided Picasso with the opportunity to present his work in an entirely new context, one that linked it with the French tradition of seventeenth-, eighteenth-, and nineteenth-century art.

Well aware of Paul Rosenberg's business acumen, Picasso had come to the dealer in January of 1918 when his difficult financial situation probably caused him to sell a Renoir he owned.[8] There is nothing to suggest, though, that they developed a friendship before their season in Biarritz. Wildenstein knew less of Picasso's work, but he was aware of the artist's growing presence in society. Evidently persuaded that their clients, shepherded by tastemakers such as Errazuriz, would make Picasso a success, the two dealers gave his work serious attention. No doubt they studied the pictures that he had sent from Paris, and their commissions for portraits evince their satisfaction with what they saw. Picasso portrayed only the wives and children of the dealers, but these images are tied to the business discussions he was conducting with the men. The most ornate of Picasso's pencil portraits is a rendering of Madame Wildenstein (fig. 25).[9] Here, his stylistic homage to Ingres is particularly well suited to the wife of the man whose gallery specialized in the work of the master of Montauban. Nonetheless, Picasso's major portrait of the summer is of Madame Rosenberg and her young daughter, Micheline (fig. 26). Unlike the intimate scale of the pencil sketches, the large size of the picture translates Picasso's delicate draftsmanship into a grand painting, one that was intended for public display.

As a result of his discussions with Rosenberg and Wildenstein *chez* Errazuriz, Picasso gained a position in the market that was truly extraordinary. In partnership, Rosenberg and Wildenstein offered to represent him worldwide. One can only imagine Picasso's glee at this coup, which immediately gave him security and prestige beyond that of any other living artist. It must have seemed as if his early dream that Durand-Ruel would stock his work had finally come true.[10]

Until Wildenstein dropped out of the agreement in 1932 and Rosenberg assumed complete sponsorship, the two dealers split the Picasso market between them. They bought from him in equal shares, Wildenstein representing his work in America, and Rosenberg in Eu-

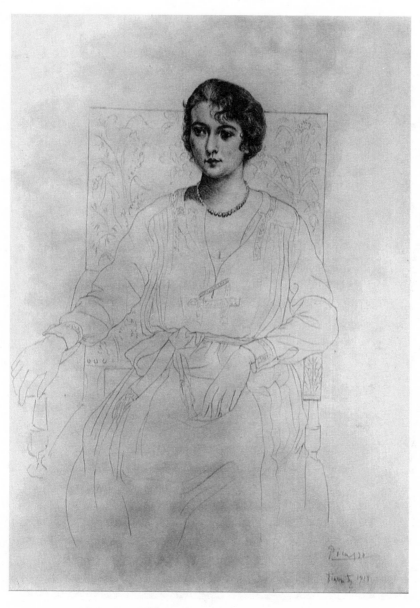

25. Picasso, *Portrait of Madame Georges Wildenstein*, 1918
(Private collection, New York)

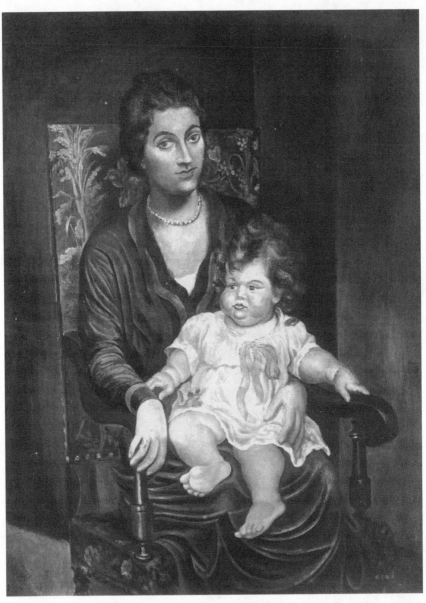

26. Picasso, *Portrait of Madame Paul Rosenberg and Daughter*, 1918
(Private collection, Paris)

rope (there was no significant market in the Far East or Latin America yet). The only living artist handled by Wildenstein, Picasso joined a stable that held a vast inventory, with many acknowledged master-pieces. Yet, from the beginning, Wildenstein remained discreetly in the background. Rosenberg was the dealer publicly associated with Picasso and the one who orchestrated his career. Even in the ground-breaking exhibition of the artist's work that Wildenstein held at their New York gallery in 1923, Rosenberg appeared as impresario.

While Picasso's portrait of Madame Rosenberg and her daughter confirmed his ties to the gallery, its nearly academic style exhibited his new eclecticism. Among his recent portraits, only that of Koklova, painted the previous year, could equal the picture in importance, and Picasso was well aware that its manner more closely resembled society portraiture than anything commonly considered avant-garde. In a pri-vate joke with Madame Rosenberg, he even signed a sketch of the painting "Boldini" (fig. 27).[11] The portrait caused a great stir when word of it reached Paris in the fall. On September 27, Rosenberg wrote to Picasso (who was still in Biarritz): "Everyone knows that Picasso painted the portrait of my wife and daughter. Léonce heard about it from Cocteau and, naturally, wishes it were Cubist, even though 'Miche' is 'rondiste.' "[12]

Rosenberg's account captures both Picasso's shifting position in the Parisian art world during the final months of the war and the nature of his relationship with his new dealer. Deftly playing off the depiction of Micheline's plumpness against his brother's programmatic dedica-tion to Cubism, Rosenberg manages to support Picasso's stylistic eclec-ticism and dismiss Léonce's restrictive devotion to theory. In fact, his breadth of aesthetic interests was considered so distinctive that it soon became known as the "House of Rosenberg style"—as one reporter characterized the sensibility that reigned at the Galerie Paul Rosen-berg. "The best way to appreciate everything from the ancient to the modern is through the *Raison sociale* Rosenberg, Paul Rosenberg. And if the Ancient is sold on the mezzanine, don't suppose that the New is 'traded' on the ground floor. Between these two floors there is a satisfying equilibrium, often interrupted by combinations that are hap-hazard, advantageous, but never jarring."[13]

These are also the qualities Picasso captured in the portrait of Paul Rosenberg that he drew in the winter of 1918–19 (figs. 28, 29). Like

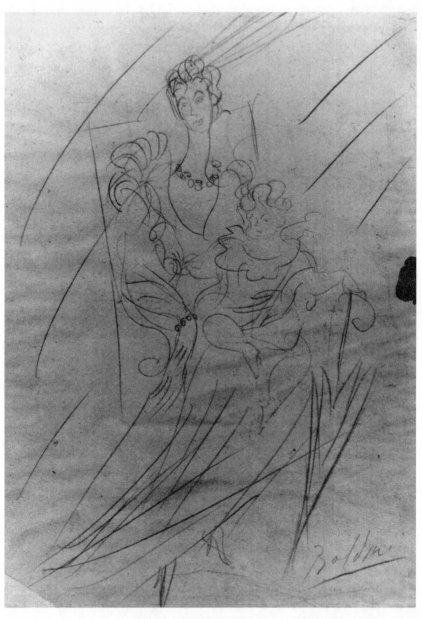

27. Picasso, *Parody Portrait of Madame Paul Rosenberg and Daughter*
(signed "Boldini"), 1918 (Private collection, New York)

that of Rosenberg's wife and daughter, this exquisite image endows its subject with great dignity, but its rendering in pencil, rather than oil, and its informal composition convey a spontaneity lacking in the painting. Unlike his wife, who is surrounded by a strict high-backed *fauteuil*, Rosenberg sits crosswise in an armless chair and casually drapes his left arm along its back, as his right hand rests on his crossed knees. (The gesture shows off his attenuated fingers, in which he took great pride.) The formality of his double-breasted suit and high-buttoned shoes does not so much contrast with as complement this loose pose by suggesting the blend of ease and sophistication that, coupled with the intense scrutiny of his gaze, others noted as characteristic.

He lost no time in acquiring a stock of Picasso's work. In August 1918, he paid Picasso over 16,000 francs for works of art (most of it for the portrait of Madame Rosenberg and their daughter), and the third partner in his enterprise, Jos. Hessel, spent another 5,500 francs.[14] By the end of the year, the consortium had spent an additional 29,000 francs for drawings and paintings (probably including the major Cubist painting of 1918, *Harlequin with Violin "Si Tu Veux"*; fig. 30). The

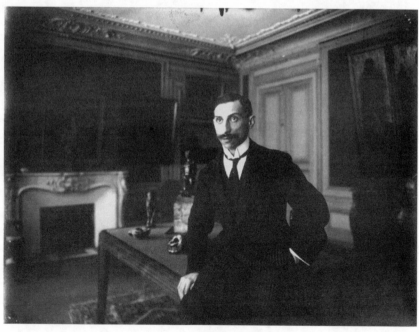

28. Paul Rosenberg, 1920s
(Private collection, New York)

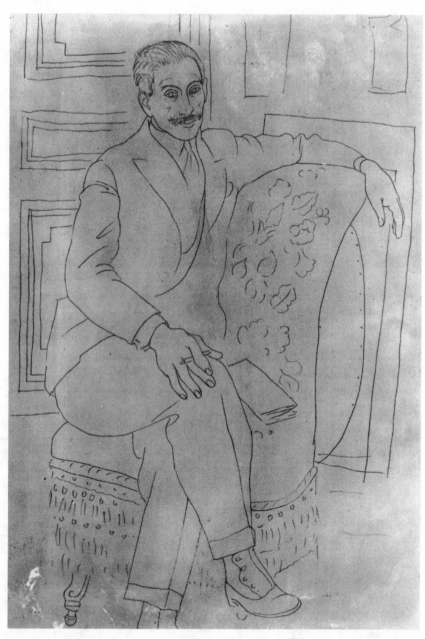

29. Picasso, *Portrait of Paul Rosenberg*, 1918–1919
(Private collection, New York)

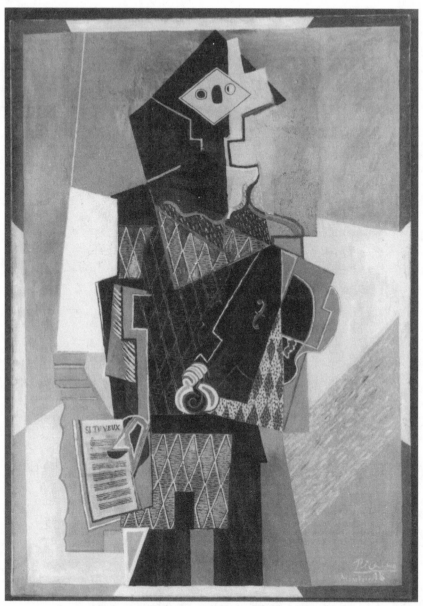

30. Picasso, *Harlequin with Violin* (*"Si Tu Veux"*), 1918
(Cleveland Museum of Art)

PAUL ROSENBERG

ADRESSE TÉLÉGRAPHIQUE
ELPÉROSEN – PARIS

RUE DE LA BOËTIE Nº 21
TEL. ÉLYSÉE, 45-11, PARIS

31. Note of receipt from Picasso to Rosenberg, 1919
(Pierpont Morgan Library, New York)

five-month total of over 50,000 francs was by far the largest sum Picasso had earned since the lapse of his contract with Kahnweiler in the summer of 1914 (fig. 31).[15]

Although Picasso never signed a contract with Paul Rosenberg (probably because his agreement with Kahnweiler had proved unenforceable), he did grant him a verbal contract *de première vue*, or first refusal,

which remained in effect for over twenty years. Moreover, in the fall of 1918, Picasso moved into the house next door to the building that contained Rosenberg's gallery and private residence, on the very proper rue La Boétie. Picasso had not only survived the war, he had fashioned a new aesthetic and commercial alliance.

By early 1919, Paul Rosenberg was acknowledged among the trade as Picasso's dealer, and in the fall he held his gallery's first exhibition of Picasso's work. His brother's show that summer, consisting primarily of works purchased from Kahnweiler or Picasso during 1913–16, had presented Picasso as the head of a Cubist movement. But Léonce's strategy had backfired. Many perceived these followers, such as Jean Metzinger and Gino Severini, as mere copyists, and the great prewar movement as a moribund school only slightly less rigid than the academic system it had rejected. Picasso's circle believed that he had to distance himself from the movement, though he had never given up his own Cubist explorations. In this context of shifting reputations as the art world set a new course in the aftermath of the war, Picasso's embrace of Neoclassicism, a style usually associated with conservative taste, would be heralded as a renewal of the avant-garde—even as Picasso entered the established circles of patronage that had dismissed many of the avant-garde's earlier innovations.

Rosenberg was more polite about Léonce's exhibition than Cocteau had been, but there is no doubt he wished to detach Picasso from the public reception of Cubism at his brother's exhibition. He expressed far more interest in Picasso's activities in London, where Picasso was designing another ballet for Diaghilev. On June 10, he noted that "the exhibition at my brother's doesn't look very complete. Too few of your paintings, and the concert on Sunday was not very much appreciated by the visitors."[16] If his remark probably implies that there were too many paintings by other artists, his other comments also suggest that he paid little attention to the exhibition. Instead, his letters overflow with enthusiasm for Picasso's accounts of London society and with his own tales of life in Paris. It is particularly unfortunate that Picasso's side of the correspondence appears to have been lost, since Paul thought that it deserved to be published.

Addressing Picasso as "mon cher Casso," the nickname given him by the young Micheline, Rosenberg adopted a frivolity quite unlike his brother's earnestness. On July 4, in a letter with a hand-inked black

border, he announced with mock seriousness the death of Picasso's pet parakeet. Rosenberg was as fascinated with Picasso's social triumph as were the tabloid reporters who filled the gossip columns with accounts of the many fetes in his honor. This lionizing by the English establishment convinced Rosenberg that Picasso had definitely escaped bohemia and was now "a member of the ultra chic!"[17] For his part, Picasso's inscription of a study for the ballet he was working on, *Le Tricorne,* to "mon cher Paul Rosenberg son ami Picasso" confirms the sense of partnership the artist and the dealer already shared (fig. 32).

The exhibition that Rosenberg conceived for his gallery that fall would introduce this worldly Picasso. The show, which ran from October 20 to November 15, did not include any of the Cubist paintings he had bought from Picasso over the previous year and a half, but it did highlight Picasso's remarkable production since their association began. It consisted entirely of drawings and watercolors—167 of them.

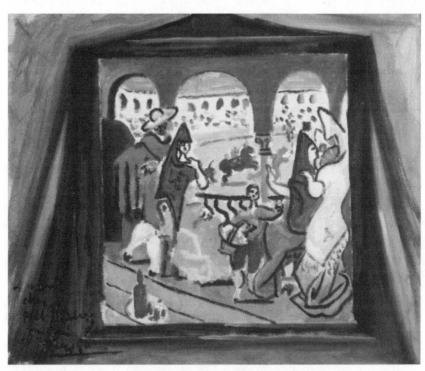

32. Picasso, *Study for the Curtain of Ballet* Le Tricorne, 1919
(Private collection, Paris)

Organized by subject in the catalogue, the works swept across Picasso's full range of interests: Harlequins and Pierrots, Scenes of the Bullfight and Circus, Dancers, Windows at Saint-Raphaël, Figures, Still Lifes, Landscapes, Portraits, and, finally, three drawings after Ingres and Renoir (fig. 33). The sheer volume and variety of work on display overwhelmed many viewers. By choosing to show drawings instead of paintings, Rosenberg subtly balanced the artist between retrospection and foresight. He presented the medium in which Picasso had most fully elaborated a return to classicism, and he positioned Picasso as an artist whose work was best characterized by openness and exploration rather than by dedication to a particular style.

The catalogue essay by André Salmon confirmed this reorientation. As one of Picasso's oldest friends in Paris and a witness to the invention of Cubism, Salmon certainly could have offered a historical perspective on Picasso's development and might have been expected to emphasize the pioneering years. Yet his essay mentions the past only to reject its relevance; his focus is entirely on the future and on Picasso as its creator. During the previous year, in his role as an art critic, Salmon had criticized the tendency he observed among some artists to reduce Cubism to a set of precepts that bore little relation to what Picasso and Braque had produced before World War I.[18] In his catalogue essay, he dismissed those obsessed with such formulaic versions of the past and praised Picasso's new eclecticism.[19]

The critical reception of the show not only recognized but celebrated Picasso's departure from Cubism. For example, J.-G. Lemoine, a critic for the important newspaper L'intransigeant, elaborated Salmon's motif by applauding Picasso's aesthetic adroitness in transcending Cubism: "He agilely pirouettes over cubism, which now bores him. He jumps over impressionism. He jostles Courbet in passing and falls on his knees before Monsieur Ingres, to whom he gives a big salute."[20]

In advance of the show, Picasso gave an unusual interview chez lui that manifests just how perfectly calibrated his life and work were as he became accustomed to the comforts Paul Rosenberg and Georges Wildenstein had begun to provide.[21] The reporter, Georges Martin, was impressed and a bit surprised by the luxury of Picasso's quarters. He describes how, arriving at the artist's building "on the very bourgeois rue La Boétie," he ascends to Picasso's apartment in a "very smooth" elevator and waits in the dining room for the "jeune maître"

(Picasso was thirty-eight). After taking in the calculated contrast be-tween the central table, "unpretentiously Louis-Philippe," and the walls hung with "very cubist little pictures in very classic frames," Martin caustically notes the presence of a birdcage containing a new parakeet, "as in the homes of old ladies, and the most modern watercolors of Georges Lepape [a popular fashion designer]." Finally, Picasso enters, "young and freshly shaved in pajamas 'de crepon blanc,' " and takes him on a tour of the studio, which in contrast to the public room exhibits a state of chaotic disorder, with African sculp-tures crowding "a big wooden Christ transferred from some Spanish church."[22] "Dominating this capernaum a figure of a woman—almost perfectly academic, but with an intense charm that reveals his talent —smiling before a drapery bordered with heavy ornaments."

In front of this painting (presumably his 1917 portrait of Koklova), Picasso begins to recount his life story. But, instead of emphasizing his difficult early life in Paris, his association with the avant-garde, or his aesthetic achievements, he delivers an account of his rise to fame and fortune. Beginning with his childhood in Spain, he cites his "hon-orable mention" in the Madrid Salon and then moves on to his rise to acclaim in France. Here, Picasso singles out Olivier Saincère as one of his first collectors, and calls attention to Saincère's current position as secretary to the president of France.[23] Then, to demonstrate his worldwide status, Picasso tells Martin that his pictures even hang in Russia, alongside those of Matisse and Cézanne, and that "the Bolshe-viks, it appears, carefully safeguarded them during the last revolution."

When Picasso finally refers to his aesthetic accomplishments, it is to characterize his shift from the Blue to the Rose period as reflecting the "spiritual tranquillity" that he derived from his increasing material comfort. He mentions Cubism only as another outcome of this free-dom and then calls to Martin's attention that "an exhibition of my work is opening at the gallery of a dealer on the rue La Boétie, a neighbor. *Voilà toute ma vie.*"

As if to confirm the accuracy of Martin's account, Picasso's contem-porary sketches record both his new apartment and his increasing af-fluence. Picasso drew both the ordered dining room (including the birdcage) and the chaotic studio described by Martin, but even more revealing is his view of what might be called the "salon Picasso"— Koklova seated in their sitting room, surrounded by a group of artists

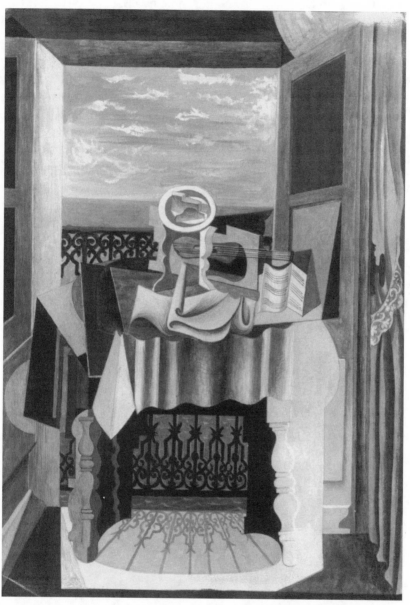

33. Picasso, *Still Life in Front of a Window, Saint-Raphaël,* 1919
(Berggruen Collection, extended loan to National Gallery, London)

and critics (Jean Cocteau, Erik Satie, and Clive Bell; fig. 34).[24] Far from a bohemian gathering, this worldly coterie of sophisticates poses with elegant detachment. Without questio, they are at ease in the plush interior of the "very bourgeois" rue La Boétie, but one might doubt whether they would rest so comfortably in the rough quarters of the old Bateau Lavoir. Drawn during the course of Picasso's first show at Paul Rosenberg's gallery, the portrait documents the elevated style of life to which the newlyweds had become accustomed during the first year of their relationship with Picasso's new dealers. And it reflects the calculated transformation of his status that Picasso flaunted to Martin for public consumption. It is not surprising that in January 1919 Picasso had begun to collect his press clippings.[25]

Nor is it surprising, given Picasso's emphasis on his worldly success, that the two artists to whom Picasso rendered homage in the show were Ingres and Renoir. The choice of Ingres is more predictable, since Picasso's close friends, such as André Level, had recognized that the nineteenth-century master underlay the openness to Neoclassicism

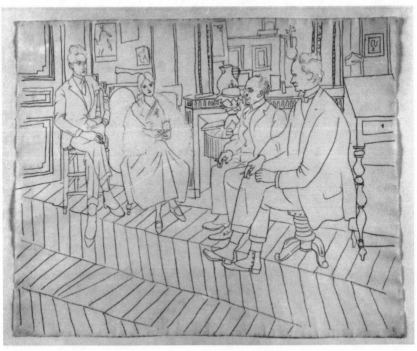

34. Picasso, *The Artist's Sitting Room on the Rue La Boétie*, 1919
(Musée Picasso, Paris)

that Picasso had shown since 1914. Moreover, by 1919 Ingres was widely acclaimed among avant-garde artists. Renoir, on the other hand, was still held in disrepute by many of them. As Jean Cocteau wrote to the Cubist painter Albert Gleizes in January 1918: "More and more I'm against Impressionist decadence . . . I say down with Renoir the way I say down with Wagner."[26]

Picasso not only disagreed with the common dismissal of Renoir as the least adventurous member of the overly accessible Impressionist school but openly affirmed the relevance of Renoir's work and life for the very qualities that others condemned. Picasso admired Renoir enough by January 1918 to have already acquired *Woman Reading*; he sold it to Paul Rosenberg that month for the hefty sum of 8,500 francs. In the following years, he made several paintings and drawings that explicitly refer to Renoir and the Impressionist movement. The conception of Impressionism evident in these works, however, does not reflect the emphasis on landscape that we often assume was the sole basis of the movement, at least in the paintings of Monet, Pissarro, and Sisley. Instead, Picasso was attracted to a different set of Impressionists, those who portrayed modern urban life, particularly Renoir and Manet, who presented scenes of fashionable ladies and gentlemen during the 1860s and 1870s.

These images of bourgeois comfort correspond in many ways to Picasso's new life as he portrayed it in his sketch of their salon. In his copy of Renoir's *Le Ménage Sisley*, Picasso transcribed Renoir's celebration of his fellow artist's conjugal bliss as the two companions self-consciously pose in fancy dress.[27] By accentuating the abundant flesh of Renoir's couple, Picasso added a touch of ridicule to the scene without disrupting its air of self-satisfaction. Continuing the theme of bourgeois luxury, Picasso painted a large canvas of a man and a woman dancing in an ornate interior, *Lovers* (1919; fig. 35), that he facetiously signed "Manet" with a great flourish. No doubt Picasso had in mind the artist's *Nana* and its depiction of cozy indulgences as a wealthy man visits his mistress.[28] Yet Picasso's painting appears to celebrate frivolous pleasures without retaining the edginess of Manet's guilty voyeurism. Instead, Picasso's dancing couple wheels with a glee that strongly recalls Renoir's images of the dance from the 1880s. Even Renoir's foreground motif of a hat or bouquet cast on the ground in the heat of the moment is reflected in the newspaper Picasso's couple

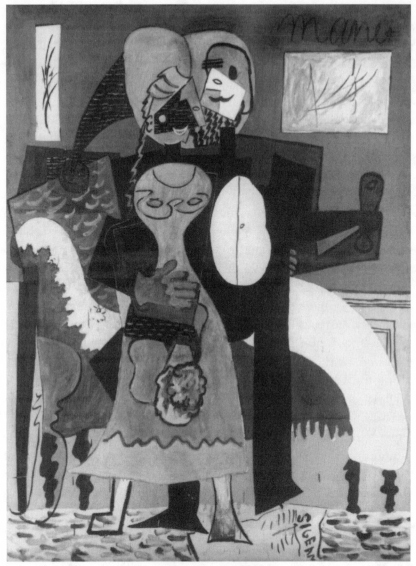

35. Picasso, *Lovers*, 1919
(Musée Picasso, Paris)

tramples underfoot.[29] Beyond these veiled references to Impressionism, Picasso's decision to sign this Cubist painting "Manet" explicitly claims kinship with the original figures of the modern movement, who had by then passed into tradition.

The historical continuity embraced in Picasso's art is a direct reflec-

tion of his new circumstances, particularly his position in the Paul Rosenberg gallery, which surrounded him with the achievements of nineteenth-century artists. There, Picasso was one of only a few twentieth-century artists (Marie Laurencin was one other). Rosenberg showed Picasso's work because he believed it represented a continuation of the French artistic tradition that stretched back not merely to the nineteenth century but to the eighteenth and beyond. Living next door and even at times flashing new paintings at the window for Rosenberg's comments, Picasso was immersed in the milieu of the gallery, and his work was nearly swamped by the scores of canvases by old and modern masters that flowed into the elegant building. Rosenberg's photo inventory for late 1918 to 1919, for example, begins with the substantial total of twenty-two Picassos, but then swells to include twenty-three Pissarros, sixty-six Renoirs, thirteen Sisleys, and fourteen Lautrecs, as well as a scattering of pictures by Puvis, Redon, Rubens, and Le Nain, among others. In a venue that mirrored his intermittent ruminations about his relation to the masters, Picasso was now required to claim a place in their tradition.

All the artists of the Post-Impressionist generation had been dead for a decade or more, but two of the original Impressionists survived: Monet and Renoir. Still vigorous in his eighties, Monet held court at Giverny, where Rosenberg and other dealers visited him in the hope of acquiring paintings, and the ones in the gallery certainly presented Picasso with some excellent examples to fuel his thoughts. In the fall of 1918, Rosenberg displayed Monet's *Woman with Fans* (priced at 300,000 francs), and the following year he purchased the Deudon collection, which included one of Monet's *Gare St. Lazare* series, among other fine Impressionist paintings.[30] Nonetheless, he was far more involved with the seventy-eight-year-old Renoir. On his regular buying trips to Renoir's home in the south of France, he not only loaded up on Renoir's pictures but also introduced the elderly master to the work of his newest artist. In the summer of 1919, Rosenberg wrote enthusiastically to Picasso about Renoir's astonished response and his desire to meet him.[31]

Although Renoir's failing health and his death in December 1919 make it unlikely that the two met, Picasso did render homage, not only by including work "after Renoir" in his fall show but also by copying a photograph of him some time toward the end of the year, possibly

after Renoir died (fig. 36).[32] Taken in 1912, when Renoir was seventy-one, the photo shows the full effects of time on his frail body; his horribly misshapen hands, in particular, expose the difficulty of his continuing effort to paint. In his transcription, Picasso employed a heavy line to emphasize these deformities and other evidence of Renoir's advanced age. In contrast to his nearly contemporary copy of Renoir's *Ménage Sisley,* with its Impressionist grace, Picasso's portrait evokes Renoir's later struggle.

It was the diversity of Renoir's art and life that fascinated Picasso and spoke to his own quandary at this point of transition. Throughout the twentieth century, Renoir's reputation has remained controversial because of the apparent opposition between his early and his late work. Praise for his Impressionist paintings of the 1860s and 1870s has been countered by widespread dismissal of the art of his last forty years, when he intentionally modified Impressionism to construct a style that reclaimed classicism for modern art. Only in recent years, as conventional ideas about what constitutes modernism have collapsed, has the significance of this ambition been widely recognized.[33] Yet, not only was Picasso aware of this issue of Renoir's position in modern art, he found it of great relevance to his own attempt to redefine the avant-garde.

As early as 1912, Apollinaire had defended Renoir's late work when it appeared totally outdated to many in the avant-garde: "While the aged Renoir, the greatest painter of our time and one of the greatest painters of all times, is spending his last days painting wonderful and voluptuous nudes that will be the delight of times to come, our young artists are turning their backs on the art of the nude, which is at least as legitimate an art as any other."[34] There is little doubt that Picasso found these late, often dismissed works crucial to his assimilation of the classical tradition in the years around 1920. Picasso's dialogue with Renoir underlay the transformation of his own work from a primarily Cubist mode to the eclectic variety of Neoclassicism; one might even say that his investigation of Renoir's art fueled his own solution to the apparent conflict between modernism and classicism. Furthermore, Renoir's late paintings—classicizing images of nudes, shepherds, and bathers rather than Impressionist scenes of modern life—constituted the bulk of Rosenberg's inventory.

Depending on one's aesthetic point of view, Picasso's Neoclassicism

of the late teens and early twenties represents either an eclectic blossoming or a chaotic decay because of his refusal to work in an exclusively Cubist style. Yet, stylistic complexity is the central issue of Picasso's art in these years, and it was crucial to his worldwide fame. Perhaps more than any other work of art, a painting with the pedestrian title *Studies* (1920) provides remarkable insight into both Picasso's

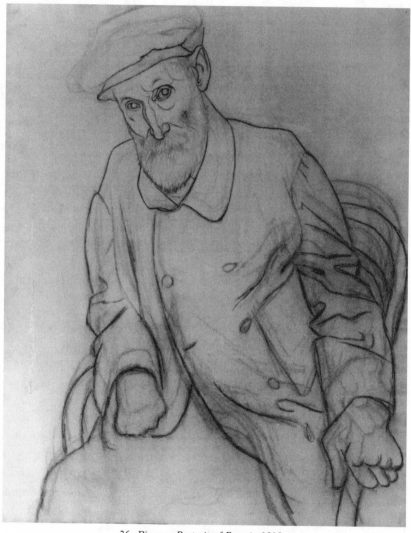

36. Picasso, *Portrait of Renoir*, 1919
(Musée Picasso, Paris)

37. Picasso, *Studies*, 1920
(Musée Picasso, Paris)

conception of his standing in the art world and Renoir's role in his
transformation (fig. 37). Long disregarded by scholars and secluded in
the artist's private collection, this puzzle-picture has recently been ac-
claimed as not only "Picasso's key work of this time" but also "a man-
ifesto or summa at a critical point in Picasso's career."[35]

Although Picasso mixed classicizing and Cubist styles in other

works, none so pointedly juxtaposes these apparently contradictory modes. At first glance, one might dismiss *Studies* as merely a chance assemblage of unrelated sketches that Picasso set down on a canvas much as he might have done on the page of an album. Or, if one credits the composition with the potential for coherence, one might reach for the technique of collage to explain its additive nature. The painting's consistent rendering in oil on canvas, however, bears little relation to the explorations of diverse materials that underlay Picasso's and Braque's collages.

Nonetheless, the picture's flat checkerboard pattern does imply a Cubist grid, and it is this structure that contributes to an impression of the entire canvas's coherence. Furthermore, the individual elements of the grid are distinctly ordered. Highly finished Cubist still lifes frame the outer edges of the canvas, while figures rendered in a sketchily classical style nearly crisscross its center. Most of the still lifes share a similar set of objects, particularly a heavily footed glass, and the figural images are even more consistent. The female profile and its two flanking studies of massive hands model details of the woman who dances with a man near the upper left. One scholar has mused that Picasso might have surrounded the Cubist still lifes with painted borders to suggest that "they represent a phase behind Picasso" and that he left the contours of the figural images more vaguely defined to imply that "they are fresher works." Although this difference in treatment may simply reflect opposing stylistic vocabularies, one based on flatly rendered rectilinear planes and the other on modeled curvilinear anatomies, there is no question that Picasso has heightened an opposition of styles by matching it with different subjects. As another scholar succinctly states: "Realism applied to figure; Cubism applied to still life."[36]

The conflict represented in this painting, however, is one not simply of genres (still life versus figure) or styles (Cubism versus Neoclassicism) but rather of aesthetic traditions and the hierarchies that defined the differences between the academic and the avant-garde in the early twentieth century. Infra-red photographs reveal that Picasso painted *Studies* over a copy of Rembrandt's *Raising of Lazarus*. Although we do not know who executed this copy (it is doubtful Picasso did), Jean Boggs concludes that "in painting a summa of his own position at this moment in his career he liked to remind himself that he was part of

a tradition that went back into the past like the sources he was using for his classical forms."[37]

If this painting is a summa of Picasso's aesthetic position in the years after the war, it is primarily because of his meditation not on Rembrandt or even on classical works but rather on the more problematic figure of Renoir. The image of an embracing man and woman in *Studies* has already been identified as "a dancing couple in everyday clothes straight from Pierre Auguste Renoir." And the large-scale portrayal of a couple in isolation brings to mind Renoir's three great images of the dance from 1882–83 (*Dance at Bougival, Dance in the City,* and *Dance in the Country*), as well as his less monumental cabaret scenes of the 1870s, such as *Ball at the Moulin de la Galette.*

Picasso's reference to Impressionism to reflect the comfort of his new life is only one aspect of his dialogue with Renoir. In opposition to the graceful image of the dancing pair is the confusion of the painting's piecemeal pattern. Yet this structure too has a source in Renoir's work, and it is tied to his late style. When Renoir began to turn away from Impressionism in the 1880s, he challenged himself to develop a style that would link his art with the tradition of Western art reaching through the Renaissance to ancient Greece. "In 1879 he could be hailed as the principal painter of the everyday life of modern Paris," John House observes, "yet by 1886 he was insisting on the prime importance of the nude. In the 1870s he had developed an apparently effortless sketch-like technique, yet he spent the following decade in the shadow of Ingres and the artists of the Renaissance, teaching himself how to paint and draw . . . With the increasing success and confidence of his later years, he felt able to claim a place within the mainstream of the western classical tradition."[38]

One of his means of addressing this challenge and achieving the resolution of conflicting styles that defined his late manner was his unusual practice of sketching on canvas. Writing in 1920, the year Picasso painted *Studies,* the critic Arsène Alexandre explained that Renoir "multiplied his sketches, throwing numbers of them on a single canvas, here and there, heads of girls and children, flowers, fruit, fish, game—whatever he had in reach at the moment."[39] In contrast to the Impressionist style, with its apparent spontaneity, the technique enabled Renoir to analyze stylistic alternatives and evaluate potential subjects methodically, side by side. Since the canvases were experiments,

the raw evidence of his search, Renoir did not intend to exhibit them, but many of them he sold to raise money. As a result, they became well known in his later years. Ambroise Vollard purchased quite a few and reproduced a score or so in his 1918 monograph on Renoir. Vollard, however, was also among those responsible for the near-extinction of this peculiar species soon afterwards, because he and other dealers sliced the canvases up to sell the individual sketches as independent paintings. Among the few extant today is *Mythology; Figures from an Ancient Tragedy*, purchased by Picasso after Renoir's death and now in the Musée Picasso in Paris. It consists of several classically draped nudes related to Renoir's plans for a decorative composition on the theme of Oedipus.

On many of these canvases, Renoir juxtaposed not only different subjects but also different styles, experimenting with renderings based on the broad stroke of Impressionism or the tightest academic mode (fig. 38). In *Studies*, Picasso adopted this heterogenous result of Re-

38. Renoir, *Studies: Women's Heads, Nudes, Landscapes, and Peaches*, c. 1895–96
(Location unknown)

noir's essays and constructed a painting whose coherence depends on his self-conscious inquiry into the problem that Renoir had addressed before him—the relationship between avant-garde and traditional styles. For Picasso, these styles were Cubism and Neoclassicism. Painted the year after Renoir's death, *Studies* is Picasso's most explicit acknowledgment of Renoir's relevance in the search to define a new artistic position.[40]

Picasso's involvement with Renoir was not limited to the issue of aesthetic opposition; it also underlay his solution in the Neoclassical works of the early 1920s. The fleshy women lounging in the hot sun for which Renoir became famous in the last decades of his life were not merely escapist fantasies of sensual abandon. The classical poses of these monumental nudes evoke ancient origins, while their coiffed hair and tanned bodies place them in the modern Mediterranean. They offer a resolution between a Neoclassical rendering of the female nude and the Impressionists' preoccupation with the evanescence of light and color. Though they do not present a seamless union, Picasso found them useful to his effort to expand the options of the twentieth-century avant-garde.

At Paul Rosenberg's gallery, Picasso could not have escaped these elephantine creations of Renoir's later years if he had tried. In the block of sixty-six Renoirs that Rosenberg obtained during Picasso's first year with the gallery, at least half were late works. Among the group was a large painting entitled *Eurydice*, which depicts a seminude woman seated in a landscape (fig. 39). (Rosenberg had known the picture since at least 1917, when he had borrowed it to include in his benefit exhibition of French nineteenth-century art.) Her drapery and pose, based on the ancient "spinario" figure, denote her origins in the classical tradition, just as her rolled hair and rouged face are a modern reference. Picasso liked the painting enough to buy it, and it remained in his collection until his death, by which time he owned seven paintings and drawings by Renoir—more than by any other artist except Matisse. And all the Renoirs were late works.

There is little doubt that Picasso's Neoclassicism of the early 1920s is substantially based on Renoir's re-creation of an Arcadian past. *Eurydice*, for example, bears a remarkable resemblance to Picasso's 1921 *Seated Nude Drying Her Foot* (fig. 40).[41] Although Picasso presents a view from the other side of the figure, he maintains the pose and the

39. Renoir, *Eurydice*, or *Bather Seated in a Landscape*, 1895–1900
(Musée Picasso, Paris)

partially veiled nudity of Renoir's woman. What unquestionably links
Picasso's pastel to Renoir's painting is the figure's deviation from clas-
sical proportions to the gigantic bulk with which Renoir endowed his
painted and sculpted goddesses, as well as the placement of the figures
in a Mediterranean landscape. Nonetheless, Picasso's bather is not a

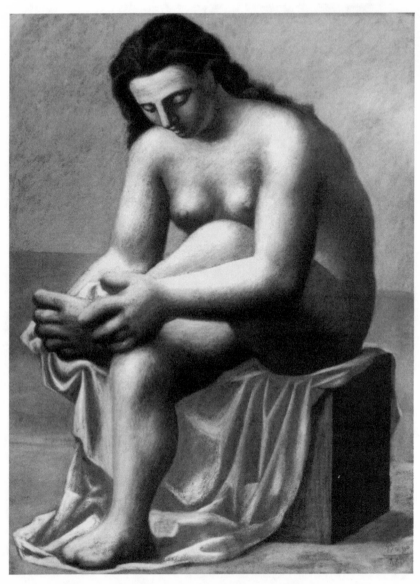

40. Picasso, *Seated Nude Drying Her Foot*, 1921
(Berggruen Collection, extended loan to National Gallery, London)

reproduction of the Renoir, not even to the extent of his copy of the Sisley *ménage*. In many of his classicizing figures, Picasso imposed an austerity that strips Renoir's blowsy women of their makeup, hardens their bodies, and reduces the Impressionist's lush landscapes to their barest elements. Picasso's bathers are far less available than Renoir's; their physical toughness is coupled with melancholic, meditative expressions that psychologically distance them from the audience.[42] If Picasso's Neoclassicism is frequently less a direct dialogue with the ancient past than an engagement with Renoir's attempt to bridge the gap between modernism and classicism, Picasso's conclusions seem far less hopeful than his predecessor's.

Picasso was well aware that his prosperity depended on his dealer's ability to sell works by the Impressionists and older masters for large profits. Until the art market soared in the mid-twenties, Paul Rosenberg did not sell many Picassos, certainly not enough to offset his annual purchases and exhibition expenses. Even though Picasso's paintings were expensive relative to those of other contemporary artists (except Matisse), they did not command the prices of Impressionist work.[43] Rosenberg is reliably said, for example, to have purchased the extensive Deudon collection in 1919 for the huge sum of 1.1 million francs, but he immediately sought to cover most of this cost with only two of the pictures—Manet's *The Plum* and Monet's *Gare St. Lazare* —each of which he priced at 500,000 francs.[44] Compared to these works, Picasso's were small game, but they offered the long-term potential for great profits. Rosenberg's business in older art gave him the freedom to wait.

The economic climate in France after the war did not encourage hopes for immediate sales. Writing in his diary on January 1, 1920, Rosenberg's school friend and fellow art dealer, René Gimpel, observed:

1919 has seen the peace signed and the soldiers passing under the Arc de Triomphe. But the war isn't over. Our mines are flooded, 500,000 buildings have been destroyed, from the North Sea to the peaks of Alsace, 1,500,000 combatants sleep under war-torn soil. Our railways have been used beyond their limits. We owe 40 billion francs. We can send nothing abroad. The value of the franc falls every day . . . Under these frightful conditions, the cost of living is going up,

salaries are doubled, trebled, and so they have to be. The Russian Revolution has all the bourgeoisie in a flutter . . . We live in hard times.[45]

Rosenberg's letters to Picasso confirm that the art market did not escape the general economic malaise. On September 8, 1920, he wrote: "The season is not beginning brilliantly, everyone is very pessimistic about the world economic situation, and everyone talks about the bad industrial affairs, which will have repercussions on works of art—they really do sell at crazy prices. One must hope for a return to a more sane situation." But according to the Cubist painter André Lhote, the conditions still persisted in November 1921, when he wrote to his patron, Gabriel Frizeau, that "right now collectors aren't buying anything."[46]

Nonetheless, throughout these years Rosenberg bought Picasso's work at an increasing rate, and his purchases included both the artist's past and current pictures. To begin 1920, Rosenberg gave Picasso nearly 17,000 francs for five paintings. They included two large Cubist pictures: the just-finished *Young Girl with a Hoop* and *Green Still Life* that Picasso had painted over five years earlier in Avignon (fig. 41). The fact that Picasso still had one of his major paintings from the summer before the war demonstrates not just that Picasso probably valued the picture but also how slowly his work had sold in the interim. In November, Rosenberg bought one of the largest canvases in the *Open Window* series for 13,000 francs, the highest price so far. And he followed up the next month by buying seven more paintings for nearly 30,000 francs. Several other small purchases brought the total Rosenberg paid Picasso during 1920 to 67,025 francs. In addition, Picasso earned 20,000 francs from other dealers (Léonce Rosenberg and Berthe Weill) and from Léonide Massine and Count Beaumont. Besides these last sales to the theatrical community, Picasso collected 13,000 francs for designing the ballet *La Pulcinella*. Thus, his annual income was over 100,000 francs. This impressive sum, however, was effectively less than the 50,000 francs Picasso had earned from Kahnweiler in 1913, because prices had more than tripled during the intervening years.[47]

In 1921, Picasso did better, although almost all his recorded income came from Rosenberg's purchases of four paintings, eight pastels, fif-

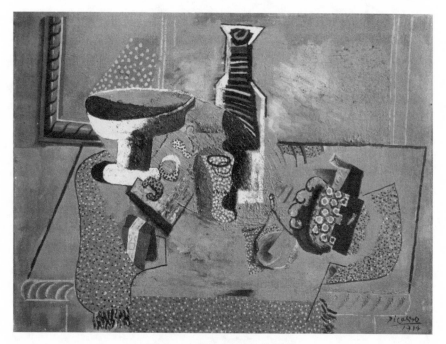

41. Picasso, *Green Still Life*, 1914
(Museum of Modern Art, New York)

teen watercolors, and fourteen drawings for 121,000 francs (fig. 42).
This very considerable sum for a group that included so many works
on paper is partly explained by their large size. A single pastel, *Two
Female Nudes*, measuring 24½ by 19 inches, brought 6,000 francs—
2,000 more than Léonce had paid for *Harlequin* in 1915. Now Picasso's
major paintings commanded triple or quadruple that amount. On Jan-
uary 18, 1921, Paul paid 15,000 francs for *Seated Woman Reading a
Letter*, and five months later he bought *Two Female Nudes* for 18,000
francs (fig. 43). Though due in part to inflation, this jump in Picasso's
prices reflects both Rosenberg's enthusiasm for the Neoclassical works
and his recent success in selling some of Picasso's earlier Cubist
paintings.

Although Rosenberg had managed to find buyers for some of the
drawings he had shown in 1919, the fanfare with which he announced
a sale in June 1920 suggests that it was a rare occasion. Breathlessly,
he wrote the artist: "I must tell you the miracle, the most unbelievable,
. . . the most inconceivable thing, which will stop you in your tracks

and restore your spirits and calm your uncertainties. Yes, my dear fellow, I sold a . . . Picasso."[48] Yet, by the fall, Paul had landed the man who would be one of his best clients during the early twenties, John Quinn.

A prominent New York lawyer who had helped organize the Armory Show and had later contributed significantly to the support of France during the war (he was awarded the Legion of Honor in 1919), Quinn was one of very few Americans who eagerly collected the twentieth-century avant-garde.[49] He had begun buying Picasso's work in 1915, and by the time of his death in 1924 he would own at least twenty-seven of them in a collection that comprised approximately 1,450 items. Not surprisingly, his first purchases of Picasso's work were pieces from the Blue and Rose periods that Vollard supplied to the Carroll Galleries in New York; by the end of the war he was moving into Cubism. In September 1920, this interest brought him in contact with Léonce Rosenberg, who sold him one of the still lifes he had purchased from Picasso early in the war. By November, however,

42. Note of receipt from Rosenberg to Picasso, 1921
(Pierpont Morgan Library, New York)

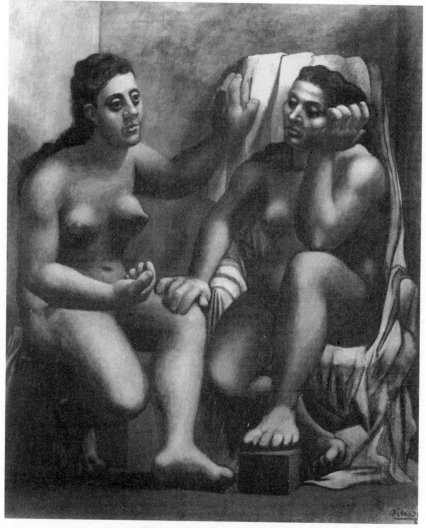

43. Picasso, *Two Female Nudes*, 1920
(Kunstsammlung Nordrhein-Westfalen, Düsseldorf)

Quinn made his first purchase from Paul Rosenberg, who became his primary supplier of the artist's work.

On this first occasion, Quinn bought two of Picasso's most important Cubist paintings of the postwar years, *Harlequin with Violin* ("*Si Tu Veux*") and *Young Girl with a Hoop*, for a total of 60,000 francs. At that price, Paul tripled his investment and found proof that America might well offer a rich market for Picasso's work. The following

August, Quinn spent another 57,000 francs on two more paintings, but this time he shifted to Picasso's new Neoclassical style, and he remained an avid purchaser of these paintings for the remainder of his life. Since Rosenberg had bought Picasso's *Two Female Nudes* for 18,000 francs only two months before he sold it to Quinn for 27,000 francs, he must have been pleased to realize a profit of fifty percent with such alacrity. The painting was Picasso's largest Neoclassical composition to date and is nearly the size of *Three Women at the Spring*, which he would paint the next summer and which Quinn would buy in May 1922, along with a large *Mother and Child* and *Small Giants*, for 75,000 francs.

It may appear that the Picasso market was booming by the time of this last purchase, but that was not the case. The fact that Quinn made this last acquisition directly from Picasso, instead of through the gallery, was a rare exception to Rosenberg's arrangement with the artist. It demonstrates how unusual Quinn's purchases were at this time when the pool of buyers was still very shallow and how willingly Rosenberg waived his profit to keep Picasso in his stable. Since Quinn paid the artist a retail price, Picasso realized at least twice the amount he would have received from Rosenberg. Yet, notwithstanding this opportunity for profit, Picasso rarely seems to have conducted direct sales of his contemporary work after he joined the gallery.

In making this considerable financial sacrifice, Picasso was actually investing in his future; he relied on Rosenberg not only to sell his work but also to cultivate his reputation through exhibitions and publications. Acting with Picasso's approval and generally with his direct collaboration, Paul assiduously sought to establish that reputation on a new plateau, not simply as a leader of the avant-garde but as a modern master—indeed, the greatest master of twentieth-century art. By the beginning of 1921, Paul had decided it was time to begin this campaign by presenting a retrospective exhibition of Picasso's work that would demonstrate the artist's dual achievements as a Cubist and a Neoclassicist.

Unlike the 1919 show, this one would consist primarily of paintings, and they would be selected from a wide range. The catalogue records thirty-three oils among the thirty-nine works exhibited during the months of May and June 1921. Far from concentrating on Picasso's current work, these paintings were chosen to show the development

of his art since the beginning of the war and create a context for his recent Neoclassical style. The nearly twenty Cubist paintings included a still life of 1914, which Rosenberg borrowed from Count Beaumont, and the near-abstract *Portrait of a Man* (1916), loaned by Madame Errazuriz. (The citation of these prominent lenders in the catalogue no doubt helped confirm Picasso's status.) Perhaps the most surprising inclusion was the great *Harlequin* that Léonce had purchased in 1915 and that now apparently belonged to Paul, probably in settlement of accumulated debts. At least one American reviewer already recognized the painting's importance when he suggested that "the almost famous 'Harlequin,' . . . as the most representative expression of the cubistic school (the most ingenious, too), an invention from end to end, ought to find its way into a museum." (This did not occur until 1950, when the Museum of Modern Art acquired it.)

Juxtaposed to this masterpiece of wartime Cubism were Picasso's contemporary departures into Neoclassicism. Perhaps for the first time, Picasso publicly exhibited his 1917 *Portrait of Olga*, and Rosenberg included the 1918 *Portrait of Madame Paul Rosenberg and Her Daughter*.[50] These family portraits served as an introduction to Picasso's recent paintings of monumental figures, such as *Italian Woman* and *Woman Seated in an Armchair*. As if to round out the show, Rosenberg presented two earlier works: a large Rose period gouache of two circus boys and an analytic Cubist painting of 1912.

The presence of this last painting, *The Aficionado*, is especially surprising.[51] Although Rosenberg consistently supported Picasso's Cubism, he did not make an effort to retrieve the prewar pictures. He was committed to the contemporary Picasso with whom he worked and played, not to previous incarnations. The hermetic phase of analytic Cubism, in particular, held no great interest for him, and its unpredictable market was not an enticement either. Nevertheless, from time to time he bought an analytic picture from a collector, and the presence of *The Aficionado* may merely reflect its availability in his stock. On the other hand, he chose a significant time to publicize his acquisition.

During the course of his show, the dam that had been holding back a flood of Cubist pictures finally burst. After protracted negotiations between French officials and the German nationals whose collections had been sequestered during the war, the government initiated mas-

sive sales in the summer of 1921. On May 31, Wilhelm Uhde's collection, containing thirteen pictures by Picasso, was dispersed at auction. But the process really began with the sale of some of Kahnweiler's stock on June 13–14.[52] The auction of 127 works, including twenty-six by Picasso, was the first of four sales that in two years would dump 705 paintings by the gallery's artists on a market that was only slowly recovering. The 132 Picassos in this group apparently constituted sixty percent of the pictures Kahnweiler had purchased from Picasso during 1908–14; Kahnweiler seems to have sold about ninety during the six years he handled Picasso's work. Yet now the market was asked to absorb half again that number in two years. Not surprisingly, prices rapidly sank to abysmal levels.

These approaching sales were common knowledge in the art world, and many of the artists struggled to stop them. Rosenberg would have had direct information about their timing from his brother or Picasso, both of whom were urging prompt action—but out of very different motives. Having agreed to serve as the expert for the auctions, Léonce was actively promoting them as a great way to gain publicity for Cubism.[53] While almost all the artists involved believed that he was crazy to predict success, Picasso had reason to encourage the sale of Kahnweiler's property. Still without the 20,000 francs his dealer owed him from 1914 and smarting from the memories of that difficult time, Picasso appears to have sought both repayment and retribution. Unlike most of his confreres, Picasso had a secure position in an established gallery and therefore could separate himself from Kahnweiler and the prewar avant-garde by blending in with Paul Rosenberg's nineteenth-century masters. Braque soon followed suit. After punching Léonce in anger over his role in the liquidations, Braque left the Galerie de l'Effort Moderne to join the Galerie Paul Rosenberg.[54]

Paul's inclusion of The Aficionado, a painting that Kahnweiler had once owned, evoked the sad denouement of the earlier epoch only to point to the vitality and very different styles of Picasso's current work. As Kahnweiler noted with some amazement, Rosenberg did not buy a single Picasso from the auctions.[55] Like the artist himself, he was clearly more concerned with the present and the future.

To those unfamiliar with Picasso's recent work or Rosenberg's 1919 exhibition, the 1921 show was a revelation. The American reviewer who so praised the 1915 Harlequin headlined his article "Airy Hand-

spring Is Done by Picasso. New Style of the Arch-Extremist Not in Any Way Related to Cubistic Designs That Set Pace for Imitators."[56] For the initiated, such as André Salmon, Picasso's ability to ride two horses at once was old news, but his cozy accommodation to the rue La Boétie deserved comment: "Picasso is exhibiting more or less at home, in a gallery so close to his studio that the paintings and drawings fall inside one by one like newspapers tumbling off the publisher's press."[57]

Both Picasso and Rosenberg understood the value of the press, and they cultivated critics who shared their aesthetic and could help sway public opinion. In his first Parisian exhibition, at Vollard's gallery in 1901, Picasso had given several of his paintings to critics who had written laudatory reviews. During his first exhibition at Paul Rosenberg's gallery, he had entertained Georges Martin in his private quarters, and in the months before the 1921 show he brought a larger project to Rosenberg. He recommended that Rosenberg purchase a book-length manuscript on his work by the poet and critic Pierre Reverdy. Picasso had known Reverdy since the Bateau Lavoir years, and Reverdy had been a strong supporter of Cubism in his wartime journal *Nord-Sud*, so he might seem an odd choice at a moment when Picasso was deeply involved in Neoclassicism. Yet, both men were then searching for new artistic approaches, and they became especially close during the early 1920s. Picasso drew at least two portraits of Reverdy in 1921 and another portrait and illustrations for Reverdy's 1922 volume, *Cravates de chanvre*.

Although it is unclear whether Rosenberg commissioned the manuscript on Picasso or more passively agreed to buy a work that was already in progress, he corresponded with Reverdy about both the purchase price (three thousand francs) and the progress of the text until the author delivered the final manuscript on April 26, 1921. Like many other writers, Reverdy asked for an advance payment and then pleaded for patience as he delayed in finishing the project. (He received both.) The book was not published until 1924, when it appeared in the Nationale revue française series "Les peintres français nouveaux"; nonetheless, the correspondence with Rosenberg and references in Reverdy's text to Picasso's contemporaneous work demonstrate that it was written during late 1920 and early 1921.

Reverdy's essay is both an ardent affirmation of Picasso's talent and

a strong defense of his shift from Cubism to classicizing styles. Beginning with the theme that Picasso's "genius" is characterized by its "gushing" vitality, Reverdy dismisses those who would limit Picasso to Cubism. Singling out a picture of two monumental female nudes from the fall of 1920, Reverdy throws his support behind Picasso's Neoclassicism by praising "the incontestable mastery" with which Picasso produces "an art that prolongs the ancient tradition and also lays the foundation for a new one."[58]

Judging from Picasso's portraits of Reverdy and his contributions to *Cravates de chanvre,* he must have been pleased with the text of Reverdy's book on him. Although these mutually supportive activities among artists and critics were generally too informal to have been documented in a revealing manner, they were widespread. They represent another crucial alliance in the process of developing modern artists' reputations. An artist's relationship with his dealer may have been more clearly specified and more enduring, but the critics' presence should not be overlooked. Moreover—as in this case—artist, dealer, and critic frequently worked in concert to build a public reputation. During the 1920s, Picasso's growing rapprochement with André Breton would be his most important relationship with a critic and a dominant force in both his career and the development of Surrealism.

During the summer of 1921, artist and dealer pursued their burgeoning enterprise. In an unprecedented series of monumental canvases, Picasso measured his position in the art world. His two versions of the *Three Musicians* are often described as culminating works, whether in terms of their Cubist style or of their reference to the intellectual circle that supported Picasso's early work, the "bande Picasso" of Salmon, Jacob, and Apollinaire.[59] Such retrospection seems particularly apt at this point in Picasso's career. By the summer of 1921, not only was his Neoclassical style firmly established, but it was widely praised in the press and beginning to be sought after by collectors. Rosenberg's exhibition had procured this public recognition, and Picasso could now feel confident of his dealer. He could finally assure himself that a new era had been launched.

Thus, it is not surprising that he matched the *Three Musicians* with an equally ambitious work in the Neoclassical style. Realizing that *Three Women at the Spring* announced a new phase of Picasso's dia-

logue with tradition, Rosenberg responded with his usual aplomb: "My dear fountain-beautiful, Thank you for your kind letter and lovely drawing. You have really joined the school of Fontainebleau! A new manner to add to the already long list of your different styles."[60] Picasso sold *Three Women* directly to Quinn the next spring and parted with the two versions of the *Three Musicians* over the next four years. When Rosenberg finally acquired them, they became the centerpieces of his displays.

Having achieved success with his show, Rosenberg turned his attention to promoting Picasso's work around the world. He started with a June 1922 show in Munich at the gallery of Kahnweiler's former collaborator, Heinrich Thannhauser, but he dreamed of an exhibition in America, where he rightly judged the greatest potential market to be. In July 1920, he had with great fanfare commissioned Picasso to paint a large group of pictures for an exhibition in an American museum:

> I hope that your stay at Golfe Juan les Pins has been profitable for your art, because I will not hide from you that I need a large number of canvases for this winter.
> I am organizing an exhibition of Cubist and non-Cubist work by Picasso in a major American museum. Think of the effect that will have, on both the old and the new continents. In one of the oldest great cities of America and in one of the most beautiful museums in the country, next to the Verrocchios and Pollaiuolos and the great masterpieces of the past. Picasso will return to America in glory . . . Therefore, you must make me beautiful paintings of high quality. I am now placing an order for 100—deliverable this fall!![61]

Although remarkable for the scale of its ambition, Rosenberg's plan was not without precedent. In the mid-1880s, Durand-Ruel had staged exhibitions of the Impressionists in America before opening a branch of his gallery in New York and thereby salvaging his failing European operation. Unlike those ventures, Kahnweiler's attempts to show the Cubists at the Washington Square Gallery and the shows held at the Photo-Succession and the Modern Gallery in the teens, Rosenberg's plan called for the prestige of a museum setting and an exhibition of monumental size.[62] Indeed, it was the model for the great monographic exhibitions of the 1930s—at the Galeries Georges Petit and

the Zurich Kunsthaus in 1932, the Wadsworth Atheneum in 1934, and the Museum of Modern Art and the Art Institute of Chicago in 1939–40.

Before forging ahead, Paul consulted John Quinn. Through his agent in Paris, Henri-Pierre Roché, Quinn strongly advised against such a large exhibition. He dismissed the proposed location, the Art Institute of Chicago, because he thought that city "a waste of time and money, with no sales," and he felt certain that economic conditions would doom the enterprise. Writing in December 1920, he predicted: "This is not going to be a good year for the sale of art things in this country. As I wrote before, the bottom has dropped out of the stock market. People who made fortunes in the last two years are likely to lose them all . . . So I am not at all sure that 1921 is a good time for Paul Rosenberg to have an exhibition in Chicago." Nonetheless, Paul stuck to his plan.

In the summer of 1921, while Picasso was painting *Three Musicians* and other monumental canvases, Rosenberg reminded him: "I want to organize a Picasso show in New York this winter. Also, . . . I am in need of new canvases, and many of them."[63] What greater encouragement could an artist have than to paint with a worldwide audience in mind? As a further stimulus, Rosenberg sent Picasso the American review of the 1921 show cited earlier to demonstrate the interest in his work across the Atlantic.[64] And with the continuing impetus of Quinn's purchases, both the artist and his dealer seriously pursued plans for an exhibition in America.

The first museum exhibition of Picasso's work in America was not organized by Rosenberg; it was the result of Picasso's connections with Prince Wladimir Argotinsky-Dolgoroukoff, a Russian aristocrat who had long patronized Diaghilev's ballet and who, having moved to Paris at the time of the revolution, had joined Picasso's circle. Through him, contacts were established with one of the few American groups willing to show avant-garde art.[65] Before the founding of the Museum of Modern Art in 1929, hardly any institution in the country—and none in Manhattan—would exhibit European modernism.[66] Thanks to the adventurous founders of the Arts Club of Chicago, that city was probably the most hospitable place in the United States for the presentation of modern art. By renting space from the Art Institute, the Arts Club managed to present its shows in Chicago's most prestigious museum.[67]

While Rosenberg continued to seek a proper venue, Argotinsky arranged for the Arts Club to show fifty-three of Picasso's drawings in the spring of 1923. The prince's letters to the Arts Club demonstrate how closely Picasso followed developments as the group sought to expand the tour. "Picasso wants to know the place where will be his exhibition in New York and is waiting for a formal official invitation from the Committee of Museums organizing his exhibitions in America."[68] Once arrangements were finalized for a single venue in Chicago, Picasso and Argotinsky selected work to highlight the variety of his achievement from 1907 to 1922 and supplied detailed instructions for the matting and display of the drawings. The artist's substantial role in these preparations is clearly registered by Argotinsky's regular references to what "Picasso suggests" and "Picasso wants" and to "the desire of Picasso."[69] Besides constituting the first museum exhibition of the artist's work in America (or anywhere else), the works were for sale, with the Arts Club taking a ten percent commission. Although the show seems to have been a popular success, a sanguine entitled *Head of a Woman*, which the club purchased, and a pencil drawing of bathers were the only works that sold.[70]

During 1922, Rosenberg had continued to discuss his plans with Quinn. Always practical, Quinn's remarks were no longer directed toward the question of whether the show should be mounted but rather were concerned with the matter of whom Rosenberg should affiliate with in New York. Countering Rosenberg's interest in an established gallery such as Gimpel or Wildenstein, Quinn argued for Joseph Brummer, a dealer devoted to contemporary art. Although Rosenberg thanked Quinn for having saved him a lot of money by dissuading him from organizing a show the previous year, he explained that he could not accept Brummer: "I have rented for several years, the galleries of my friend Wildenstein, and I am obliged to do every exhibition in New York in his firm. As I shall do always very fine shows, of modern art, from Ingres to Picasso, he rent me the gallery at a very low price; he was clever enough to understand, that an exhibition of fine paintings, will bring him a lot of customers to whom he might sell old paintings."[71] Without revealing the full extent of his partnership with Wildenstein, Rosenberg confided in Quinn as not only a valued client but, increasingly, a business colleague. Likewise, Quinn sent Rosenberg his regrets when he heard that the Picasso show Rosenberg had organized

at Thannhauser's gallery in Munich had not been a financial success.

Quinn's support for Rosenberg as Picasso's promoter did not moderate his own ambitions as a collector. The more Quinn learned about the art business, the more he maneuvered to arrange a commercial relationship with Picasso that excluded the dealer. Plotting with Roché, Quinn wrote in January 1922: "I think that he [Picasso] and I would both profit by it [an agreement for direct sales], for I think he would get more prompt payment from me than he would from Rosenberg, and I would be saved the commission that he would pay to Rosenberg, and, as you say, the difference would be worth taking into consideration and would enable me to buy more of his work than if I bought through Rosenberg."[72] When, in the following months, Quinn successfully negotiated the purchase of three paintings (*Three Women at the Spring, Mother and Child,* and *Small Giants*) directly from Picasso, it seemed as though his plan was working and Rosenberg's alliance with the artist might soon end.

By the fall of 1923, Rosenberg had made arrangements with the Arts Club. His only requirements were that his name appear on the catalogue as lender and that the club pay shipping and insurance expenses from New York; in turn, he agreed to supply the Arts Club with a series of shows for display at the Art Institute.[73] Beginning with Picasso, it continued with Braque and Marie Laurencin later in the year. As before, the enterprise was a partnership, since the club continued to collected commissions on sales.

For Rosenberg, the deal initiated an international network that linked commercial galleries with public institutions in a joint effort to build both the markets and the reputations of his artists. With Picasso's full cooperation, he selected work designed to serve as the beginning step in a long campaign. For the first time since they began representing Picasso, Rosenberg worked formally with Wildenstein, at whose New York gallery the exhibition stopped before proceeding to Chicago (fig. 44).[74] The venture was important enough for Rosenberg to journey to America and accompany the pictures across the country—pioneering modernism.

For this groundbreaking exhibition, they chose a core of ten current paintings, which were introduced by three paintings from 1922, two pastels from 1921, and one pastel from 1920. Of the sixteen works in the show, not one was Cubist. Instead, they began with a Neoclassical

composition of two female nudes and continued through a group of bathers to two *Maternitys*. The ten current paintings were some of the most exquisitely beautiful images Picasso ever created. Both in subject matter and style they returned to his work of twenty years before, but now through the lens of his recent involvement with Renoir and the classical tradition. Their frequent subjects of saltimbanques, harlequins, and musing women recall his primary subjects of the Blue and Rose periods, as do their monochromatic tonalities saturated with red, blue, and gray. The size and scale of these monumental personages fit the tradition of classical figure painting, and the delicacy of their drawing glides back through Picasso's early work to the virtuosity of Renaissance and Mannerist masters.

This group of pictures accurately reflects the direction of Picasso's work during 1923 and 1924, even if it neglects his diversity. There is little doubt that this particular slice was intentional. Rosenberg's letters to Picasso acknowledge the calculation that went into the selection and remark on the visitors' responses. On November 26, during the New York run of the show, Rosenberg reported: "The one that should

44. Wildenstein & Co., *Exhibition of Recent Work by Picasso*, New York, 1923
(Courtesy of Wildenstein & Co.)

have pleased them the most, the *Seated Harlequin*, pleases the least; the suffragettes choose the *Woman in a Blue Veil* and *The Reply . . .* That is as we foresaw."[75]

His regular accounts, beginning with the Atlantic crossing and ending with his evaluation of Chicago as a center for modern art in America, convey the adventurousness of the enterprise. Moreover, they provide a vivid and rare portrait of the nascent audience in America during the 1920s. En route to New York, he confided that it was "heartbreaking to leave my wife, children and friends, which include you"; but upon arrival he quickly regained his enthusiasm and admitted, in anticipation of the opening, his satisfaction with the "marvelous effect" that the pictures made in Wildenstein's gallery and the "astonishment" of advance viewers, though they "were not buyers."[76]

By November 21, he reported that the show was "a great *succès d'estime et moral.* Everyone finds it marvelous and says, Finally, a good exhibition of beautiful paintings!" But five days later, his euphoria had been sobered by practical considerations: "Your exhibition is a great success and, like all successes, we have sold absolutely nothing! The public crowds in, and the press speaks with one voice. Everywhere reproductions appear in the newspapers, in the magazines, but what about the buyers?" Rosenberg began to realize how difficult and slow the process of winning a dedicated audience would be: "One must be strong like me, or crazy like me, or persistent like me to undertake this enterprise. Nonetheless, thanks to your works and the publicity that I have generated around them I am very well known, but that isn't enough . . . Despite everything, I am happy to have done this, and it will pay off for me in old age or for my young son."[77] Indeed it did, when he moved his gallery to New York at the beginning of the Second World War and his son, Alexandre, joined him after fighting with de Gaulle's forces. During the intervening years, Paul's focus on this long campaign resulted in a growing stream of exhibitions devoted to Picasso's work in this country, particularly at the Wadsworth Atheneum in 1934 and the Museum of Modern Art in 1939. For the present, however, he depended on American collectors to come to Paris as Quinn had: "I think that the best plan would be to concentrate on meeting people here and count on 21 Boétie for sales—it is the only, the best place."

In his own account of the New York visit, Quinn revealed how intensely Rosenberg worked to develop the American market. Himself known for his relentless devotion to business, he complained to Roché that Rosenberg never stopped promoting his artists:

> Rosenberg has had his Picasso show at Wildenstein's gallery on Fifth Avenue now for three weeks . . . [He] was very, very anxious to come to see my things. Finally I had to agree to have him come up. [Felix] Wildenstein [director of the New York office] and he accepted my invitation to dinner yesterday evening . . . Wildenstein is a perfect gentleman . . . [Rosenberg] disgusted everybody by constantly turning to me and asking me to "come in to see me so I can show you a wonderful portrait of Madame Cézanne." And again, . . . "Mr. Quinn, why don't you come in and let me show you a wonderful new Lautrec?" . . . Everyone was disgusted by Rosenberg constantly talking shop. When we checked him off it, he would come back to it again.[78]

Quinn's dinner party was probably only one of many occasions Rosenberg spent drumming up interest in his gallery and artists. His goal, he told Picasso, was to meet as many people as possible and convince them to visit him in Paris.

Quinn knew that American collectors were not willing to pay the prices Rosenberg was asking, and he showed his own business acumen by plotting to exploit the show's lack of sales:

> Rosenberg has been bitterly disappointed in the reception of Picasso here and in his failure to make sales. That will be a setback to Picasso in Paris. Picasso will want to make sales to you [Roché] or me in the . . . next four or six months. *And he will not do so.* The stand-off attitude can be played by both sides. Picasso stood you off after we saw him this autumn. Now when he comes to you or speaks to you about selling things to me, you can stand him off . . . I think you can frankly say: "Mr. Quinn thought that we had a friendly understanding, honorable to both sides . . . [He] felt that your decision this fall not to do any business with him direct was not in the spirit in which he had dealt with you a couple of years ago."[79]

Although Quinn had failed to sever Picasso from Rosenberg, he understood his importance in the still small market for Picasso's work and resented Picasso's unwillingness to sell to him directly. Quinn's death the next year would prevent him from springing his trap, so it remains unclear who was the more wily strategist, he or Rosenberg. Despite their combative relationship, Quinn and Rosenberg clearly understood each other very well. Quinn's judgment about the effect of the show's financial failure on Paul provides a tonic to the dealer's more upbeat reports to Picasso, while confirming Paul's perseverance against what must have appeared to be a great setback.

Wildenstein's director of exhibitions confirmed the critical success of the show when he wrote to the Arts Club on December 6 to apologize for the delay in forwarding it. Evidently it was so popular that the gallery had been obliged to hold it over. He warned that "it may be that one or two of the Picassos will be withdrawn as transactions are pending."[80] On December 10, though, all sixteen pictures were shipped to Chicago.[81]

Buyers' resistance is not hard to understand. Although the works had been chosen to entice American collectors, their prices were no bargains, ranging from $1,500 for a pastel to $6,500 for the largest paintings.[82] Compared to prices for work by contemporary American artists, they must have been stupendous; they even substantially topped the high prices Quinn had been paying for Picasso's recent work. In May 1922, for example, he had purchased two big paintings of 1921 for $6,832.[83] Clearly, Rosenberg was willing to wait, and Quinn may have somewhat exaggerated the dealer's disappointment.

When the show moved to Chicago, Rosenberg went along. "Naturally, I will accompany it, as impresario," he told Picasso.[84] He arrived on December 17, one day before the opening. Although taking pleasure in the fact that Picasso's paintings now hung in a major American museum (among the Old Masters, as he had predicted they would three years before), he was cautious about the show's reception: "I very much doubt that it will obtain the same success as in New York or that we will sell anything. Despite that, the effect of the show will be enormous." Even though he foresaw correctly that there would be no sales, he had great praise for Chicago, which he considered "a beautiful city and the most important artistic center in America."[85]

Among the largely laudatory press reports of the show in New York

and Chicago are reviews by critics who, though sympathetic to the avant-garde, nonetheless registered puzzlement at the selection of works. Noting that many devotees of modern art might be disconcerted to find that the Picassos were not Cubist, Henry McBride, a leading critic, defended such viewers against the charge that they were reactionary: "But a reformed Picasso? Academicians don't you believe it."[86] In an issue of the modernist magazine *The Arts* that reproduced most of the paintings in the show, Forbes Watson admitted that many past admirers of Picasso's work were wondering if the accessibility of the show meant that it had been assembled for the American market.[87] Indeed it had been, but the group of pictures exhibited in the United States presented the view of the artist that Picasso and his dealer wished to promote in Paris too, as the final stop at the Galerie Paul Rosenberg proved.

There, the show remained essentially the same. Most of the early works were deleted since the Paris crowd did not require an introduction to Picasso's work, and these pictures were replaced with three portraits of Koklova and their young son, Paulo, as well as a number of drawings. But the core group of stately paintings depicting saltimbanques, harlequins, and pensive women remained.[88] Much to Rosenberg's satisfaction, their consistent format, similar subjects, and harmonious moods created an impression of a unified series. Drawing upon his experience with the Impressionist market, he had long urged Picasso to paint in series. In advance of the 1921 exhibition, he had even pleaded with him for a specific group:

> I remind you,
> my harlequins!!!!!!!!!!!!!!!
> my harlequins!!!!!!!!!
> my harlequins!!!!
>
>
> Equally, think about the fact that I need pictures and that you *promised* to make them in . . . series (see Monet).[89]

When Picasso finally complied two years later, Rosenberg paid the princely sum of almost 244,000 francs for the twelve Neoclassical paintings that constituted the heart of the touring show of 1923–24 and three Cubist still lifes that were not exhibited.[90] Perceiving that

Picasso's Neoclassicism had reached a stage of accessibility that could win a wider audience for his work, Rosenberg priced the paintings to reflect their place among the masters. At 100,000 francs, the largest canvases struck other dealers as remarkably expensive for contemporary art; nonetheless, at least one sold. Rudolf Staechelin, a collector from Basel, bought *Seated Harlequin* (fig. 45). It joined one of Picasso's first Neoclassical harlequins, *Harlequin with a Mask* of 1918, which Staechelin had purchased six years before.[91] As Quinn's earlier purchases had demonstrated, Picasso's Neoclassical oeuvre was established. It attracted collectors quite apart from his continuing Cubist work.

Like the American critics, some of their French counterparts were puzzled by the selection offered. Unsympathetic reviewers dragged out the old accusation that the shifting styles evinced insincerity and that Picasso was once again exploiting the public. To this, André Salmon replied that the artist's stylistic evolution was abundantly clear and that his detractors should not expect a mere perpetuation of the past. The current paintings were the product of his dialogue with his early work as much as with the classical tradition, because the "pure Harlequins of 1924" formed "a perfect unity with the Blue and Rose periods."[92]

Despite this symmetry, Maurice Raynal leveled a much more serious charge against the show—censorship of Picasso's career: "It is regrettable that Paul Rosenberg did not decide to hang a group of works that presents the *current* different tendencies of Picasso's art." Like Salmon, Raynal was an old friend of the artist, but he also remained a committed advocate of Cubism when Salmon, among many others, had bent with the aesthetic winds. Based on his inside knowledge, Raynal noted that the Cubist works he had seen in Picasso's studio were conspicuously absent. Moreover, he unfavorably compared the "naturalism" of the show's paintings to the "most rare plastic combinations" of Picasso's designs for another public event, the ballet *Mercure,* which would premiere in June.[93]

Although Rosenberg's constant discussion of business matters with Picasso makes it impossible to believe that the selection was made without the artist's full approval and cooperation, the show marked a turning point in Picasso's career. Never again would he exhibit work that was primarily in a Neoclassical mode, and during the next year his art shifted away from the accessibility that it had developed over

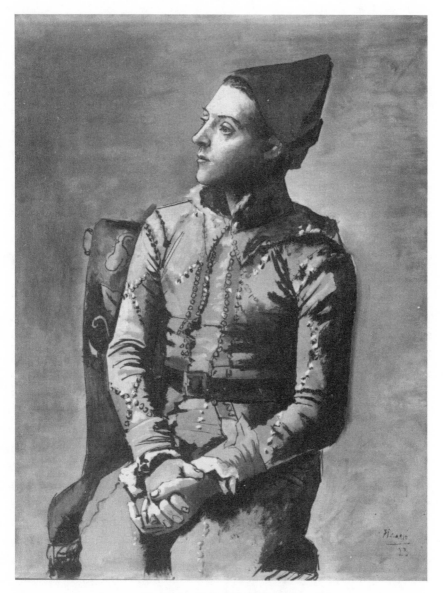

45. Picasso, *Seated Harlequin*, 1923
(Kunstmuseum, Basel)

the preceding five years.[94] There is no evidence that Rosenberg attempted to interfere with this change; in fact, he celebrated Picasso's commencement of a new series of Cubist still lifes the following summer. Yet Raynal's remarks were not simply *retardataire*. The exhibition

and the premiere of *Mercure* in the summer of 1924 would define a fundamental divide in Picasso's public life and art. Not only would he end his participation in ballets for many years to come, but he would turn away from the worldly life he had cultivated since *Parade*, and which Paul Rosenberg had so smoothly supported.

By the mid-twenties, Neoclassicism had become the vogue, much as Cubism had ten years before, and Renoir was a widely respected figure. The retrospective exhibitions of his work in the years after his death particularly elicited praise for his Neoclassicism. This reevaluation reflected a desire to affirm traditional values after the disruptions of the First World War.[95] The "call to order," as Cocteau characterized the trend in 1926, reversed the common negative appraisals of Renoir, inspiring many avant-garde artists to accommodate their art to chauvinistic beliefs in a French or Mediterranean tradition.[96] Picasso, in addressing the classical tradition before most others did, appears to have been at least as deeply influenced by his past art and professional life as by political events.

Moreover, even as he had explored Neoclassicism, he had maintained an aesthetic distance that conveyed his skepticism that paradise could be regained, as Renoir and others asserted. One manifestation of this doubt was his unwillingness to relinquish Cubism even as he adopted classicizing styles. Despite his lack of respect for a Cubist school, Picasso continued to paint Cubist pictures throughout the postwar years. In *Studies* of 1920, for example, he gave Cubism and Neoclassicism the same weight. Across the surface of the painting, they remain separate but equal. Yet the underlying Cubist grid, with its freedom to reorder the world, lends coherence to the entire composition. As Picasso said in a 1923 interview, his different styles were not exclusive phases in an evolutionary process but alternatives from which he selected according to his expressive goals.[97] His response to the succession of styles that defines the common conception of avant-garde art before World War I was not to claim discovery of "the next step" but to accept a situation characterized by multiplicity, where the past as well as the present and the imagined future could be explored.

There is a great deal of restlessness even at the height of Picasso's devotion to Renoir and indulgence in the pleasures of his new life on the rue La Boétie. It can be glimpsed in his slightly ridiculous versions of the Sisley *ménage* and Manet's lovers, but it is most explicitly ap-

parent in his still lifes and interiors. There, Picasso directly portrayed his ambiguous response to his luxurious new surroundings. Much as the reporter Georges Martin had singled out the birdcage in Picasso's apartment as a particularly bourgeois emblem, Picasso used it to symbolize his desire not to be limited by his new lifestyle. As early as 1919 he made a watercolor that sets up a direct comparison between the caged bird and himself seated in his apartment (fig. 46).[98] The symmetry of this pairing and the way Picasso's stiff posture echoes the parakeet on its perch suggest more than a formal analogy. Both the bird and the man appear to be confined, the bird by gilded bars and

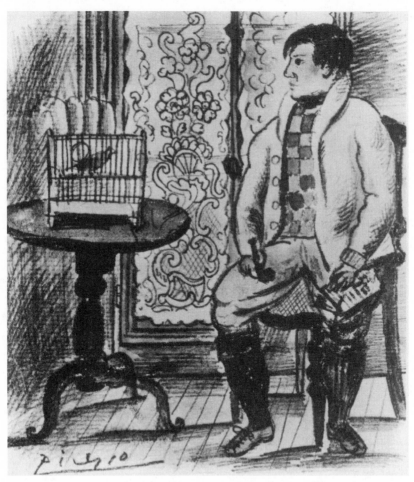

46. Picasso, *Self-Portrait with a Bird Cage*, 1919
(Location unknown)

Picasso by the elegant window grille. Even the artist's drab clothes don't show his accustomed flair. Underneath his heavy cardigan, the scintillating diamonds of the harlequin's costume have sunk into flat rectangles.

While this image from Picasso's first months in his new home, when he flaunted his achievement of conventional success to Martin, may demonstrate that he was already worried about its potential to restrain his creativity, there is no doubt that by the summer of 1924 he began to separate himself from the world of the rue La Boétie to explore an apparently opposing sensibility. Coming on the heels of his American tour, the public controversies surrounding his show at Rosenberg's gallery and his participation in the ballet *Mercure* launched a new Picasso—the genius of Surrealism.

THE ETERNAL
PERSONIFICATION
OF YOUTH

□

Two months after the international tour of Picasso's harlequins, saltimbanques, and other costumed characters had finally closed, Picasso revived its carnivalesque mood for another gala event. Instead of painting a canvas, however, he presented himself to Parisian society in the guise of one of his favorite performers. By appearing in the costume of a toreador at a much-discussed ball and posing there for a portrait by Man Ray, Picasso elided his life among the haut monde with the art he had just displayed to the broad public (fig. 47). As he stood before Man Ray's camera in his sumptuous regalia, Picasso assumed a posture of erect confrontation that conveyed a lordly hauteur, enhanced by the exotic glamour of his dark sequined jacket and black tie.

As if there were any need to confirm the formality of this image or Picasso's preeminence within it, a pair of women in white frame him at the center of the photograph. On Picasso's left, Olga Koklova gathers her skirts in the first stage of a bow. She looks beyond Picasso to meet the gaze of the woman who stands at his right and who almost joins hands with her to enclose the artist. Posing slightly behind these two women and staring into the camera, Picasso radiates a solitary grandeur. Perhaps no other image—the framing women, the luxurious

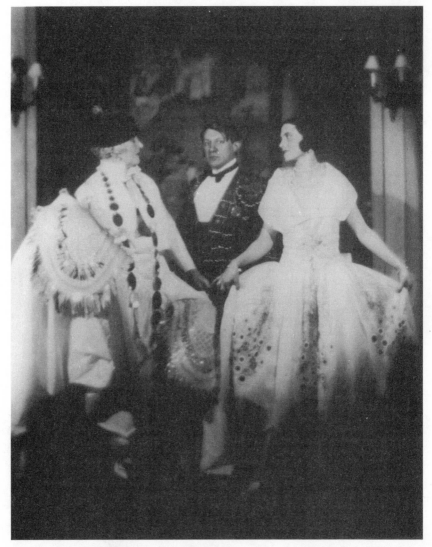

47. Man Ray, *Picasso, Olga Koklova and Eugenia Errazuriz at the Beaumont Ball for Mercure*, 1924 (Courtesy of Lucien Treillard, Paris)

costume, and the self-confident air—could better capture the position that Picasso had attained among the "ultra chic."

In this balletic composition, the artist does not favor his wife but instead turns slightly toward the opposing woman, who wears a torea-dor's cap and holds her embroidered shawl as if it were a cape unfurled before Picasso's bull. Her prominence should not be surprising, since

she is Eugenia Errazuriz, who had played such a crucial role in securing Picasso's place in high society. Her appearance with him in Spanish costume may even be a reprise of their performance eight years before at the Soirée Babel, when they sang Spanish folk songs and danced to much acclaim. Now, the sponsors of that event, Count and Countess Beaumont, had again invited their conception of *le monde* to revel in celebration of the count's collaboration with several artists on a series of theatrical evenings. The ball occurred on the opening night of these summer entertainments, "Les soirées de Paris," and it particularly honored Picasso for his contributions to the ballet *Mercure*, which premiered that evening.[1]

The Soirée Babel of October 1916 and the ball for the Soirées de Paris in June 1924 circumscribe not only the years of Picasso's enthrallment with the ballet but also his immersion in its society, on the arms of Errazuriz and Koklova. The photographs documenting the evening show the members of this social world. One records the seating for the dinner, with Picasso surrounded by other prominent artists, such as Colette; Paul Rosenberg is there too (fig. 48). If it is unlikely

48. Picasso and Rosenberg at dinner for *Mercure* opening, 1924
(Private collection, New York)

that business was discussed at table, among this group it was generally mixed with pleasure. Picasso's continuing engagement with this world over nearly eight years would seem to cast doubt on the sincerity of his complaint to Juan Gris during the production of *Parade* that he found ballet society oppressive because of the excess of beautiful women and radiant jewels.

Yet *Mercure* was the last ballet Picasso designed until after the Second World War. Its premiere announced a departure in his art, and its reception encouraged a shift from the haut monde. Although not without precedent in the work of his recent glamorous years, his new style reached back to Cubism in order to engage the issues of a resurgent avant-garde. The critical controversy that would erupt over *Mercure* and the resulting alliance between the artist and his defenders in the fledgling Surrealist movement would nurture a transformed Picasso, an artist who put aside Neoclassicism to resurrect an avant-garde that had seemed to die with the recognition of a "school of Cubism" during the First World War.

The arrival of Surrealism supplied a context for shaping the public reception of Picasso's art. The Surrealists' ardent praise paved the way for Picasso to renew his position in the avant-garde without forsaking the Cubism he had always refused to dismiss entirely. Nor would he have to deny himself the luxuries of his life on the rue La Boétie. His persona, built on rapid transformations, once again metamorphosed to encompass his attachment to both worlds. In the midst of the seemingly endless financial expansion of the twenties, Picasso's collaboration with Paul Rosenberg reaped previously unimaginable profits. Picasso was able to augment his recently achieved eminence with the stimulation of new avant-garde directions.

Even more than in the years immediately following the war, his life and art presented a duality that few artists could bridge successfully, and his awareness of this attenuated state led him to intensify his meditations on the vagaries of public reputation. These ruminations did not remain private. Picasso's acceptance of a commission to create a monument to Guillaume Apollinaire forced him to formulate a public response to the issues that shaped his reputation, as they had that of his close friend and compatriot. As a public monument, the Apollinaire memorial was Picasso's most ardent attempt before the *Guer-*

nica mural of 1937 to capture the spirit of the avant-garde and convey it to a broad audience.

All these issues initially came into focus through the events surrounding the creation of *Mercure*. Picasso's curtain and sets for the ballet gave the public the first sight of a different side of his art, an approach that in many people's minds was quite opposed to the classicism of his elegant figure paintings. After all, the designs for *Mercure* had prompted Maurice Raynal to herald a renewal of Cubism and to publicly criticize Rosenberg for not presenting this work in Picasso's spring show. We must assume that Picasso and Rosenberg knew full well that the *Mercure* sets would soon showcase Picasso's new Cubist style. What better way to demonstrate the diversity of Picasso's work than to present its opposing modes in two distinct but closely timed events? The strategy suggests that another reshaping of Picasso's image was under way.

Raynal had no right to accuse Rosenberg of ignoring Picasso's Cubism. Among the purchases Rosenberg had made in October 1923 to stock the touring show were three Cubist paintings of the sort that lead directly to the *Mercure* sets.[2] Throughout the period of Picasso's Neoclassicism, Rosenberg had regularly bought Cubist pictures; their small proportion in his acquisitions reflects the fact that Cubism remained only an undercurrent in Picasso's work until the summer of 1924. The three paintings he purchased in October 1923, however, mark the slow resurgence of Cubism in Picasso's oeuvre. At least one was begun during the summer of 1922, when Picasso was in Dinard, and all three were finished during the following months.

While two of the paintings, *Still Life with Fish* and *Guitar*, are as large as the exhibited figures, they are little more than variations on the subject of the still life before an open window that Picasso had initiated in 1919 and had first presented that year in Rosenberg's inaugural exhibition of his work. The third, however, a smaller canvas also called *Guitar*, demonstrates the stylistic departure that would astonish the critics who saw the curtain and sets for *Mercure*. By first reducing objects to outline and volume and then detaching these two components from a normal descriptive relationship, Picasso created a new Cubist style in which line floats free of mass to suggest fluid, multilayered reliefs (fig. 49). With extreme simplicity, the *Mercure* sets

49. Picasso, *Curtain for* Mercure, 1924
(Musée National d'Art Moderne, Paris)

embodied the same formal principle by presenting true reliefs com-
posed of rattan tracery backed by curvilinear flats to represent scenery
and characters, particularly Mercury and the Three Graces. To many
contemporary observers, the minimalism of this rendering suggested
an invention and spontaneity that was highly prized.

Although the ballet was a collaboration among Picasso, the chore-
ographer Léonide Massine, and the composer Erik Satie, its impact
rested mainly on Picasso's contribution. According to Douglas Cooper,
"The episodes of the ballet . . . were intended to evoke various aspects
of Mercury's mythological personality: the god of fertility, the messen-
ger of the gods, the cunning thief, the magician and the henchman of
the Underworld." Yet it was "essentially Picasso's ballet . . . Picasso's
interpretation of the scenes, his decor, his stage effects, his use of
colour, his inventive groupings dominated the spectacle."[3]

Picasso's decision to expose his new idiom while it was still devel-
oping (few paintings yet existed) indicates both his confidence in it
and his eagerness for it to be recognized. In a spirit of experimentation

recalling his use of *Parade* to introduce his Neoclassicism, Picasso chose a theatrical venue, a forum less freighted with critical expectations than an exhibition of paintings would have been. Nonetheless, the fanfare suggests that Picasso believed this first concerted effort to reinvigorate Cubism since the war (despite some remarkable individual achievements, such as the two versions of the *Three Musicians*) offered both a public rebuttal to the moribund reputation of contemporary Cubism and a private solution to the doubts he had addressed in work such as *Studies*, his heterogenous painting of 1920.

In shifting his attention back to Cubism, he sought a path of escape from the dissipation of the prewar avant-garde that had originally played such a prominent role in his reconsideration of the classical tradition. By painting Harlequin and Pierrot on the *Mercure* curtain, Picasso highlighted his stylistic virtuosity, because he depicted them not in the classicizing style of the recent exhibition paintings but rather in his new Cubist mode.[4] The public alignment between Picasso and the Surrealists that emerged during *Mercure* would soon expand to encompass Paul Rosenberg's gallery and infuse most of the artist's remaining exhibitions there.

In selecting *Mercure* for the debut of his reinvigorated Cubism, Picasso apparently saw no contradiction between his art and the program of the Soirées de Paris. Such theatrical events were traditionally sponsored by aristocrats like the Beaumonts, and theirs was a world Picasso had been inhabiting since his participation in *Parade*; yet it was just this alliance that made *Mercure* a center of controversy in the summer of 1924. Despite its conventional origins, *Mercure* became a cardinal event in the formation of a new Parisian avant-garde, as the rising generation of artists associated with the Dada movement asserted their independence from the artistic establishment. Their acceptance or condemnation of Picasso's participation in *Mercure* became a touchstone in defining their respective aims: to reinvigorate the prewar avant-garde or to dismiss artistic tradition altogether. While André Breton acclaimed the event by celebrating Picasso for his ability to perpetuate "a troubling modernity," Francis Picabia ridiculed Picasso as a has-been who created "a modern anxiety in the manner of Paul Poiret," the fashion designer.[5]

Until *Mercure*, the young avant-garde critics of the Dada movement had generally confined their discussion of Picasso's art to praise for his

role as an inventor of Cubism. They shared his disdain for the postwar direction of that movement and had chosen mostly to disregard his pursuit of a classical tradition. Thus Picasso could indulge his varied interests with confidence that his public reputation was secure among both his own generation and the rising one. His participation in *Mercure* changed the situation. It galvanized the Dada critics to debate his status and to express the criticisms of his worldliness that many of them had kept private. The ballet focused the charges, covertly circulating through the Dada movement for several years, that he had sold out to the establishment. Coming so recently after sympathetic critics on both sides of the Atlantic had raised doubts about his classicizing paintings, these strident attacks by young artists whom Picasso had tolerated and even supported must have exacerbated his long-standing uneasiness about his position in the haut monde.[6]

By the early 1920s Dada had arisen as a movement that dismissed both Léonce Rosenberg's brand of Cubism and the call to order. Equally opposing the strict asceticism of the *effort moderne* and the worldly indulgence of many of the Neoclassicists, the Dadaists sought to resurrect art as an instrument of political and social change. In this endeavor, they viewed artists' collaboration with the ballet as a corrupt affair. So it is not surprising that the Soirées de Paris was condemned for its links with the aristocracy. The question was whether Picasso should be dismissed along with Beaumont, Massine, and Satie.

To many Dadaists, Picasso's participation demonstrated a degree of decadence that could no longer be overlooked. Yet for André Breton and his circle at the magazine *Littérature,* who were struggling to propagate a movement independent of Dada, their confreres' condemnation of *Mercure* was a godsend. In vociferously rising to Picasso's defense at the ballet's premiere, they sought not only to isolate Picasso from his collaborators but also to present him as a paragon of their new movement, Surrealism. As critics in the audience booed Picasso's participation, Breton and his friends defended him so vigorously that the police were called to throw them out. According to Louis Aragon, Breton yelled, "Long live the genius," and another member of the group, Francis Gérard, turned to Picasso and screamed, "You see, Picasso, Beaumont has us thrown out by the police because we are applauding you."[7]

As the arguments intensified over the following week, Breton and

his friends convinced several newspapers to run an effusive "Hommage à Picasso." (It was this statement that prompted Picabia to publish his retort that Picasso's modernity was equivalent to the fashions of Poiret.) Signed by Breton and fourteen other artists and writers, including Louis Aragon, Max Ernst, and Philippe Soupault, it proclaimed "profound and total admiration for Picasso, who defies consecration and goes on creating a troubling modernity at the highest level of expression. Once again, in Mercure, he has shown a full measure of his daring and his genius and has met with a total lack of understanding. This event, which we regard as exceptional, proves that Picasso, *far more than any of those around him*, is today the eternal personification of youth and the absolute master of the situation." Although one might be inclined to assume that Picasso would pay little attention to such fawning by relative newcomers, the evidence suggests otherwise. He inscribed and saved the copy of the "Hommage" that appeared in the journal Comoedia.[8]

With the controversy continuing, Aragon offered a clarification, hoping to "stop the prattle": "I think that nothing stronger than this ballet has ever been presented in the theater. It is the revelation of an entirely new manner by Picasso, which owes nothing to cubism or to realism and which surpasses cubism just as it does realism."[9] Not only had Breton and his colleagues defended Picasso from those who condemned the Soirées de Paris, they had hailed his contribution as a significant departure from his previous work. Aragon's characterization of Picasso's new art perfectly positioned it in the current aesthetic battles. By proposing that the Mercure sets surpassed both Cubism and realism, Aragon provided a rationale that conveniently detached Picasso from the moribund Cubist school and the dominant Neoclassical revival. He offered Picasso a position in the vanguard of contemporary art—not only a respected place in its pantheon—by aligning the new work with the budding movement of Surrealism. Aragon's conception of Picasso's development echoed Breton's promotion of his movement ten days before the premiere of Mercure: "Symbolism, cubism, dadaism are far in the past; *surrealism* is the order of the day." With Picasso's reputation in danger of losing its avant-garde edge, the Surrealists' intervention publicly restored Picasso to his accustomed position. During the following decade, Surrealism would be a primary inspiration for his art and the principal context for its public reception.

In the midst of a season fraught with the shifting vagaries of public reputation, Picasso confronted this question in his own work. The day of the *Mercure* premiere, an auction had taken place to fund a monument to Guillaume Apollinaire; Picasso had already agreed to make the sculpture. The commission, which would occupy him for most of the next six years, would require him to define his own conception of Apollinaire's achievement in relation to the often opposing evaluations espoused by other factions in the art world. And one of the leading parties to this debate was Breton. In fact, Breton's interpretation of Apollinaire's legacy was central to his promotion of Surrealism. By autumn 1924, Picasso was becoming increasingly involved with Breton and his fight to establish the movement. Indeed, Picasso, like Apollinaire, became one of Breton's chief piers in the effort to lay a foundation for Surrealism.

Breton had first encountered Picasso in November 1918 at Apollinaire's apartment, where the poet lay fatally ill with influenza. At the time, Breton was merely one of many aspiring young writers who sought the approval of Apollinaire, and Picasso took little notice of him. Yet, their shared appreciation of Apollinaire's achievement would become a strong tie between them. When Breton did enter Picasso's life, it was not through issues of aesthetics but along the seemingly unlikely avenue of commerce. In the summer of 1921, the prominent couturier Jacques Doucet had hired Breton as his librarian, hoping to build a collection of contemporary art. (Aragon, too, worked for Doucet, as his private secretary.) Breton's salary of 20,000 francs a year was modest compared to Picasso's earnings, but it enabled Breton to marry and to pursue his artistic activities free of serious financial pressure for several years.[10] Doucet's employment of Breton and Aragon, ignored by most historians, suggests that the Surrealists, far from merely ridiculing the establishment, willingly cultivated prominent figures who might patronize them. Certainly such calculation characterized Breton's relationship with Picasso. Having used Doucet's fat purse to gain entry to Picasso's studio, he did not merely urge the artist to sell paintings to Doucet; he also promoted himself as a worthy inheritor of Apollinaire's mantle of critic, poet, and impresario of the avant-garde. As with his stewardship of young artists, Breton freely coupled commercial support with aesthetic commendation; in doing so, he merely

continued the behavior that André Salmon had praised at the Peau de l'Ours auction.[11]

Without doubt, Breton's greatest coup for Doucet was the purchase of *Les Demoiselles d'Avignon* from Picasso's private collection in February 1924 (fig. 50).[12] The sale was a cardinal event—not because it registered a record price (it didn't) but because it marked a fundamental divide in Picasso's career. In selling the *Demoiselles*, Picasso broke his last major link with the great pioneering years of Cubism and closed the door on his prewar career. The question is not so much why Doucet bought the painting as why Picasso finally let it go. Unlike

50. Picasso, *Les Demoiselles d'Avignon*, 1907
(Museum of Modern Art, New York)

his sale of *The Family of Saltimbanques* to André Level in 1908, soon after he had completed the *Demoiselles*, Picasso's parting with this masterpiece certainly was not motivated by financial distress. Nor had there been any lack of offers; over the years, several people had tried to buy the painting, but Picasso had refused. By the early 1920s, it was the only major prewar painting that he still retained.

The price Doucet paid—either 25,000 or 30,000 francs—is evidence that the sale of the *Demoiselles* was no normal business deal.[13] Compared to Picasso's recent prices, it was a bargain. Almost exactly one year before, Paul Rosenberg had purchased the Philadelphia version of *Three Musicians* for 30,000 francs.[14] Although the two paintings are of comparable size, their prices should not have been equal or close to equal. Not only is the *Demoiselles* a more important painting, but its age merited a premium. Only four months earlier, Vollard had sold John Quinn two smaller and less important, if more conventionally attractive, Blue period pictures for a total of 100,000 francs.[15] And seven years later, in the depths of the Depression, another American collector, Chester Dale, would pay $20,000 (approximately 510,000 francs) for *The Family of Saltimbanques*.[16] Moreover, Rosenberg's 30,000 francs for *Three Musicians* was a wholesale price. Rosenberg would have asked at least double that figure from collectors, and it would not have been an outrageous sum. Since he had no control over the sale of works Picasso retained from the years before their alliance, he played no active role in the transaction with Doucet. But he almost certainly counseled Picasso that Doucet's price was too low for his contemporary work, let alone for a painting of such paramount importance.

Why did Picasso go through with the deal? Perhaps Doucet's reputation as a connoisseur and his high standing in French society encouraged Picasso to believe that his painting would be accorded greater respect in Doucet's collection than it would have received in most others. Yet, Doucet seems not to have been overly solicitous; he is reported to have tried to drive down the price by complaining to Picasso that the *Demoiselles* was a difficult painting to display, one that he could not comfortably hang in his wife's drawing room. But after all, Doucet was assembling a challenging collection of contemporary art, not buying house pictures. Perhaps Doucet's suggestion that he intended to leave his collection to the state led Picasso to hope that his picture would enter the Musée du Luxembourg as Manet's

Olympia had twenty-nine years earlier with the Caillebotte bequest and hang beside it on the museum's walls. Still, such an eventuality was extremely conjectural and, in fact, never came to pass, despite the efforts of Doucet's widow. Moreover, even if Doucet was an appropriate owner for the painting, there remains the question of timing. Picasso and Doucet had been acquainted for approximately a decade (Picasso had drawn Doucet's portrait in 1915), and there is a good chance Doucet had known the *Demoiselles* for years, from either visits to Picasso's studio or its display in the Salon d'Antin, which André Salmon had organized at the shop of another couturier in 1916.[17]

The new element in the relationship was André Breton. He was the catalyst during the protracted negotiations. Besides keeping up Doucet's enthusiasm, he pursued the probably more difficult task of convincing Picasso that the time had come to part with the long-treasured work. Breton's letters to Doucet suggest his approach. He heralded the painting's historic importance, writing that it "marked the origin of cubism," but he also emphatically affirmed its continuing relevance:

A single certitude: *Les Demoiselles d'Avignon*, because through it one enters solidly within Picasso's laboratory and because it is the node of the drama, the center of all the conflicts that gave birth to Picasso and that eternalize him, I fully believe. It is a work that for me singularly surpasses painting, it is the theater of everything that has happened over the last fifty years, it is the wall before which passed Rimbaud, Lautréamont, Jarry, Apollinaire, and everyone else we still admire. If it disappeared, it would take with it the largest part of our secret.[18]

Although we cannot be certain that Breton took this tack in his discussions with Picasso, he once again emphasized the painting's power when he published a rare reproduction of it, along with an effusive paean to Picasso, in the July 1925 issue of *La révolution surréaliste*. It may well have been Breton's profound allegiance, rather than Doucet's prestige and wealth, that finally swayed Picasso.

Breton's praise restored the painting to a position of influence that it had not held since its debut, when Braque had confessed that looking at it was equivalent to being forced to eat tow or drink kerosene.[19] Picasso acted at the very moment he was rekindling the painting's disturbing intensity in his current work. And this personal renewal,

too, stemmed largely from his growing engagement with the Surrealists, who acclaimed the *Demoiselles* as a beacon for contemporary art. It appears that in the long process of cultivation that preceded the sale, Breton used his discussions with Picasso to transform their relationship from a business contact into an intellectual comradeship.

During the three and a half years between Breton's appearance in Picasso's studio as Doucet's art adviser and his publication of the *Demoiselles* in *La révolution surréaliste,* the relationship slowly built toward the commitment Breton manifested at *Mercure.* The Surrealists' demonstration of support at that public event merely reflected the private friendship that had matured with the discussions over the *Demoiselles.* At *Mercure,* the dual tracks of private and public cultivation firmly converged. But even after the negotiations over the *Demoiselles* ended, the painting continued to link Breton and Picasso, because Doucet had bought it on the installment plan and apparently did not make his final payment until December 1924.[20]

As early as November 1922, Breton had begun to parlay his private relationship with Picasso into a public endorsement, when he wrote to "reassure" Picasso "on the subject of the painting" and went on to solicit an artistic contribution to his literary review: "I hope that *Littérature* and myself are not too lowly in your eyes. Aragon has told you how much I would like, if it is not presuming too much, for you to permit us to reproduce something. From a distance, I feel a bit more confident about asking you."[21] Breton was in Barcelona to deliver a lecture on the evolution of modernism in which he emphasized Picasso's key role. As in his correspondence with Doucet, Breton argued that Picasso held "the fate of painting" in his hands. And in a formulation Aragon would repeat during the *Mercure* controversy, Breton set Picasso apart from both "cubist doctrine," which Picasso "was the first to ridicule," and "all this fuss about a classical renaissance . . . a return to naturalism . . . absolutely null and void."[22] Breton thereby conveniently dismissed the Neoclassicism that dominated Picasso's current work without commenting on it directly. Apparently his approach paid off since the May 1923 issue of *Littérature* contained a reproduction of *Lovers,* Picasso's lusty variation on the Impressionism of Manet and Renoir—not on the classicism of the academy.

Two months later, at a Dada event called the Soirée du Coeur à barbe, Breton made a more dramatic show of his support for Picasso.

In the midst of this rambunctious evening, a hanger-on, Pierre de Massot, delivered a litany of denunciations in the best Dada fashion. No one took offense at his belittling of André Gide, Francis Picabia, or Marcel Duchamp, but when he called out "Pablo Picasso, dead on the field of battle," Breton sprang into action. Perhaps Picasso's presence in the audience made the insult seem more serious, or perhaps Breton, with his instinct for self-promotion, sensed an opportunity. Two of Breton's friends, Robert Desnos and Benjamin Peret, leaped onto the stage and restrained Massot while Breton raised his cane and struck the startled speaker on the right arm so violently that the bone cracked. Having avenged Picasso's honor in this uneven duel, Breton and his friends returned to their seats. As Massot hurried offstage, the crowd rushed the perpetrators of this attack, but Tristan Tzara alerted the waiting police in time to prevent a brawl and end the event with a proper sense of scandal.[23]

Such a demonstration must have flattered Picasso. By the following fall, Breton was ready to ask Picasso to return the favor. As he was preparing the final proofs of his book *Clair de terre*, Breton pleaded with Picasso to supply something, anything, for the volume, but preferably a portrait: "I am asking the impossible of you, that you consent to having the volume open with a portrait of me by you, a dream that I formed long ago but have never had the audacity to mention to you . . . I do not know whether you are in Paris, or if you will soon return. If not, my God, I don't think there is anything to do, unless you have at hand something that could pass for my portrait, without eyes, without nose, without mouth, and without ears."[24] The gambit proved successful, and *Clair de terre* opened with a portrait, all features included (fig. 51). Now Breton had proof of Picasso's support for his approach to contemporary art, and he redoubled his efforts.

When the controversy broke over *Mercure*, Breton could not have been more pleased. It occurred just as he was fighting to establish his Surrealist movement, which the publication of the Surrealist Manifesto in October 1924 and the first issue of *La révolution surréaliste* two months later would confirm. In the intervening months, Breton not only distinguished his principles from those of his former confreres in the Dada movement but also waged an intense campaign to wrest the historic but ambiguous term *surrealism* from the generation of prewar poets who vociferously denounced his attempt to appropriate

it and, in the process, to reshape the legacy of its creator, Guillaume Apollinaire. Although Breton punched one of his adversaries, Ivan Goll, the battle more closely resembled the polemic over *Mercure* than the mugging at the Soirée du Coeur à barbe. It raged through the literary press, particularly in *Le journal littéraire*, which had run the "Hommage," and drew both Picasso's attention and his likely participation.[25]

Like Breton's pursuit of Picasso to buttress his position as a leader of the avant-garde, his choice to name his movement Surrealism aligned his future with another's past achievements—Apollinaire's.[26] In the pursuit of this legacy, the blessing of Picasso carried great weight. We know Picasso followed the debate because he inscribed and kept an article by Maurice Martin du Gard, entitled "Le surréalisme? André Breton," which appeared in the October 11 issue of *Les nouvelles littéraires*.[27] One month before, Breton had drawn Picasso into the fray. Right in the center of a text that moved from Breton's invocation of Apollinaire's tragic death ("In homage to Guillaume Apollinaire, who had just died, . . . Soupault and I designated under the name of *surrealism* the new mode of pure expression") to Breton's precise redefinition of the term ("Surréalisme, n. m.") and citation for the "Encyl. Philos." appeared the portrait of Breton that Picasso had drawn for *Clair de terre*. In case the image was not immediately recognized, it bore the caption "André BRETON (Dessin de Picasso)."[28]

With Breton's successful establishment of his Surrealist movement by the end of 1924, Picasso's collaboration became more evident. Not only did *La révolution surréaliste* regularly reproduce Picasso's work (with his approval), but the issue of July 1925 displayed five of his paintings and the opening installment of Breton's "Surrealism and Painting," which was filled with praise for Picasso's work. Breton's letters reveal Picasso's cooperation in preparing this issue and evince his high esteem for *The Dance* in particular. Lamenting the poor quality of the proofs he had sent Picasso, Breton assured him: "But you know how much I am committed to reproducing this painting, without which I would almost lose interest in the next issue of *La révolution surréaliste*."[29]

Picasso was not in the habit of joining artistic movements (as his rejection of a Cubist "bloc" had confirmed), so his increasingly visible support of the Surrealists implied a remarkable sympathy. Even

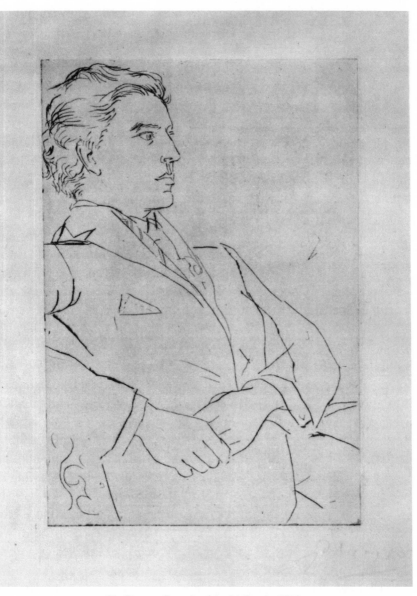

51. Picasso, *Portrait of André Breton*, 1923
(Museum of Modern Art, New York)

though he preserved his independence by never officially joining the movement, his regular participation in its events was noteworthy. Moreover, by the summer of 1925, Surrealism had displaced Neoclassicism as the driving force of his art. Years later, Roland Penrose recorded Picasso's attitude toward the movement: "He still asserts that of all that was going on during the twenties their activities were the most interesting . . . The surrealist movement owed its strength to an alliance between poets and painters and an attitude towards human conduct which transcended purely artistic considerations. Picasso found again, in association with the poets, the climate he had known before the war."[30] This revival would shape his plans for the monument to Apollinaire as the decade passed, but it is widely believed to have taken hold during the year between the premiere of *Mercure* and the presentation of *The Dance* in *La révolution surréaliste*.

Even more than his opposing treatments of Harlequin in Paul Rosenberg's show and on the *Mercure* curtain, *The Dance* and its less well known pendant, *The Kiss*, mark a return to the primary subject matter of Picasso's Neoclassical phase in order to radically subvert its meaning through his new idiom. No longer depicting a graceful ballet or a warm embrace between mother and child, these paintings erupt with the force that Breton had recognized in the *Demoiselles* and channeled into Surrealism. While *The Dance* orchestrates a traditional ronde into a nearly ecstatic ritual of commemoration for Picasso's old comrade Ramon Pichot, who had recently died, *The Kiss* instills the bumbling domesticity of Picasso's Neoclassical families with such passionate intensity that the image has generally been identified as the coupling of two consenting adults. Robert Rosenblum suggests that *The Kiss* may be Picasso's response to the recently exhibited paintings of the Surrealist and fellow Spaniard Joan Miró. Whatever the case, these two paintings represent the renewal of the *Demoiselles*'s power in a new, distinctly Surrealist, context.[31]

Yet Picasso did not sign the movement's manifestos. Nor, observes Elizabeth Cowling, did he attend the "virtually obligatory group meetings."

[H]e does not even seem to have joined in the collective games; he did not allow his behavior to be regulated by Surrealist ideology. But the distinction between his position and that of certain other "Sur-

realist" artists cannot have seemed clear-cut to insiders or outsiders at the time, even if it does today. (Miró and Arp, for instance, were hardly more committed to group action or ideology than he.) For— at any rate during the life-span of *La Révolution surréaliste*—Picasso was prepared to see himself linked repeatedly with Surrealism, collaborating to the extent that he allowed brand new works to be reproduced in its pages. Later he would insist, sometimes tetchily, on the fundamental differences of outlook, but at the time there was enough that he valued in Surrealism to make him willing to meet the Surrealists halfway.[32]

Although there is no doubt that Breton was the suitor who aggressively courted Picasso, not only the Surrealists benefited from Picasso's willingness to associate with them; while Picasso enhanced the Surrealists' stature, he, in turn, drew on their energy to escape being categorized as a has-been like Paul Poiret.

In meeting the Surrealists halfway, Picasso did not surrender his recently established security. He kept one foot firmly planted in the beau monde and pursued his career with Paul Rosenberg. Still reminiscing about the Beaumonts' ball for *Mercure* two months later, Rosenberg sought Picasso's advice on vacation spots: "Is la mieux société found in St. Raphaël, and do you have any friends there?" Upon his return to Paris, he eased into the fall season by passing on to Picasso the news that John Quinn had died: "Perhaps you know that Quinn is dead and they are talking about selling his paintings! What a beautiful sale that will be, 25 of your canvases as well as ones by Matisse, Braque, Rouault, Douanier Rousseau, etc."[33] The fact that Rosenberg would announce with such apparent nonchalance the death of the man who had probably been his best client for contemporary art indicates how rivalrous their relationship had been during the previous year, when Quinn had posed a threat to his relationship with Picasso.

When the auction of Quinn's estate finally occurred in February 1927, many admirers of modern art were disappointed to note that his Picassos were not among the 811 items in the catalogue.[34] Whether Rosenberg simply leaped at an opportunity to buy the group at a discount or whether he had second thoughts about the likely results of so many contemporary paintings being sold at auction so soon after the disastrous Kahnweiler liquidations, he preempted the sale by pur-

chasing the pictures directly from the estate, thus regaining for inventory the remarkable group of works Quinn had purchased from his gallery, as well as from his brother and Vollard.

Even before this addition of fifty-two paintings and sculptures, Rosenberg had jokingly complained to Picasso about the "innumerable paintings" he had in stock: "I must move 250 in order to find the one I am looking for."[35] The gallery's log confirms the large number of pictures flowing into the storerooms and shows that by the early twenties the balance had shifted. The inventory, which had once consisted predominantly of works by the Impressionists and Post-Impressionists, swelled with paintings and drawings by artists increasingly recognized as twentieth-century masters—Braque, Matisse, and Laurencin, but most of all Picasso.[36] In May 1924, Rosenberg had held his first show of Braque's work, thereby reuniting the two creators of Cubism under the same roof for the first time since the war had ended their association with Kahnweiler. With the continuing backing of Wildenstein's fifty-percent share, he was building the massive inventory of twentieth-century art that would become the cash cow to support his introduction of younger artists.[37]

His purchases from Picasso during 1924, however, were minimal. Except for 24,000 francs, for eight large red-chalk drawings, the only other recorded payment by Rosenberg that year was the balance he owed for the pictures that composed the traveling shows of 1923–24.[38] The complete absence of paintings among his selections is exceptional, perhaps a response to the very limited commercial success of the shows. Nonetheless, his purchases soon resumed, and the price he paid for each of the big but simple line drawings equals what the major paintings had brought only five years before. A fee of 528 francs from *Vanity Fair* magazine for the right to reproduce Picasso's work demonstrates that the shows had accomplished the goal of raising his profile in America.[39]

In the aftermath of those exhibitions, Picasso finally allowed Kahnweiler to revive their commercial relations—although only in the most tentative fashion. Despite repeated attempts since his return to Paris in 1920, Kahnweiler had had no luck reinstating the cordial relations they had enjoyed during the years before the war. Even after Kahnweiler paid the disputed twenty thousand francs, Picasso appears to have kept him at bay for six months before allowing him to make even

a modest purchase (three lithographs for a total of three thousand francs), followed by a similar acquisition in February of 1924. Clearly, Kahnweiler's new business, called the Galerie Simon, posed no serious competition to Rosenberg's hegemony, although Kahnweiler was beginning to extend his stable to some of the postwar generation of artists, such as André Masson.[40]

In 1925, Rosenberg made up for his lack of purchases the previous year. On January 21, he bought twenty paintings for a total of 328,000 francs, and on July 7, he took an additional ten paintings and two drawings for another 129,500 francs.[41] Besides constituting a record total of over 457,000 francs, these extensive acquisitions marked a shift away from the body of work he had collected in 1923. Instead of mixing a few Cubist pictures into a batch of Neoclassical ones, he chose only five classicizing works and twenty-seven Cubist ones. It is plain from these purchases that Rosenberg's commitment was not limited to Picasso's Neoclassical paintings, as some critics have claimed it was.[42] When Picasso reinvigorated Cubism in the mid-twenties, Rosenberg supported it without reservation, as he did each transformation in Picasso's style. Indeed, it was this process of renewal that fascinated him and caused him to urge Picasso to "give me a vision of a new Picasso."[43] Both artist and dealer, for all the attention they paid to the art world's responses to Picasso's individual styles, knew that his growing fame rested less on a particular idiom than on the virtuosity and sheer variety showcased by his metamorphoses.

Rosenberg's commitment to Picasso's contemporary work helps explain his relative lack of interest in the art that preceded his association with Picasso. His neglect of Picasso's career before the war should be taken not as a rejection of Cubism but as a reflection of their collaboration in promoting recent work over that of the increasingly distant past. Among the first purchases of 1925 were two great paintings that contain the seeds of Picasso's postwar Cubism—*Harlequin and Woman with Necklace* and the version of *Three Musicians* that the Museum of Modern Art later acquired. At two meters square, *Harlequin and Woman* is nearly the size of the *Demoiselles*; it sprang from Picasso's Roman sojourn to design the sets, costumes, and vast curtain for *Parade*. Its sprightly style and its subject, a dancing couple, invest the austere hermeticism of wartime Cubism with the lighthearted pleasures of Picasso's new life among Diaghilev's troupe. Most likely, it

had first been exhibited the year following its execution, in Paul Guillaume's joint exhibition of Picasso and Matisse, but had gone unsold and had since languished in Picasso's studio. With *Three Musicians*, it charts the line of Picasso's Cubism from 1917 through *Seated Harlequin* of 1924 and the seventeen other paintings included in the purchase. Moreover, by paying fifty thousand francs for each of the earlier pictures, Rosenberg made a commitment (at least in financial terms) that far outweighed the support Doucet had demonstrated in buying the *Demoiselles*. We do not know whether the timing of the sale was dictated by Picasso's decision to sell or Rosenberg's to buy. Quite possibly, it reflected their mutual desire to demonstrate the evolution of Picasso's recent work.

Although Rosenberg soon sold *Harlequin and Woman* to the Baron and Baroness Gourgaud (who would be among his best clients throughout the rest of the 1920s), the likely asking price of at least 100,000 francs makes it seem he did not expect to sell either painting quickly.[44] He held on to *Three Musicians* for twenty-four years until the Museum of Modern Art finally bought it in 1949. Nonetheless, the market must have been strengthening because Rosenberg soon made his other big purchase of 1925. Once again, it consisted entirely of Cubist paintings, except for two pastels and two drawings in Neoclassical styles. Yet most of these paintings did not portray the commedia characters of *Harlequin and Woman* or *Three Musicians*. Instead they adopted the subject of still life. As if to emphasize that still life had long been important to Picasso's postwar Cubism, Rosenberg also bought the monumental *Table, Guitar, and Bottle* (1919), now in the Smith College Museum of Art. All together, his extensive series of purchases suggests that both artist and dealer recognized Picasso's new work as a significant departure. Rosenberg was building a stock so as to be able to represent its heritage and variety when the time arrived to reveal it publicly.

Not only was Picasso continuing his fecund course but the economy was finally beginning to turn the corner. Despite several changes of government and economic policy, financial instability persisted into the mid-twenties. Even France's invasion of the Ruhr in January 1923 had not secured the nation's finances; during 1924 and 1925, inflation once again devastated living standards, and the franc sank to fourteen percent of the value it had had in the months before the war. The

return of Raymond Poincaré as premier in June 1926 (he had served as wartime president, among other posts), however, brought stability to the French economy. In the late 1920s, France's industrial production expanded at a rate higher than even America's.[45]

Rosenberg responded to the improving environment not only by stocking up on his artists' work but also by renovating his galleries. Rooms that had been quite grand seemed almost austere compared to the imposing new quarters, designed to serve the burgeoning clientele for modern art. In a long letter accompanying the receipt for his July purchases, Rosenberg apologized for his lack of recent correspondence and his rare delay in paying (which Picasso had noted with irritation). The press of shoppers had been overwhelming: "My gallery is open, but not yet finished . . . All the clients in the world are in Paris and occupy me from morning until night." Yet, within this social whirl, he was still reticent with his artist about sales: "That doesn't mean a lot of business, but it does take lots of time." Nonetheless, he reported to Picasso that the auction of Maurice Gangnat's large collection of modern paintings (including scores of Renoirs) had done well and that his new artist, Georges Braque, was "always very successful with the public." Although this was perhaps a friendly goad to Picasso, Rosenberg conceded that the entire market had exploded: "Paintings have become a *bourse*. The universal demand for French paintings is unbelievable."[46]

By 1925, the market for the Paris school, as modern French painting was becoming known, was firmly established throughout Europe and America. Even a few adventurous Japanese collectors were beginning to buy the work of the avant-garde.[47] As sales increased and dealers profited, both Picasso and Matisse shared in the good fortune by negotiating new agreements that substantially increased the prices they received. Since Matisse had a formal contract with Bernheim-Jeune, it is easy to chart the rise of his prices. In his contract covering 1920 to 1923, he received 7,000 francs for a standard canvas measuring approximately 116 by 80 centimeters, a number 50 format. (Most prices continued to be calculated according to the size of the work.) Even though retail prices in the broad French economy remained relatively stable during that time, his next contract, which covered 1923 to 1926, raised the price of a painting of the same size to 11,000 francs, an increase of 57 percent over the period, or close to 20 percent a year.

(As it turned out, retail prices nearly doubled over the same span.) By the time Matisse signed his first contract with Paul Rosenberg in July 1936, a canvas of that size commanded 30,000 francs. This leap of 173 percent over the previous ten years reflects the soaring prices of the late 1920s; yet it is impressive when one realizes that during five of those ten years prices had been depressed because of the worldwide economic collapse.

Picasso's situation was even more fluid. During the boom years of the twenties, Picasso used his freedom from a written contract to push his prices up faster than Matisse had with Bernheim. In June 1921, Rosenberg had paid him 7,500 francs for a number 50 canvas (for which Matisse received 7,000 from his dealer). But this relative equality soon evaporated. By October 1923, Picasso was receiving about 17,000 francs for these canvases. He had increased his prices by 127 percent in just over two years and surpassed Matisse by 6,000 francs (or 55 percent). By July 1925, Picasso's prices had inched up again to 19,000 francs for the same size painting, while Matisse's remained fixed. Picasso's prices would leap to the point that by 1929 he would receive approximately 20,000 francs for a canvas only one-third the size.[48]

Rosenberg rushed to finish his gallery renovations by the fall 1925 season and urged Picasso to imagine his work in the new surroundings: "At the least it will be good, even wonderful, if I see here the beautiful Picasso exhibition that we plan to hold."[49] The show, the largest that Rosenberg had yet presented of Picasso's work, would open in June 1926 and display many of the paintings he had purchased earlier that year. Even as Picasso and he planned their greatest joint venture, their relationship was changing significantly. Although Picasso maintained the lifestyle he had adopted through his enriching association with Rosenberg, he had nonetheless altered its terms. Whereas the previous summer the two had swapped gossip about which Côte d'Azur port was the most glamorous, Picasso was increasingly isolating himself from his dealer. Eight days after flattering Picasso with a vision of the anticipated exhibition, Rosenberg could no longer resist confronting him over his withdrawal: "I begin to be seriously concerned about your silence. What does it mean? Never have you left me so long without news or without giving some sign of life. Write to me and calm me

down." The lapse was not an anomaly. For the next few years, Rosenberg's letters to Picasso would be spiked with reproaches for his lack of communication: "Your absence surprised me very much," "Your silence astonishes me, not a word since you left. If you don't have a pen, grab some pencils!"[50] The bantering exchanges of the early 1920s rarely recur. The friendship was cooling, and the partnership was taking on the character of a more conventional business affiliation, even if a highly lucrative one.

This fundamental change was a question not simply of Picasso's relationship with Rosenberg but of his reorientation away from the beau monde. Just as he distanced himself from his dealer, Picasso became increasingly aloof from his wife and from supporters like Eugenia Errazuriz. Even Jean Cocteau, whose multiple roles as poet, critic, and dramatist might have seemed to promise continued importance in Picasso's life, slipped into disgrace by 1926.[51]

These shifts in Picasso's personal and intellectual circle coincided with his increasing involvement in Surrealism. Although his receptiveness to the Surrealists' message of revolt was stimulated by his growing uneasiness with the conventionality of his marriage and of Kolkova's tastes, such differences should be placed in a larger context.[52] Picasso's reorientation of his career was affected as much by professional matters as by marital ones; particularly significant were his always ambiguous relation to Neoclassicism, the mixed critical response to the 1923–24 shows, and the boost that his friendship with Breton received from the controversy over *Mercure*. Moreover, the change in Picasso's personal and professional life represented not a repudiation but rather an expansive metamorphosis. It was a rejuvenation for an artist the Surrealists already regarded as "the eternal personification of youth." Picasso appeared quite capable of overcoming the contradictions many would see between his continuing attendance at the events of his wealthy patrons and his participation in the Surrealists' programs. This duality also characterized the exhibition of his work. Two or three of his paintings (apparently lent by Jacques Doucet and Paul Rosenberg) appeared in the first exhibition of Surrealist painting, held in November 1925; yet his major presence that season was in the exhibition of fifty-eight of his paintings at Rosenberg's the following summer. The contents of this exhibition reveal

not only that Picasso maintained his professional ties with Rosenberg while he explored Surrealism, but also that these two apparently disparate spheres of activity were deeply entwined.

Rosenberg's exhibition opened in the gallery's fully renovated rooms on June 15, 1926 (figs. 52, 53). Continuing the pattern of alternating Neoclassical and Cubist work, this large selection showcased Picasso's revitalized Cubism, an expansive form of Cubism that embraced the full range of his styles from Neoclassicism to realism and the newest Surrealist departures. Filling the ample space, it demonstrated Picasso's fertility as nothing had since his first exhibition at Rosenberg's in 1919. Moreover, it explicitly recalled that era; arranged chronologically

52, 53. Galerie Paul Rosenberg, *Exposition d'oeuvres récentes de Picasso*, June–July 1926 (Courtesy of Paul Rosenberg & Co., New York)

in the catalogue, the works spanned the years from Picasso's alliance with the gallery through the first months of 1926. Although the great bulk of the paintings dated from 1923 to 1925, the years 1918, 1919, 1921, and 1926 were represented by one picture each. These brief prefaces and epilogues provided an interpretive context for what lay between. The first three paintings in the catalogue were *Harlequin "Si Tu Veux"* (1918), *Young Girl with a Hoop* (1919), and the version of *Three Musicians* later acquired by the Museum of Modern Art. Joined by twenty works from 1923, these pictures covered the period of Picasso's Neoclassicism with only the slightest acknowledgment of its existence. The choice suggested that Picasso had always been a Cubist and that he continued to take the style to further heights.

Although Rosenberg had purchased this canvas of *Three Musicians*

from Picasso the previous year, the other two pictures were ones that had recently returned to stock, having been bought back from John Quinn's estate. But Rosenberg did not merely preface the exhibition with whatever earlier paintings he had on hand. Among the pictures that arrived with the Quinn shipment was a painting that, if paired with *Three Musicians,* would have demonstrated Picasso's concurrent mastery of Neoclassicism and Cubism—*Three Women at the Spring.* By withholding it, and the other Neoclassical paintings Quinn had owned, the artist and the dealer explicitly chose to segment Picasso's career.

The impression of fecundity comes not just from the number of paintings dating from the previous three years (twenty from 1923, seventeen from 1924, seventeen from 1925) but also from their expanding size and evolving style. Almost all the paintings of 1923 are quite small, suggesting essays in preparation for more substantial works. With 1924, much larger, number 60 canvases begin to appear (130 × 97 cm.), and the following two years are dominated by them. In all, at least sixteen paintings in the exhibition were imposing number 60 canvases, with one—*Mandolin and Guitar*—even larger, and another five slightly smaller 50s. (In contrast, the touring show of 1923–24 had included only five 60s.) There is little doubt that Picasso had painted this series of large pictures so as to exhibit them in the show. During 1925 Rosenberg had responded by paying Picasso 437,000 francs for twenty-eight paintings, two pastels, and two drawings—many of which appeared in the exhibition.

Ringing the spacious central salon, twelve of the large 1924–25 canvases were arrayed to create a magisterial effect. All the small canvases were banished to the side rooms so that the audience was not distracted from the grand series, uniform in size and closely related in subject matter. Among these works, two earlier canvases anchored the long axis of the room. Instead of hanging in an anteroom, as the catalogue order might suggest, *Harlequin, Young Girl with a Hoop,* and *Three Musicians* were strategically placed in the main group. Centered across the long expanse of the salon, the costumed characters of *Three Musicians* confronted the earlier *Young Girl with a Hoop; Harlequin* hung nearby with its musical invitation to dance: "Si Tu Veux."

These paintings dominated the audience's perception of the other works on view. Within the main salon, *Three Musicians* dwarfed the

rest of the pictures, and its placement between two of Picasso's recent figural paintings offered a bridge between the performers in the early works and the still lifes so frequent in the later ones. On the right, *Woman with a Mandolin* extends the musical theme of *Harlequin* and *Three Musicians*, while on the left the combination of figure and bust in *Woman with Sculpture* interpolates between the surrounding still lifes and their classical sculptures (fig. 54).

This cardinal triad of paintings invested the series of still lifes that unfolded along the long walls of the salon with issues of analogy and transformation that had always been central to Picasso's art but that took on a sharper focus with the juxtaposition of figure to bust to compotier or mandolin. The extremely flexible framework of Picasso's vigorous new Cubism enabled him to achieve an integration of styles and exploration of formal metamorphoses hitherto impossible. Its curvilinear lattice enfolded both the elegant classicism of the antique busts and the precise realism of the musical instruments in paintings such as *The Red Table Cloth* (1924, fig. 55), without disrupting the continuity of each composition. Quite unlike the jarring juxtapositions of Picasso's first efforts to reclaim realism, in works such as *Woman in an Armchair* (1913), and the uneasy peace of opposing styles in *Studies* (1920), these monumental paintings of figures and still lifes display a Cubism of such maturity and confidence that it subsumed apparently contradictory styles without diminishing its visual authority. For Picasso and Rosenberg, who kept several of the pictures to hang in his dining room, these paintings demonstrated a masterful resolution of the issues that had roiled Picasso's art over the course of the previous ten years.

Besides constituting a moment of perfect balance in Picasso's art, several of the paintings also pointed toward new initiatives. As William Rubin has written, another painting in this exhibition, *Studio with Plaster Head* (1925), "is at a dividing line of Picasso's career. Its underpinning remains Cubist, but aspects of its facture and color and, above all, its imagery point to the surreal and expressionist dimensions his art would increasingly assume over the following two decades."[53] Hung next to *The Red Table Cloth*, *Studio with Plaster Head* presented a radically different mood of "urgency and emotional pressure" that is particularly embodied in the contrasting treatments of the classical bust in each painting—one a nearly uninflected silhouette and the

54. Picasso, *Woman with Sculpture*, 1925
(Mr. & Mrs. Daniel Saidenberg, New York)

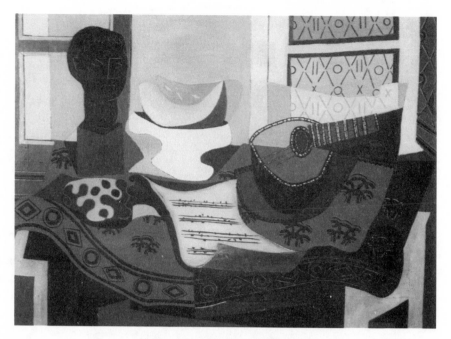

55. Picasso, *The Red Table Cloth*, 1924
(Private collection, New York)

other almost animate due to its bold three-dimensionality and multiple views. Another painting, which hung opposite *Woman with Sculpture* at the farthest extension of the salon, most pointedly explores the multiple creative directions that underlay these diverse stylistic initiatives. In *The Drawing Lesson* (1925), an intensely rendered classical bust is juxtaposed to a child absorbed in the act of drawing several pieces of fruit. If this painting's relevance to the contents of the current exhibition was not immediately apparent, *The Drawing Lesson* hung in the midst of eight small still lifes that bear a striking resemblance to the one depicted in the larger painting.[54] Yet it is the juxtaposition between the animate figure and the inanimate statue that sparks the theme of metamorphosis and identifies the wide-ranging meditation on transformation that pervades this exhibition.

This strong current of psychological exploration is hard to miss in the largest of the recent works on view, *The Dance* (figs. 56, 57). The reproduction of this painting one year before in *La révolution surréaliste* has fairly been taken as demonstrating Picasso's rapprochement

with Breton, but the painting's presence in Rosenberg's gallery has only recently been noted.[55] Instead of loaning the painting to, say, the exhibition of Surrealist painting, Picasso chose Rosenberg's gallery for its debut. Not only does *The Dance* mark Picasso's exploration of the extreme passion prompted by the death of Ramon Pichot, but its theme of commemoration links it to Picasso's earlier meditation on Apollinaire's passing in *Three Musicians*, the other vast canvas of three figures on display.[56] Because Picasso did not sell *The Dance* to Rosenberg, as he had sold the other paintings in the show, there can be no doubt that he wanted it on view. His choice to display it amid this celebration of luxurious postwar Cubism reveals the complexity of his

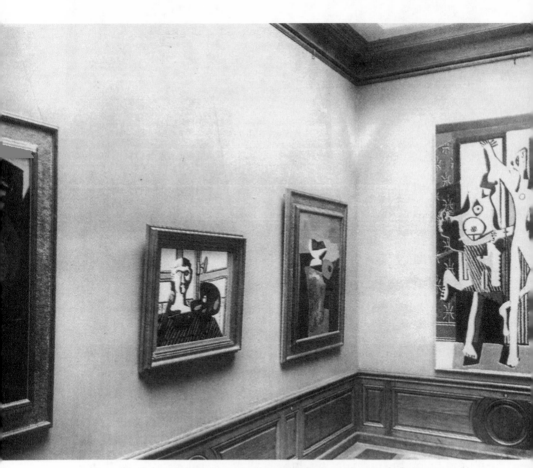

56. Galerie Paul Rosenberg, *Exposition d'oeuvres récentes de Picasso,* June–July 1926 (Courtesy of Paul Rosenberg & Co., New York)

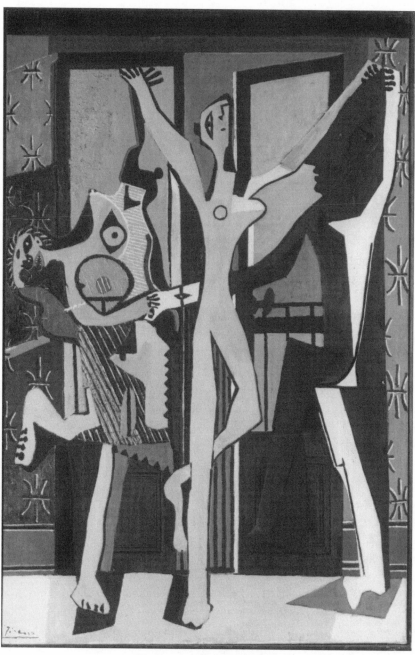

57. Picasso, *The Dance*, 1925
(Tate Gallery, London)

artistic personas at this crossroads and demonstrates that Rosenberg's gallery remained the essential, if no longer exclusive, forum for the shaping of his public reputation.

As he had on the occasion of his first exhibition in 1919, Picasso opened his studio to a journalist before the show and divulged for public consumption some of the ideas informing the work about to go on view. The critic, Christian Zervos, had just launched a journal, *Cahiers d'art,* and would soon become so devoted to Picasso that he would spend most of the next fifty years producing a catalogue of the artist's oeuvre. Unlike Georges Martin seven years before, Zervos ignored Picasso's comfortable circumstances; Picasso's presence on the rue La Boétie was very old news. Zervos gives no hint of having been taken on the grand tour or of having been enticed with anecdotes of worldly success. Instead, he records only Picasso's ruminations on the artistic process. Beginning with the portentous line "In three days Picasso will let us see his recent work," Zervos plunges into the conception that underlies these syncretistic paintings: "His thought appears to us more complex and more universal than in the past . . . more liberated . . . so that his art is becoming a scandal." Picasso's temperament, he writes, is "devoured by everything curious" to the extent that "all the efforts of contemporary painting come together and annul and transform themselves . . ." He goes on to summarize Picasso's state of mind: "The spirit of adventure—that is to say, the true spirit—that thought should count on chance, that will should not limit the unforeseen that comes from the subconscious. The revelations of the soul cannot be regulated by the willful operations of the spirit."[57]

This characterization of Picasso's work may seem far removed from the parade of grand still lifes ringing Rosenberg's well-appointed rooms. Yet Picasso himself not only supports Zervos's interpretation but speaks to the issue of realism that underlies the painting of still life. "In excess, one finds virtually all the possibilities of tomorrow," he says. Wishing to hear "the soul speak," he claims that "understanding of the exterior world never appeared very satisfying to me." Echoing Mallarmé, he says he likes "to roll the dice for a good idea" and to seek "intuitive elements" and "revelation." These words suggest Picasso's increasing rapprochement with Surrealism and the ephemerality of this moment of crystalline balance in his art.

Matching the intimate character of Zervos's text, the photographs

illustrating the article show private views of Picasso's studio, ones that appear informal but that nonetheless display the exhibition pictures in ensembles that reveal associations only hinted at on the walls of the gallery. One photograph, for example, shows *Still Life with Plaster Head* on an easel in a corner of the studio (fig. 58). The picture is in a raw state; without the elegant frame it would wear in the exhibition, it looks undressed, especially in contrast to the traditionally framed works that line its lower edge. The calculation of this display resides not just in this contrast but also in the selection of works themselves: a small painting of Koklova's head plays off the sculptural bust in the large canvas, and the surrounding works present variations on the subject of still life. Yet these pictures were not slotted for the exhibition and the portrait of Koklova would clearly have been out of place. Having been completed in May, the still lifes, however, were among Picasso's most recent works, yet they clashed with the exhibition paintings. Unlike their crafted enclosures, these collages are untraditional in their choices of paper and use of string, as well as in the informality of their construction. In both size and style they clearly differ from the large oils that defined the exhibition; yet, being small, they are also easily dismissed as essays. Standing beside the centrally

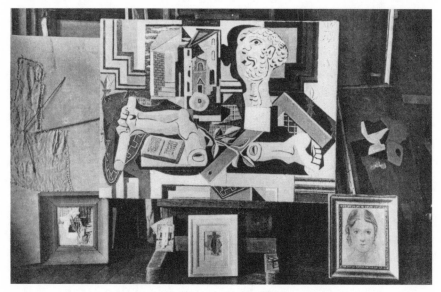

58. Picasso's studio, 1926

placed *Still Life with Plaster Head* is an equally large canvas, whose subject of a guitar is articulated with only the crudest materials of tacks, hemp, rough cloth, and a wooden knitting needle against a painted board. The juxtaposition of these two works defines opposing approaches to art: one based on the subtle rendering of illusions through oil paint and the other on the brutal imposition of illusion on everyday things. The disturbing intensity of *Still Life with Plaster Head*'s imagery has been translated into the substance of the *Guitar* itself.

Also made in the spring of 1926, this *Guitar* is generally taken as another sign of Picasso's exploration of Surrealism, but it may well refer to other segments of his career as well. By allowing Breton to reproduce the collage in *La révolution surréaliste*, Picasso accepted its placement in a Surrealist context.[58] Yet Picasso's appearances in the Surrealist camp, no matter how important for the direction of his art, were only one part of his public persona. The photographs of Picasso's studio suggest that, while the *Guitar* may reflect the Surrealist's sensibility of revolt, it should not be confined to that context.

Like the other collages, it may evince Picasso's response to the sight of his paintings in Rosenberg's new galleries. He created these collages in the midst of preparations for the show, and all their early publications coincided with it; indeed, the issue of *La révolution surréaliste* in which *Guitar* appeared is dated the day of the vernissage. Although they were made too late for inclusion in the catalogue, it is difficult to believe that their absence is merely a question of timing. For all of Rosenberg's enthusiasm for Picasso's stylistic transformations, the extreme departure from traditional technique in these collages is beyond anything Rosenberg ever showed or acquired. Their repudiation of painting placed them outside the tradition to which his gallery was devoted. Yet he included *Still Life with Plaster Head* and *The Dance* in the show and, in later years, bought and showed many of the pictures that share their violent syntax. Quite possibly, Picasso also did not wish to exhibit the collages at the time. After producing this intensely contrary and experimental suite he returned to easel painting as the medium to elaborate his increasing exploration of Surrealism.

While the eruption in Picasso's work during the preparations for the 1926 show suggests an intensification of his doubts about his life on

the rue La Boétie, the exhibition received wide acclaim. Sympathetic critics found no reason to regret the choice of works, as some had during the last exhibition, and most did not even bother to discuss them. Instead, they took the show as an occasion to celebrate Picasso's long career and confirm his leadership of the avant-garde.[59] Critics no longer circled the contemporary work to assess whether Picasso had finally failed; they accepted him as an artist who enjoyed the stature of a secure historical figure and turned to writing accounts of his early career. Despite his presentation to Zervos, Picasso seems to have accepted this acclaim and his association with Rosenberg's gallery.

Though the commercial partnership was to continue, Rosenberg would not hold another one-man show of Picasso's paintings until 1936 and would include a selection of his pictures in only a few group exhibitions during the intervening decade. This lapse of public displays is due both to the buying frenzy of the late twenties, when Rosenberg was too busy selling pictures to organize many shows, and to the dead calm of the early thirties, when doing so would have served little purpose. It also marks a period when Picasso grew so distant from the milieu of the beau monde and the rue La Boétie that Rosenberg referred to him as his "invisible friend."

During these years, Picasso devoted much of his energy to another type of public address, one that took him outside his accustomed haunts to grapple with a project that might engage a far broader audience—Apollinaire's funerary monument. Like many of his contemporaries, Picasso had long ago dismissed public sculpture as a viable genre because it seemed too encumbered by popular demands for moralizing or sentimentality. Nevertheless, he accepted the commission and the obligation of working with a governing committee, because the sculpture was intended to stand on the grave of his dear friend and colleague (fig. 59). This remarkable attempt at collaboration—so different from his partnership with Paul Rosenberg —would fail, but Picasso would not only create his most important sculpture of the years between the wars but also give form to his most profound meditation on the question of artistic reputation.[60]

Apollinaire's sudden death in 1918 had reverberated through the art world. For over a decade, he had been the lighthouse of the avant-garde, his beacon illuminating the continually changing sea of contemporary art. With the extreme disruptions of the First World War, his

leadership was even more sought after than before, and his loss left the art community without its seasoned guide. He became known as "le poète assassiné" after the title of a volume of loosely autobiographical stories he had published in 1916. The many literary and artistic journals for which he had written so voluminously tolled his death, and one of them, SIC, immediately announced plans for a monument.[61] As the most famous artist closely associated with Apollinaire, Picasso was the obvious choice to design it. Under the circumstances, he could not refuse, but the challenge should not be underrated. It required him to depart entirely from his previous sculpture so as to revitalize the tradition of the public monument. Moreover, Apollinaire, who has been described as "the opposite of a statue" because of his state of constant intellectual ferment, was no easy subject to fix in marble or bronze.[62]

These artistic problems, combined with practical delays, postponed the project for a long time. Two years elapsed before a permanent grave was obtained in Père Lachaise Cemetery and a committee was empowered to raise funds for the monument. As finally constituted, this group of twenty-eight men and one woman ranged across the arts and included some of the most important writers, editors, and artists in twentieth-century France: Elemir Bourges, a winner of the Goncourt prize; the publisher Gaston Gallimard; Alfred Valette, the editor of the prestigious Mercure de France; the artists André Derain and Maurice Vlaminck (besides Picasso); the poets Max Jacob and André Salmon; and André Level. Despite this illustrious assembly and the dogged efforts of its leader, the literary critic André Billy, money trickled in slowly. Only after an auction of works donated by approximately sixty-five artists (including Matisse, Chagall, Gris, Severini, and the artists on the committee) raised over thirty thousand francs in the summer of 1924 did the committee finally secure sufficient funds to finance a large sculpture.

Even then, the project languished for several more years as neither Picasso nor the committee rushed to complete the job. Yet none of them missed the gatherings that occurred every year at Apollinaire's barren grave in the Père Lachaise Cemetery and then generally adjourned to a café on the Place Gambetta, where warming libations elicited reminiscences of the poet and kept alive the hope for a monument. (Remarkably, these meetings still take place, although the par-

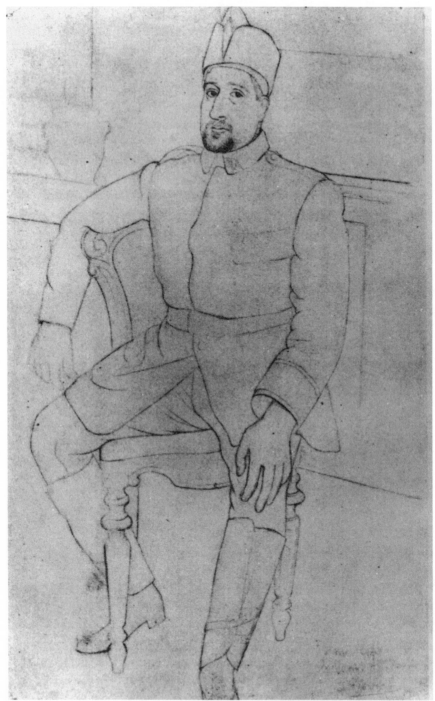

59. Picasso, *Portrait of Guillaume Apollinaire*, 1916
(Private collection, Paris)

ticipants are now primarily scholars of Apollinaire's work rather than fellow poets and artists.) During the memorial of November 1927, however, Picasso startled the group by announcing that his plans for the monument were complete. Inviting the committee members to visit his studio to decide on a final design, he assured them that the monument could be erected by the following year—the tenth anniversary of Apollinaire's death.

After waiting so long, André Billy recorded their great anticipation leading up to this gathering on the rue La Boétie. ". . . one day Picasso held a meeting in his home so that we could make our choice among several designs. How amazing! There was an entire sketchbook of them! An entire sketchbook of funerary projects! Think of it! What luck!" When the committee actually saw Picasso's proposals, though, their enthusiasm vanished. "Upon reflection," André Billy later wrote, "it became clear that these designs had not been made for a tomb . . . and we dispersed with melancholy."[63]

The problem was not that Picasso had failed to create designs for Apollinaire's tomb. The real problem lay elsewhere—in the conflict between his conception of the poet's legacy and that of the committee. Not long after the viewing in Picasso's studio, Billy related the events to Paul Léautaud, whose diary entry captures the vast gap between artist and sponsor: "Picasso brought something bizarre, monstrous, crazy, incomprehensible, almost obscene, a sort of undefinable block from which it seemed as if sexes protruded here and there. [Billy] had the idea that in reality Picasso had not made something for the monument and so had showed the gathering whatever he could pull out of his boxes. [Billy] told me laughingly: 'Apollinaire would no doubt have been enchanted if he could have seen that on his tomb. That would have amused him. That would have given some originality to Père Lachaise.' "[64]

All evidence suggests that Picasso truly had intended the designs for Apollinaire's tomb. The unfortunate thing is that Billy and the others refused to take them seriously, a fact that is all the more ironic since Billy's sarcastic remarks aptly captured both the spirit of Picasso's proposal and its appropriateness to Apollinaire. As best we can tell, Picasso showed the committee both a sketchbook filled with drawings and a small sculpture, both of which he had made during the summer and fall of 1927 (fig. 60).[65] Whether drawn or modeled, all portrayed a stand-

ing or running figure whose massive bulk has been transformed to project a polymorphous sexuality. Often known as "Metamorphoses" because of their plastic modulations, the designs display what John Golding calls a "witty but grotesque sexuality": "the human head is often reduced to a grotesque pinpoint, while the enormous breasts, sex and limbs (particularly the legs) are inflated almost out of recognition and appear to be composed of tumescent substance, half pulp, half bone . . . sometimes their arms can be read as phalluses and occasionally head and neck too acquire a thrusting, masculine urgency."[66] Confronted with these explicitly perverse images, the committee was outraged.

Yet many would say that the designs were appropriate, depending

60. Picasso, *Metamorphosis*, 1927
(Musée Picasso, Paris)

on how one remembered Apollinaire and what one thought of Père Lachaise. Opened in 1804 at the behest of Napoleon, Père Lachaise was the largest and most prestigious cemetery in Paris. Covering its 118 acres of precipitous hills and dense groves are hundreds of monuments so encrusted with sculpture that the cemetery resembles a fully populated city even when no visitors are present. Buried in its ornate tombs are many of the leaders of nineteenth-century French culture: Chopin, Géricault, Nerval, Ingres, Corot, Daumier, Delacroix, Balzac, and Wilde, among others. (More recently, Jim Morrison has joined the elite list of denizens.) Although the most imposing monument in the cemetery is Bartholomé's *Monument to the Dead* (1899), a classicizing procession of draped mourners filing into a sepulchre, many of the memorials to artists and writers deviate far from conventional tombs. Most notorious was Oscar Wilde's monument by Jacob Epstein, whose Assyrian pile flanked by conspicuously male angels drove the authorities to declare the work pornographic and to veil it soon after its dedication. Until about 1922, when the mysterious shattering of the angels' genitalia ended the controversy, energetic supporters regularly protested by pulling off the shroud.

Standing not far from Apollinaire's grave, Wilde's monument provided a precedent for Picasso's outlandish designs. In contrast to the traditional images of mourning found on most of the tombs, Picasso's would have stood as a monument to rude vitality. Its burgeoning sexuality and repudiation of conventional morality are emblems of exuberance amid the staid commemorations of the past. In this sense, Picasso's proposal for the Apollinaire monument would have captured the poet's constant striving to reinvigorate his art and discover the new. Moreover, the specific imagery of Picasso's monument would have recalled the work in which Apollinaire most explicitly pursued this goal.

In *Les Mamelles de Tirésias*, the play for which he coined the term *surrealism*, Apollinaire embodies his vision of modernity in creatures strikingly like Picasso's androgynous monsters. As the title implies, confusion and contradiction of genders are responses to the author's admonition "to enlarge the horizons, multiplying vision ceaselessly, . . . to proceed continually toward the most startling discoveries."[67] Physical transformation symbolizes social revolt, as the play's main character, Thérèse, rejects the traditional roles of women by meta-

morphosing into a man and assuming the name Tirésias. Mixing the serious issue of repopulation during wartime with outrageous burlesque escapades, Apollinaire presents Thérèse as a savage Zanzibarian who proclaims her independence by removing her balloon breasts and bouncing them at the end of strings before exploding them and throwing balls from her bodice into the audience. Then she grows a beard and concludes her transformation into a man "as virile as a bull." Meanwhile, her husband matches her performance by becoming a woman and bearing over forty thousand children before both assume their original sexes and roles at play's end. Besides providing a source for *The Rocky Horror Show, Les Mamelles de Tirésias* created characters of startling power whose sexual high jinks galvanized issues of artistic and social liberation.

At its first performance, in 1917, critics recognized the play's importance, and they continued to praise it throughout the 1920s. Thus, it may seem surprising that the committee rejected a monument that so strongly evokes one of Apollinaire's last and highly acclaimed works. The explanation lies in the evolution of the poet's reputation during the years following his death and the composition of the group that sought to fix his image for the ages. The original announcement of the committee identified its members as "the oldest companions of Apollinaire."[68] The vast majority of them had befriended him during the years before the First World War, when they were all building their careers. In deciding to memorialize Apollinaire, they sought not only to honor him but also to enshrine their era as having finally joined the French tradition. This elision was in keeping with the classicism that spread throughout French culture during the war, and it required that Apollinaire be cleansed of his rebelliousness in order to be certified as a classic. As one committee member, the patron and critic Roche Grey, wrote in 1924, "The French should consider Guillaume Apollinaire as the national poet . . . The people should sing certain of his poems as the Greeks sang those of their bards."[69] This interpretation of his legacy required a particular form of statue—a portrait bust. That was exactly what the committee demanded and what Picasso refused to supply.

The committee's memory of Apollinaire was not fallacious; it was simply partial. During the war, he had become a patriot, voluntarily serving in the army and writing in support of the French cause. But

like Picasso, he was never a thoroughgoing traditionalist. Even while acting as a censor for the French government, he maintained ties with the Swiss Dadaists. During his last two years, Apollinaire took under his wing the rising generation of poets and critics, especially Breton and Aragon. Yet even though the writer Rachilde, in a chauvinistic mood characteristic of the postwar years, questioned "if there were not too many bizarre people on the committee: foreigners, Cubists, Bolsheviks, Dadaists, and other sorts of *boches*," hardly any of these friends of Apollinaire were present.[70]

By chance, though, at precisely the point in 1924 when the committee had finally raised enough money to erect a monument, Breton began his campaign to appropriate Apollinaire's evocative term *surrealism*. The image of Apollinaire as a classical French figure was publicly challenged by radicals who sought to found their movement on a vein of the poet's work that Billy, Grey, and the others had consistently disregarded or even repudiated. The controversy raged through the literary press as the two camps traded salvos over who was best qualified to assume Apollinaire's mantle. In its midst, the premiere of *Mercure* brought Picasso into the fray on the side of the Surrealists. Their proclamation of him as the eternal personification of youth was irresistible; it captured the spirit of perpetual renewal that had driven both his career and Apollinaire's.

It was from this conjunction of events and Picasso's increasing involvement with the Surrealists over the next few years that his first proposals for the monument to Apollinaire arose. When Picasso presented them to the committee in 1927, the group must have understood their relevance to Apollinaire's work, but they also knew how deeply opposed they were to its perpetuation through Breton's Surrealism. Equally, Picasso knew that the committee required a portrait bust. What he offered them flouted both their instructions for the monument and their stewardship of Apollinaire's legacy. It is unlikely that Picasso ever intended to follow the committee's specifications, but his greatly enhanced status by the mid-1920s and his divergent interpretation of Apollinaire's contribution finally caused artist and committee to part company.

Despite this split, Picasso did not drop the commission; its theme was too important to his examination of the issues that shaped his career. In November 1928, he stated that he had completed a new

model. This time, the news even made the papers; the *Mercure de France* reported: "Pablo Picasso announced to the widow of Apollinaire that the maquette for the monument is entirely finished; it will be executed in bronze and can be inaugurated by the following April."[71] Picasso wasn't exaggerating; with the help of a sculptor and metalsmith, Julio González, he needed only to enlarge the small versions they had already constructed.

For this project, his definitive solution for the monument, Picasso turned to *Le poète assassiné*, a work that was widely admired by the committee members and the Surrealists alike. Many of the events recounted in this picaresque tale were loosely based on his life, including an intimate friendship between the main character, a poet called Croniamantal, and an artist, the Bird of Benin. Throughout the art world, this artist, who was distinguished by his African name and his equal talent as a painter and a sculptor, was assumed to be Picasso. And in a drawing of 1917, Picasso acknowledged the identification by joining in the role-playing. He copied a portrait that Jean Cocteau had drawn of him as the Bird of Benin and placed a volume of *Le poète assassiné* in his right hand; as he embraces Koklova, he spins a roulette wheel with his other hand.[72]

In "Apotheosis," the final chapter of *Le poète assassiné*, the Bird of Benin creates a monument for Croniamantal, who has been murdered by an antagonistic public. Without much exaggeration, one could say that in "Apotheosis" Apollinaire presented the monument he would wish for himself. Fittingly, it is the antithesis of a conventional statue. Instead of standing on a pedestal, it is dug into the earth; instead of consisting of massive bronze, it is a cavity faced with reinforced concrete. The monument created by the Bird of Benin is a hole excavated in the forest and shaped to resemble Croniamantal: a statue in reverse.

"A statue of what?" Croniamantal's girlfriend, Tristouse, wants to know. "Of marble? or bronze?" Those are too old-fashioned, the Bird of Benin tells her. He "must sculpt a profound statue out of nothing, like poetry and glory." Tristouse is delighted: "A statue of nothing, a void, that's magnificent." The next day, he executes the monument, digging a trench about half a meter wide by two meters deep and sculpting the interior to resemble Croniamantal. He and some workmen build a reinforced-concrete wall eight centimeters thick, except at the bottom, where it is thirty-eight centimeters deep: "Thus the

void had the form of Croniamantal and the hole was filled with his phantom." In its final form, the monument that Apollinaire creates for Croniamantal literally turns a conventional sculpture upside down and buries it in the earth so that its hollow center becomes the container of the dead poet's spirit. Reinforced concrete substitutes for the outdated material of bronze.

By the mid-1920s, the monument in *Le poète assassiné* was recognized not only as a literary trope but as an inspiration for actual sculpture. In 1928, the Surrealist critic Roger Vitrac described Jacques Lipchitz's recent "transparent" sculptures as "exposing to the full light of day the famous and illusory statue out of nothing in *Le poète assassiné*.[73] So it is not particularly surprising that Picasso turned to the same source that year. In comparison with the works of Lipchitz and his contemporaries, however, Picasso's sculptures are riveting articulations of "nothingness"; moreover, their placement on the poet's grave in Père Lachaise would have left little doubt as to their meaning.

Rising from a sheet-metal base, machined rods bend and cross to articulate a loosely enclosed envelope of space (fig. 61). Although the final sculpture would have been cast in bronze to preserve it from the elements, it would have maintained the sleek lines of the maquette's iron rods. These "lines in space," as Daniel-Henry Kahnweiler dubbed them, trace a schematic central figure whose forward thrust crisscrosses the loosely delimited space of the sculpture. The dynamic rhythm of the rods energizes the surrounding void and draws the viewers' attention to it. Thus, Picasso preserved Apollinaire's description of a sentient emptiness enclosed by a figure, dispensing, however, with Apollinaire's conventional touch of reproducing the dead poet's features.

Even without the physical setting of Apollinaire's grave, André Breton had no difficulty interpreting the meaning of these sculptures when he saw them scattered among supplies on a shelf in Picasso's studio during the early 1930s: "These figures, these iron-plated objects, have only to aim bottles of varnish or turpentine in other directions for their own impalpable volume to stand out against the latter's palpability, so that it is life itself that becomes, that *is*, part of their total transparency, so that it is the philter of life itself that distends them, from one metal rod to another."[74] Once again, the ease of interpreta-

61. Picasso, *Monument to Guillaume Apollinaire*, 1928
(Musée Picasso, Paris)

tion suggests how closely aligned Picasso's monument was with the Surrealists' view of Apollinaire and his legacy.

Writing in the mid-1950s, André Billy cites the statue to Croniamantal as "one of the most pleasing inventions of *Le poète assassiné*," and he acknowledges Picasso's long-standing desire to base his monument to Apollinaire on it.[75] Yet, when Picasso presented his maquettes to the committee in the fall of 1928, they were met with the same disbelief that had doomed the first proposal. To some, the flimsy wire constructions were merely laughable. If they did not exhibit the obscene bulges of the 1927 drawings and sculpture, their radical vacuity seemed equally contrived to offend those who were adamant in their desire for a realistic portrait of Apollinaire. Serge Férat, the treasurer of the commission and the artist who ultimately carved the stele that now stands on Apollinaire's grave (fig. 62), dismissed Picasso's projects as ephemeral—not substantial enough to stand as enduring monuments to Apollinaire or powerful enough to overcome the lugubrious atmosphere of a cemetery.

In fact, this is exactly what Picasso's monuments, particularly the airy constructions of 1928, would have accomplished. In contrast to the massive gray mausoleums that fill Père Lachaise, one of these transparent armatures would have been startlingly fresh. Set off by the surrounding stone structures and articulated by the crisscrossing rods, Picasso's unconventional and dynamic monument would have been a perfect medium for Apollinaire's still-vital spirit. As it turned out, Picasso's only public sculptural tribute to the poet was the bust of Dora Maar, his companion in the late 1930s and early 1940s, which he donated for a monument that was erected beside the church of Saint-Germain-des-Prés in 1959.[76]

The failure of the commission was inevitable, given the growing intellectual differences between the committee and Picasso. Even more crucial than this disagreement, however, was the fact that the artist and the commissioners could not communicate. Even though both admired the statue in *Le poète assassiné* and understood its appropriateness as a model for a monument to Apollinaire, the primarily literary background of the commissioners did not enable them to appreciate Picasso's designs, and Picasso was unable to convince them. Ironically, this tragic situation reinforced the fundamental role Apollinaire had played during his lifetime. A writer firmly grounded in

62. Apollinaire's tomb, Paris
(Courtesy of the author)

French literary tradition, he had nonetheless embraced, promoted, and spawned some of the most innovative developments in the visual arts of his time. He was the linchpin that joined these artistic worlds, and with his death, they split once again. Although Picasso realized that Breton was struggling to reforge this union in the Surrealist movement, Apollinaire's "oldest and most intimate friends" could neither perpetuate his achievement nor accept other claimants.

In the midst of the negotiations, Picasso took his case to the press. He invited the critic E. Tériade to his studio and showed him the maquettes he had prepared for the committee. Tériade described them as demonstrating Picasso's desire "to make a sculpture that stands in space and derives its force from the air" and also cited Picasso's wish to build them on a large scale out of pylons of iron or another material. He quoted Picasso as saying they were designs for the monument: "I would like, at this time, to base the monument to Apollinaire on these ideas."[77] Clearly, Tériade grasped the concept of the sculptures, even without any evident mention of *Le poète assassiné*, and he acclaimed them. Nonetheless, the committee did not budge. Soon afterwards, Picasso created his third and final version of the monument, but there is no evidence he ever offered it for Apollinaire's grave. Instead, he cast this sculpture, *Woman in a Garden*, in bronze and placed it on the grounds of his country house at Boisgeloup—as a private commemoration of his friend.[78]

There is one more document from these months that must be considered. It is a photograph of Picasso in his studio, quite possibly taken at the time of Tériade's visit (fig. 63). More sharply than all of the preceding slow accumulation of evidence, this instantaneous image captures Picasso's position in the conflict and returns us to the questions of his own public reputation that constantly shadowed his contributions for the Apollinaire memorial. Picasso stands in a corner, staring into the lens. Posing for the camera, as he had four years earlier at the *Mercure* ball, Picasso strikes a jaunty stance. With one hand holding a cigarette and the other on his hip, he presents himself as an assured man of affairs. Manifesting his wealth and position, his dress could not be further from the conventions of artists' attire. Indeed, if one did not immediately recognize the riveting stare of those large eyes, one might easily mistake this man wearing a homburg hat, an overcoat, and a dark double-breasted suit, white shirt, and tie as a

collector visiting a studio. By his stance and costume, then, Picasso makes the point that he is as prominent as the patrons who have traditionally been courted by artists. This propriety, this bourgeois success, is, after all, the image that the committee wished to promote of Apollinaire as well. It would seem fitting for this dapper gentleman artist to turn out a proper bust of the poet for the crowds to admire.

For Picasso, of course, this persona was only a half-truth or even a setup. Picasso does not stand isolated in the studio. He is surrounded by his work, and these abundant paintings, drawings, and sculptures evoke an image of their creator directly opposed to that of the well-appointed man who stands among them. The photograph is contrived to affirm Picasso's success while also demonstrating that as an artist he has not become decadent. As if to disprove the charges of effeteness leveled by Picabia and others, Picasso uses the strategy that the Surrealists had lifted from Apollinaire: the shock of contradiction to undermine superficial appearances. Picasso orchestrates the image to convey the message that, no matter how wealthy and prominent he may have become, his art continues to provoke. Resting on a table

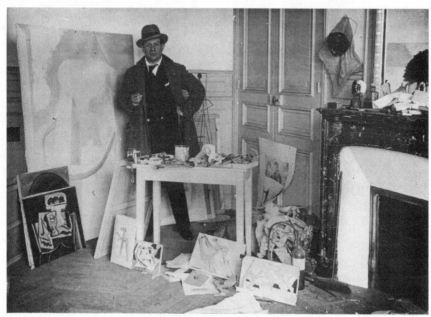

63. Picasso in his studio, 1928
(Courtesy of Roger Violet, Paris)

before him, a version of the monument to Apollinaire carries the weight of this argument. Juxtaposed with his comfortable girth, the bare wires of the construction could not seem more unlike their maker. The model speaks of the continuing evolution of Picasso's art, and, as a monument to Apollinaire, it would have extended Picasso's address beyond the studio to the public space of Père Lachaise.

Even if any of his monuments to Apollinaire had been erected, it is unlikely they would have reached beyond the initiates of Le poète assassiné to a broader public. Instead, it was his collaboration with Paul Rosenberg that continued to shape and expand his reputation and influence. Since Rosenberg had not been a participant in the avant-garde of the prewar years and therefore did not know Apollinaire well, he took no role in the plans for the memorial. The auction of donated works, for example, was overseen by Paul Guillaume, who had often sought Apollinaire's advice. Nonetheless, Rosenberg subscribed to the auction and showed no signs of discouraging Picasso's involvement with his old comrades.

Rosenberg's enthusiasm for Picasso's stylistic transformations continued unabated. In announcing the close of Picasso's great exhibition of 1926, Rosenberg had addressed the artist as "the famous Cubist painter" and had told him that he was maintaining a "salle Picasso," in which his pictures were surrounded by the works of Corot, Degas, and Renoir. While affirming Picasso's place among the masters, he admonished him not to rest on his laurels: "Give me a vision of a new Picasso."[79] True to form, Picasso produced the "monstrous" figures of the late 1920s. Rosenberg steadily bought these pictures, and he presented selections of them in the group format he had adopted.[80] In 1929, 1930, and 1931, he organized shows that displayed Picasso's new work in conjunction with that of his contemporaries: Braque, Matisse, Léger, Laurencin, and, on at least one occasion, Derain.[81] Although it was probably not Rosenberg's intention, this format highlighted Picasso's stylistic departure at the expense of his neighbors. As the installation photographs of the 1929 exhibition evince, the hanging in the main room juxtaposed Picasso's radically distorted figures of 1926–28 with far more decorative paintings by Laurencin and Matisse (fig. 64). In the 1930 exhibition, Picasso's paintings again overwhelmed the other artists' work by occupying at least half of the main gallery with a dozen or more paintings (fig. 65).

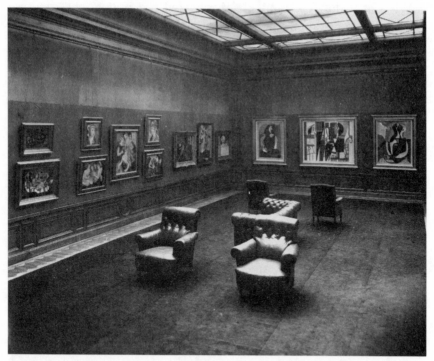

64. Galerie Paul Rosenberg, *Exposition Picasso, Braque, Derain, Matisse, Léger, and Laurencin*, 1929 (Courtesy of Paul Rosenberg & Co., New York)

As in the previous show, paintings from Picasso's studio series dominated the 1930 exhibition, particularly the *Painter and Model* (1928; fig. 66), which was also shown in 1929, and *The Studio* (1927–28).[82] These two paintings, his masterpieces of the late twenties, demonstrate more than any others the centrality of the Apollinaire commission. Not only does *The Studio* share the vocabulary of the wire constructions in its crisp linear definition of forms enclosing envelopes of shape, but the site of both paintings—the artist's studio—invokes the theme of the Apollinaire monument, especially the proposal of 1928. Apollinaire's meditation on the nature of creativity in *Le poète assassiné*, his decision to memorialize Croniamantal by a void "like poetry and glory," shares with Picasso's studio paintings a depiction of art as an intangible process best portrayed through constant metamorphosis. In his paintings and in his monument to Apollinaire, Picasso put aside classicism to embrace innovation as the key to artistic stature.

Without a doubt, Rosenberg recognized the importance of these paintings. He acquired them soon after they were completed, and he continued to expand his stock of current work as the market rose to a peak in the fall of 1929. So inflated did prices become that Viscount Charles de Noailles bought one of Picasso's very small Dinard paintings from Rosenberg for 43,000 francs.[83] Most of the series, painted in 1928, measured no more than ten by fifteen inches (several are visible in the photograph of Picasso in his studio in late 1928). John Quinn had paid 12,000 francs for the somewhat larger *Sleeping Peasants* (1919) in 1921.[84] The phenomenal increase (nearly fourfold in eight years) signaled the top of the market. What Rosenberg had characterized in 1926 as an art *bourse* sank with the crash of the American stock market in October 1929.

Despite their importance, neither *The Studio* nor the *Painter and Model* sold quickly. The American collector Walter Chrysler bought *The Studio* in the early 1930s through Valentine Dudensing, a New

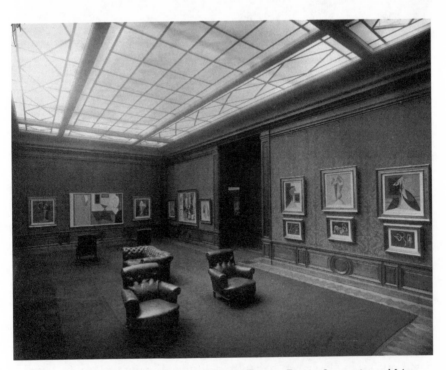

65. Galerie Paul Rosenberg, *Exposition Picasso, Braque, Derain, Laurencin, and Léger,*
1930 (Courtesy of Paul Rosenberg & Co., New York)

66. Picasso, *Painter and Model*, 1928
(Museum of Modern Art, New York)

York dealer, and later gave it to the Museum of Modern Art. *Painter and Model* did not sell until 1933, when another American, Sidney Janis, acquired it for a collection of modern art that he would donate to the Modern in the late 1960s. Interviewed at the time of his gift, Janis recounted how he managed to get the picture by trading a much more modest Matisse:

And the first painting that we bought was a Matisse, *Interior at Nice*, which we acquired about 1927/28, and that picture I no longer have, but I can tell you a rather interesting tale of how that picture figures in my acquisition of the Picasso *Painter and His Model*. That picture was painted by Picasso in 1928, and in 1929 Paul Rosenberg, who lived in the same house that Picasso did (or I probably should put it the other way, Picasso lived in Paul Rosenberg's house), on La Boétie, and Rosenberg had this exhibition with new works by Picasso. And in that show was the *Artist and His Model* and also the stunning

Studio picture which I think Walter Chrysler gave you some time ago. Well, the *Artist and His Model* was in that show and I fell in love with it, and I came every day to look at it. And I finally got together with Paul Rosenberg on it, and he gave me a very handsome allowance on the Matisse *Interior at Nice,* and I acquired this picture. After the deal was sealed, I asked Paul Rosenberg, "Why did you part with this magnificent picture on a trade-in on the Matisse?" He said, "Janis, I'll tell you. The Matisse I can sell immediately, the Picasso I wouldn't be able to sell for thirty years." And I was the proud possessor of a great Picasso.[85]

If Janis correctly recollected that he first saw *Painter and Model* in Rosenberg's 1929 exhibition (rather than in the 1930 show), then the negotiations stretched over more than four years. Both Janis (who had made a fortune in the shirt business) and Rosenberg were hard bargainers, but the hopeless state of the art market was on the collector's side. No greater evidence of this reversal could be offered than the "very handsome allowance" Paul gave for that Matisse. No doubt the *Interior at Nice* is a fine picture; still, it is part of a pleasing but often slight series that does not have the historic significance of Picasso's *Painter and Model.* As the financial crisis intensified, however, Rosenberg readily admitted his willingness to swap a difficult, great picture for a less important but more salable one. Clearly, the easy profits of the twenties had ended.

With the collapse of the market, Rosenberg's purchases from Picasso also declined rapidly. At the time of the group show in April and May 1929, his log shows the acquisition of sixteen paintings, with another twenty-three added in anticipation of the exhibition in March and April 1930. But from that time until the winter of 1933–34, when Rosenberg bought twelve works from Picasso, he would not add more than one or two new works a year and only a few more older ones (generally from distressed collectors). Instead, he tried to weather the Depression by shifting his focus back to nineteenth-century art. His limited acquisitions were devoted to this field, and his exhibitions concentrated on the nineteenth-century masters (1931), Monet (1933), and Renoir (1934). Rosenberg would not hold another one-man show of Picasso's work until March 1936. Even the group show of 1931 seems to have centered on the "classic" Picassos of the mid-twenties, such

as *The Red Table Cloth, Woman with a Mandolin,* and *Still Life with a Bottle of Wine.*

Rosenberg's right of first refusal did not require him to purchase Picasso's full production (as Picasso's contract had required Kahnweiler to do), and he acted quickly to decrease his financial commitments to his artists. Still, the huge success Picasso had enjoyed from his relationship with Rosenberg during the previous decade left him in a secure position.

Unlike during the financial collapse at the beginning of the First World War, this time Picasso could afford to wait. Increasingly, he lived not in his apartment on the rue La Boétie but about forty miles northwest of Paris, at Boisgeloup, which he had purchased in June 1930. Secreted there with his mistress, Marie-Thérèse Walter, whom he had met in 1927, Picasso yet again transformed his image. Rosenberg highlighted this change with his accustomed flair. Punning on the name of Picasso's country house, he wrote on June 25, 1930: "Dear evaporated and invisible friend, lord of the Jealous Wood [*Bois jaloux*] and other places, you have become more rare than the triangular stamps of 'Good Hope.'" Picasso would maintain his lordly distance throughout the final decade of their business partnership, when his achievements were acclaimed in a series of museum retrospectives in both Europe and America.

LORD OF THE
JEALOUS WOOD

□

GALERIES GEORGES PETIT

O n June 16, 1932, a lavish retrospective of Picasso's work opened in Paris at the Galeries Georges Petit (fig. 67). A cagey American journalist recorded the scene:

> The opening of the show was more of a society than an art event—
> one of those evening affairs at which those who do not know any
> better arrive around 9:30, as the invitation asks them to, and to which
> the celebs wander in with a bored air about midnight. Duchesses,
> diplomats, monocles, tail-coats, nude spines, such diamonds and
> pearls as are not in pawn, bottled tan on the women, larded hair on
> the men, a few paunchy politicians who like to be "among those
> present," champagne, microscopic sandwiches and sharp-eyed dealers
> trying to read the thermometer of Picasso's value five years from now,
> made up a No. 1, 1932 "Vernissage."[1]

Displaying 225 paintings, seven sculptures, and six illustrated books, the exhibition was a blockbuster. Apart from its sheer size, the show ranged across Picasso's career from 1900 to the early months of 1932. Yet, for all its similarity to the giant museum exhibitions that would

follow, it did not include a single work lent by an institution and it was not organized by a cultural foundation. The lenders were the powerful financiers and industrialists of America, such as Chester Dale and Stephen Clark, whose collections would contribute so much to the

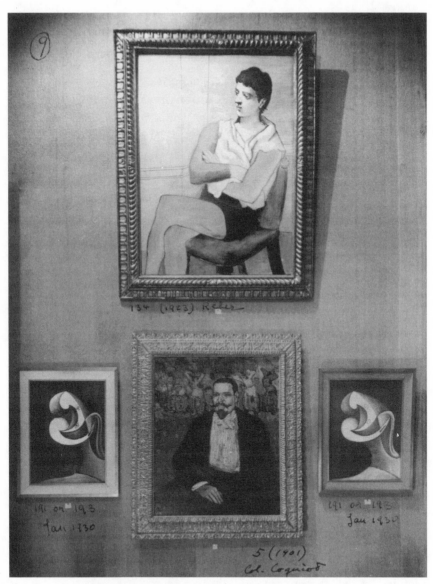

67. Galeries Georges Petit, *Exposition Picasso*, June–July 1932
(Courtesy of Alfred H. Barr, Jr., Archives, Museum of Modern Art)

holdings of the Museum of Modern Art and the National Gallery; the aristocrats of France, including Baron Gourgaud and the Viscount de Noailles, who would similarly enhance the Beaubourg's collections; and the cosseted Swiss collectors, such as G. F. Reber and Joseph Müller, whose works would grace the museums of Zurich and Basel, among others.[2]

At the time, several of the institutions to which these lenders ultimately contributed did not yet exist, and very few of those in operation sought contemporary art, even that of Picasso. As the decade passed, they would begin to expand their collections and, in the process, take on the function of exhibition organization previously fulfilled primarily by the commercial galleries. Not only would the Georges Petit exhibition travel to the Zurich Kunsthaus, but it would serve as the model for the Picasso retrospectives staged at the Wadsworth Atheneum in 1934 and the Museum of Modern Art (in conjunction with the Art Institute of Chicago) in 1939–40.

As museums assumed the role of defining contemporary artists' careers for the public, dealers receded into the background, yet they continued to play essential roles. Curators frequently relied on dealers' knowledge of artists' work and sought their assistance in securing the loans of art and the substantial sums required to realize large retrospectives. Despite the dealer's lower profile, the great exhibitions of the 1930s were in many ways the culmination of the promotional program Picasso and Paul Rosenberg had initiated over ten years before.[3]

In the early thirties, the market for contemporary art was still dominated by a handful of private collectors. Galleries that had seen ballooning numbers of buyers during the late twenties were left with vast oversupplies. Among the sixty-two lenders to the Petit exhibition, fourteen were dealers, who contributed the lion's share of works in the show from their bulging inventories. Without doubt, Paul Rosenberg led the group. But to the public eye, it was the prominent collectors, who swept into Paris for the celebratory dinners and opening party, that certified the vernissage as a gala event. Such scenes had been common at Picasso's openings since his inaugural show at Rosenberg's gallery, but this time the proceedings were on a grander scale. Shirking such glamour, Picasso confided to the American reporter that he planned to skip the opening and go to a movie.

Besides seeming odd for a man who was said to attend "every re-

ception and elegant evening," his remark is particularly surprising since Picasso was the curator of the show.[4] Not only had he played a large role in selecting the works but he had also installed them: "I've been hooking these things on the wall for six days now and I've had enough of them" is what he was reported as saying.[5] Despite his evident fatigue, his dismissal of the opening is all too characteristic of the contradictory personas he had long cultivated. And according to Sidney Janis, Picasso indeed failed to appear.[6]

Aware of the artist's reputation for unpredictability, the reporter remained skeptical about Picasso's real intentions—"maybe that about the movies was just another pose"—while he cleverly insinuated the contradictions he perceived in this event.[7] If the crowd managed to perpetuate an appearance of easy prosperity, they were adorned only with "such diamonds and pearls as are not in pawn." The financial disasters spreading from the crash of the American stock market had overwhelmed the art market much as had the panic of the early 1920s. But this time it would not soon be reversed. In these extremely uncertain times, the dealers did indeed need to take the temperature of the Picasso market with great care because they could not count on the escalating prices that had fueled the profits and widening audience of the mid- and late twenties. Such difficult times required arrangements different from the freewheeling competition of the twenties, when the entrepreneurial dealers such as Paul Rosenberg, Paul Guillaume, and the Bernheims had prospered. The Galeries Georges Petit was a paradigm of the new relationships among dealers and collectors that formed in the early thirties.

Although bearing an illustrious name in the history of modern art, the gallery was far from its origins when the Picasso retrospective hung in its vast halls on the rue de Sèze. Founded in the late 1880s, it had by the 1890s wrested many of the Impressionists from their first dealer, Durand-Ruel, and presented such important exhibitions as Monet's *Mornings on the Seine* and Norman coast series. According to Emile Zola, who knew the Parisian art world inside out, Petit was the "apotheosis" of dealers when the Impressionist market soared and competition among marchands, including Paul Rosenberg's father, became intense. Yet despite a flamboyant sense of fashion, Petit did not follow the path of Rosenberg or the Bernheim brothers by renewing his stock with artists of the twentieth-century avant-garde. Characteristically,

one of his last productions before his own death in 1921 was the estate sale of Degas's studio.[8]

Petit's gallery passed into the hands of his more farsighted competitors. Having had a share in the business for decades, the Bernheims took control after his death and, in partnership with a colleague, Etienne Bignou, used the gallery primarily as an auction house throughout the twenties. Ironically, the crash of 1929 and its widening repercussions in Europe seemed to offer the opportunity to reinvigorate the aging institution.

Beginning in 1930, the Bernheims and Bignou responded to the hopeless state of the market by convincing their colleagues in the trade to band together to present exhibitions that, though no longer affordable for individual dealers, offered the possibility of generating sufficient publicity to make them worthwhile. Rather like the war period, the early years of the Depression shattered many old alliances between artists and dealers but forged new consortiums among former competitors. During the boom years, Paul Rosenberg had encountered problems with Marie Laurencin, whom he had had under contract since 1912. After accusing him of not paying her what she was worth during the last month of the bull market in October 1929, she flew into a rage when he counseled her one month later not to order any more seven-thousand-franc Chanel coats. She refused to cut back; yet her effort to cultivate competing relationships with Paul Guillaume and other dealers fizzled out.[9] With his contacts in both Europe and America, Rosenberg had immediately understood the gravity of the situation and correctly judged that no one could keep Laurencin in Chanels any longer.

Instead of dividing the dealers, the Depression encouraged alliances between those who already dominated the market. While the lesser figures went broke, the Bernheims, Rosenbergs, and Wildensteins worked in greater concert than they ever had before. With the disappearance of most clients, their fierce competitiveness subsided into cooperation for self-preservation. When the market had soared in 1927, Rosenberg had adroitly dodged an interviewer's effort to elicit his opinion of his fellow dealers: "I have for each of them the same respect they have for me."[10] In the heat of competition, that respect was surely rather slight; when Rosenberg rebuked Laurencin just before the crash for her efforts to secure other dealers, he accused her of selling to his

enemies.[11] Yet the Georges Petit exhibitions, and the Picasso show in particular, demonstrated how much the situation changed when the art market came to a halt.

Besides a truce among dealers, this period saw another development that seemed to overturn fundamental relationships: instead of keeping collectors at arm's length, dealers formed business partnerships with some of their best customers. In the early 1920s, Paul Rosenberg had fought bitterly to keep John Quinn from coming between him and Picasso; yet, by the end of the decade, Bernheim and Bignou allowed Chester Dale, a collector as important as Quinn, to buy a large block of stock in the Galeries Georges Petit. In later years, Dale was quite candid about his motives. Like Quinn, he wanted to gain quicker and more comprehensive knowledge of which pictures were available and to reduce the prices he paid by eliminating the dealer's markup. Perhaps the Bernheims and Bignou accepted him on the board of the gallery because they knew he was too skilled at business to be kept in the dark. Although Dale accused them of sometimes trying to exclude him from management decisions—often made over lunch at The Sporting Club, where the dealers habitually gathered—he effectively became both a dealer and a client in the tradition of shifting alliances that characterizes the art market.[12]

Even if the dealers saw their profits from Dale's purchases decline, they benefited considerably from his broader participation in the market and his support for the Georges Petit program. Dale's financial investment and driving presence helped make the Galeries Georges Petit a dynamic institution between 1930 and 1933, when the prolonged Depression finally forced its investors to liquidate the firm.

The first production of the revived Petit was specifically designed to diversify the old establishment. The directors began with an exhibition called *One Hundred Years of French Painting* because it "rendered homage" to the gallery's founder while enabling them to "renew the chain" by including twentieth-century artists.[13] In fact, although the exhibition began with the Barbizon painters and passed onto the Impressionists and Post-Impressionists, over half of the works came from the *école moderne*—from Bonnard and Vuillard through Picasso, Matisse, and Léger.

Having opened a new path, the gallery pursued it with two landmark exhibitions: *Matisse* in June and July 1931 and *Picasso* one year later.

Both shows were remarkable not only for their size and the international range of the loans but, more important, for their effort to treat these mid-career artists as deserving the attention accorded historical figures. This merging of the past and present was, of course, what Rosenberg had been developing during the previous decade or more.

In the introduction to the Matisse catalogue, the Petit directors affirmed their desire "not to be frozen in the nineteenth century," but they were careful to state that the show was not a strict "retrospective or apotheosis," because Matisse was still very active. (He was then sixty-two and would have two more productive decades before his death in 1954.) The choice to begin with Matisse was probably a matter of convenience. As his longtime dealers, the Bernheims had ready access to him and a large inventory of work on hand. In fact, the show did not require much cooperation from others in the trade, but the organizers were careful to include loans from the "international elite" of collectors on both sides of the Atlantic.[14] Not surprisingly, Dale was prominent among them. During the preceding two years, he had bought at least two of Matisse's recent canvases from the Bernheims and Bignou, and both of them were included in the exhibition. In the middle of the run, he purchased another work on view from Bignou. These transactions suggest his roles as an investor (buying in advance of an important event that would raise an artist's prices—"insider trading" as it has come to be called) and a stockholder generating business for the firm.[15] As if in confirmation of his prominence, Dale and his wife, Maud, received the places of honor surrounding Matisse at the opening banquet. Maud, who spoke fluent French and was the connoisseur of the family, was seated on Matisse's right, while Chester sat next to the wife of one of the Bernheims, who was on Matisse's left.[16]

In a sense, the organizers were correct to say that the show was not a retrospective. Although it presented 141 paintings, including many important works from the teens (such as *Goldfish and Sculpture* [1912], *Artist and Goldfish* [1914], and *The Yellow Curtain* [1915]), over sixty percent dated from 1919 to 1929 (no works of the 1930s were represented). This emphasis on the recent Nice period did not give the show the balanced treatment that would be expected of a retrospective, but the many prewar masterpieces in Russian collections were unavailable. Moreover, everyone involved—artist, dealers, and collectors—had an interest in promoting his current work.

Among the long list of international lenders, Paul Rosenberg appeared as the owner of a few pictures. Although five years later he would become Matisse's primary dealer, his contribution was rather modest, and he does not appear to have played a significant role either. Despite the impression of a museumlike event created by the succession of masterpieces and extensive loans from prominent private collections, the exhibition was organized by the dealers who had represented Matisse since 1909 (except for an interruption of two years during the war). But to undertake the next exhibition, the even larger Picasso retrospective of 1932, required not only the agreement of the artist but also of Rosenberg and his partner, Georges Wildenstein.

If not for the Depression, it seems quite unlikely that this collaboration would have occurred. Rosenberg briefly continued his practice of presenting only group shows of contemporary artists: in 1930 he mounted an exhibition of Picasso, Braque, Laurencin, and Léger; and in 1931 he showed them all, plus Matisse, once again (fig. 68). But then he stopped until 1936, when the slowly recovering market probably prompted him to return to exhibitions of twentieth-century art with a show devoted to Picasso's recent work. Before then, however, Rosenberg and Wildenstein had reason to entertain seriously an offer to participate in a large exhibition, even if they were not its organizers.

The presence of Chester Dale on the Petit board probably did not hurt the chances for collaboration. Not only had Dale been one of Wildenstein's and Rosenberg's major clients for Impressionist and Post-Impressionist pictures since the mid-twenties, but he had recently begun to concentrate on Picasso's work. In October 1928, he had bought a Blue period painting, *Mother* (1901), from Wildenstein in New York for $6,900, and the following year he bought a major early work, *Juggler with Still Life* (1905), from Paul Guillaume for $8,000. Unlike most other collectors, however, Dale did not curtail his purchases during the Depression but rather moved in to buy even more important paintings at low postcrash prices. In 1930, he switched his business to Paul Rosenberg, and over the next couple of years he purchased a remarkable set of Picassos, which he continued to augment through the thirties.[17]

Many of these paintings are now in the National Gallery in Washington; they constitute some of the artist's most important paintings from before and after the First World War. In May and June 1930,

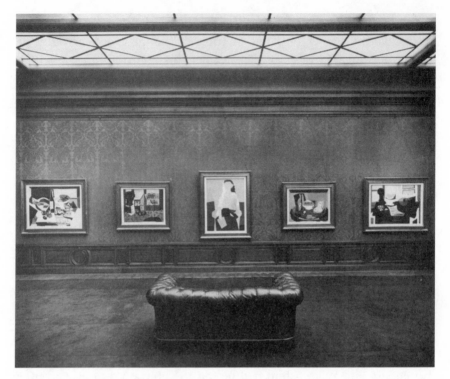

68. Galerie Paul Rosenberg, *Exposition Picasso, Matisse, Braque, Laurencin, and Léger,*
January–February 1931 (Courtesy of Paul Rosenberg & Co., New York)

Dale bought five of Rosenberg's best pictures. As if he were setting
up a mini-retrospective, Dale acquired one work from the Blue period,
Tragedy (for $18,000); one from the Rose, *Adolescents* (also $18,000); a
Cubist painting, *Large Still Life* ($14,000); followed by a smaller *Clas-
sical Head* ($6,000) and a *Portrait of Olga* that had appeared in the
1923 tour (during the seven intervening years, its price had soared from
$5,000 to $25,000).[18] These transactions suggest that the tough eco-
nomic times did not so much lower the prices as improve the quality
of pictures offered to Dale; moreover, he soon closed a deal that both
made his name as a Picasso collector and confirmed him as an astute
financier.

In February 1931, Dale bought the painting that had established
Picasso's reputation in the international market—*The Family of Sal-
timbanques.* Having purchased it at the Peau de l'Ours auction, Hein-
rich Thannhauser had sold it to a private collector, who, in turn, used

it as collateral to secure a loan after the crash.[19] Dale heard from Valentine Dudensing, his dealer in New York, that the *Saltimbanques* had been repossessed and now resided in a Swiss bank vault while a consortium of dealers bargained with the bankers over an asking price that may have approached $100,000. Understanding bankers' desire for cash rather than for illiquid property, Dale had Dudensing cable a much lower offer, with a deadline of twenty-four hours. Much to the irritation of the dealers, who apparently did not know Dale was on to the picture, the bank accepted his bid. Dale acquired the painting for the modest sum of $20,000.[20] Apart from its importance in Picasso's career, the *Saltimbanques* was twice the size of *Adolescents* (also of 1905), which Dale had purchased the previous year for only ten percent less. Much like André Level, who bought the painting from Picasso when the artist badly needed the money in 1908, Dale got a great picture at a bargain price. This time, however, Picasso neither participated in the transaction nor suffered economic need. He had become more financially secure than at least one of his collectors.

Given the *Saltimbanques'* status as an early masterpiece in Picasso's oeuvre, one would have assumed that Dale's possession of the canvas assured its presence in the Petit retrospective. Yet it was the most important of Picasso's pre-Cubist works not to appear. Its absence, however, was simply a practical matter. The painting was so large that it had been necessary to take it off its stretcher in order to get it into Dale's New York apartment, and Dale had no desire to risk damaging it by repeating the operation; instead, he sent the *Adolescents*.

Most of the other important early paintings were included in the Petit retrospective, including *The Burial of Casagemas*, courtesy of Ambroise Vollard, who apparently still retained it from his 1906 sweep of Picasso's studio; *La Vie*, owned by Bignou; and *Two Nudes*, which was among the works Paul Rosenberg had purchased from the Quinn estate. At least two of the Peau de l'Ours pictures were on display—most important, the *Harlequin on Horseback*—and André Level played a role, in his new incarnation as the director of the Galerie Percier, by loaning two or more early Cubist works.[21] Despite the absence of the *Demoiselles*, Cubism was well represented through the beginning of the war by loans from private collections that included *Woman with a Mandolin*, *Portrait of Uhde*, and *Woman in an Armchair*. Many of these pictures had been picked up cheaply at the forced sales of Kahnweil-

er's stock. (The diminished stature of Kahnweiler is evidenced by the fact that neither he nor the Galerie Simon was listed as the lender of even one Cubist work.) Madame Errazuriz's *Portrait of a Young Girl, Harlequin* of 1915 (long since passed from Léonce Rosenberg to Paul and on to the private collector Alphonse Kann), the huge *Harlequin and Woman with Necklace* (sold by Paul Rosenberg to the Baron and Baroness Gourgaud), *Portrait of Olga*, and *After Le Nain* (loaned from Picasso's private collection) briefly traced the difficult war years.[22]

For the period between 1918 and 1932, Rosenberg dominated the show. These years of his association with Picasso now constituted nearly half of the artist's professional career. Although Rosenberg was officially listed as the lender of only eight paintings (Picasso included a few from his personal collection, such as *The Pipes of Pan* and *The Dance*), almost all the substantial oeuvre of the period had passed through his hands. Much of it had been featured in his exhibitions during the twenties and had long been recognized as of major importance. *Young Girl with a Hoop*, one of Paul's first purchases in 1918, had also been one of his first sales to John Quinn, repurchased after Quinn's death and included in the 1926 exhibition. *Two Nudes*, also sold to Quinn and reacquired, had joined the collection of G. F. Reber. Both versions of the *Three Musicians* appeared, one loaned by Rosenberg and the other by Reber. And several of the paintings from the touring show of 1923–24 returned, now sold: the *Blue Veil* and *Seated Saltimbanque* to Reber and *The Lovers* to Mary Hoyt Wiborg. Except for the huge *Mandolin and Guitar*, which now belonged to Reber (and today is in the Solomon R. Guggenheim Museum), and the dusky still life in the collection of the viscount de Noailles, Rosenberg held many of the canvases that had constituted the core group of his 1926 show, such as *The Red Table Cloth, Still Life with a Bottle of Wine*, and *Woman with a Mandolin*.

Kahnweiler lent *The Studio* (1928), presumably a direct purchase from Picasso. He was not, however, taking over Picasso's newer work: Rosenberg lent *Painter and Model, The Studio*, and *Female Profile* he had shown in 1930. The Wildenstein gallery made its single appearance as the lender of *Metamorphosis* (1929), a selection that did not reflect its specialization in the Blue and Rose periods but highlighted its role with Rosenberg as Picasso's primary dealers. Finally, the large

group of works representing the previous two years came directly from Picasso's studio, not from Rosenberg's inventory.

According to the catalogue preface, Picasso intended to represent each phase of his career. No doubt he made choices in collaboration with Rosenberg and other dealers (as he had since at least 1918), but the idiosyncratic selection reflects Picasso's taste. Although there were works from every year of his career, beginning with 1901, the distribution was neither evenly proportional nor calibrated to match contemporary critical opinion. Instead, it suggests Picasso's personal view of his oeuvre—seen through the lens of his most recent work. After a solid group from the Blue and Rose periods, culminating in twelve works from 1905, only four minor works from 1907 represented Picasso's "African" phase. Then the importance of analytic Cubism was acknowledged with eleven works from 1909 and the synthetic phase with ten from 1912.

If the fifty-five works devoted to Cubism during the eight years from 1907 to 1914 seem only adequate, the forty-three covering the three years from 1923 to 1925 were lavish. This group far outweighed any other in the exhibition, and the eighteen from 1924 alone equaled the set from 1932—making these the two largest annual groups in the show. The mid-twenties pictures included several of the elegant figure paintings that had formed the centerpiece of the 1923–24 shows but even more of the grand still lifes and figures of the 1926 exhibit. Given the size of this group, it is noteworthy that neither of the challenging rope-and-nail *Guitars* of 1926, which had remained in Picasso's collection, appeared. Nor was *The Dance* accompanied by *The Kiss*.

The advice of Paul Rosenberg may be evident here (several of the paintings came from his private collection), but one cannot discount Picasso's own choice. Unlike the Matisse show, this one was not weighted toward contemporary work, as one would expect an exhibition organized by an artist and his dealers to be. The Picasso show included an average of only about twelve works for the years from 1926 to 1931. It is not until the four months from December 1931 to March 1932 that it erupts with twenty-two paintings. And it is in relation to this group that the 1923–25 selection appears relevant. These two sets of paintings are linked by the unusually large size of their canvases and by their images of quiescent figures and still lifes—quite

in contrast to the violently contorted anatomies that characterized the works of the intervening years. Picasso's desire to emphasize this aspect of his oeuvre probably explains his omission of the *Demoiselles*. A strategy of selecting past work to support the most current is also suggested by the group of books and sculptures.[23]

Picasso may have called attention to this continuity within his work in order to assert his independence from outside influences. Pierre Daix speculates that Picasso's turn to sculpture in the early 1930s may have been prompted by what he had seen in Matisse's 1930 show at the Galerie Pierre (which included at least sixteen recent sculptures). Similarly, Matisse's Petit retrospective may have fueled his burst of painting in late 1931: "The decorative sumptuousness . . . suggests a rivalry with Matisse."[24] Much as the war had brought these two masters of twentieth-century art together at Paul Guillaume's gallery in 1918, the Depression led them to show in the same rooms at the Petit.

The most explicit evidence of Picasso's hand is the hanging of the pictures. Picasso's arrangement ignored the standard chronological succession that is de rigueur among curators. On first view, the works seem to have been hung wherever the delivery men left them, but on closer examination the calculation in Picasso's groupings emerges. Sometimes the paintings follow a particular phase of his oeuvre, but more often works from different periods are placed in the same ensemble. In one case, the 1905 standing nude *Girl with a Bouquet* is flanked by two of his recent "bone" figures (1929). Directly above the Rose period adolescent hangs one of Picasso's monumental Neoclassical paintings of a mother and child. It, in turn, is flanked by another Rose period picture, depicting an equally massive woman, *La Coiffure*, and an even earlier Blue period portrait of a man (fig. 69).

Despite their different dates, all these paintings treat the same subject—the human figure—on a monumental scale. In constructing this group and the many others that mapped the show, Picasso directed the viewers to examine the internal coherence of his art. Instead of laying out his work to trace an evolution from period to distinct period, he confused the pattern by doubling back to contradict such a simple progression and call attention to both the remarkable consistency of subject matter and the variety of interpretations. This freedom of association, as opposed to a more plodding academic method, reflects an artist's constant mining of his past work to fuel his future

creations. It is very hard to believe that any curator would have taken such liberties. But this arrangement also served Picasso's ends by portraying his career as one of self-reflection independent of outsiders. One might even say that the installation was a work of art in itself.

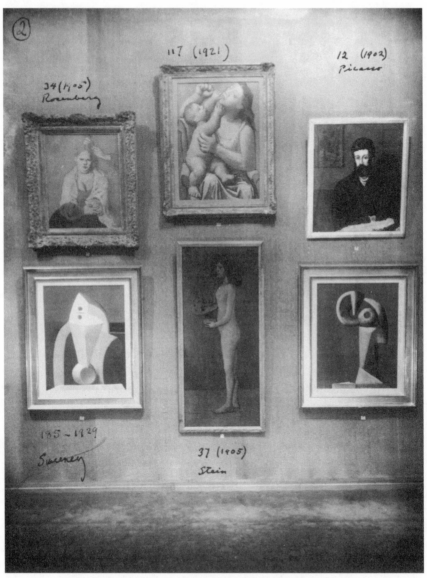

69. Galeries Georges Petit, *Exposition Picasso*, June–July 1932
(Courtesy of Alfred H. Barr, Jr., Archives, Museum of Modern Art)

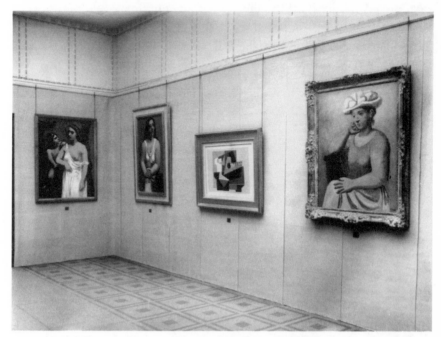

70. Zurich Kunsthaus, *Picasso Ausstellung*, September–November 1932
(Courtesy of Archiv des Zuricher Kunstvereins)

Such subtleties were lost on the critics, who generally took offense at the devotion of such a grand retrospective to a contemporary artist at mid-career.[25] Nonetheless, a version of the show traveled to the Zurich Kunsthaus (as the Matisse show had to Basel). Although forty-nine works did not leave Paris and forty-three were added in Zurich, this show essentially maintained the balance that the Petit exhibition had. On the walls of the Kunsthaus, however, the exhibition looked entirely different, since Picasso did not make the journey to install the pictures, and the curators mostly fell back on a conventional chronological display (fig. 70).[26]

ALFRED BARR'S FIRST CAMPAIGN

The Petit exhibition could have had another venue—the Museum of Modern Art in New York. Beginning in the early 1930s, America would increasingly become the site of major exhibitions of twentieth-century

art. Already in 1930, Alfred H. Barr, Jr., the director of the newly created museum, had begun negotiating for what he hoped would be the first American retrospective of Picasso's work. In the summer of 1932, his wife and lieutenant, Margaret Scolari Barr, traveled to Paris to study the Petit retrospective, and it is due to the Barrs' meticulous attention that we have photographs recording Picasso's installation. One might assume that Alfred Barr would have considered the Petit show a godsend because it included so many of the works that he considered Picasso's masterpieces. Certainly the Zurich curators believed it offered a remarkable opportunity. Yet, to Barr, the idea of accepting an exhibition that had been organized by the trade was problematic, if not anathema. Even if he could have supplemented its core of works with other loans, as the Zurich curators did, he was unwilling to be perceived as following in the footsteps of dealers.

This attitude marks a fundamental departure in the history of exhibiting twentieth-century art. It is particularly characteristic of the conception of modern art propagated by Alfred Barr and disseminated by the Modern in the decades when that institution largely defined the presentation of contemporary art in American museums and strongly influenced policies abroad as well. This almost puritanical desire for isolation from the market was not shared by all museums, either in America or abroad, and it failed to acknowledge the degree to which the Modern was dependent on dealers to execute its exhibitions. Nonetheless, it identifies one of the positions that shaped the Modern as it rose from a small outpost in New York to the worldwide dominance it achieved with exhibitions such as the Picasso retrospective of 1939–40.

Having been named director a few months before the Museum of Modern Art officially opened in November 1929, Barr lost little time beginning preparations for a Picasso exhibition.[27] On June 25, 1930, he cabled Jere Abbott, his associate director at the museum: "GREAT PICASSO SHOW POSSIBLE PICASSO LENDING OWN COLLECTION PLUS REBER PLUS PERHAPS ROSENBERG."[28] Earlier that month Barr had visited Picasso's studio with the American collector Albert E. Gallatin and Gallatin's French agent, Jacques Mauny, at whose urging Barr had asked Picasso if he would support an exhibition of his work at the Modern in 1931.[29] The telegram reflects both Barr's great excitement at Picasso's apparent acceptance and his quick work in soliciting other

loans to flesh out the show. But, as Barr's use of "perhaps" suggests, there was a sticking point.

Without the cooperation of Rosenberg and the dealers who controlled the Galeries Georges Petit, especially Etienne Bignou, Barr could not accomplish his goal. Moreover, his desire to maintain his independence from the trade ultimately gave the dealers even greater control. Picasso, meanwhile, was no mere pawn in the machinations. On June 21, 1931, almost exactly one year after his optimistic cable to Abbott, Barr sent him another wire. Instead of confirming plans for the fall exhibition, this message recorded the collapse of Barr's plans: "PICASSO ABSOLUTELY POSTPONES TEMPERAMENTAL REASONS REBER REFUSES WITHOUT PICASSO'S APPROVAL." The history of this reversal and Barr's desperate struggle to resurrect his dream of a Picasso retrospective at the Modern reveal in excruciating detail the exquisite web of bitter competition and mutual support that bound artists, dealers, and curators during these crucial years when the art of the twentieth-century avant-garde began to be welcomed in America's leading museums.

Picasso's reasons for refusing to cooperate were not merely temperamental. They included both his desire not to be distracted from his work and his Parisian dealers' advice that he resist being rushed by this relative newcomer. Only three months before Picasso pulled out, however, Barr thought that he had harnessed all the major forces in the art world. Regarding the trade, he had optimistically confided to Mauny: "Our plans for the Picasso exhibition are progressing. We have the support, I believe, of the Wildenstein group, of the Bignou group, and I hope of Paul Rosenberg, so far as the great dealers are concerned."[30] Upon Picasso's withdrawal, Barr turned not to the trade but to Reber to plead his case. As perhaps the foremost private collector of Picasso's work during the late twenties (he would be bankrupt by 1934), Reber was a strategic choice. Like Barr he could be perceived as above commercial considerations; yet, unlike Barr, he retained sufficient power over the market to influence both the artist and his dealers.

Barr poured out his fears to Reber. He meticulously traced the alliances he discerned among the dealers, and he plotted a strategy to take advantage of their persistent rivalries: "First of all I feel that a Picasso exhibition in Paris next spring is probable. I think Picasso

might be willing; I think also that Bignou and Rosenberg would form a temporary coalition once it was certain that Picasso would be willing to exhibit in N. Y. in November 1932. Rosenberg would probably not consent to an Exhibition in the Georges Petit Gallery, but would, I think, be willing to join forces with Bignou were the Exhibition to be held *on neutral ground.*"[31] Although Barr had realized that the dealers were not necessarily going to give his plans the green light, he misjudged both their willingness to collaborate on the Petit show and the likelihood of their support for an exhibition on the "neutral ground" of New York—that is, at the Museum of Modern Art.

Because Bignou was active on the Petit board, Barr saw him as the chief rival to his plans, and he carefully considered Bignou's reliability: "The relation between Bignou and the Museum has changed radically during the last month. Previously as he admits he had been hostile and had committed sabotage on several occasions. Now he is, externally at least, friendly and actively cooperative." According to Barr, the recent comradeship was based on their mutual involvement in presenting exhibitions of Matisse's work. The Petit retrospective had opened two weeks earlier, and Barr had agreed to borrow a group of its pictures to include in his fall show at the Modern. Clearly concerned that he might appear diminished by this collaboration, Barr aggressively asserted to Reber his independence from Bignou: "As a matter of fact the pictures for our exhibition have been chosen and are being borrowed by the Matisse family and myself. Our indebtedness to Bignou is confined to the paintings borrowed from the Georges Petit Corporation."[32]

As Barr sought to build the Modern's reputation, the Petit group's activity in organizing the Matisse show and the coming Picasso exhibition would weigh heavily on his plans. Already in his letter to Reber, he imagined a connection: "It seems possible therefore that Bignou having helped us with the Matisse show may no longer feel under any obligation to work with us in the Picasso exhibition." Barr realized, too, that Picasso's refusal to allow a show in the fall of 1931 had played into the dealer's hands: "A few weeks ago Bignou believed that your influence would persuade Picasso to join with you in assisting us with an exhibition this year, he was willing enough to cooperate because time would have been lacking during which he might organize his forces. But during the next twelve months he will scarcely remain

inactive and it may well be that he will contrive to secure the balance of power."

Barr believed that he was fighting a battle to preserve his museum's independence from the trade's infiltration. By way of preparing Reber for another round with Picasso, he invoked the authority of the museum's trustees: "Our Trustees would be much chagrined and might even lose interest in a Picasso exhibition in Nov. 1932 if a similar exhibition for commercial reasons were to have been held in Paris a few months before." Finally, he laid out his strategy: "I think we must attempt to do three things: 1) Get Picasso to commit himself to an exhibition in the Museum of Modern Art in November 1932, if possible *without previously holding a European Exhibition.* I think we could point out to him what is perfectly true, that it is only in the Museum of Modern Art that an Exhibition could be freed from political-commercial circumstances and resulting compromises. 2) . . . make advances to other European Collectors . . . 3) as soon as Picasso commits himself . . . secure the American owned pictures."

Here was Barr's clearest statement of his position. Simply by virtue of being organized by dealers, a show was compromised by "political-commercial circumstances"; while an exhibition sponsored by a museum, or at least the Museum of Modern Art, was free of such complications. Yet both sets of organizers would draw from the same group of works and negotiate with the same lenders, whether dealers, private collectors, or institutions (though quite rare in those years)—any of which might be motivated by self-interest. It would be hard to argue that the Modern's 1931 Matisse show was more important than the Petit's—in either the number or significance of the works it included. Although Barr's selection was more evenly spread across the artist's career, it did not necessarily constitute a more informative presentation or a more distinctive curatorial statement.[33]

In the case of Picasso, it is harder to evaluate what Barr had in mind. His papers do not contain any lists of the works he hoped to include, but there is one document that indicates his overall preferences.[34] Splitting Picasso's career into thirteen chronological periods, Barr assigned each period a grade of no stars to three. According to these judgments, Barr would have chosen a show that differed significantly from the Petit exhibition. Counter to popular opinion and the Paris show, Picasso's early work through the Rose period would have been

dismissed by Barr (1901–06 scored zero, or "unimportant") and the "African" period would have been emphasized among the work of his first decade. To Barr, the period of 1906–07 constituted one of Picasso's four peak (or "most important") periods, primarily because of the *Demoiselles* (referred to by Barr as "Doucet"). Following that, 1907, 1908, and 1909 were "less important," one-star years, but 1910–12 rose to the "important," two-star category; both 1912–13 and 1914–15 attained the "most important," three-star category.

After these years of collage and synthetic Cubism, 1915–17 plunged to the "unimportant" category. The "Classical/Cubist" works of 1918–21 and the "Classical Cubism" of 1922–25 each received two stars. Beginning with 1926, Barr gave Picasso's recent work a consistent three stars. He would therefore have placed far greater emphasis on Cubism than did the Petit show and would have downplayed the great still lifes and figures of 1923–25 that constituted the centerpiece of the Paris show. Finally, the Surrealist work of the late twenties would have been given equal weight with that of the early thirties. Although not without some significant shifts of emphasis, this conception of Picasso's career would guide Barr's choices for the 1939 retrospective. These preferences would also soon become the foundation of scholarly discussion of Picasso's work. Even if Barr did not originate these judgments, his exhibitions and catalogues played a large role in disseminating them throughout the art world.[35] One must keep in mind, however, that Picasso selected the Petit show. At the very least, he worked in concert with the organizing dealers, and he hung the pictures.

In contrast to the real complexity of relationships within the art world, Barr's distinction between galleries and his museum seems rather naive. But he was fighting to distinguish his activities and the program of his fledgling museum from the pattern of dealer-initiated exhibitions (often linked with museums) that had so far dominated the presentation of modern art and still wielded more power than he could marshall. As it turned out, the Modern's trustees were not particularly perturbed by the idea that their Picasso show would follow in the wake of a retrospective at Petit. But Barr was. It seems likely that his objections were based both on principle and on self-interest. After all, Barr wanted to establish himself as a leading scholar and curator of modern art, as well as to differentiate the program of his museum from the

activities of the dealers. His search for a distinctive position, so fraught with its own pragmatic compromises, would drive his professional life for years to come.

Serving as Barr's emissary during the summer of 1931, Reber seemed to regain Picasso for the Modern's cause, but Barr's satisfaction was wiped out by news from his erstwhile friend Etienne Bignou. On July 10, 1931, Bignou told Barr that Picasso had agreed to participate in a show the dealers would present the following spring—the retrospective at the Galeries Georges Petit. Barr related the events to Reber. Bignou had asked whether the Modern had plans for a French exhibition in early 1932, and, "receiving a negative answer," he had claimed the territory: "Last Friday Bignou said definitely that he was planning a Picasso exhibition for next Spring and that Picasso had agreed to assist him." Barr must have been stunned, but he "made no comment." Although he tried to keep fighting, Barr knew he had lost his battle to curate the only Picasso retrospective of 1932: "Such an exhibition would, however, probably alter the attitude of the Trustees toward a Picasso exhibition in America. There are considerable disadvantages in following in the footsteps of the Georges Petit galleries twice within two years . . . The situation is however very difficult for we must not antagonize Bignou."[36] Apparently, Bignou did not feel such an obligation to Barr.

Despite these intense intrigues among dealers, curators, and collectors, the central player was, of course, Picasso. Quite characteristically, he had vacillated throughout the negotiations. Since most of the discussions with Picasso were carried out by Reber, who left no known accounts of their conversations, it is difficult to reconstruct exactly what Picasso said to the competing parties. In June 1931, before Bignou had any firm plans to present a dealer-organized show, Picasso apparently acted on his own to cancel the exhibition Barr had projected for the following November. But during July, he seems to have spun in the crosswinds of opposing interests.

The issue seems to have turned on whether Barr would have exclusivity. Although Bignou's question to Barr suggests that he wanted his show to be first, the dealers gave no evidence of wishing to prevent the Modern from presenting an exhibition. After all, the Petit show did travel to the Zurich Kunsthaus (where it was altered by the curators), and the Matisse show had appeared in Basel. The problem was

Barr's conviction that he could not present a Picasso exhibition if one organized by the trade had previously appeared in Europe. Yet, as Barr finally admitted, the dealers had more clout. They saw no reason to allow the young curator of a new museum to grandstand. Picasso probably cared little for this argument over priority, nor is he likely to have been much impressed by Barr's assertion of his institution's moral superiority. Though Picasso may have been willing to cooperate with Barr, he was not willing to damage his relations with the dealers on whom he depended for his livelihood.

Barr spent the winter of 1931–32 spinning his wheels. In December, the museum drafted a formal letter to Picasso renewing the offer for an exhibition in the fall of 1932. But Barr was constantly looking over his shoulder. In a confidential note, Barr counseled the museum's president, A. Conger Goodyear, to tell Picasso point-blank that the museum was opposed to playing second fiddle to a dealer show:

> May I bring up once again the question of the Picasso Exhibition at the Georges Petit Galleries before I prepare a final draft of our letter to him [Picasso]. As the letter stands I have cut out any reference to our objections to an exhibition at a dealer's gallery in Paris previous to ours.
>
> As I recall, you told Mr. Dale over the telephone that you would regard an Exhibition of Picasso at the Georges Petit Galleries this spring as an "unfriendly act" providing of course that we continued to expect a Picasso Exhibition this fall. He has doubtless informed Bignou of this.
>
> We have not, however, stated this in so many words to Picasso himself. If in the spring we found that Picasso had consented to a large exhibition at the Georges Petit, we would have no document to show that we had any long-standing objections to this.[37]

Dale had once again crossed the conventional divisions in the art world. Not only did he sit on the Petit board but he had been a founding trustee of the Modern. (He relinquished his position at the museum in late 1931.) Although there is no evidence Dale tried to stop Bignou's plan, Barr had good reason to assume that he had told the dealer about Goodyear's territorial behavior.

The remarkable thing is that, six months after Barr's plans disintegrated, no one had actually told Picasso why the Modern was being

so difficult. Perhaps Barr and his colleagues had concluded that Picasso wouldn't care very much about such delicacies. Even Barr was beginning to have second thoughts. In his note to Goodyear, he equivocated: "It may be that you have changed your mind about this matter of prestige. In view of the success of the Matisse Exhibition I do not feel as strongly as I did that it would be unhappy to have a Picasso Exhibition following one in Paris." Goodyear finally solicited the opinion of the trustees, whose disapproval had been cited regularly in the preceding months, and reported: "I spoke to Mr. [Paul J.] Sachs and to Mrs. [John D.] Rockefeller yesterday about the Picasso exhibition. They both feel that even though there would be an exhibition in Paris the coming spring, this would not really matter to us. I think, therefore, that we can safely go ahead with the arrangements regardless of a possible exhibition in Paris."[38] Nonetheless, the resulting letter to Picasso, dated January 13, 1932, included the statement "it would be much preferable if your great retrospective exhibition took place in New York before being shown in Paris."

Two days later, the museum finally canceled the show. The board directed Barr to inform Picasso that the museum would recommend that "no exhibition of his work should be held in America for the time being until the present financial crisis has passed."[39] Barr duly carried out these instructions, adding to the trustees' citation of economic constraints the explanation that "the financial crisis has become much more severe since last year."[40] Yet in all the discussions over the previous year and a half, there is no mention of financial difficulties, even in the final exchanges between Barr, Goodyear, Sachs (the leading art historian on the board), and Mrs. Rockefeller (a founder). It is hard not to conclude that it was more convenient for the museum to cite such forces beyond its control than to state explicitly the more likely explanation that Barr's unwillingness to play a subsidiary role to Bignou and company had scotched the deal.

The exhibition's collapse caused Barr great frustration; it seems to have even taken a toll on his health. By the late spring of 1932, the trustees had granted Barr a full year's leave of absence to recover from stress so debilitating that he appeared to be on the verge of a nervous breakdown. During the two and a half years of the Modern's existence, he had completely devoted himself to it. Sufficing with a tiny staff and temporary quarters, he had overseen almost every aspect of its oper-

ations. By the early months of 1932, he was exhausted. Severe insomnia and eye irritations restricted his effectiveness to the point that a physician felt an extended period of complete liberation from professional duties was required.[41] On top of his continuing responsibilities, the failure of his Picasso project may well have been the last straw. He could not put it out of his mind. As Barr spent the summer in New York preparing the museum for his departure, his wife went to Paris to study the Petit retrospective.[42] Under the circumstances, its success must have been excruciating for Barr.

Seven years would pass before Barr again undertook the task of organizing a retrospective of Picasso's work, and during that time the prestige of the Modern and of its director would grow immensely—based both on the museum's program of exhibitions and on its acquisitions. Nonetheless, when Barr returned to his long-delayed project, he would still have to strike bargains with the dealers. This time, however, they were perfectly willing to let the Modern organize the show while they stayed in the background. To Barr they may still have evoked images of "political-commercial" compromise, but they remained both necessary to his success and deeply involved in it.

Before leaving this long, if futile, campaign, we should briefly return to June 20, 1931, the day Picasso called off the show that had been scheduled for the fall. In his telegram to Jere Abbott, Barr had written that "Picasso absolutely postpones temperamental reasons." This judgment was a matter of opinion at the very least. A month later, Barr was more specific. In a letter to Mauny, he recounted that "after several conversations Picasso refused on the grounds that he wished to carry through to its culmination his present 'period' before holding a retrospective." If true, this would hardly be a temperamental reason to put off a show. It is surprising that Barr was not sympathetic to the artist's desire to have his most recent work properly represented. There may, however, be another aspect, one Barr could reasonably have characterized as temperamental: he also noted that "Picasso's final refusal came about a week after the opening of the Matisse exhibition at the Georges Petit Gallery . . ."[43]

There is little doubt that Picasso had already studied the show's extensive contents closely. Since the last retrospective of Matisse's art in France had taken place in 1910, the current one must have been a revelation for everyone interested in twentieth-century art. It may also

have been quite unsettling for Picasso. After a steadily productive winter and spring, he finished very little during the summer and fall of 1931. Only in December did he begin the series of monumental figures and still lifes that formed the finale of his exhibition at Petit in the summer of 1932. Was this dry spell caused by Picasso's momentary doubts before the demonstrated accomplishments of his rival? If so, Picasso may well have withdrawn from Barr's planned show in order to produce a body of work that would stand with the Matisses on view. The combination of Matisse's show and the promise of his own the next year certainly could have spurred him to produce the great paintings of the following winter.

In the light of the Modern's withdrawal for financial reasons, it is interesting to note that both the Paris and the Zurich shows were moneymaking ventures. While commercial activity by a business enterprise like the Galeries Petit is assumed, such involvement by a museum like the Kunsthaus is less expected. The Zurich catalogue, however, straightforwardly reveals the economic origins of the show in both its French and Swiss incarnations. It identifies eighty-five works that were for sale. Among these, seventy had also appeared in the Paris show, so one can conclude that at least a third of the Petit exhibition was available for purchase. Clearly the American journalist was right when he cautioned readers that "they say nothing is for sale, but don't offer big money unless you want to part with it."[44] Like Paul Rosenberg's joint ventures with the Arts Club of Chicago in the twenties, these retrospectives involved a commercial incentive, even if it was not overt.

All of the most recent works were for sale, and except for *Pitcher and Bowl of Fruit* (1931), which was Rosenberg's, all of them were owned by Picasso. As Rosenberg had not continued his practice of purchasing the exhibition pictures, Picasso's direct financial stake was considerable. Perhaps, like Marie Laurencin, he hoped that by cultivating relations with other dealers he might overcome Rosenberg's retrenchment. On the other hand, perhaps Rosenberg welcomed the opportunity to share his costs with a consortium of dealers. Either way, the occasion offered both artist and dealer the chance to explore new arrangements in commercial viability.

Not unexpectedly, few pictures sold. Certainly by the time Rosenberg held his next solo show of Picasso's work, in 1936, many of the

Petit paintings were his property. According to Laurencin, Picasso was still deeply dependent on Rosenberg's commercial guidance in November 1933: "He hasn't got a hold over me as he has over Picasso and Braque. For instance, Ida Rubinstein commissioned me the other day to do a work with Picasso and Braque, and Picasso said to me, confidingly: 'What will Rosenberg say? Rosenberg's in America.' Picasso fills me with pity, he is like a child."[45] Although Laurencin's assertion of independence sounds a bit hollow, her description of artists' reliance on their dealer accurately reflects the great financial uncertainty of those years.

THE WADSWORTH ATHENEUM RETROSPECTIVE

In his constant search for business, Rosenberg made another trip to America during the last months of 1933. It would prove to be no more remunerative than the previous ones, but it would result in his forming an alliance with A. Everett "Chick" Austin, Jr., the director of the oldest and then one of the most innovative museums in the country, the Wadsworth Atheneum in Hartford, Connecticut. Through this remarkably symbiotic relationship, Rosenberg would serve, however discreetly, as the primary curator of the first retrospective of Picasso's work in America. Austin would appear as the impresario of the exhibition, which rivaled in importance the Petit and Zurich shows when it opened to widespread acclaim in February 1934 (figs. 71, 72).

Unlike Alfred Barr and his colleagues at the Modern, the staff of the Atheneum showed no qualms about the trade, instead involving dealers in every aspect of their show. Indeed, by welcoming that support, the Atheneum scooped the Modern in the race to present a retrospective of Picasso's work. For Rosenberg, the collaboration was only another in a long list; as he had admitted to Picasso after the Arts Club show of 1923, he knew that developing a market for contemporary art in America would require extensive cultivation. Despite the boom of the late twenties, it was still far from securely established, and museum exhibitions were needed to validate his artists' reputations.

So, in late 1933, Paul once again voyaged to America. Although he went there ostensibly to solicit loans for an exhibition of Daumier's

work that the French national museums would present the following year, he characteristically took the opportunity to discuss business with the various collectors and curators he met. (Presumably the Louvre was not offended by such mixing of commerce and curatorship.) Also characteristically, he kept Picasso informed of economic realities. Writing from New York on December 16, 1933, he told Picasso that he had just returned from a trip to Kansas City and other points west. His conclusion was that "the situation is no better here . . . but this only means that I must return because the country remains very rich." It was in this context that he then stated the case for the Atheneum retrospective: "You know that the museum in Hartford, which is in Connecticut, near Boston, wants to give you a show. I am lending them my most beautiful canvases and I recommend you contribute also. There is a great interest in the arts here, and there is a great market to conquer for you." Over the next month, Rosenberg would

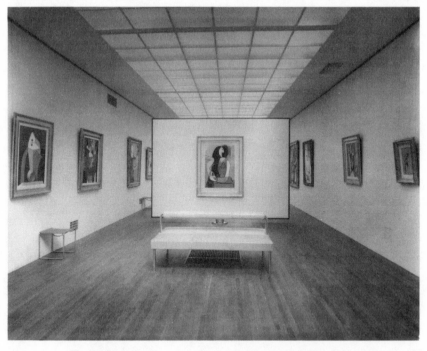

71. Wadsworth Atheneum, *Picasso Exhibition*, February 1934
(Courtesy of Wadsworth Atheneum, Hartford)

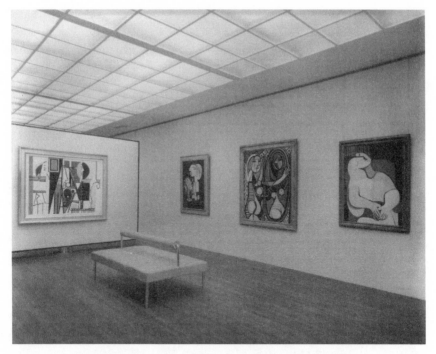

72. Wadsworth Atheneum, *Picasso Exhibition*, February 1934
(Courtesy of Wadsworth Atheneum, Hartford)

throw himself into making the Atheneum show the best that could be
arranged on such short notice.

Chick Austin had received his board's approval for the exhibition
on November 14, 1933—only eleven weeks before it was to open. (In
fact, it was originally scheduled for even earlier.[46]) Austin's aim since
coming to the museum in 1927 had been both to build the permanent
collection and to make Hartford "the art center of New England."[47]
By 1928, his reputation had already spread to the more cosmopolitan
Parisian dealers, such as René Gimpel, who jotted down this sketch of
the director:

He is about twenty-four and has been at the museum only a year.
The town was asleep, his youth and intelligence have conquered all
hearts, and he has made the money flow in torrentially. He has ob-
tained about $600,000 for a museum which had nothing. How has
he brought about this miracle? By giving a ball in the museum. Ev-

eryone enjoyed it and after that all swore by him. Who can say what future may be in store for this institution, thanks to this Don Juan, friend of the great masters? He has come to acquire my Fra Angelico and an enchanting Avignon primitive, Christ on the Knees of the Virgin.[48]

Although the source of the funds had less to do with a ball than with a bequest of over one million dollars received soon after his arrival, Austin did orchestrate a remarkable series of cultural events until his resignation in 1945.[49]

Part of his charm was the catholicity of his tastes. While he spent most of his acquisition funds on Old Masters, he also sought to include the moderns. In the spring of 1931, he bought a tiny but exquisite Neoclassical painting by Picasso through Wildenstein for the modest sum of $2,500.[50] And according to James Thrall Soby, his friend and a future curator at the Museum of Modern Art, Austin especially admired Picasso among contemporary artists: "he never stopped insisting that the greatest of these men was Picasso."[51] Although Austin never acquired the large collection of Picassos he longed for, he did tentatively schedule a Picasso show for the spring of 1932. No doubt he knew of the Modern's ongoing efforts when he began planning in the fall of 1931, but he must have felt there was room for both shows since he asked Barr to loan works.[52] Unlike Barr, however, Austin never got beyond the initial inquiries, and more pressing matters delayed his show for two years.

When Austin resumed the project and obtained approval from his board, he immediately announced to the press his plans for the first Picasso retrospective in America. Yet this Picasso show was only one of the several landmark events he planned. In fact, the exhibition was secondary to the inauguration of the Avery Memorial, a new wing that had taken six years to complete. Since the style of this building was strictly modernist, Austin no doubt believed that Picasso, as the "most famous of contemporary French painters," was the perfect choice to adorn the austerely elegant galleries in their first public appearance.[53] (Presumably Austin chose to disregard that Picasso evinced no interest in modernist architecture.) Completing the building and opening the Picasso show on the same day was a herculean task, but even this pair

of challenges did not constitute Austin's full menu. Austin planned to follow these events with the premiere of *Four Saints in Three Acts*, an opera by Gertrude Stein and Virgil Thomson, on the very next day. Even Alfred Barr was impressed by Austin's ambition and perseverance. Barr wrote to him only a few weeks before the deadline: "I admire your extraordinary initiative and courage in putting on this opera and this Picasso exhibition. Either one would be enough for any ordinary mortal museum director."[54]

As the master of this three-ring circus, Austin justly received acclaim, but the sheer range of duties prevented him from devoting much time to each individual event. As Barr had implied, no one could do all those things at once, yet Austin knew how to pull it all off gracefully. According to Henry-Russell Hitchcock, the renowned architectural historian who participated in many of Austin's programs, "He had charisma. He bubbled over with ideas, and they were so stimulating that everyone was willing to work with him and for him. But he was no scholar, no researcher. It's true that he used many of his friends as experts. But there was almost no aspect that he wasn't involved with. We used to say that Chick picked up things by osmosis. He seemed to absorb the books that other people were reading without reading them himself. And I think especially in the art world he knew what was going on as soon as it started."[55] Among Austin's lieutenants for the Picasso show were Hitchcock and James Soby, already an adventurous Picasso collector in his own right. By pooling information with others in the small club of American museum officials, such as Jere Abbott (who had left the Modern to become director of the Smith College Museum), they put together a sparse list of potential loans. In the final exhibition, only four works came from museums. Instead of institutions or their private patrons, the real sources for the show were dealers, particularly Wildenstein and Rosenberg.

Austin singled them out for recognition both in the catalogue and in his private correspondence, even though the extent of their role was left unspecified for mutual convenience. After all, Austin's extremely varied activities at the museum over the years had not allowed him the time to become an expert on Picasso's work; nor, apparently, had he ever met the artist or seen either the Paris or the Zurich retrospective. He pursued some lenders directly, making a rather opti-

mistic appeal, for example, to the State Department for support in obtaining the loan of the Shchukin collection, then held by the Soviet government.[56]

He got his first serious assistance from the New York branch of Wildenstein. Austin had been an active buyer, particularly of Old Master pictures, during the lean years of the Depression, so he knew Felix Wildenstein, the head of the New York office, quite well. Apparently Austin quickly informed him of his desire to do the show, because on November 29, 1933, Georges Wildenstein wrote to Picasso, his neighbor on the rue La Boétie, that he had received a request from his cousin in New York: "They would particularly like the beautiful portrait of Madame Picasso [probably the winner of the first prize at the 1930 Carnegie International in Pittsburgh] and several other paintings from your different periods." After this plea for Picasso to loan some of the paintings he had retained for his personal collection, Wildenstein tried to justify the sacrifice: "The museum in Hartford, which is extremely well directed and is actively campaigning for French painting, is organizing a very important exhibition and I think it will be in your best interest and the best interest of your work to be well represented."[57]

Unfortunately for Austin, Rosenberg and Wildenstein had severed their business relations the previous year, and now only Rosenberg (with some private backers) represented Picasso.[58] Georges Wildenstein's appeal therefore carried little weight and failed to convince Picasso to contribute. Without Rosenberg's assistance, Austin would have been limited largely to the small number of paintings, mainly from the Blue and Rose periods, that were available to him in America through Wildenstein and friends in the museum world.

By December 16, when Rosenberg wrote to Picasso soliciting his participation, Austin had made contact with the man who could deliver the loans he wanted. With great rapidity, the exhibition then took shape. The opening phrase of Rosenberg's request to Picasso indicates his awareness of Wildenstein's earlier support for the show; yet, despite his tardy entry, Rosenberg soon became the chief contributor. On December 19, Austin cited Rosenberg's participation as cause for the Dales to lend: "Mr. Rosenberg has very kindly agreed to let us have some of his most important pictures and I am writing to ask whether you would be willing to cooperate with us and lend some

examples from your very fine collection . . . I should be most grateful to include the large 'Mountebank Family' and the 'Bateleur à la Nature Morte.' " When Mrs. Dale turned down his request on the grounds that these pictures were too big to travel and offered instead only a small *Classical Head*, Austin refused without pursuing the matter further, thereby missing the chance to borrow any of the other pictures in the collection or to build his ties with this eminent couple.[59]

Presumably at Rosenberg's suggestion, Austin also cabled Paul Guillaume to request the loan of *Woman with a Crow* and *Woman in Yellow*. Apparently thinking that he was dealing with an unsophisticated provincial, Guillaume peremptorily replied: "WITH PLEASURE ONLY NO FRENCH DEALER OR COLLECTOR GIVE MORE THAN TWO PICTURES." Since Austin depended on Wildenstein and Rosenberg, this condition was impossible. Guillaume withdrew, protecting his image: "SINCERELY SORRY NOT COLLABORATE BUT COULD NOT ONLY CONTRIBUTE AS YOU MUST UNDERSTAND NECESSITY PROTECT REPUTATION OF THE LARGEST COLLECTION IN PARIS."[60] As the agent of Albert Barnes (who, of course, also did not lend to the show), Guillaume was a major player in the market for Picasso's early works, but his claim to preeminence was vastly overblown. Having failed to sign Picasso during the war, he had never managed to challenge the alliance with Rosenberg.

On December 21, Rosenberg traveled to Hartford to see the new building and discuss the upcoming show. To the *Hartford Times*, the visit was important news; the paper lauded him as the "owner of the most important Picasso collection in the world."[61] Just before returning to France, Rosenberg sent Austin a list of the works he had agreed to lend. Besides sixteen of his own pictures, he included loans from private collections in America and France that he was arranging.

He had spent his time in New York not only beating the bushes for the Louvre's Daumier show but also promoting the Atheneum's bill. Austin followed up the leads he suggested, writing to Earle Horter, a Philadelphia collector who owned fifteen Picassos, saying, "Mr. Rosenberg has informed me that possibly you would be willing to lend some of your paintings and drawings to our exhibition . . . ," and to a New York collector named F. Ohwald, "I am very anxious to include your beautiful Abstraction about which Paul Rosenberg is so enthusiastic."[62] Neither lent; Horter was forced to refuse because he had already

agreed to display his collection at the Philadelphia Museum in the hope of selling it to them.[63]

Rosenberg's crucial role in the selection of the show is best demonstrated by a letter from Sidney Janis: "Mr. Rosenberg was over and informed me that you were too busy to drop in and see my Picassos, but that you were definitely interested in having 'Vive La' for the show . . . I suppose Mr. Rosenberg has informed you that I now own the large 'Atelier,' 1928, which you are including in the show . . . If you think you would be interested in seeing my other Picassos, will you please arrange to do so at once."[64] Apparently, Austin did find time to visit him and took two more pictures, another still life of 1914 and a *Seated Figure* of 1927.

In addition to the American loans, Rosenberg pursued European collectors on his return to Paris. By the time the *Ile de France* sailed for New York with his pictures on January 24, he was able to include seven other paintings: two from Madame Errazuriz, three from Baron Fukushima, and two from Baron Gourgaud (whose wife, Eva Gebhardt, was American).[65] Given the short notice, it is not surprising that all the European loans came from Paris, but this certainly limited the comprehensiveness of the exhibition. For example, none of Reber's more than seventy Picassos could be brought from Switzerland. Still, Rosenberg's extensive loans from his own stock partially overcame the difficulty. He sent nineteen of his own pictures, several of which usually hung in his private apartment. As he lamented to Austin, "All my dining room is spoiled as those fine paintings are taken from the walls, but it is worth to please you." His own pictures constituted a quarter of the seventy-eight paintings in the show; when his other Parisian loans are combined with the pictures he scouted in New York, he probably provided close to half the paintings in the exhibition. No wonder Austin thanked him so prominently.

Rosenberg performed yet another service for Austin, one of even greater symbolic importance than his yeoman duty in assembling so many pictures. To validate the show and generate publicity, Austin thought it critical for Picasso to loan part of his private collection. He listed Picasso first among the contributors and headed the press release with the statement that "Picasso himself lending several important pictures, some of recent date." Yet, there is no evidence Austin had any direct contact with him; moreover, his statement to the press

proved to be exaggerated. Austin depended entirely on the mediation of dealers, Wildenstein and then Rosenberg, to secure Picasso's participation. It was not readily forthcoming. Rosenberg emphasized his role in the difficult negotiation (and protected his franchise) when he wrote to Austin on January 17: "I know, that *of my recommendation*, Picasso has lent three paintings." Although a minor contribution compared to what he gave the Petit and Zurich shows, these pictures, apparently all small Neoclassical works of the early 1920s, demonstrated Picasso's goodwill.[66] They had to suffice, because at the last minute Picasso withdrew the group of his "recent" work that the Atheneum's press release had trumpeted.

Only two days before the *Ile de France* was to set sail, Rosenberg wired Austin the unfortunate news: "SORRY PICASSO RETRACTS PAINTINGS REMAIN HIS PROPERTY DON'T MENTION MY NAME." The next day, he tried to mitigate the disaster by telling Austin that some works that had been catalogued as Picasso's property were actually his own: "THREE PAINTINGS LENT BY PICASSO WOMAN BEFORE MIRROR TULIPS AND BUST WOMAN SEATING ARE DEFINITELY MY PROPERTY MENTION MY NAME IN CATALOGUE."[67] As it turned out, these paintings of 1932 were the only recent works to appear in the exhibition.

Despite Austin's promotion of his show as "the first American retrospective exhibition of Picasso" and the urging of both Wildenstein and Rosenberg that it would benefit his reputation as well as his market, Picasso remained unconvinced of its importance. In his increasing seclusion at Boisgeloup, isolated not only from America but even from the Parisian society he had long frequented, he seems not to have been impressed by events transpiring in the city of Hartford, "near Boston" as Paul had told him. Oddly enough, Gertrude Stein also refused to lend her extensive collection of Cubist works. Perhaps she was less willing than Rosenberg was to have her walls bare; yet, considering that the Atheneum was staging her opera as part of the inaugural program, one would have expected more cooperation. The fact that Picasso and Stein were no longer close could be significant. She may have had no desire to contribute to his acclaim in America, especially when it might upstage her own success.

Rosenberg's cables suggest that he simply bought Picasso's three recent paintings, thereby ensuring their inclusion in the show. Austin, however, did not comply with his request to mention his name in the

catalogue. Perhaps the wire arrived after the catalogue had gone to press; whatever the case, the paintings (numbers 70–72) appeared as "Collection of Pablo Picasso." Rosenberg was still not eager to make the speculative purchases he had made in the twenties, but with these three paintings (one of which—*Girl Before a Mirror*—the Modern would acquire four years later for $10,000) he couldn't go wrong.

Even if the exhibition did not include any truly contemporary work, this triad of paintings formed a suitable finale for what was an impressive, if somewhat unbalanced, retrospective. More than the Petit and Zurich exhibitions, the Atheneum's show reflected a conception of Picasso's career that was shaped by two primary forces: the popular appeal of his early work and a promotion of his art during the Paul Rosenberg years that virtually ignored the first decade of Cubism. Given Austin's limited knowledge and the role of Picasso's dealers in organizing the exhibition, such an emphasis is understandable. Indeed, Austin's willingness to serve largely as a figurehead is suggested by the fact that the only text in the catalogue that might be construed as critical is a quote from La Fontaine's fables that appears as the epigraph: "Familiarity in this existence makes all things tame: for what may seem terrible and bizarre, when once our eyes have had time to acclimatize, becomes quite commonplace." It had been suggested to Austin by Rosenberg, who wrote that he thought it suited Picasso very well.[68]

If the Georges Petit exhibition had been the consummate opportunity for Picasso and his dealers to present their view of his career, the Atheneum show was a reprise in a minor key. Almost a quarter of the paintings were drawn from 1895 to 1906, with nearly half of these representing the extremely popular two years of the Rose period (1905–06). Their presence was facilitated by Wildenstein and an associate, Josef Stransky, who had developed a specialty in these pictures to serve the American market. Among the most impressive works in this group were the *Toilette* (lent by the Albright-Knox Museum) and the remarkable *Self-Portrait* of 1906. The latter was the single contribution of Albert Gallatin, the creator of the Museum of Living Art at New York University, who had skipped the earlier European shows because he preferred to keep his collection on view in New York.[69]

By comparison, the Cubist years of 1907–18 were seriously underrepresented. These twelve years of incredible fecundity were glossed

with only eleven works—none of them outstanding until the period of the war, for which Madame Errazuriz's familiar *Portrait of a Young Girl* (1914), her *Man with a Pipe* (1916), and Wildenstein's *Italian Woman* (1917) provided three major examples of the emerging shift from Cubism to Neoclassical styles. In contrast to this period, the final fourteen years of Picasso's oeuvre, beginning with Paul Rosenberg's arrival in 1918 and running through 1932, were represented by four times as many works.

These forty-four paintings (half of them provided by Rosenberg) were fairly evenly distributed across the period, except for a concentration of twenty works from 1923 to 1925 that repeated the structure of the Petit show. The early postwar years were well represented by a huge version of the *Open Window* series, Neoclassical paintings from Picasso's own collection, and some that had once belonged to John Quinn, as well as the version of *Three Musicians* that Rosenberg retained. The Atheneum's one Picasso painting, the small *Female Nude* of 1922, also appeared in this section. Unfortunately, the show did not inspire the museum's patrons to acquire additional, and more significant, Picassos.

Despite its limitations, the Atheneum's show was a major achievement. Not only did it present the most comprehensive survey of Picasso's work yet seen in America (including a section of sixty drawings and prints I have not discussed), it successfully garnered widespread publicity for the museum, the dealers, and Picasso.

Thanking Rosenberg for his assistance, Austin wrote that "there were twenty-one thousand people who saw the pictures," and he acknowledged "how much the Trustees and I appreciate your great generosity in helping us so magnificently to arrange our Picasso exhibition."[70] Unlike most such letters, this one was not polite hyperbole. For his part, Rosenberg sent congratulations "for the tremendous success you had," avowing that "I shall always be very proud to have been of certain utility to you, and you can be sure that I shall always help you with my feeble means." Indeed, he envisioned future relations between the museum and his gallery ranging across the spectrum of activities, from exhibitions to acquisitions. He went on to ask whether he and Austin could meet to discuss a Renoir the Atheneum was considering for purchase, and he passed on the news that Soby had not responded to his letter regarding the large *Open Window* that had

appeared in the exhibition and that, presumably, Soby had discussed buying.[71]

Both Rosenberg and the Atheneum staff understood the commercial and aesthetic link that joined them and underlay their activities, whether in a private gallery or in the ostensibly cloistered setting of a public museum. Rosenberg now presented a new variation on the theme. Immediately following the Atheneum exhibition, he opened a show in New York that included several of the paintings that had hung on the Atheneum's walls. But he supplemented them with paintings by Matisse and Braque, thereby presenting a phalanx of the three most prominent contemporary artists in France. Since his partnership with Wildenstein had ended, he presented the show in the local branch of Durand-Ruel, where he had just staged an exhibition of nineteenth-century French art.

DURAND-RUEL, NEW YORK

Henry McBride called Rosenberg's exhibition "the finest collection of modern art yet to be seen in America."[72] His praise was probably not exaggerated. Besides twenty-three Picassos, the show presented thirteen paintings by Braque and ten by Matisse. Including such major works from the Atheneum show as *La Coiffure* (1906), *Portrait of a Young Girl* (1914), *Three Musicians* (1921), *The Reply* (1923), and *The Red Table Cloth* (1924), it also showcased nine of his truly recent works. During 1933, Picasso had completed few paintings, but he had made a series of watercolors and gouaches that challenged the pre-eminence of oil painting in his oeuvre. Depicting the sculptor in his studio with models and classical busts, the series extends the still lifes of the mid-twenties, such as *The Red Table Cloth*, by infusing them with a Surrealist disorientation. First exhibited in this New York show, the group ranged from the highly finished *Sculptor, His Work, and His Model* to the loosely washed *Sculpture and Boat on the Seashore*.[73]

The display of Picasso's work began with 1901 and meandered through his career to the final gathering of 1933. The Matisses, however, were confined to the ten years from 1915 to 1924; nonetheless, they included *Plaster Torso* (1919), *Artist and Model* (1918–19), and *Interior* (1923).[74] For Braque's first substantial appearance in New York

since the Armory Show of 1913, Paul chose work from 1927 to 1931. The most impressive of these paintings was the great *Gueridon*, which Duncan Phillips acquired the following June by trading Rosenberg two paintings jointly valued at $20,000.[75] *Art News*—already established as the most widely circulating art magazine in America—had reproduced it on the cover of the March 17 issue. The choice may have been influenced by the fact that Rosenberg had for many months advertised his stock on the journal's back cover, but the picture's quality made its selection well deserved.

The varied presentation of the artists' work reflects their relationships with Rosenberg. Picasso's survey coincides with his many years with the dealer and the emphases of the Atheneum show. On the other hand, Braque had more recently joined the gallery (his first show with Rosenberg had been in 1924), and Matisse would not sign his first contract with him until 1936 (leaving Rosenberg dependent on the secondary market for acquisitions).

As he had done during his visit to America for the 1923 exhibitions, Rosenberg sent Picasso a lengthy report. He enclosed McBride's review and even drew a plan of the gallery to show the location of each work.[76] Far from a cursory letter of congratulations, his account was a detailed analysis of the latest campaign. Yet this time Paul's pleasure was laced with resentment. After rebuking Picasso for not having kept him informed of activities in France, he described the arrangement of the pictures: "When I had hung them, I found exactly what I had expected—that on the maroon background I had ordered for the wall, they looked superb and of a formidable resonance and exquisite freshness." The maroon cloth immediately established an environment that contrasted with the austerity of the Avery Memorial's white-painted partitions.

With plan in hand, Paul described his provisional hangings until he arrived at the final arrangement of the pictures. Entering the gallery, visitors passed through a hall hung with Picasso's five watercolors and gouaches of 1933. From there, the room opened to reveal the distant wall hung with three of the major Picassos—*Three Musicians* centered between *Still Life with Biscuits* and *Still Life with the Head of a Sheep*.[77] "One saw the *Three Musicians* from afar," Rosenberg reported, "and it made a majestic effect, like in the exhibition of 1926." Not only the sheer number but also the primary positions of the Pi-

cassos made them the heart of the exhibition. Rosenberg even went so far as to claim that the Durand-Ruel exhibition was superior to the Atheneum's, and he lamented that he had not presented a solo exhibition: "that would have been magnificent for me, but perhaps not for the public. That will be for another time, and that took place at Hartford; yet I think by being more reductive my exhibition had a greater impact and was more expressive."

According to Rosenberg, "the public was divided":

> I turned left and right saying what one can in five minutes, because I was immediately encircled as in the Louvre. *Art News* reproduced eight paintings and published an article with the catalogue of the exhibition and the dates. The catalogue is sold for 25 cents, which means 6F 25 to us. We have sold seventy-two per day! The articles are lukewarm, except McBride . . . The others are descriptive, and the one by Royal Cortissoz, whose interest stops at Corot, is an open attack. But that doesn't matter at all, and yesterday 304 people, having paid 6F 25, came to see the show, even though it was St. Patrick's Day, and 200 of them in costume stood in line fifty meters down the street from Durand-Ruel.

It must have been fascinating to see these costumed revelers confront the Harlequin, Pierrot, and Monk of *Three Musicians*.

Rosenberg had no illusions about a quick payoff: "I think that this exhibition will do a great deal of good because it puts before the public's eyes an exhibition that is new to them, about which they have heard but never seen. They must be passionately impressed, and some of the most experienced and prescient amateurs could not refrain from saying that it is the most beautiful exhibition ever mounted. The public has realized that it is alive, and more alive than ever." Taking the long view, as he had after the disappointing results of the 1923 tour, Paul concluded with reassurance: "You see that even though I am blasé and the crisis was disastrous, I have kept my word and the hope of better times to come."

McBride's assessment of the exhibition confirmed that Rosenberg's claims were not overblown. "It is too bad that the times are what they are," McBride had written, "for under happier conditions this series of pictures might have been swept en bloc into our modern museum."

Of course, he meant the Museum of Modern Art. In 1934, the Modern owned only four Picassos. One, a gouache entitled *Head* (1909), had been donated by Saidie May in 1930 and lent by the museum to the Atheneum's retrospective. The three others were paintings: *Seated Woman* (1926–27), bought from the artist in 1932 (presumably after the museum's plans for an exhibition were canceled), as well as *Green Still Life* (1914) and *Woman in White* (1923), both part of the Lillie P. Bliss bequest (*Woman in White* is now in the collection of the Metropolitan Museum of Art). The issue of *Art News* that carried the laudatory article reported that the Modern had just announced the acquisition of the Bliss collection, so these last two paintings were not yet officially a part of the museum's holdings. Nor were Matisse and Braque any better represented.

As Barr built what would become the finest collection of Picasso's work in the world (and one of the best representations of Matisse and Braque as well), he searched the market for desirable paintings. At times dealers abetted his goals, and at other times they hindered him, as they had over his plans for an exhibition three years earlier. In the summer of 1934, the negotiations and intrigue focused on *Three Musicians*, both the version that had been the centerpiece of Paul's exhibition and the version that he had sold to Reber in the late 1920s.

Reber was now bankrupt, and his large collection was either on the market or held as collateral for his debts. In 1934, Jim Ede, a curator at the Tate Gallery in London, explained the situation to Barr in a *"very confidential"* report: "I've now got all the dope on Dr. R . . . He shelters mostly now behind Rosenberg, but really deals with any dealer from Paris who has some root in Lucerne and for good reasons nearly all the Paris dealers have bureaus in Lucerne."[78] The collapse of worldwide financial markets had hit the wealthy enclaves of Switzerland hard enough to shake loose a great deal of art, and the dealers were rushing in to broker sales, secure stock, and reassure their artists about the future of the market.

In the case of Reber, Rosenberg's primary client for contemporary art in the boom of the late twenties, the situation was desperate. As Ede discreetly advised: "I believe that everything he has is for sale— he quotes (to his agents) *enormous* prices but is, I think, prepared to consider no matter what price. It is best to buy in Lausanne where there isn't so much bluff. The 'Three Musicians' Picasso is in his

house—suggested price go to 100,000 francs (french). I can get a friend of mine to negotiate. He lives in Lausanne and is OK—P.P.S.—Now don't give me away! It would be disastrous—I've got all this dope almost out of his house."

As the dismal thirties dragged on into the forties, Reber's continuing financial distress would lead him to offer his services to Hermann Göring and abet the Nazis' voracious search for culture, but in 1934 Reber himself was the subject of intrigue. Barr immediately took up the trail, hoping to entice one of his most acquisitive trustees, Stephen Clark: "I think you should know that I have confidential information that the Three Musicians or Three Masks by Picasso, 1921, formerly in the Reber collection, is now apparently in the possession of a bank following Reber's recent collapse on the Paris bourse. The friend who gave me this information tells me he thinks 80,000–100,000 francs French would take the picture. This would be an astonishing bargain, perhaps less than one-quarter of Rosenberg's lowest price for his version which is about the same size."[79]

Now that both versions were available, Barr struggled to decide which one to pursue. He had to evaluate both aesthetic merit and commercial value. After some hesitation, Barr concluded: "I think I prefer Rosenberg's by a little bit though Reber's is richer and more complex and is the later and therefore presumably the finer version." Nonetheless, he chose to push Clark to purchase the "astonishing bargain"—Reber's picture. "I wish I could talk with you for I feel I might have a chance of persuading you to make a bid for this painting as a gift to the Museum. I feel it is really one of the greatest twentieth century paintings, a picture which would distinguish our collection and above all would remove immediately the stigma of our not being sufficiently modern." Although the Bliss bequest had greatly expanded the museum's coverage of Post-Impressionism, the director was sensitive to its paucity of major twentieth-century works. Under these conditions, he made an aesthetic compromise by recommending the version of Three Musicians that he judged inferior. Presumably, he believed its price made it a real possibility for the Modern.

As is often true, the trustee was better informed about the market than the director was, and Clark was unwilling to act on Barr's advice. On July 18, he dashed Barr's hopes: "I am sorry to say . . . that, owing

to the financial situation, it will not be possible for me to purchase the Picasso and give it to the Museum. I have given up all idea of purchasing this picture or the version belonging to Rosenberg, although he has been pestering me to do so, and has greatly reduced his price."[80] Clearly, Rosenberg had continued to pursue potential buyers in the aftermath of the Atheneum retrospective and his own exhibition at Durand-Ruel. Knowing that purchasing power lay with private collectors rather than with institutions, he had bypassed Barr. Somewhat gruffly, Clark used the occasion to inform the director of his ignorance.

Shrugging off the rebuke, Barr persisted in his efforts to acquire a version of the painting. Since Rosenberg had left his in New York in the hope of selling it there, Barr borrowed it. He positioned it as the centerpiece of his major fall show, *Modern Works of Art: Fifth Anniversary Exhibition*, thereby prospecting for another donor. In the catalogue, Barr even described the painting as Picasso's "greatest cubist composition."[81] Yet the Modern's eventual acquisition of this version (rather than Reber's) is dependent more on the vagaries of the marketplace than on the aesthetic preferences of its director.

Throughout 1935 and 1936, Barr continued to campaign for Reber's painting. Having negotiated a price of $10,000, however, he could at first raise only $4,800. By the fall of 1936, just as he had finally succeeded in gathering the necessary funds, the painting was purchased by Albert Gallatin (in partnership with the painter and collector George L. K. Morris). Gallatin trumpeted his acquisition to the press and placed the picture on exhibition at his Museum of Living Art. Barr wrote to congratulate him but could not repress his frustration: "I am delighted that this great painting has finally been acquired for a New York public collection. I won't conceal a slight tinge of bitterness . . . it must be at least three or four years since we had luncheon together and I told you of my great desire to purchase this painting for the Museum . . . The Museum's failure . . . is the worst disappointment I have had in seven years as director."[82]

If Barr had indeed brought the painting to Gallatin's attention, then he had good reason to feel resentful. It would be thirteen years before he acquired Rosenberg's version for the Modern. According to Barr, he could have purchased it in 1936 for $20,000. In 1949, it must have cost the museum far more.[83]

GALERIE PAUL ROSENBERG

As the art market slowly began to regain vitality, Rosenberg staged a show of Picasso's recent work in his gallery during March 1936. This was Picasso's first exhibition in Paris since the Petit retrospective of 1932, and the new art reflected the upheavals that had governed his life during the intervening years. As if to acknowledge that the Petit retrospective certified his transition from the bohemian he had once seemed to be to the worldly master he had long been, two reminiscences of his life in the Bateau Lavoir had appeared in 1933—Gertrude Stein's *Autobiography of Alice B. Toklas* and Fernande Olivier's *Picasso et ses amis*. Yet they had not been received as accounts of a distant and benign past; for both Picasso and Koklova, they were impertinent intrusions, especially Olivier's book. Although Koklova was offended by Stein's account of Picasso's unconventional early life, particularly his romantic liaisons, it was Olivier's memoir that caused the real problem. To appease his wife, Picasso sought to prevent the book from being published. When it appeared nevertheless, she blamed him.[84] But Picasso had his own reasons for trying to suppress the book.

The few monographs that had appeared in the 1920s had not carried the weight of either Stein's or Olivier's account.[85] As one of Picasso's earliest patrons and a respected writer, Stein possessed the stature to offer an authoritative interpretation of Cubism. As Picasso's lover during more or less the same years, Olivier, on the other hand, could provide the intimate record of his personal life. Koklova did not wish to be reminded of her predecessors, but Picasso also found reason to oppose Fernande's book: he did not want to lose control of his public image. As Pierre Daix writes, "The publication of Fernande's memoir drove Olga to distraction, while he himself found little to appreciate in a maneuver by his former companion which made her some money at his expense. But above all he felt that his private life belonged to him, and that included whatever transpired between him and his women. His love affairs were, if he chose, inspirational sources for his work. They did not belong to anyone else. He resented the book's publication (he told me that he had 'never read it') as an intolerable intrusion and a betrayal of his confidence."[86]

The distinction Picasso made is crucial but hypocritical. His constant mining of his intimate life to enrich his art had resulted only a

few years earlier in the great series of paintings depicting his mistress Marie-Thérèse Walter. The sheer size of these canvases and their frequent subject of a seated woman recall his paintings of the early and middle twenties and continue his dialogue with the tradition of Western figure painting. Yet these images of Walter combine this public address with a revelation of sensuality and sexual desire that had not occurred in past paintings of this nature. Since it appears likely that Picasso created the pictures of late 1931 and early 1932 specifically for display in his upcoming retrospective at the Petit, their revelatory goal becomes even more apparent. It continued to characterize his work through the mid-thirties, even though his relationship with Walter remained secret.

Picasso's willingness to present these intimate moments for public consumption was probably stimulated by his continuing sympathy with the Surrealists' efforts to foreground the unconscious, but it also depended on his ability to prevent intrusions on his personal life. While Breton rightly acclaimed Picasso's exposition of his private imagination "dans son élément" (the "élément" being his studio), Picasso used his great wealth, his cosseted position with Paul Rosenberg, and his seigneurial sanctuary at Boisgeloup to regulate access rigorously.[87]

Olivier's memoir disclosed less intimate material than did his paintings of Walter, but it was infuriating nonetheless, because it lay beyond his control. Moreover, it was relevant not only to his past life but also to his current behavior. Not long after its public exposure of Picasso's relationship with Olivier, Walter gave birth to a daughter by him, Maya. Koklova moved into the Hôtel Californie in June 1935 and took their son, Paulo, with her.

Picasso described the ensuing period as "the worst time in my life."[88] To reestablish some domestic order, he asked an old friend, Jaime Sabartès, to become his secretary. Beginning with his arrival in November, Sabartès recorded an intimate though worshipful account of these tumultuous months. Not only had Picasso's household been completely disrupted, but the likelihood of a divorce was threatening his art as well. His private collection would be the primary subject of a settlement, and its division would separate him from many of the objects he doted on with superstitious obsession. Instead of sketching the comfortable salons of the rue La Boétie apartment, as he had during his early years there, he now shut himself in his bedroom and

almost ceased to draw or paint. Only Sabartès and a few other trusted friends were allowed to visit during this period of near-isolation in the heart of Paris.

According to Sabartès, Picasso attempted to strip his life of its embellishments and return to an austerity that recalled the early experiences they had shared:

> Picasso was endeavoring to recapture the simplicity of our life as young men, despite the manifold and profound changes in us and around us. He wanted to return to a bygone period in our lives; he neither painted nor sketched and never went up to his studio except when it was absolutely necessary, and even then he put it off from day to day, no matter how urgent. In order to occupy his imagination, he wrote—with a pen if he found one handy, or a small stub of pencil—in a little notebook which he carried about with him in his pocket. He wrote everywhere.[89]

For Paul Rosenberg, Picasso's curtailed production was only one of the problems that strained their association. The relationship had begun in the weeks after Picasso's marriage, and Koklova had relished the life Rosenberg had fostered on the rue La Boétie. As the couple's marriage became increasingly troubled, Rosenberg had maintained a balance between, on the one hand, his personal admiration for and professional alliance with Picasso and, on the other, his (as well as his wife's) cordial friendship with Koklova. Thus the official breakup of the marriage placed the Rosenbergs in a difficult position.

It was particularly hard for Rosenberg because his role as Picasso's dealer made him a party to the extremely complicated separation negotiations. A note to Picasso dated November 20, 1935, suggests the desperation they all felt during those troubled months. "From Boisgeloup the notary will take us in the Hispano (there is nothing, nothing else to do) . . ." Besides lending moral support, Rosenberg's most onerous task was to prepare an inventory of Picasso's work so that this vast chunk of their community property could be settled. Picasso, who abhorred the idea of having his work split up, must have alternated between helping and hindering Rosenberg's efforts. No doubt Rosenberg had his own reasons to discourage the process, as he was apprehensive about losing control of half of the pictures and possibly

flooding the market, especially during those recessionary years. In January 1936, he warned Picasso: "As each day we get closer to the end of the inventory, you put yourself and you put me in a delicate position. You understand very well that I had no more desire than you did to accomplish this work, that I accepted out of pure friendship. My report is almost ready."[90] Luckily for both of them, Picasso convinced Koklova not to seek a formal divorce and a division of the property.[91]

Rosenberg pursued his public promotion of Picasso with customary energy. Given the somewhat accusatory tone of his comments on the inventory, one might expect that their professional relationship was strained, but he immediately shrugged off any difficulties to plunge into plans for an exhibition: "we must know yes, or no, whether you agree to do it. It is announced, and in case you plan to change your mind, you must give me sufficient notice to organize another to replace it."[92] Under the present conditions Picasso may well have hesitated. Having produced relatively few paintings since 1932, he must have felt uneasy about displaying the work. Nevertheless, the exhibition of "oeuvres récentes" opened at Paul's gallery on March 3, 1936 (figs. 73, 74).

The twenty-nine paintings and drawings did not manifest the consistency evident in Picasso's previous appearances. It began with a still life of 1931 and continued with twelve paintings of 1932. These included several of the pictures that had been fresh works in the Petit exhibition, such as *Nude on a Black Couch*, *The Dream*, and *Girl Before a Mirror* (figs. 75, 76, 77). Since Rosenberg had not held a Picasso exhibition since 1926—nor, apparently, even included a large number of his works in a group show since 1931—these pictures might be called recent, but certainly not current. There was no painting or drawing from 1933, the year the memoirs of Gertrude Stein and Fernande Olivier had appeared. To represent 1934, however, Picasso and Rosenberg marshaled a fine group of four large oils (including *Woman Reading*), five small oils (including three paintings of bullfights), and seven watercolors or gouaches (several of which had been shown two years before at Durand-Ruel in New York).[93] Yet, considering that there were no works from 1935, the overall exhibition was both spotty in its chronological coverage and unusual in the emphasis placed on drawings to represent his work. Since the pictures were not hung chronologically, these inconsistencies were not as apparent as they might have

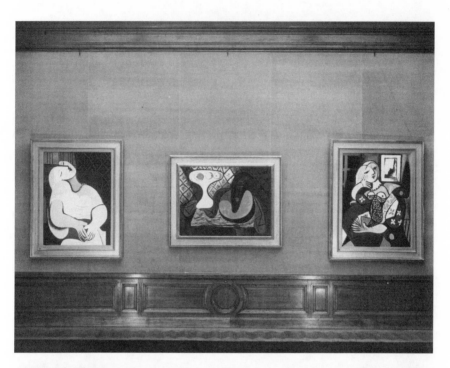

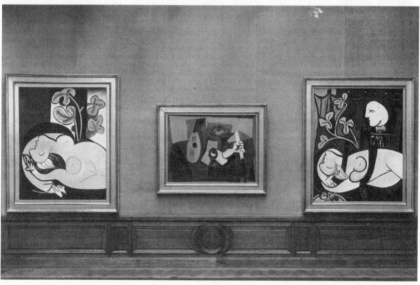

73, 74. Galerie Paul Rosenberg, *Exposition d'oeuvres récentes de Picasso*,
March 1936 (Courtesy of Paul Rosenberg & Co., New York)

75. Picasso, *Nude on a Black Couch*, 1932
(Private collection, San Francisco)

been, but there is little doubt that the irregularities of the show—particularly the complete absence of work from 1935, the year of his separation from Koklova and of Maya's birth—reflect the disruptions of Picasso's last few years.

Sabartès's account of the exhibition, his first as a member of Picasso's household, contains no hint of these complications. Not surpris-

76. Picasso, *The Dream*, 1932
(Mrs. Victor Ganz, New York)

ingly, it is entirely flattering. For all his biases, however, his rendition does capture many of the contrasts and contradictions that characterized Picasso's life. Sabartès begins by commenting on the exhibition's popular success:

77. Picasso, *Girl Before a Mirror*, 1932
(Museum of Modern Art, New York)

From the first day the crowds were huge. Many of the big canvases were of very bright colors arranged in broad, precise blocks, so that each color played its role independently, and together the pictures imparted such an impression of light that if they did not illuminate the room, they evidently inflamed the spirit. The room seemed to be of much vaster dimensions and the pictures resembled windows aglow with images of cut glass. Emotion gripped the spirit of the visitor who at first preferred to be alone to contemplate the pictures leisurely, and then to be in company in order to exchange impressions.[94]

To those unfamiliar with Picasso's work, the scale and color of the 1932 paintings may well have created a fresh, joyful effect, and the first Picasso show in ten years did excite the Parisian audience.

In the midst of this success, Sabartès gives a rare description of Rosenberg working the opening: "Rosenberg, exuberant, danced about from group to group shaking hands, listening to questions, taking care of everybody and giving constant orders to his assistants. There were so many people that at first one could not locate even a known face. But before long I recognized Braque, Kahnweiler, Colle, Pierre Loeb and many others. As for Picasso, he was only to be seen in the work exhibited." Apparently, Picasso once again skipped the vernissage, preferring to leave such public events to his dealer. But he was far from isolated: "[B]ecause of [the exhibition's] importance, the stir that it made, and its nearness, there was an extraordinary parade of visitors to Picasso's house. Generally he was not in." One of the lucky admirers was Douglas Cooper, who over the next decades would assemble one of the finest collections of Cubist art and write several important books on it. As Sabartès recounts it, Cooper had already mastered the flattery required to charm the gatekeeper and gain access to the master:

On the ninth, in the afternoon, it was Cooper's turn. He said he had attended the exhibition every day, and had bought a still life of very mellow tones, with a glass vase and some flowers in it, a basket of fruit on the right and a goblet on the left . . . The fact that he had chosen the picture I liked best won him my sympathy. Since Picasso was not in, I asked him to write down a message for him: "I could not help coming up here to tell you how much I enjoyed your ex-

hibition. It was really magnificent. One is happy for a whole week after seeing it."

This is what one of the richest and brightest scholars of modern art was reduced to by the aura surrounding Picasso. Even Kahnweiler, who was maneuvering to regain his past prominence in Picasso's circle, is reported by Sabartès to have called the exhibition "Michelangesque! Michelangesque!"

Presumably Picasso perceived the hyperbole and, at least in part, avoided his fans to insulate himself from it. But he did join the crowds now and then, and, even when apparently secluded, he wanted to know what people were saying. In the privacy of his bedroom, Picasso would spread out the clippings sent by his agency and discuss the reviews with Sabartès. When he visited the exhibition, he was over-whelmed with obsequious praise. He told Sabartès that one of those who now acclaimed the show as "marvelous, simply marvelous" had condemned the very same pictures ten months before, when he saw them during a private visit to Boisgeloup: "He was scandalized . . . he thought these pictures were decadent and unhealthy; that this way of painting showed signs of exhaustion—it was deplorable." Even now, after decades of dealing with collectors and critics, Picasso was still subject to their exaggerations, both of praise and criticism. In response to their fickleness, Picasso told Sabartès, "So you see! But what does it matter? Everybody is like that. I'm going away." Yet, instead of truly ignoring the public response, Picasso ordered Sabartès to stay in Paris: "For the time being I prefer you to remain. You'll keep me posted on what goes on, and I'll be satisfied." Clearly Picasso found it easier to play his role from afar.

During the two years following the exhibition, Rosenberg still did not make the large annual purchases that had been customary throughout the twenties. He bought five or ten pictures a year, only enough to cover Picasso's basic expenses. But in November 1938 he made an investment on the scale of his early purchases: he bought thirty-six paintings. As in the past, the massive acquisition anticipated an exhibition he was planning; it opened on January 17, 1939. It would be their last substantial venture in the commercial arena.

Held at Rosenberg's gallery, it presented thirty-three of the thirty-six paintings he had just purchased. All were still lifes, and most of

78. Galerie Paul Rosenberg, *Exposition Picasso (Oeuvres Récentes)*, January–
February 1939 (Courtesy of Paul Rosenberg & Co., New York)

them dated from 1937, although both 1936 and 1938 were also rep-
resented. According to Sabartès, Picasso had painted them in the
countryside, "breathing pure air, free from extraneous worries"; they
"were a kind of narrative of the intimate life of the man in terms of
familiar objects, of what he ate and drank, and loved to keep before
his eyes and could not part with. These cups, plates, casseroles, pots,
pans, knives, forks and spoons were the only utensils capable of har-
monizing with the fishes, flowers, fruits, and pies characteristic of this
atmosphere."[95] Although most of the paintings in the show did portray
these domestic objects, not all were so banal. The centerpiece, the
picture that anchored the long wall of the main salon, rejected the
quotidien. Painted in April 1937, *Bust of a Minotaur in Front of a
Window* places the mythological figure in a table setting much like
those in the other pictures (fig. 78).[96] It evokes Picasso's long-standing
fascination with a creature admired by the Surrealists and important
for the *Guernica* mural that he painted in the weeks following its com-
pletion. It suggests that Picasso may not have been so carefree as Sa-
bartès and others thought.

News of Rosenberg's exhibition quickly traveled beyond Paris. Meric
Callery, an American collector living in Paris, sent Barr a report that
countered Sabartès's worshipful account: "R's present show of Picasso
is surprising in that it is so pretty, colorful and gay. They have had
over 600 people per day to see it. Rosie is in a state of great excitement,

it is as though the pictures were painted specifically to his taste! Anyhow it is a lesson in color and composition to Matisse and Braque but hardly a satisfaction to us who admire Picasso for a quite different quality."[97] Perhaps Callery was truly surprised by the show's effect in a city enduring a bleak winter and rumors that spring might bring war, but her patronizing attitude toward Picasso's work and Rosenberg's delight should prompt skepticism. Her eagerness to ingratiate herself with Barr would prove useful, though, as her position on the periphery of Picasso's circle made her a valuable aide.

THE MUSEUM OF MODERN ART RETROSPECTIVE

During the seven years since his failed attempt to organize a Picasso retrospective at the Museum of Modern Art, Barr had strengthened his institution to the point that he could now resurrect his goal of presenting an exhibition devoted to the work of "the greatest living artist."[98] The museum's permanent collection of Picasso's work had grown by only three paintings, yet these were of such importance that it ranked first among museum collections of his art.

In 1935, Barr had welcomed Walter Chrysler's donation of *The Studio* (1927–28), the most austere of Picasso's meditations on the activities of the atelier. Three years later, an even more exceptional event had occurred. Thanks to the unexpected generosity of Mrs. Simon Guggenheim, Barr had been given an opportunity to exercise his curatorial choice by outright purchase rather than through the more passive process of accepting works donated from existing collections. Mrs. Guggenheim had offered to buy a major work chosen at the discretion of the director. For once freed of even the need to build a coalition of donors and satisfy their tastes as well as the needs of the museum, Barr made a bold choice. He selected Picasso's *Girl Before a Mirror*, which Mrs. Guggenheim dutifully purchased from Paul Rosenberg for $10,000, even though she did not initially like it.[99] Even though the painting had been featured in both the Petit and the Atheneum retrospectives, its recent vintage made it controversial. Its selection would probably not have been possible without Mrs. Guggenheim's largesse (the first of many such acts), and its inclusion in the museum's holdings enabled Barr not only to enlarge his representation of Picasso's work

but also to highlight his goal of opening the collection to contemporary art.

The truly landmark purchase of these years, indeed probably the most important single acquisition ever made by the Modern, was *Les Demoiselles d'Avignon*.[100] Having pried the painting away from Jacques Doucet's widow, the firm of Seligmann had shipped it across the Atlantic. Given the political uncertainty in Europe, the economic resurgence of America, and the rising popularity of modern art there, New York was the most likely home for the painting already acknowledged as the chief icon of the twentieth-century avant-garde. Moreover, the growing cultural status and economic clout of the Modern made it the likely purchaser, whereas in the past some private individual would have become the owner. Nonetheless, Barr encountered great difficulties in closing the deal. An anonymous cash contribution of $10,000 was insufficient, and further donations were not forthcoming. To meet Seligmann's price of $28,000, the museum had to sell a painting by Degas, *Racetrack*, which it had acquired in the Lillie P. Bliss bequest; the sale was the Modern's first significant deaccession from its "permanent" collection.[101] In this rather convoluted arrangement, Seligmann was in the enviable position of both selling the *Demoiselles* to the museum and selling the Degas on its behalf; the firm potentially profited from both the markup on the Picasso and any amount on the Degas beyond what the Modern required to fund the purchase. Despite the complexity, there can be no doubt that the *Demoiselles* was the most expensive acquisition in the museum's ten-year history. The protracted purchase extended from November 1937 until late November 1939, when the Degas was sold; the *Demoiselles* officially became the museum's property in April of that year.

Barr had prepared the way for his acquisitions by staging exhibitions that set forth his belief that Picasso was the fundamental figure in twentieth-century art. Instead of rushing to make less significant acquisitions, he had bided his time, building support for truly important, and concomitantly expensive, purchases. The exhibitions that definitively put the Modern on the map as an international institution and presented Picasso's centrality were *Cubism and Abstract Art*, which ran from March through April 1936, and *Fantastic Art, Dada, Surrealism*, which opened in December 1936 and closed early the following year.

These two nearly continuous shows were Barr's survey course for the museum public; they articulated his conception of the essential developments in twentieth-century art. The dependence of his views on Picasso's career is evident from his choice to begin with Cubism (rather than Matisse and Fauvism) and to trace a line to Picasso's current involvement with Surrealism. With Picasso placed in context, the next step was to devote an entire exhibition to him alone. This became the retrospective of 1939–40; the acquisitions of the previous two years were stimulated by the approaching exhibition.

Opening two months after France and Britain declared war on Germany, the Picasso retrospective was a vast undertaking in extremely uncertain times. Its accomplishment would signal the passing of artistic leadership from Europe to America as the Paris School collapsed and war swept across the Continent. Because the show required more resources than the Modern alone could muster, Barr organized it in conjunction with the Art Institute of Chicago. Yet Barr's primary role in the selection of works, his authorship of the catalogue, and his scheduling of the show's debut at the Modern stamped it as his production. Its success would not only certify the museum as the leading institution devoted to modernism but also convince the museum's trustees to devote a large proportion of their acquisition funds to Picasso's work once hostilities had ceased.

By the beginning of 1939, Barr and Daniel Catton Rich, the director of the Art Institute, were ready to announce their plan to the public. Art News heralded the upcoming exhibition as "the most ambitious event that has been undertaken in this country" and laid out the general program for the show: "This exhibition . . . will consist of about three hundred examples from all periods of the Spanish painter's work. Although paintings in oil will be principally emphasized, Picasso's sculpture and graphic art in various media will also be represented." The magazine seemed already star-struck: "Material for the exhibition will be borrowed from the most famous collections and museums of this country and abroad in addition to which a number of works never before exhibited anywhere will be lent directly from the studio of the artist himself."[102]

Of course, Barr and Rich had not made their public announcement

without having discussed the project with crucial lenders; the international art world was already buzzing with the news. Meric Callery's confidential account of Picasso's current show at Rosenberg's gallery was not idle gossip; it was part of her campaign to facilitate Barr's project. A few weeks before, Barr had thanked her for her offer to keep him apprised of potentially threatening developments in France: "You were most thoughtful to have asked whether you could help us with Picasso. As I told you before, we would very much appreciate having your sympathetic interest in the rather complex problem of manoeuvering through the devious intrigues which surround Picasso." Such is the reality curators must confront in preparing exhibitions but it is usually masked by the public displays of affection that accompany the finished product.

Barr also frankly confessed his concerns: "Picasso's own good will I think we have, but he is capricious and irresponsible so that it is possible that in the end we would find ourselves without his collaboration. I would greatly appreciate your keeping us informed, if you can, of his state of mind and also of the attitude of other key persons involved such as Rosenberg, Reber and the others."[103] His acknowledgment that the show might have to be accomplished without the artist's participation is sobering indeed. Having weathered a previous Picasso campaign and many succeeding exhibition projects, Barr was now a seasoned professional, who more straightforwardly assessed the risks of his very ambitious enterprise.

He soon learned that something like the "devious intrigues" he feared was already afoot. Callery warned that Rosenberg—in league with Picasso—was against the planned retrospective:

Rosenberg seems adamantly [sic] opposed to a large Picasso show. He says that 100 oil paintings are all that a person can see. He has persuaded Picasso of this too. He is going to write to you to suggest that you do it in sections or periods . . . it will be very difficult for you if Rosenberg is against you as he has great influence with Picasso. He has a way of knowing how to poison Picasso's mind. I have seen him at it many times. Let me know if you would consider any other way of presenting the pictures, and if not give me your arguments and I will do what I can with Rosie.[104]

Echoing Barr's reference to the machinations surrounding Picasso, Callery laid the blame on Rosenberg. Yet there is no doubt Picasso played a large role in the decision.

Rosenberg's statement to Barr was as strong as Callery had warned it would be, but his reasons for opposing the show were less expected:

> Mrs Callery informed me that you have the intention to exhibit next year at the Museum of Modern Art 300 pictures by Picasso; I also read this information in American art paper.
>
> I spoke to Mr. Picasso on this subject and he and I find great objections to such a show; we are afraid to tired the public by showing 300 pictures although the periods are very varied. Mr. Picasso would prefer that you cut his works in different periods of his life and I am of the same opinion as I believe that to see an exhibition of 300 paintings would work more against than for the artist.
>
> If you accept these suggestions I will be pleased to collaborate with you by lending you for your show the finest pictures I possess, otherwise, I will be very sorry not to be able to contribute to your manifestation as Mr. Picasso told me that he would not like me to lend pictures or to help the organization of such a show.[105]

Once again, Barr was at the mercy of the dealers he fought so hard to separate himself from. But this situation was far worse than the stillborn effort of 1931–32. Not only was Barr now an experienced professional at the head of a highly visible institution, but the show had already been publicly announced in collaboration with another august museum. To withdraw the project would have brought disgrace to Barr as well as to the staff of the Art Institute. It might even have ended his career at the Modern.

Realizing that he could not dismiss either Rosenberg or Picasso, Barr struggled to compose a response. His first draft was unguarded; it clearly reflected his initial shock and puzzlement:

> We are rather surprised to have your letter of February 23rd for, as you will recall, Mr. Goodyear and I called upon you last June in order to ask your cooperation in preparing a great Picasso exhibition under the joint auspices of the Art Institute of Chicago and our own

Museum. We understood clearly at that time that you would be with us in this difficult and important enterprise.

About that time Mr. Goodyear and I called on Picasso himself who also promised most cordial cooperation in working with us and the Art Institute of Chicago . . .

Having had what we believed to be your agreement and approval, together with that of Picasso, Mr. Goodyear and I reported to our Board of Trustees, and to the Director and Board of Trustees of the Art Institute of Chicago, who had authorized us to propose the exhibition. The exhibition is now announced and public expectation has already been aroused not only in the two greatest cities of America, but among many thousands of people outside of these cities who would be interested in seeing the exhibition. It would be a really serious affair if you and Monsieur Picasso were to withdraw your cooperation at this late hour.

Barr's beseeching tone is coupled with his admission that "we heartily agree with you that 300 paintings would be too many."[106]

This apparently crucial disagreement was based on a misconception. Barr had never intended to include three hundred paintings; that figure was an estimate of the total number of works in the show, only 150 of which would be oils. Taking another week to craft his final draft, Barr overcame his initial surprise and presented a very different front. The reply he actually sent to Rosenberg was much calmer and more self-confident, deferential without seeming desperate. Quickly disposing of the question of numbers, Barr sought to reestablish his leadership: "Since our conversation last summer I am afraid there has arisen some misunderstanding about the Picasso exhibition, which the Art Institute of Chicago and the Museum of Modern Art have been planning. We most heartily agree with you that an exhibition of 300 paintings would be far too large, and wish to assure you that we have never intended to show this number. Our plan is to limit the oil paintings to 150 at the very most . . ." Buttressing this position with references to preceding retrospectives, Barr promoted the importance of the exhibition he hoped to present: "One hundred and fifty oil paintings would be only *two-thirds* of the number shown in the Paris retrospective and the even more extensive exhibition in Zurich. The grand total at Zurich was in fact 460 items but we agree, I think, that a more concentrated and succinct exhibition would be better appreciated by

our public. Yet we should take care not to restrict too much a retro-spective exhibition intended to represent at full length the magnifi-cently fecund genius of Picasso." In an obvious gesture of flattery, Barr then added that, in making the selection, "we would need not only your help in lending and securing paintings but also your expert knowl-edge, for you more than anyone else, during the past 20 years, have been the most influential friend and supporter of Picasso." Thus he acknowledged Rosenberg's long stewardship of Picasso's career, while reserving for himself the laurel of scholarly authority.

After reminding Rosenberg of the visits he and Goodyear had paid the previous summer to secure the participation of artist and dealer, Barr returned to the institutional support the project enjoyed and, finally, extended a peace offering:

> Having had what we believed to be the agreement of both Picasso and yourself, Mr. Goodyear and I reported favorably to our Board of Trustees and to the Board of Trustees and the Director of the Art Institute of Chicago, who had authorized us to propose the exhibi-tion. The exhibition is announced and public expectation has already been aroused . . .
>
> Won't you reassure us as soon as you can that Pablo Picasso and his distinguished representative Paul Rosenberg are going to help us present in the two most important art centers of America the *finest* (though not the largest) exhibition of the work of the foremost artist of our time? To do this we must all work together. The result could be something that both the artist and yourself would be proud of— especially if you could both be persuaded to come to America for the exhibition![107]

Instead of the desperate plea against causing public embarrassment that ended his first draft, Barr's final letter wielded both the carrot and the stick to encourage the participation of artist and dealer.

Writing to Callery the same day, Barr enclosed a copy of his letter to Rosenberg, which he acknowledged "we have thought over very carefully," and recounted a more unvarnished version of the situation, admitting that "We are a long way from the center of things and feel rather helpless." Despite the unavoidable conclusion that he had too confidently taken the artist's and dealer's assent the previous summer as a blanket endorsement of his curatorship, he could not accept that

it might be possible to construe their conversation as indicating any-thing other than complete acquiescence to his plans: "I still cannot understand why he should go back on what was a formal, though un-written, agreement. Mr. Goodyear and I paid an official call on him, asked his cooperation, which he promised—though Heaven knows with what mental reservations. Picasso, too, was most cordial and ap-parently confirmed his intention to cooperate with us in subsequent conversations with other people."[108] Despite his awareness of the sub-tlety and complexity of competing ambitions in the art world—he struck out a reference to "the intrigues which at all times surround Picasso"—Barr seems to have been unable, or unwilling, to play by those rules. Besides these differences of personal style, however, there remained a more fundamental disagreement. Although Barr wanted the assistance of Picasso and Rosenberg, he did not expect his overall direction of the exhibition to be questioned, while they clearly thought they had the right to intervene.

He did not hide his desperation from Callery: "We set our hearts on a grand retrospective show of the greatest living artist. It would be a bitter disappointment as well as a serious embarrassment to the Art Institute of Chicago as well as to ourselves if it fell through." It is hard to believe that he could feel so powerless as the director of the Modern and, perhaps even more surprising, that he would confess his sense of futility so baldly. He was clearly admitting his dependence on the trade.

The entire situation was remarkable. Certainly from our present per-spective, it seems unthinkable that an artist or his dealer would refuse to participate in an exhibition of that artist's work at the Museum of Modern Art. Quite to the contrary, the imprimatur of the Modern is universally sought—and it has been for decades. Even in the late 1930s, no other artist or dealer would likely have rejected the oppor-tunity for such a show. Yet in the case of Picasso—already the most famous artist of the twentieth century—and Paul Rosenberg—the representative of Matisse, Braque, and Léger, as well as Picasso—the circumstances were different.

Rosenberg's grounds for disagreement were substantial, yet profes-sional rivalry cannot be entirely dismissed. Since we have no record of what Meric Callery told him about the composition of the exhibition, it is impossible to know whether he truly believed that it would include

three hundred paintings. The announcement in *Art News* cited the curator's intention of including "three hundred examples from all periods of the Spanish artist's work" and went on to say that "paintings in oil will be principally emphasized," so perhaps Rosenberg assumed that the show would consist chiefly of paintings. Whatever the case, he used the situation to his advantage. By attacking at the very outset, Rosenberg forced Barr to admit the indispensability of dealers and explicitly offer him a role in selecting the exhibition. Even though Barr had accumulated ten years' experience as director of the museum, he had not yet taken over from Rosenberg the authority to shape Picasso's reputation. With the completion of the exhibition, however, the torch would be passed. The combination of the Modern's growing stature and the war's destruction of Rosenberg's long alliance with Picasso would cause an abrupt shift of power.

Rosenberg's criticisms were not based solely, or even primarily, on squabbles over turf. As the man who had orchestrated Picasso's career for twenty years, Rosenberg had a distinct conception of how best to show Picasso's work. After the simple fact of his willingness to cross the Modern, the most surprising aspect of the misunderstanding is his stated reason for speaking out. Instead of demanding to include certain works from his stock or the collections of his prime clients, as we might expect of a dealer hoping to capitalize on the exhibition, Rosenberg based his criticisms on what one might call scholarly grounds.

Certainly Rosenberg's goal of presenting Picasso's work in the most advantageous light reflects his role as a promoter. But Barr, too, wished to acclaim "the foremost artist of our time." The two men's disagreement points out the lack of a clear-cut division between the activities of the dealer and those of the curator. After all, Rosenberg had organized exhibitions of Picasso's work for museums when Barr was still a graduate student. His proposal that Barr present a series of smaller shows devoted to the artist's periods was a reasonable alternative to what he envisioned as a single, overwhelmingly large exhibition. (This format has been used a number of times since, most recently by the Bielefeld Kunsthalle in 1988, *Picassos Klassizismus*, and in 1991, *Picassos Surrealismus*.)

By taking the position that Picasso's work required more editing than he expected Barr to undertake, Rosenberg implicitly acknowledged that Picasso's art was uneven and not always of exhibitable qual-

ity. Picasso apparently accepted this position; Rosenberg was one of the few members of Picasso's circle who were willing to tell him that his work was sometimes flawed or at least not fully resolved. Although some might see it as interference, this advisory role was the responsibility of the dealer, based on their partnership, and it was a foundation of Rosenberg's relationships with his artists. His contracts reflected this principle, as they did not require him to purchase all of an artist's production; for the right of first refusal, he agreed to purchase a certain amount of the artist's work—but selectively.

Once Rosenberg read Barr's reply, he immediately threw his support behind the project: "I have just received your letter of March 20th for which I thank you . . . I see that you only intend to exhibit 150 paintings. This, of course, changes the situation and in that case I shall be very glad to contribute to your manifestation." Affirming that he was confident Picasso would accept the clarified plan, Rosenberg repeated his basic concern: "My intervention was based on the fact that too many pictures of the same artist would not help his propaganda. Certainly, there were too many pictures in the Zurich exhibition."[109] In his slightly maladroit translation of "propaganda" from French to English, Rosenberg revealed the fundamental issue between Barr and himself. The advocacy implied by that choice of words might be considered appropriate for a dealer's show, but applied to a museum exhibition, it undercuts the freedom from "political-commercial" compromises that Barr had long sought to assert.

During the following months all remained calm as Barr prepared to select the works that would appear in the exhibition. To make these subtle judgments, he needed to be in Paris, where he could see many of the paintings and discuss them with other experts. Despite their earlier antagonism, Barr and Rosenberg worked together closely during this crucial phase of the project. Barr's wife, Margaret, recorded his exultation: "To Paris to assemble the Picasso show, scheduled to open November 15. How many years A. has hoped and worked and schemed for this!"[110]

Once installed in Paris, however, Barr encountered an even greater obstacle. With the possibility of hostilities increasingly likely, collectors were safeguarding their pictures. In Paris, the vaults of the Banque de France had begun to rival the galleries of the Louvre or the Jeu de Paume. Picasso and Rosenberg were among those who had already

taken the precaution of storing their pictures in the bank. Few collectors were willing to allow their possessions to be transported across dangerous seas for exhibition in America. Loans from Germany, Eastern Europe, and even Switzerland were nearly impossible. Barr was essentially restricted to France and Britain (where there were few important Picassos) for foreign loans. Moreover, he could not examine many of these works firsthand or, if he could see them, it was only in cramped, poorly lighted storage vaults. Under the circumstances, Paul Rosenberg became even more important to the success of the exhibition than Barr had anticipated.

Instead of touring the private homes of collectors and the galleries of dealers, the Barrs spent much of their time holed up in Rosenberg's house. Largely isolated from the scores of paintings that had recently been displayed throughout Paris, they pored over his extensive photographic archive of Picasso's work. As Margaret Barr recounted, "They [Alfred and herself] spend much time in a room on the second floor of Paul Rosenberg's house above his gallery on the rue La Boétie. As there is no table large enough, A. disposes all the photographs on the floor. Rosenberg sends up tea every afternoon and drops in. A. asks, 'Which of these two pictures do you prefer?' and Rosy responds, 'You two are young—I can't go crawling around on my knees!' " Meric Callery also speeded the project by lending Barr her list of American collectors.[111]

By the middle of July, the job was substantially complete. Meric Callery would send nine works, while Picasso would lend thirty-three and Paul Rosenberg forty.[112] Besides being the largest lenders, Picasso and Rosenberg contributed many of the most important works in the exhibition. Indeed, Picasso had turned out to be helpful. Not only did he submit to a "long interrogation" as Barr sought to pin down the chronology of his work, but he allowed the museum to take such masterpieces as *The Dance* (1925) and *The Pipes of Pan* (1923), which he had retained for his private collection.[113] Given the uncertainty about when, if ever, these touchstone pictures might be returned to him, it is remarkable that he let them go. Regarding Rosenberg's loans, Barr explicitly acknowledged their significance when he wrote to Tom Mabry, the secretary of the museum, that he was having them sent to New York at the museum's expense because "it would be better to insure the importance of the show by making certain that we have

Rosenberg's pictures."[114] Besides two great paintings of 1904–05 (*Actor* and *Two Nudes*), Rosenberg's works swept across the years of their association.[115] In Barr's eyes, his greatest contribution was his version of the *Three Musicians*. It was in Buenos Aires, where it had been sent for exhibition, and would not arrive in New York until nearly a month after the exhibition had opened.

The paintings' departure for New York did not necessarily settle whether they would appear on the walls of the Museum of Modern Art. Barr alerted Mabry to a matter of some delicacy: "Should you see the Picasso owned pictures you will find some that may not seem first rate. As I shall explain, we could not in the end avoid taking these. There are, however, many important works . . ."[116] Apparently Picasso had not been quite so cooperative as it had first appeared. His willingness to lend the pictures Barr coveted for the show was qualified by the requirement that Barr also take some that he considered much less desirable. Writing to Rosenberg in early August, Barr was quite plain about Picasso's coercion: "Should you see Picasso, don't forget to sound him out on the possibility of releasing us from the agreement which we made, under threat, to hang all of his loans. As you know, we took the loans originally with the understanding which he suggested himself that not all of them be hung."[117] Barr had again been caught by the more subtle maneuvers, and greater power, of others. Although this time he appealed to Rosenberg for assistance in massaging the recalcitrant artist, Picasso's threat was not to be dismissed —even if he would never see the exhibition in New York or Chicago.

All Barr could do was feed Rosenberg evidence to support the exclusion of the works: "The exhibition is now seriously overweighted in the five years between 1927 and 1933. I have already shown paintings which he has lent to one or two of our best American critics. They agree that the exhibition would be improved by the omission of three or four of his pictures. This is a diplomatic matter of some difficulty. If you succeed, we shall bless you!" Eighteen of Picasso's thirty-three loans were confined to those years, so it is understandable that Barr felt they were out of proportion to the whole. If Rosenberg pleaded Barr's case to Picasso, he must have done so to no avail, since all of Picasso's loans from 1927 to 1933 appeared in the show. Nonetheless, the incident is a testament to Rosenberg's crucial role. As he

had so many times before, Rosenberg worked behind the scenes to facilitate the curator's work by scouting loans, judging works, and trying to keep an increasingly autocratic artist in line.

As the summer of 1939 ended, Barr scrambled to assemble the remaining loans. Germany's invasion of Poland on September 1 and the subsequent declaration of war by Britain and France made Barr's efforts nearly hopeless. By wisely having secured most of the European pictures during July and August, however, he could be confident that the exhibition would take place even if no more pictures were forthcoming. The disastrous turn of political events inspired him to pursue art with even greater vigor; the conditions brought out a near-missionary zeal that seems to have often underpinned his promotion of modern art. Writing to Rosenberg on September 12, Barr confided: "The war has come making picture exhibitions seem unimportant, yet in a way we must believe that painting is more important than war."

After this inspirational moment, however, Barr returned to nuts and bolts: "We have no word about the *Three Musicians* which you informed us would be delivered to our Museum from Buenos Aires. We would greatly appreciate, even in this terrible crisis, having some word from you both about the *Three Musicians* and the loans coming from London." In a postscript, Barr asked for news of Picasso and the group of sculptures that the artist had promised to cast specifically for the exhibition: "Since Picasso almost never writes letters, we hope that you will send us some word of him too." (Picasso didn't even respond to Nelson Rockefeller's telegram inviting him to the opening.)[118] "We still hope there may be some chance of receiving sculpture from him." Unfortunately, the new casts never arrived.

It is difficult, more than fifty years later, to imagine how close Barr came to being overwhelmed by contemporary events. The installation photographs taken by Charles Sheeler record the methodical chronological hanging with the clarity of his precisionist eye (Figs. 79, 80). The catalogue of the exhibition, *Picasso: Forty Years of His Art*, includes a few apologies in the foreword but does not betray the absence of major works that Barr had hoped to include. The over 350 paintings, drawings, prints, and sculptures have stood in the minds of scholars and the public alike as the culminating public display of Picasso's

achievements during the first half of the twentieth century and the model for the great series of retrospectives that continued through the museum's 1980 exhibition.

Barr's show far surpassed any previous one in America. The only contender was the Atheneum exhibition, and it had consisted of only seventy-seven paintings (plus an assortment of drawings). Moreover, the fact that America soon became the primary guardian of Picasso's reputation has enhanced the memory of Barr's pioneering exhibition. His continuing stream of publications, especially his sequel, *Picasso: Fifty Years of His Art* (1946), and his successful campaign to maintain the museum's collection as the finest selection of Picasso's work in the world lent weight to his first monographic treatment. Certainly, the exhibition and its catalogue deserve much acclaim.

Yet, in the broader context of international exhibitions, Barr's retrospective appears both less groundbreaking and more fractured by significant omissions. The real comparison is with the Petit rather than with the Atheneum exhibition. Not only were that show and its Zurich variant the largest and most comprehensive retrospectives yet held, but Barr specifically looked to them as his point of departure. He cited

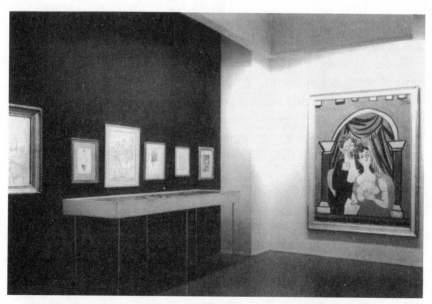

79. The Museum of Modern Art, *Picasso: Forty Years of His Art*, November 1939–January 1940 (Courtesy of Museum of Modern Art, New York)

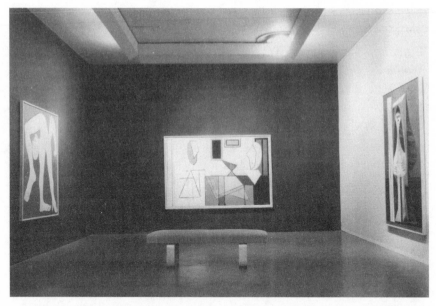

80. The Museum of Modern Art, *Picasso: Forty Years of His Art*, November 1939–
January 1940 (Courtesy of Museum of Modern Art, New York)

them in his correspondence with Paul Rosenberg, he annotated their catalogues extensively, and he kept an extremely rare set of photographs documenting Picasso's hanging of the Petit exhibition.

At first glance, Barr's exhibition appears superior by virtue of its sheer size—the issue that had so troubled Rosenberg and Picasso. At nearly 360 items, it included over a hundred more works than the Petit exhibition had. Barr could reasonably assert that it was "the most comprehensive presentation of Picasso's work so far assembled."[119] Yet much of the comprehensiveness reflected the fact that it also covered the seven years since the Petit show. The two exhibitions' treatment of Picasso's career through 1932 are quite comparable.

In the catalogue, Barr had cited the inclusion of "almost all of his eight or ten capital works" as evidence of the exhibition's importance. Masterpieces from every phase of his career, beginning with the Blue period, were displayed: *La Vie, Boy Leading a Horse, Portrait of Kahn-weiler, Still Life with Chair Caning, Harlequin with Violin ("Si Tu Veux"), Two Seated Nudes,* both versions of *Three Musicians, The Dance,* and *Seated Bather,* as well as the Modern's own *Demoiselles, The Studio,* and *Girl Before a Mirror.* Yet crucial paintings were miss-

ing. Although the exhibition was in New York, Chester Dale apparently once again refused to lend *The Family of Saltimbanques*. *The Burial of Casagemas, Woman in an Armchair,* and *Harlequin and Woman with Necklace* also did not appear, even though they had been in the Petit retrospective. Several works that Barr had thought were committed, such as the *Portrait of Gertrude Stein* and *Harlequin*, appeared only in the catalogue, not on the walls of the museum.[120]

These gaps reflect not only the difficulty of securing objects from their owners for the lengthy duration of such shows but also the particularly arduous conditions under which Barr organized his exhibition. By the selection of works he did present, however, Barr offered a significant reinterpretation of Picasso's career, one that would influence popular and scholarly opinion for decades to come. In many ways, Barr's choices reflect the preferences he had sketched out in preparation for his failed retrospective of 1931–32. Although he revised that project by giving Picasso's early work the prominence it had traditionally received (indeed, he included more turn-of-the-century work than had the Petit), he took the opportunity to highlight the "African" work of 1907, which the Petit had neglected but which he had assigned three stars. Surrounded with several studies, the *Demoiselles* was the centerpiece of this group.

While Barr gave the Cubist years up to the First World War the same prominence as they had had in the Petit show and in his previous plan, he treated the war years differently. In his 1931 chart, he had judged the work of 1915–17 "unimportant." As realized, the Modern's show displayed far fewer (and less significant) paintings than the Petit had, but it represented Picasso's budding involvement in the theater, as initiated by *Parade*. His expanded artistic activities had been ignored in the Petit exhibition's emphasis on painting. Barr downplayed the heterogenous phase between the mid-teens and mid-twenties—when Picasso alternated between Cubist and Neoclassical modes—by including only sixteen works from 1922 to 1925 (versus the Petit's thirty-six). The shows gave equal prominence to the work of the twenties and thirties.

The shifts of emphasis, however slight, mark a fundamental reinterpretation. By deemphasizing Neoclassicism in order to give more significance to the earliest phases of Cubism, Barr altered the balance of Picasso's career. Instead of promoting a link between the Blue and

Rose periods and the majestic figures and still lifes of Picasso's years with Paul Rosenberg (whether Neoclassical, Cubist, or Surrealist), as had the Petit and Zurich shows, Barr joined the challenging, "barbaric" artist of the "laboratory or, better, a battlefield of trial and experiment"—the *Demoiselles*—with the turmoil of *Guernica* and its surrounding work.[121] "It is worth noting," Barr observed, "that Picasso at the present time is particularly interested in the work of this Negro Period."[122] The recalibration mirrored the changes in Picasso's work since 1932, as he shifted from the fluid grace of his Marie-Thérèse paintings to the threatening images of the years from the Spanish Civil War to World War II. Yet, because most popular and scholarly evaluations of Picasso's achievements would dismiss his work after World War II, Barr's emphasis on the early years of Cubism in conjunction with the Surrealist phase of Picasso's career became the standard.

Besides this reevaluation of the artist's overall attainment, Barr made another significant contribution. He altered the mix of works representing the phases of Picasso's career in a way that allowed the audience to delve into Picasso's creative process as if eavesdropping on his activities in the studio. Unlike in previous retrospectives, only about half the works in Barr's exhibition were paintings or major drawings (somewhat exceeding the ceiling of 150 he projected in February 1939); the other half consisted of sketches, prints, and a few sculptures. By so substantially changing the blend, Barr demonstrated that Picasso's diversity encompassed many media as well as varied styles. (In the process, Barr also covered some of the holes left by paintings he could not obtain.) His approach allowed viewers to examine major paintings in the context of preliminary sketches that had not previously been considered desirable for exhibition.

The prints and drawings in the preceding retrospectives were afterthoughts. They were few in number and chosen to demonstrate nothing other than Picasso's skill as a draftsman. Paul Rosenberg had often shown Picasso's drawings in his gallery, but he had presented them as masterful independent works, not as contingent designs. Barr's selection, however, frequently interwove paintings, drawings, and prints. By surrounding the *Demoiselles* with three of its preliminary studies, Barr laid out the evolution of the composition from a conventional narrative set in a brothel to its final direct confrontation with the observer. *Guernica* provided an even richer subject for this elaboration.

The fifty studies Barr included enabled the audience to trace almost day by day the development of the painting and its effect on Picasso's art. Barr's hanging of the works enhanced this process by adhering to a strict chronological succession—unlike Picasso's arrangement of the Petit retrospective, intended to counter the periodization of his work.

Despite these scholarly nuances, it was the array of monumental oils, particularly the classicizing paintings of Picasso's early and middle career, that made the exhibition a huge success. Recognizing the crucial collaboration of Picasso and Rosenberg, Barr kept them apprised through regular cables and letters. On November 15, the opening day, Barr sent the same exuberant message to both of them: "PICASSO OPENING GRAND SUCCESS YOUR PAINTINGS MAGNIFICENT MANY THANKS." As the exhibition continued to garner praise, he showered them with reviews from *Time*, *Newsweek*, *The Nation*, and *The New Republic*, as well as the *New York Times* and the *Herald Tribune*. He told Picasso that the exhibition was a "COLOSSAL SUCCESS 60,000 VISITORS SURPASSING VAN GOGH EXHIBITION."[123]

The press covered the exhibition more as a social event than as an artistic enterprise. There were very few seasoned art critics in America, and most of the reporters assigned to the story made little effort to evaluate Picasso's work. A rare exception was the critic for the *New York Times*, Edward Alden Jewell, who declared *Les Demoiselles d'Avignon* "dubious in the extreme" and most of Picasso's recent work "rubbish" but who grudgingly admitted that "the importance of Pablo Picasso as a force in the development of modern art should on no account be underestimated." More characteristically, the *Newsweek* reporter dwelled on the social and commercial whirl surrounding the show. He noted, for example, that "three fashionable Manhattan stores (Bonwit Teller, De Pinna, and Bergdorf Goodman) were devoting a total of 25 windows to expensive clothes inspired by his pictures."[124]

This journalist had also got wind of the conflict that nearly prevented the exhibition from taking place. His article began with the statement "When Pablo Picasso first heard the Museum of Modern Art in New York had joined forces with the Chicago Art Institute to stage a mammoth one-man show of his work, he is supposed to have protested indignantly: 'They can't do that to me!' " Picasso reputedly wanted a show of only seventy-five "major works": "Of the rest the

painter's painter says simply: 'I've done them to do the others.' " Apparently this intelligence came from someone close to Picasso, and its emergence well served his carefully honed persona. Picasso appeared not to seek the spotlight now cast on him; indeed, like Rosenberg, he had feared the retrospective might harm his reputation. Instead, it marked both the zenith and the finale of his long collaboration with Paul Rosenberg to establish his worldwide preeminence. It was, as the photographer Brassaï observed, an "apotheosis."[125]

CONCLUSION

A lthough preparations for the Modern's retrospective provided some distraction from the fears of war that dominated conversations during the summer of 1939, another event shocked the Parisian art world in late July. On the 22nd, Ambroise Vollard suffered a blow to the head that would end his life at age seventy-three. Officially, the cause was a freak accident: one of Maillol's monumental sculptures had broken free of its moorings and fallen on the dealer as his car swerved on the road. To many who recalled Vollard's bullying of artists, the scenario suggested divine justice. Among more cynical observers, rumors spread that the blow had been struck by an arm of flesh and blood rather than of marble or bronze.

Vollard's professional life had spanned six decades, from his cultivation of the reputations of Cézanne and Gauguin in the late nineteenth century to his publishing of prints and illustrated books by Picasso and Rouault. By 1918, he had already become so prominent that René Gimpel described him as "the wealthiest dealer in modern pictures . . . a millionaire ten times over."[1] During the next two decades he had discreetly pursued his interests; in 1927 he had commissioned Picasso to begin the series of a hundred prints that has come to be known as the "Vollard Suite."[2] Never quick to sell his possessions, Vollard was reputed to retain in his stock remarkably fine paint-

ings by Impressionist, Post-Impressionist, and early-twentieth-century masters. With so much at stake, it is not surprising that some suspected foul play; squabbles over the estate quickly ensued.

Yet on July 28, the art world put aside these intrigues to gather on the Left Bank at the church of Sainte-Clotilde to celebrate the final obsequies. The funeral of Vollard was far more than a diversion from the political preoccupations of those months. Whether consciously or not, those in attendance commemorated not only one of the most prominent dealers of the last half-century but also the era he had done so much to create. One might even say that the Paris School died with Vollard.

Picasso rushed to Paris from the south of France to attend the ceremony, and his willingness to disrupt his summer holiday was not exceptional among the eminences of the art community.[3] Most of the artists, dealers, and critics, as well as many of the collectors who had led French art during those glorious years also made the trip. It was the last time they would gather with their hegemony intact. In little more than a month, the commencement of war would destroy the culture that had nourished them and end the French (indeed the European) dominance of contemporary art as its center shifted to New York with America's assumption of the first place among Western nations.

For Paul Rosenberg, these events were especially wrenching, albeit not unexpected. In the three-year contract he had signed with Matisse on July 16, he had included a clause that gave him the right to cancel the agreement in the event of war.[4] Throughout the summer, he had also made preparations to protect his stock. Having turned down Alfred Barr's offer to help him store his pictures in America, he decided to send the nineteenth-century works to England and hide the twentieth-century ones in Tours. The only paintings he sent to New York were those for the Picasso retrospective and for the World's Fair. As a Jew who had vociferously denounced the Nazis for years, he felt sure that more than just his property would be endangered if France fell. By mid-August, he had taken up residence at Castel Floriac, about three miles from Bordeaux. This coastal retreat offered the best possibility for a quick escape if it proved necessary.

With the declarations of war, Rosenberg made no effort to open his gallery at the end of the summer recess. But he also did not curtail

his accustomed pace. He asked Barr to send him reviews of the exhibition, and he poured out his frustration to him: "I am anxious to know if the public has accepted the manifestation. I don't yet know what I am going to do I must wait, but I assure you that I am desperate nothing to do. It is not in my character to be without occupation . . . If I had no son, who might be called if war lasted too long, I certainly would sail to the States."[5]

Rosenberg would not do so until the fall of 1940, when the German conquest of France could no longer be disputed. His son, Alexandre, who was then twenty, would go to Britain instead of America and enlist in the British military before joining the Free French Forces,[6] with whom he would fight from North Africa to Germany over the next six years. Rosenberg moved the portion of his stock that remained in France to Bordeaux in preparation for possible shipment abroad. Unwilling to risk even a brief trip to New York for the opening of the Modern's exhibition, he remained at his country retreat, eagerly awaiting the reviews Barr would send him.

Even as he secured his stock, Rosenberg tried to maintain contact with his artists. After a brief stay in Paris, Picasso had returned to Royan, in the south of France. Although he was not far from Rosenberg's hideaway, Picasso did not spend time with him. On August 15, Rosenberg invited Picasso to visit him in Floriac. By Christmas, he could only lament their lack of communication: "You never change your habits, you never respond to letters and telegrams, even from your most loyal friend."

According to Meric Callery, Picasso was "busy taking flying trips between [Paris] and Royan" and had "very methodically" placed his art in Paris vaults.[7] With many of his financial assets deposited in Switzerland, Picasso had set an independent course that would carry him through the war in relative safety. Apparently his last official contact with Rosenberg before the war intervened occurred in late January 1940. On February 1, Rosenberg sent him a check for fifty thousand francs to cover the purchase of five paintings; this relatively small sum confirms how uncertain they considered the times to be.[8] As the war changed from one of waiting to active engagement with Germany's invasion of Holland, Belgium, and finally France in the late spring, the transaction would turn out to be Rosenberg's last under the contract

"de première vue" that had governed their relationship for the preceding twenty-one years.

With the fall of France that summer, Rosenberg fled to New York, where he was able to establish a new business based on his ties in America and what stock he had successfully removed from France. Unfortunately, most of his twentieth-century pictures—those scores of Matisses, Légers, and Picassos that were the envy of museums around the world—were seized by the Nazis at Bordeaux before they could be shipped. Like all other Jews, he was declared stateless under Nazi law, and his property was confiscated. Thus his remarkable stock was soon scattered among high Nazi officials who sought to legitimize their terror by cultivating an image of cultural sophistication.[9] In a puzzling, almost macabre twist, Hermann Göring took the portrait of Rosenberg's wife and daughter that Picasso had painted at Biarritz in the summer of 1918 to announce the beginning of the relationship.[10]

In Paris, the gallery and residence were commandeered by Alfred Rosenberg, the notorious leader of the *Einsatzstab Reichsleiter Rosenberg*, who was later hanged at Nuremberg for roundups that netted a great deal of art for the Nazis and sent many people to their deaths. Sadly, Rosenberg's business records, which he had been unable to remove from the gallery, probably facilitated some of these horrendous acts. Picasso abandoned his apartment on the rue La Boétie for a large studio on the rue des Grands-Augustins, which he had rented in 1937 to paint *Guernica.*

Only after the war could Rosenberg hope to retrieve his paintings from the dealers, collectors, and museums that had acquired them under circumstances that were dubious, if not clearly unlawful. But the situation with his artists, especially Picasso, was even more dire. During the war, he could not communicate with them, and even though he tried to reestablish the old ties as soon as Paris was liberated, the distance had grown too great.

By choosing to remain in New York, Rosenberg positioned himself extremely well for the postwar market, which would be even more dominated by Americans than it had been in the 1920s and 1930s; yet his relocation also isolated him from the contemporary artists he had long represented (fig. 81). Much like the First World War, the Second World War transformed Picasso's relationship with his dealer. Not only

did he emerge with ties to another merchant, he returned to Daniel-Henry Kahnweiler. Like Rosenberg, Kahnweiler was at risk for his life, but by transferring his firm to his sister-in-law, Louise Leiris (who was not Jewish), and hiding in the countryside during the occupation, he had preserved his position in France. By 1947, Kahnweiler had reinstated his relationship with Picasso by negotiating an exclusive contract, and he remained Picasso's primary dealer until the artist's death in 1973.[11]

The postwar years were ones of great prominence for Picasso as the recognition he had achieved in the 1930s accelerated into near-adulation by the popular press and many professionals. His position enabled him to exert control even more effectively than he had before. Françoise Gilot, his companion from 1946 to 1954, observed the pre-meditation and subtlety that underlay his actions; "in his relations with his dealers," she noted, he "played a shrewd psychological game" that he based on his experience with Vollard at the beginning of the century.[12]

According to Gilot, Picasso carefully anticipated a dealer's visit, at times by playing games in which he and she adopted the roles of artist and dealer. Picasso would "imagine in advance how the interview was going to go in general. Sometimes he would have us act out little playlets which prepared the routine of the next day if Rosenberg or Kahnweiler or, a little bit before their day, Louis Carré, was coming. Sometimes Pablo kept his own role and I would take the part of the dealer, or I would be Pablo and Pablo would be the dealer." The skits were more than mere entertainments; they enabled Picasso to plan his strategies for the actual meetings, and the preparation suggests how seriously he took the encounters:

Each question and each reply, even though it was slightly burlesqued and often turned into farce, still had to be a prefiguration of what was going to take place the next day . . . The next day I was in on the meeting as a neutral observer. At certain moments I would have a little wink from Pablo because the dealer had given a reply which duplicated exactly one I had given for him the night before. This sort of playlet had its practical uses but it was put on principally, I think, for fun. In general it had to end with the triumph of Pablo. He had

81. Paul Rosenberg, 1950s

the last word because he had more wit, more fantasy, more imagination, more arms of all kinds, than his opponent.[13]

If Picasso's resort to theater may have been prompted by a desire to amuse, the calculation behind it was far from frivolous.

Throughout his career Picasso applied his remarkable talents to winning the support of those who could enhance his reputation and bring acclaim to his art—the dealers, critics, collectors, and curators who constituted his primary audience. Though he claimed in 1918 that dealers were the enemies of artists, he negotiated an extremely advantageous treaty that both assured his independence and supported his cause. Such calculation was not unique to Picasso, nor was it mere self-promotion. It was central to the avant-garde tradition that began in the middle of the nineteenth century and that still defines the artist as an entrepreneur in modern culture.

NOTES

INTRODUCTION

1. In a letter of December 2, 1918, to Picasso, Léonce Rosenberg defended himself against this accusation (Picasso Archive, Musée Picasso, Paris).
2. Letter of March 24, 1916, from Léonce Rosenberg to Picasso. (Picasso Archive, Musée Picasso).
3. Daniel-Henry Kahnweiler with Francis Crémieux, *My Galleries and Painters*, New York, 1971, 91.
4. Cecil Beaton, *Photobiography*, London, 1951, 120.
5. The term *modernism* has long been the subject of acrimonious debate. Partisans of a particular ideology have frequently attempted to limit its definition to a distinct set of characteristics and a finite period of time within the last two centuries. As these arguments have continued, however, it has become evident that *modernism* as it was used by critics and artists in the nineteenth and twentieth centuries was, and continues to be, an extremely varied phenomenon that cannot be circumscribed by a single definition. I use the term in this more polymorphous, and more traditional, sense.
6. Francis Haskell, *Patrons and Painters: A Study in the Relation between Italian Art and Society in the Age of the Baroque*, London, 1963, 17. It is not my purpose to locate the origin of a link between commercial success and critical acclaim in building artists' careers, and I certainly do not mean to suggest that the link began in the Baroque. I hope to pursue the historical origins of this nexus, but I believe it is sufficient to observe here that it occurred, if intermittently, long before the nineteenth and twentieth centuries. For a recent study of the relation of art and wealth during the Renaissance, see Richard A. Goldthwaite, *Wealth and the Demand for Art in Italy, 1300–1600*, Baltimore and London, 1993.
7. Harrison C. White and Cynthia A. White, *Canvases and Careers: Institutional*

Change in the French Painting World, Chicago and London, 1965; rpt. 1993, 13, n. 6. For a recent study of the development of a market for the work of the Barbizon artists, see Nicholas Green, "Dealing in Temperaments: Economic Transformation of the Artistic Field in France during the Second Half of the Nineteenth Century," *Art History,* March 1987, 59–78.

8. Quoted in William D. Grampp, *Pricing the Priceless: Art, Artists and Economics,* New York, 1989, 15.

9. Mark Roskill, ed., *The Letters of Vincent van Gogh,* New York, 1974, 339–40.

10. Although Cézanne's lifespan was normal for his time, it was significantly shorter than those of most of the Impressionists. Moreover, the fact that Cézanne did not have a one-person exhibition until 1895 delayed public recognition of his work to the time when most Post-Impressionists were beginning to become known.

11. Françoise Gilot and Carlton Lake, *Life with Picasso,* New York, 1964, 287.

CHAPTER 1

1. Among the 145 lots in the auction, fifty-four artists were represented for an average of 2.7% works per artist. Works by Picasso and the Fauves constituted 34%: Picasso (12 works), 8%; Matisse (10), 7%; Derain (5), van Dongen (1), Raoul Dufy (1), Friesz (3), Manguin (2), Marquet (3), Metzinger (3), Puy (6), Rouault (3), and Vlaminck (1). The Nabis accounted for an additional 13%, for a total of 47%: Bernard (2), Bonnard (1), Denis (2), Filiger (1), Maillol (1), Ranson (1), Roussel (5), Serusier (3), Valotton (2), and Vuillard (1). The largest remaining group (16%) can roughly be called Impressionist and Post-Impressionist: Forain (7), Gauguin (1), van Gogh (1), Guys (6), Luce (1), Pissarro (1), Redon (5), and Signac (1). Most of these works were drawings by Forain and Guys. The final 36% of the collection (53 works) consisted of a wide variety of primarily twentieth-century paintings and drawings—only two artists were represented by more than two works: Utrillo (4) and Laurencin (3). The dominance of Picasso, the Fauves, and the Nabis becomes far greater when their sale prices are considered; see n. 53.

2. The documents establishing the association are dated February 24, 1904. The contract specifies in detail the purpose of the organization, the rules of its activities, and the obligations of its members. Article 5 establishes its ten-year life. The core members were André Level and his brothers—Emile, Jacques, and Maurice—who were joined by Georges Ancey, Robert Ellissen, Maurice Ellissen, Jules Hunebelle, Félix Marchand, Frédéric Combemale, Jacques Raynal, Jean Raynal, and Edmond Raynal. Since two shares were split (Emile/Maurice Level and Jacques/Jean Raynal), there were eleven voting shares.

Besides the many newspaper accounts of the auction, only one study of the association has appeared—"Quand on vendait la Peau de l'Ours" (*L'oeil,* March 1956, 16–21) by Guy Habasque. Seminal works by Malcolm Gee (*Dealers, Critics, and Collectors of Modern Painting: Aspects of the Parisian Art-Market between 1910 and 1930,* New York and London, 1981) and David Cottington (*Cubism and the Politics of Culture in France 1905–1914,* disser-

tation, Courtauld Institute, 1985), however, discuss the group. Also relevant are Robert Jensen's article "The Avant-Garde and the Trade in Art" (*Art Journal*, winter 1988, 360–67) and his dissertation, "The Marketing of an Avant-Garde: Dealers, Ideology and the Trade in Modernism between France and Germany" (University of California, Berkeley, 1987), which was unavailable for consultation.

3. For the legal history of artists' rights and the *droit de suite*, see John Henry Merryman and Albert E. Elsen, *Law, Ethics, and the Visual Arts*, second ed., Philadelphia, 1987, 213–38.

4. Guillaume Apollinaire, "La vie anecdotique," *Le Mercure de France*, March 16, 1914, 432–33.

5. André Salmon, *Souvenirs sans fin*, vol. 2 (1908–20), Paris, 1956, 259–60.

6. *Moniteur*, June 25, 1867. Reprinted in Victor Hugo, *Hernani*, ed. Pierre Richard, Paris, 1971, 209. I would like to thank Dori Katz of the Comparative Literature Department of Trinity College for discussing Hugo's play with me.

7. Although the source in La Fontaine was noted at the time (André Warnod, "La vente de la 'Peau de l'Ours,' " *Comoedia*, March 3, 1914, n.p.), it has recently been misidentified by James Neil Goodman, who states that the group "chose the name Peau de l'Ours in the spirit of 18th-century French Colonials in the New World. A rough equivalent in English would be 'The Bear-Skin Trading Company' " (Preface to *Cubism: Le Fauconnier, Gleizes, Kupka, Marcoussis, Metzinger, Valmier, Villon*, New York: James Goodman Gallery, 1989, n.p.). This explanation is quoted in Judith Cousins and Pierre Daix's "Documentary Chronology," *Picasso and Braque: Pioneering Cubism*, ed. William Rubin, New York, 1989, 445, n. 222.

8. André Level, *Souvenirs d'un collectionneur*, Paris, 1959, 17. For the possible influence of Matisse's project for a consortium, see n. 19.

9. Level, *Souvenirs d'un collectionneur*, 10.

10. For the most recent and comprehensive study of the market for Impressionist painting, see Anne Distel, *Impressionism: The First Collectors*, New York, 1990. For many years, John Rewald has written prescient essays on the collectors and dealers of Impressionist and Post-Impressionist art; see "Theo van Gogh as Art Dealer" and "Paul Gauguin—Letters to Ambroise Vollard and André Fontainas," in *Studies in Post-Impressionism*, ed. Irene Gordon and Frances Weitzenhoffer, New York, 1986, 7–115 and 168–213, and *Cézanne and America*, Washington, D.C., 1989.

11. Eugène Blot, *Histoire d'une collection de tableaux modernes: 50 ans de peinture (de 1882 à 1932)*, Paris, 1934, 54. The sales were held on May 10, 1900, and May 10, 1906, at the Hôtel Drouot.

12. Level, *Souvenirs d'un collectionneur*, 17. In a letter of November 30, 1903, to his brother Emile, Maurice Level outlined the association that would become La Peau de l'Ours. On December 2, 1904, Maurice sent him a draft of the agreement (Level family collection).

13. The contract of February 24, 1904, specified that André Level would be the director of the association and could only be replaced because of misconduct. Although the majority of members had to approve all purchases, only the director could propose works for consideration (Article 4). Every January each

share was obliged to contribute 250 francs; the eleven shares provided an annual purchase fund of 2,750 francs ($550). In 1991 dollars, this would be approximately $209,318. Once purchased, works were available for members to hang in their homes (Article 5).

The annual return on prices is based on the rate of annual compound interest required to meet the sale prices over the period specified (internal rate of return). The average inflation rate is based on the *Consumer Price Index for U.S. Cities* compiled by the U.S. Department of Labor, Bureau of Labor Statistics, for 1913–90. While not exact, the difference between the annual return on prices and the average inflation rate offers a rough idea of the deflated, or real, rate of return. Estimations of current dollar values of past sums are calculated by applying the average inflation rate as a rate of annual compound interest over the applicable period. For an estimate of the present value of *The Family of Saltimbanques* based on these figures, see n. 55. At an annual compound rate of 8%, the painting's current value would be approximately $11 million. My thanks to Diane Zannoni of the Economics Department of Trinity College for helping me obtain and analyze these government records.

14. An official Level family notice of July 1920 listing the brothers' titles reflects their professional prominence: André Level, general administrative secretary of the Compagnie des Docks et Entrepôts de Marseille; Emile Level, general director of the Banque National de Crédit; Jacques Level, chief administrator of the Société Electro-Metallurgique Française; Maurice Level, director of the Société d'Entreprise pour la Reconstruction de Rheims. Georges Ancey (1860–1917) published a volume of poetry, *Autres choses,* in 1886 but was best known as the author of such plays as *Monsieur Lamblin* (1888) and *L'école des veufs* (1889).

15. Level, *Souvenirs d'un collectionneur,* 18. Level also bought two of Piot's watercolors in 1904. Regarding his meeting with Matisse, Level observed: "A very good comrade, he [Piot] introduced me to Henri Matisse, whose talent he greatly admired and who he knew had a family and wanted to sell. Our small committee thus bought several paintings from the latter [Matisse]." Matisse and Piot had become friends when both of them studied in the studio of Gustave Moreau during the mid-1890s.

16. In a note of March 19, 1904, Matisse confirms receipt of 550 francs from Level for the purchase of several paintings. He states that he will reclaim one of them, a snow scene (Peau de l'Ours, no. 38, date and location unknown), from the dealer Druet in order to give it to Level (thereby presumably excluding Druet from the transaction). He also mentions a still life that was a part of the purchase (*Still Life with Eggs,* Peau de l'Ours, no. 36, 1896, location unknown). In a note of March 22, 1904, Matisse apologizes for complications that have prevented Level from picking up his purchases and offers to deliver the *Interior* (*Studio under the Eaves,* Peau de l'Ours, no. 37, 1902, Fitzwilliam Museum, Cambridge) to Level's home. In a letter of April 22, 1904, Matisse discusses plans to show Level some photographs (of his work?) and asks Level's permission to borrow *Still Life with Eggs* for Vollard's show, which was scheduled to open on May 3. All correspondence is in the archive collection of the Getty Center for the Humanities. My thanks to Judith Cous-

ins of the Museum of Modern Art for telling me about this correspondence and giving me copies of it.

17. For these interpretations, see, for example, Alfred H. Barr, Jr., *Matisse: His Art and His Public*, New York, 1951, 50, and Jack Flam, *Matisse: The Man and His Art, 1869–1918*, Ithaca, 1986, 103, 106.

18. Dated 1896, *Still Life with Eggs* appears to have been the earliest painting by Matisse in the collection.

19. In a letter of July 15, 1903, to Simon Bussy, Matisse says: "In brief, my plan is to start a small syndicate that would give me enough money to work for a year in the country . . . 2400 francs would be enough—in return I would give the syndicate two canvases a month, number 10 format, say, thus 24 a year. If there were twelve people in the syndicate, say, their share would be 200 francs each. That seems to me quite modest!" (reproduced in Flam, *Matisse*, 82). I believe that Matisse's scheme for a consortium to buy his paintings probably informed Level's plan to found La Peau de l'Ours. Since Level's idea dates from his experience at the 1903 Salon d'Automne, La Peau de l'Ours postdates Matisse's scheme. Level said that René Piot introduced him to Matisse after he founded La Peau de l'Ours, so it appears that Level would have had to learn about Matisse's project from a third party. As a friend of both men, Piot would probably have known of Matisse's plan by the summer or fall of 1903 and would have been the likely (but probably not the only) conduit to Level. Although Level does not mention Matisse's plan or any other, similar scheme, he could have simply forgotten. Given this possible line of communication and the remarkable similarity of the two projects (Matisse's project also included a sale of the collection—see his letter of August 27, 1903, to Manguin, quoted in Pierre Schneider, *Matisse*, New York, 1984, 726), I am inclined to believe that Level's plan originated, at least indirectly, with Matisse. Schneider also comes to this conclusion, although without discussing how it could have occurred.

20. It is difficult to determine when La Peau de l'Ours acquired the seven other paintings by Matisse that appeared in the auction. They are no. 31, *Etude de femme*, c. 1899–1900 (Tate Gallery, London); no. 32, *L'hôpital d'Ajaccio*, c. 1898 (Musée National d'Art Moderne, Paris); no. 33, *La mer en Corse*, c. 1898 (location unknown); no. 34, *Le moulin*, c. 1898 (previously coll. André Lefevre, 1966); no. 35, *Feuillages au bords de l'eau*, 1898 (private collection, Paris); no. 39, *La nature morte à la serviette*, 1904 (Mrs. John Hay Whitney, New York); no. 40, *Compotier de pommes et oranges*, 1899 (Baltimore Museum of Art). I would like to thank Wanda de Guébriant for her assistance in identifying these paintings. Level stated only that he purchased work by Matisse "à nouveau" in 1906 and in 1910, without specifying the number of purchases (*Souvenirs d'un collectionneur*, 20, 26). Although it is tempting to associate these purchases with Matisse's shows at the Galerie Druet in 1906 and the Galerie Bernheim-Jeune in 1910, I have found no evidence to confirm this conjecture, and we know that Level did not necessarily buy from exhibitions. For Level's visits to Matisse's studio during 1907 and 1908 and his efforts to sell some of Matisse's major paintings to other collectors at a time when Matisse was considering taking a "night job" with the state because of his great financial need, see *Souvenirs d'un collectionneur*, 19. As

Level recounts, "less than one year later, he [Matisse] really began to sell." Presumably, this would have been about 1909.

21. My discussion of Berthe Weill is based primarily on her exuberant autobiography, *Pan! . . . dans l'oeil . . . ou trente ans dans les coulisses de la peinture contemporaine 1900–1930*, Paris, 1933.

22. Christian Zervos, *Pablo Picasso*, Paris, vol. 21, 1969, no. 240.

23. For Picasso's deficient grasp of French and his awkwardness in French society during the first decade of the twentieth century, see John Richardson, *A Life of Picasso*, vol. 1 (1881–1906), New York, 1991, esp. 204–05 and 416.

24. Zervos, *Pablo Picasso*, vol. 4, 1951, no. 76.

25. Weill, *Pan! . . .* , 71.

26. Ibid., 63.

27. The exhibition at the Galerie Berthe Weill ran from October through November 20, 1904. *Intimacy* was no. 37.

28. Quoted in Pierre Daix and Georges Boudaille (with the collaboration of Joan Rosselet), *Picasso 1900–1906: Catalogue raisonné de l'oeuvre peint*, Neuchatel, 1966, 215.

29. Daniel-Henry Kahnweiler with Francis Crémieux, *My Galleries and Painters*, New York, 1971, 91.

30. For an interpretation of Picasso as deeply sympathetic to anarchism, see Patricia Leighten, *Re-ordering the Universe: Picasso and Anarchism, 1897–1914*, Princeton, 1989. After quoting from a manuscript by Paul Signac ("The anarchist painter is not he who depicts anarchist scenes, but he who, without care for lucre, without desire for recompense, struggles with all his individuality against the bourgeois and official conventions through personal action"), Leighten concludes: "Such doubtless were Picasso's thoughts, however self-serving they may seem in retrospect" (131). Although it is possible that Picasso entertained these thoughts about his work, Kahnweiler's statement directly confirms Picasso's long-standing desire for financial gain.

31. See Richardson, *A Life of Picasso*, 198–99, for a revealing discussion of this series of exchanges. These activities were not unusual among avant-garde artists; see, for example, Manet's portrait of Zola (1867–68).

32. *The Blue House* was no. 17 in Berthe Weill's show of November 15–December 15, 1902. Based on Level's incomplete account, it is possible to deduce that the following works were probably also included in this group of six: no. 64, *Women and Children*, 1901 (City Museum of St. Louis, Daix and Bourdaille, no. V.9); and no. 65, *Man in a Cloak*, 1900 (Von der Heydt-Museum, Wuppertal, Daix and Bourdaille, no. II.21). The remaining three works must have come from the four that cannot be given a precise date of acquisition: no. 122, *Absinthe* (the poet Cornuty), 1902–03 (private collection, Daix and Bourdaille, no. VIII.2); no. 124, *Woman and Child*, 1901 (private collection, Küsnacht, Zurich, Daix and Bourdaille, no. VI.29); no. 127, *Domestic Interim with Child*, 1904 (private collection, Marseilles, Daix and Bourdaille, no. D.XI.6); no. 128, *Contemplation*, 1904 (Mrs. Bertram Smith, New York, Daix and Bourdaille, no. XI.12). Except for the acquisition of 1904 (*Intimacy*, no. 125), all other Picassos entered the collection after 1906: in 1909—no. 63, *The Family of Saltimbanques*, 1905 (National Gallery of Art, Washington, D.C., Daix and Bourdaille, no. XII.35), and no. 67, *Fruits dans une écuelle*,

1908 (Kunstmuseum, Basel, Daix and Rosselet, no. 199); and in 1911—no. 123, *Three Dutch Girls*, 1905 (Musée National d'Art Moderne, Paris, Daix and Bourdaille, no. XIII.2), and no. 126 *Clown on Horseback*, 1905 (Mr. and Mrs. Paul Mellon, Upperville, Virginia, Daix and Bourdaille, no. XII.24). My thanks to Pierre Daix for his aid in identifying these pictures.

33. Level, *Souvenirs d'un collectionneur*, 28.
34. Ibid., 23–24.
35. Ibid., 28.
36. Ibid., 24. In a self-portrait of circa 1907, Picasso parodied his dependence on his patrons by drawing himself as a supplicant holding his hat. Gertrude Stein enclosed the drawing, inscribed by Picasso "Bonjour Mlle Cone," in a letter of January 7, 1908, to Etta Cone. The drawing is in the Baltimore Museum of Art (1950.12.481).
37. In a note dated January 24, 1908, Level says that a framer will come the next day to measure the painting.
38. The portrait of Level is dated January 20, 1918. It does not appear in the Zervos catalogue of Picasso's work. In a note dated January 19, 1918, the day before this portrait was drawn, Level accepts Picasso's invitation to lunch the next day and says: "I haven't had a minute all week to go see Apollinaire. I hope you'll give me good news" (Picasso Archive, Musée Picasso, Paris).
39. André Level, *Picasso*, Paris, 1928, 26. For the most extensive analysis of *The Family of Saltimbanques* (including a discussion of its presence in La Peau de l'Ours), see E. A. Carmean, Jr., *Picasso: The Saltimbanques*, Washington, D.C., 1980.
40. Pierre Daix and Joan Rosselet, *Picasso: The Cubist Years, 1907–1916*, New York, 1979, 228, no. 199; purchased from Galerie Kahnweiler (archive photo no. 126).
41. The three-year contract specified prices for canvas sizes from no. 6 (450 francs) to no. 50 (1,875 francs), granted Matisse 25 percent of the gallery's profit on any sales, and stipulated—among other things—that, if Matisse sold any paintings directly, their prices would be at least twice the price paid by the gallery. These prices are considerably higher than those paid by Level in 1911. The right to accept commissions for decorations free of the gallery proved important. This category included the two canvases that Matisse painted for Shchukin in 1910—*The Dance* and *Music*. At 14,000 francs, *The Dance* was one of the most expensive twentieth-century painting sold before World War I.
42. In a letter dated September 1909, Fernande Olivier invited Gertrude Stein to visit Picasso and her new home and inquired whether the Steins' housekeeper might know of someone she could hire as a maid (Olivier, *Souvenirs intimes*, Paris, 1988, 237).
43. Besides the famous portrait of Gertrude Stein, Picasso also painted, in 1906, a portrait of Leo Stein and a portrait of Michael Stein's son, Allan.
44. Pierre Daix originally dated the portrait of Pallarès to the spring of 1909 (Daix and Rosselet, 241) but has more recently located it in the month of May (see the "Documentary Chronology" in the catalogue *Picasso and Braque: Pioneering Cubism*). The one exception to Picasso's avoidance of portraiture

between 1910 and 1915 appears to be an ink portrait of Apollinaire (Daix and Rosselet, no. 579 [1913]) that served as frontispiece to *Alcools* (1913).

45. Daix dated the portrait of Sagot to the spring of 1909, the portraits of Vollard and Uhde to winter 1909–10 or spring 1910, and the portrait of Kahnweiler to autumn 1910 (Daix and Rosselet, 240, 253, 259). In the *Picasso and Braque* catalogue, the portraits of Vollard and Uhde are dated spring [–autumn] 1910 (173 and 175) and the Kahnweiler autumn–winter 1910 (181). Since seeing the exhibition, Daix has basically accepted this revision of the chronology (see *Picasso: Life and Art*, 102).

46. See the "Documentary Chronology" in *Picasso and Braque*, 365.

47. See Centre Georges Pompidou, *Daniel-Henry Kahnweiler*, Paris, 1984, 97. See also Pierre Assouline, *L'homme de l'art: D. H. Kahnweiler (1884–1979)*, 1988, 71–74.

48. Picasso's first contract with the Galerie Kahnweiler is dated December 18, 1912. Like Matisse's contract with Bernheim-Jeune, it was for a period of three years. Based on research in the Kahnweiler Archive of the Galerie Louise Leiris, David Cottington has concluded that Kahnweiler bought at least twelve works from Picasso in 1908, thirty-five to forty-five in 1909, sixty in 1910, and forty-five in 1911 (*Cubism and the Politics of Culture*, 203, n. 116).

49. *Three Dutch Girls* is in the collection of the Musée National d'Art Moderne in Paris. *Harlequin on Horseback* is in the collection of Mr. and Mrs. Paul Mellon, Upperville, Virginia.

50. This phenomenal rise in prices in the years before the First World War extended across a wide spectrum, from so-called Old Masters to the Parisian avant-garde. See Ernest Samuel's discussion in *Bernard Berenson: The Making of a Legend*, Cambridge, 1987, esp. "The Ixion Wheel of Business," 99–118.

51. For an examination of the Drouot system, see Michael FitzGerald, "Demystifying Drouot," *Art and Auction*, October 1989, 134–43.

52. A partial list of the notices includes: Tabarant, "La Peau de l'Ours," *Paris-Midi*, February 24, 1914, 2; Valmont, "Collection de la 'Peau de l'Ours,' " *Le Figaro*, February 26, 1914, 7; Anon., "La Peau de l'Ours," *Le Figaro*, March 3, 1914, 6; André Warnod, "La vente de la 'Peau de l'Ours,' " *Comoedia*, March 3, 1914, n.p.; Seymour de Ricci, "La 'Peau de l'Ours,' " *Gil Blas*, March 3, 1914, 4; Maurice Delcourt, "Avant l'invasion," and Joachim Gasquet, "La bataille autour de la 'Peau de l'Ours,' " *Paris-Midi*, March 3, 1914, 2; Anon., "Peau de l'Ours Collection Is Sold in Paris," *New York Herald*, March 3, 1914, 11.

53. The auction total was 116,545 francs ($23,309, or in 1991 approximately $8,871,000). The twelve works by Picasso brought 31,301 francs (27%), and the ten by Matisse 17,298 francs (15%). These works, combined with those of the Fauve group, total 56% of the sale. With the addition of the Nabis (11%) and Impressionist and Post-Impressionist works (21%), the total is 88%. Besides works by van Gogh, Gauguin, Picasso, and Matisse, the highest-priced works were no. 47, Pierre Laprade, *Young Girl Singing* (2,310 francs); no. 88, Vuillard, *Woman in Blue* (2,640 francs); and no. 101, Guys, *Promenading Couple* (2,365 francs). The prices cited include the 10 percent premium paid by buyers. A second, private auction was held by La Peau de

l'Ours on March 15, 1914, at the home of Georges Ancey to distribute minor works (including nine by Raoul Dufy and five by René Piot) and one piece that did not sell in the public offering (La Fresnaye's *Still Life with Three Pots*, no. 22, which sold in the second sale to Maurice Level for 170 francs). This sale of forty-seven lots raised 3,035 francs. The highest price (320 francs) was paid for Piot's watercolor *Bouquet of Flowers* (no. 38).

54. In his account, André Salmon said that when the auctioneer's hammer fell after the sale of *The Family of Saltimbanques*, "we all rose, applauding. We restrained ourselves from singing. What? The *Paloma*, that loves so much the victor of the day; the *Marseillaise* or the Spanish royal hymn, Pablo no longer being a revolutionary, or just as well the *Langouste atmospherique*, Max Jacob's success" (*Souvenirs sans fin*, 260). Clearly Salmon's perception of this event as marking Picasso's passage from revolutionary to respected member of society caused Salmon and his friends not to mourn but rather to celebrate playfully the new status of the avant-garde artist.

Paul Jamot (1863–1939) had joined the staff of the Louvre in 1890 and risen through many departments to become adjunct curator in the Department of Painting and Drawings in 1902. (In 1919, he became the department director.) His exhibitions and publications included *La Collection Camondo au Louvre* (1914), *Manet* (1932), and *Degas* (1939).

55. Thannhauser's boast was reported by Seymour de Ricci in "La 'Peau de l'Ours.' " On February 20, 1914, Kahnweiler wrote separately to Shchukin and to Morozov to recommend that they bid on *The Family of Saltimbanques* (Kahnweiler Archive, Galerie Louise Leiris, Paris). My thanks to Quentin Laurens for confirming this information. In 1913, Kahnweiler had sold Picasso's *Acrobat on a Ball*, 1905 (Pushkin Museum, Moscow) for 16,000 francs. At 147 × 95 cm., it is less than half the size of *The Family of Saltimbanques* (213 × 230 cm.). Roughly translated into 1991 dollars, the amount Thannhauser paid in 1914 is approximately $4.18 million. When one considers the $40.7 million paid by Walter Annenberg for *At the Lapin agile* (another major painting of 1905, measuring only 99 × 100 cm.) on November 15, 1989, there seems to be little doubt that the dollar value of the *Family of Saltimbanques* has far outstripped inflation and the rate of appreciation for less important works.

56. For examinations of avant-garde artists' responses to the First World War, see Kenneth E. Silver, *Esprit de Corps: The Art of the Parisian Avant-Garde and the First World War, 1914–1925*, Princeton, 1989; Christopher Green, *Cubism and Its Enemies: Modern Movements and Reaction in French Art, 1916–1928*, New Haven and London, 1987; and Patricia Leighten, *Re-ordering the Universe*. Delcourt's article demonstrates that the derogatory association of Cubism with German culture preceded the beginning of the war rather than followed it, as has frequently been assumed. For the broader response of French society, see Robert Wohl, *The Generation of 1914*, Cambridge, 1979, and Eugene Weber, "The Nationalist Revival before 1914," *My France*, Cambridge and London, 1991, 189–204.

57. Maurice Delcourt, "Avant l'invasion," *Paris-Midi*, March 3, 1914, 2.

58. Letter of April 27, 1991, from Quentin Laurens to the author. See also As-

souline, *An Artful Life: A Biography of D. H. Kahnweiler, 1884–1979*, New York, 1991, 109–10, 111, 153.

59. According to the Centre Georges Pompidou catalogue *Daniel-Henry Kahn-weiler*, the exhibition contained thirty-two works by Picasso and ran from March through April 1913.

60. Ibid. See Christian Geelhaar, *Picasso: Wegbereiter und Förderer seines Auf-steigs 1899–1939*, Zurich, 1993, for an analysis of the Picasso market in Germany and Switzerland. The second volume of John Richardson's biography of Picasso will clarify Kahnweiler's ties with many of the German and Eastern European dealers and collectors.

61. Centre Georges Pompidou, *Daniel-Henry Kahnweiler*, 119, and Assouline, *An Artful Life: A Biography of D. H. Kahnweiler, 1884–1979*, New York 1991, 109–10, 111, 151–152. The first exhibition of Picasso's art in America had occurred at the Photo-Succession in 1911. It consisted of 83 drawings and watercolors from 1905–10 and was organized by Edward Steichen, Marius de Zayas, Frank Burty, and Alfred Stieglitz in conjunction with Picasso. All the works came from Picasso's studio. During 1914–15, works by Picasso appeared in several exhibitions at the Photo-Succession.

62. This estimation of Kahnweiler's sales is based on a comparison of the total number of Picasso's paintings and collages that appeared in the sales of Kahn-weiler's stock in 1921–23 with the number of these works that Pierre Daix identifies as having belonged to Kahnweiler (Daix and Rosselet). Since Kahn-weiler's stock was sequestered from the fall of 1914 until its dispersion at auction, the subtraction of the works sold in the Kahnweiler auctions from those known to have been owned by the gallery results in a rough estimate of the total number that Kahnweiler sold during his association with Picasso between 1907 and 1914. David Cottington's examination of the Galerie Kahnweiler records generally confirms my conclusion.

63. Letter of April 27, 1991, from Quentin Laurens to the author.

64. This sketchbook page is no. MP 764v in the Musée Picasso in Paris. It measures 22 × 17.2 cm.

65. Picasso kept these informal accounts on the inside cover and facing page of a small sketchbook (4½ × 3⅜ in). After Picasso's death, it was inherited by Marina Picasso (sketchbook no. 26, inv. 7945–7962). Besides the Peau de l'Ours payment, all the recorded receipts during the last four months of 1913 and all of 1914, except an unidentified one for 100 francs, are from Kahn-weiler (abbreviated as "K"): 15,850.15 francs on October 15, 1913; 4,950 francs on November 15, 1913; 3,250 francs on December 22, 1913; 5,688 francs on April 4, 1914; 1,650 francs on May 11, 1914; and 12,400 francs on June 8, 1914. Since Kahnweiler had agreed (on March 4, 1913) to pay Picasso 27,250 francs for his production during the first part of 1913 (and for a few older works), Picasso's income from the gallery during 1913 was at least 51,400 francs. I would like to thank Quentin Laurens of the Galerie Louise Leiris for communicating information in the Kahnweiler Archive and con-firming that the payment of June 8, 1914, was the last Picasso received from the gallery until he and Kahnweiler resumed business after Kahnweiler's return to France in February 1920.

Level's payment was included in a letter, dated April 3, 1914, that reads

in part: "You have known for a long time that the Association of the Peau de l'Ours decided at the beginning to reserve for artists 20% of the profits (net of expenses). We would be pleased for you to accept, in the attached check no. 62.927 on the Banque nationale de crédit, the part that is legitimately yours by right of authorship" (Picasso Archive, Musée Picasso). In 1991, 3,978.85 francs ($975.77) would be worth approximately $302,853.

66. E. A. Carmean proposes that the presence of Level's card in *Bottle of Bass, Wine Glass, Packet of Tobacco, and Calling Card* commemorates the Peau de l'Ours sale (78).

67. According to the document of the "Liquidation de l'Association," the 20 percent share assigned to artists was 12,641.49 francs ($2,528.30, or in 1991 approximately $962,215). Matisse was due approximately 2,000 francs. By May 29, 11,186.98 francs had been distributed, and 1,454.51 francs remained. This latter amount was primarily used to compensate widows and artists in need during the First World War through donations of small sums upon request ("Rapport du comité," dated January 9, 1920). Letters of thanks from a number of the recipients have been preserved. Many of these letters were sold by the Parisian auctioneer Stephane Deurbergue on March 27, 1984, and some are now in the archive of the Getty Center for the Humanities.

CHAPTER 2

1. Guillaume Apollinaire, "The Arts: Futurism and the Ballets Russes," *Paris Journal*, May 24, 1914; reprinted in *Apollinaire on Art: Essays and Reviews, 1902–1918*, ed. Leroy C. Breunig, New York, 1972, 394. For the general critical acclaim following the auction, see Pierre Cabanne, *Le siècle de Picasso*, vol. 2, Paris, 1975, 30–31.

2. Daniel-Henry Kahnweiler with Francis Crémieux, *My Galleries and Painters*, New York, 1971, 53–54.

3. Art historians have proposed different dates for *The Artist and His Model* (Musée Picasso, Paris), which was only discovered when the Picasso estate was catalogued. Pierre Daix suggests that Picasso began the picture before the declaration of war in August 1914 and that its unfinished state reflects the unsettling effect of the impending war on the artist's experimentation with Neoclassical styles (Daix and Joan Rosselet, *Picasso: The Cubist Years, 1907–1916*, New York, 1979, 164–66). Kenneth E. Silver proposes that Picasso began the painting after the declaration of war and intentionally left it unfinished (*Esprit de Corps: The Art of the Parisian Avant-Garde and the First World War, 1914–1925*, Princeton, 1989, 63–70). Silver views the painting's Neoclassical style as at least partly a reflection of Picasso's response to the war and an example of a conservative trend in his work and that of others. Silver's interpretation appears to dismiss Kahnweiler's statement that Picasso had already begun to experiment with classicism during the spring of 1914 and to ignore that the two drawings of a seated man appear to be linked with both the style and subject of *The Artist and His Model*. Thus, I believe that Daix's dating of the painting and his reconstruction of Picasso's response to the declaration of war more accurately reflect the facts as we know them. The exact drawings that Picasso showed Kahnweiler have not been identi-

fied. The drawing illustrated here is presumably closely related and is generally dated summer 1914.

4. See Daix and Rosselet, 164.

5. Ibid., 312.

6. As in-depth study of Picasso's work shifts from prewar Cubism to the phases during and after the war, this problem is only beginning to be addressed. See Daix, *Picasso: Life and Art*, New York, 1993; Silver, *Esprit de Corps*; Christopher Green, *Cubism and Its Enemies: Modern Movements and Reaction in French Art, 1916-1928*, New Haven and London, 1987; and Elizabeth Cowling and Jennifer Mundy, *On Classic Ground: Picasso, Léger, de Chirico and the New Classicism, 1910-1930*, New York, 1990.

7. Gertrude Stein, *The Autobiography of Alice B. Toklas*, New York, 1990, 141. The waning of Picasso's artistic collaboration with Braque is documented by their physical separation during significant periods of 1913 and 1914, as well as by Braque's admission in his letters to Kahnweiler that he was not in close touch with Picasso. See the "Documentary Chronology" by Judith Cousins and Pierre Daix in *Picasso and Braque: Pioneering Cubism*, ed. William Rubin, New York, 1989. See also Daix, *Picasso: Life and Art*, 136.

8. For the reception accorded Cubist exhibitions during the prewar years, see Pierre Daix, *Cubists and Cubism*, New York, 1982, p. 86. See also Daniel Robbins, "Jean Metzinger: At the Center of Cubism," *Jean Metzinger in Retrospect*, ed. Joann Moser, Iowa City, 1985, 9-23.

9. For a discussion of these reappraisals of Picasso's pre-Cubist work, see Cabanne, *Le siècle de Picasso*, vol. 2, 30-31.

10. Kahnweiler and Crémieux, *My Galleries and Painters*, 53-54.

11. Silver, *Esprit de Corps*, 64.

12. For the identification of the sleeping woman in *Meditation* as Fernande Olivier, see William Rubin, *Picasso in the Collection of the Museum of Modern Art*, New York, 1972, 30. For the association of the model in *The Artist and His Model* with Eva, see Daix, *Picasso: Life and Art*, 139.

13. Both Apollinaire and Braque suffered head wounds and were trepanned. Braque slowly recovered from his wound. Apollinaire never fully did, and he succumbed to the worldwide influenza epidemic in November 1918.

14. Gris wrote to Kahnweiler on October 30, 1914: "Matisse also writes from Paris . . . that Picasso, from whom I have heard nothing in two months although I have written to him, withdrew a large sum—they say one hundred thousand francs—from a bank in Paris on the outbreak of war" (Daniel-Henry Kahnweiler, ed., *Letters of Juan Gris*, London, 1956, 14-15). It seems very unlikely that Picasso could have had 100,000 francs. He may well, however, have reacted to the beginning of war by withdrawing his savings.

15. See Pierre Assouline, *An Artful Life: A Biography of D.-H. Kahnweiler, 1884-1979*, New York, 1990, 114.

16. For the inventory that was made before the collection was split, see Centre Georges Pompidou, *Donation Louise et Michel Leiris, Collection Kahnweiler-Leiris*, Paris, 1984, 170.

17. Theodore Reff notes the impact of Kahnweiler's exile on Picasso's state of mind in 1915-16 ("Picasso at the Crossroads, Sketchbook No. 59, 1916," in *Je suis le cahier: The Sketchbooks of Pablo Picasso*, ed. Arnold Glimcher and

Mark Glimcher, New York, 1986, 83. Pierre Daix observes that, once the war had begun, "Picasso lost all possibility of sales" (*Picasso créateur*, Paris, 1987, 149).

In anticipation of his return to France, Kahnweiler wrote to Picasso on February 10, 1920, to explain why the financial structure of his business had prevented him from paying the 20,000 francs. Kahnweiler wanted not only to resolve the dispute so that Picasso and he could resume their prewar business relationship but also to convince him to stop urging the liquidation of the Galerie Kahnweiler stock that the French government held. After describing his credit situation and cautioning Picasso that the liquidation of the gallery stock might not lead to the repayment of the debt, since many other creditors would also demand a share of the proceeds, Kahnweiler made an emotional appeal based on their past friendship and his devotion to the art he had championed: "Our relationship, after all, has not been the ordinary relationship between painter and dealer . . . You surely know that I have only these pictures. They are my fortune; they are also my life. I was there when you needed me" (Picasso Archive, Musée Picasso). Isabelle Monod-Fontaine briefly discusses the situation and includes an excerpt from this letter (not the passage above) in *Donation Louise et Michel Leiris, Collection Kahnweiler-Leiris*, 171. Picasso's records in the Musée Picasso indicate that he did not sell anything to Kahnweiler until the dealer paid him 20,500 francs on May 29, 1923. Presumably, this sum settled the debt from 1914, but Kahnweiler's recorded purchases over the next few years were still extremely modest (for example, three lithographs for 3,000 francs on February 8, 1924)— probably because Picasso honored his agreement with his primary dealer, Paul Rosenberg, and because he still resented Kahnweiler's earlier behavior.

18. The portrait of Vollard is Zervos 2(II).922 (Metropolitan Museum of Art, New York). For a vivid account of a lighthearted day in Picasso's life during the war, see Billy Klüver, "A Day with Picasso," *Art in America*, September 1986, 97–106, 161–63.

19. Letter of November 28, 1914, from Alice Derain to Level (Getty Center for the Humanities).

20. André Level, *Picasso*, Paris, 1928, 38. Apollinaire's review of the auction included an excerpt from the catalogue text written by Level and concluded: "I would like to meet the authors of this excellent page to shake their hands" (*Mercure de France*, March 16, 1914, 433). The opportunity came on May 24, 1914, at a concert by Albert Savinio sponsored by the magazine *Les soirées de Paris*; the resulting friendship lasted until Apollinaire's death in November 1918. For this relationship and the many letters that document it, see Brigitte Level, ed., *Guillaume Apollinaire—André Level*, Paris, 1976.

One way in which Level aided Picasso was by serving as his agent in the legal action Picasso began in late 1914 against Kahnweiler. In this unfortunate affair, Level negotiated on Picasso's behalf with both the government official in charge of the Galerie Kahnweiler's sequestered stock, a Monsieur Nicolle, and the lawyer Henri Danet, who represented Picasso against Kahnweiler. Correspondence in the Picasso Archive of the Musée Picasso records these negotiations between December 1914 and November 1920 and suggests that Picasso continued to urge the liquidation of the Galerie Kahnweiler's

stock after Kahnweiler's appeal of February 10, 1920. The stock was sold in a series of auctions in 1921 and 1923.

21. Level, *Picasso*, 38. During 1915, Picasso's handlist showed both how few sales Picasso made and the role that Rosenberg began to play in his financial survival. The list records the following receipts: from Gertrude Stein (abbreviated "GS"), 3,000 francs for two small still lifes; from Léonce Rosenberg, 3,000 francs for two small still lifes and 1,200 francs for six small drawings; and from André Level, 400 francs for two drawings; as well as nine unidentified amounts for an annual total of 25,050 francs. Gertrude Stein's purchases may have been Daix and Rosselet nos. 780 and 781; the paintings bought by Léonce Rosenberg may have been nos. 837 and 838, and the drawings may have included nos. 820, 821, and 825.

22. René Gimpel, *Diary of an Art Dealer, 1918–1939*, New York, 1966, 107 (entry for July 15, 1919).

23. Level, *Picasso*, 38.

24. E. Tériade, "Nos enquêtes: Entretien avec M. Léonce Rosenberg," *Cahiers d'art* (feuilles volantes), 1927, 2. Since La Peau de l'Ours included few Cubist works, it is worth noting that Rosenberg identified Level as a supporter of Cubism.

25. Letter of October 30, 1914, from Léonce Rosenberg to Picasso. Unless otherwise stated, all correspondence from Léonce Rosenberg to Picasso is in the Picasso Archive of the Musée Picasso.

26. Letter of December 24, 1914, from Léonce Rosenberg to Picasso.

27. Interview with Léonce Rosenberg in *Montparnasse* (June 1926) by Georges Charles, "Le cubisme ce pense M. Léonce Rosemberg [sic]."

28. Letter of December 9, 1915, from Picasso to Gertrude Stein (Gertrude Stein Archive, Beinecke Rare Books and Manuscript Library, Yale University). Reprinted in Daix and Rosselet, 248.

29. Rubin, *Picasso in the Collection of the Museum of Modern Art*, 98; Reff, "Picasso at the Crossroads," 85.

30. Letter of November 3, 1915, from Léonce Rosenberg to Picasso.

31. For interpretations of the *Harlequin* and Picasso's earlier uses of the subject, see Theodore Reff, "Harlequins, Saltimbanques, Clowns and Fools," *Artforum*, 10, October 1971, 30–43; "Themes of Love and Death in Picasso's Early Work," in *Picasso in Retrospect*, ed. Roland Penrose and John Golding, New York, 1973; and William Rubin, *Picasso in the Collection of the Museum of Modern Art*, 98–100.

32. Daix and Rosselet, 845. The authors propose that Picasso painted this watercolor in late 1915 and that the date of 1916 inscribed on it records when Level acquired it. Their conjecture corresponds to my belief that Level received it for his aid in negotiating the sale of the *Harlequin* to Léonce Rosenberg.

33. For discussions of Picasso's relationship with Matisse, see John Richardson, *A Life of Picasso*, vol. 1 (1881–1906), New York, 1991; Jack Flam, *Matisse: The Man and His Art, 1869–1918*, Ithaca, 1986; and John Elderfield, *Henri Matisse: A Retrospective*, New York, 1992.

34. It was previously thought that Matisse saw Picasso's *Harlequin* in the spring of 1916.

35. For Matisse's commercial relations with Bernheim-Jeune and other dealers during the war, see Pierre Schneider, *Matisse*, New York, 1984; and Judith Cousins's "Chronology" in Elderfield, *Henri Matisse*. Matisse was under contract with Bernheim-Jeune from September 18, 1909, to September 15, 1915. The relationship lapsed until he signed another contract on October 17, 1917. He was under contract with Bernheim-Jeune until September 1926 and continued to work with them until 1936.

36. In a letter of November 3, 1915, to Picasso, Rosenberg had agreed to pay by the end of January 1916, but in a letter of November 29, 1916, he finally acknowledged his inability to meet the price and canceled the purchase.

37. Letter of March 24, 1916, from Léonce Rosenberg to Picasso. Picasso lent his work for an exhibition held at Marius de Zayas's Modern Gallery in New York from December 15, 1915, to January 16, 1916. Having helped organize the first exhibition of Picasso's work in America at the Photo-Succession gallery in 1911, de Zayas borrowed eleven works from Picasso, including seven paintings. Among them were *Portrait of a Young Girl* (1914) and *Man in a Bowler Hat* (1915). Two of the paintings were soon acquired by American collectors: Walter Arensberg bought *Female Nude* (1910) before 1918, and Arthur B. Davies acquired *Bar-table with Musical Instruments*, probably in the late teens. In 1918, de Zayas exhibited Picasso's work in a group show. For de Zayas's role in introducing twentieth-century art to America, see Marius de Zayas, "How, When and Why Modern Art Came to New York," *Arts Magazine*, April 1980, 96–120; introduction and notes by Francis M. Naumann.

38. Letter of May 1, 1916, from Jean Cocteau to Valentine Hugo, quoted in Francis Steegmuller, *Cocteau: A Biography*, New York, 1970, 150–51.

39. For Léonce Rosenberg's relations with artists other than Picasso, see Malcolm Gee, "The Avant-Garde, Order and the Art Market, 1916–1923," *Art History*, March 1979, 95–106, and Christian Derouet, "Juan Gris: A Correspondence Restored," in Christopher Green, *Juan Gris*, London, 1992.

40. Letter of December 2, 1918, from Léonce Rosenberg to Picasso.

41. Cocteau proposed a Rose period scenario for the ballet, which Picasso and he collaborated on in 1916–17 (Pierre Daix, *Picasso créateur*, Paris, 1987, 159). John Richardson notes the apparent reference to the Peau de l'Ours sale in the print that Picasso provided for Level's autobiography (*A Life of Picasso*, 517–18, n. 4).

42. Letter of September 25, 1915, from Jean Cocteau to Picasso. All correspondence from Cocteau to Picasso is in the Picasso Archive of the Musée Picasso unless otherwise specified.

43. See Steegmuller, *Cocteau*, 137–38.

44. Letter of June 10, 1919, from Jean Cocteau to Picasso.

45. John Richardson is one of the few scholars who have realized the importance of Errazuriz in Picasso's life; see "Eugenia Errazuriz," *House and Garden*, April 1987, 76–84.

46. Letter of October 25, 1916, from Jean Cocteau to Picasso.

47. "L'adorable Eugenia" is Maya Widmaier Picasso's phrase (letter of December 8, 1991, to the author).

48. For an account of Diaghilev's visit to Picasso's studio, see Richard Buckle, *Diaghilev*, New York, 1979, 312.

49. Richardson, "Eugenia Errazuriz," 77.

50. Ibid. *Portrait of a Young Girl* is in the collection of the Centre Pompidou; *Man Leaning on a Table* is with Marlborough Fine Art, Ltd., London.

51. Errazuriz's letters to Picasso (preserved in the Picasso Archive of the Musée Picasso) contain references to several payments. Richardson cites her financial support of artists ("Eugenia Errazuriz").

52. Deborah Menaker Rothchild, *Picasso's Parade*, London, 1991, 209–38.

53. Letter of June 4, 1917, from Léonce Rosenberg to Picasso. Derouet claims that Paul Rosenberg was a part of a consortium of dealers who tried to negotiate a contract with Picasso in June 1917 but does not cite any documentation ("Juan Gris," 290). It is possible that Paul was a part of the group Léonce refers to in his letter; I do not know, however, of any documented relationship between Paul and Picasso before January 1918. Nonetheless, it is likely they had met earlier, through Léonce.

54. For a brief biography of Paul Guillaume, see Michel Hoog, *Catalogue of the Jean Walter and Paul Guillaume Collection*, Paris, 1990, 5–11. See also Colette Giraudon, *Paul Guillaume et les peintres du xxème siècle*, Paris, 1993. Guillaume's collection is housed in the Musée de l'Orangerie; his letters to Picasso are preserved in the Picasso Archive of the Musée Picasso.

55. Letter of July 1, 1915, from Guillaume Apollinaire to Paul Guillaume (Jean Bouret, "Une amitié esthétique au début du siècle: Apollinaire et Paul Guillaume," *Gazette des Beaux-Arts*, December 1970, 383–84.

56. Letters of May 6 and May 7, 1917, from Paul Guillaume to Picasso.

57. Quoted in Steegmuller, *Cocteau*, 165.

58. Letter of May 15, 1917, from Juan Gris to Léonce Rosenberg (Centre Pompidou, Paris).

59. Letter of September 1917 from Jean Cocteau to Léonce Rosenberg (Centre Pompidou, Paris).

60. For a discussion of works included in this exhibition, see Daix, *Cubists and Cubism*, 138.

61. Letter of January 12, 1918, from Paul Guillaume to Picasso.

62. Receipt of January 21, 1925, from Paul Rosenberg to Picasso.

63. For Vauxcelles's and Bissière's reviews, see Daix, *Cubists and Cubism*, 138.

64. For the critical reception of Cubism during World War I, see Green, *Cubism and Its Enemies*. Green's discussion does not discuss Picasso's particular relationship to this reception.

65. Gimpel, *Diary of an Art Dealer*, 71 (entry of November 14, 1918).

66. Letter of December 2, 1918, from Léonce Rosenberg to Picasso.

67. Several of the works in the show can be identified on the basis of published reviews. See esp. Roger Allard, "Picasso," *Le nouveau spectateur*, June 25, 1919; reprinted in *A Picasso Anthology*, ed. Marilyn McCully, Princeton, 1982, 132–35. McCully suggests that the review is of the exhibition of work by Picasso and Matisse that Paul Guillaume held in 1918; the review's date, however, and Allard's mention of the *Harlequin* of 1915 tie it to the 1919 exhibition at the Galerie de l'Effort Moderne.

68. Letter of October 30, 1914, from Léonce Rosenberg to Picasso.

69. See Allard's review in McCully, *A Picasso Anthology*, 135; J.-G. Lemoine, "Picasso," *L'intransigeant*, June 12, 1919; and Gustave Kahn, "Picasso," *L'heure*, June 27, 1919.

70. André Salmon, "Picasso devant la critique," *L'Europe nouvelle*, June 21, 1919, 1205; letter of June 10, 1919, from Jean Cocteau to Picasso.

71. Members of the Rosenberg family have confirmed to me that a business relationship between Paul and Léonce continued after they officially severed their joint activities.

72. Jacques-Emile Blanche, "Cahiers d'un artiste, Decembre 1916–Juin 1917," Paris, 1920, 89. Blanche's visit took place in January 1917.

73. "Exposition d'art français du XIXe siècle au profit de l'Association Générale des mutilés de la guerre," Galeries Paul Rosenberg, June 25–July 13, 1917.

CHAPTER 3

1. On July 7, 1918, Errazuriz cabled Picasso that the pictures had arrived. See Picasso's related correspondence with Apollinaire, in Hélène Seckel and Pierre Caizergues, *Picasso/Apollinaire: Correspondance*, Paris, 1992, 166. Although these documents do not specify the contents of the shipment, Errazuriz's use of the word *tableaux* suggests that it contained not only materials but also some paintings, either finished or in progress.

 Douglas Cooper's account of the Picassos' stay with Errazuriz (*Pablo Picasso pour Eugenia*, Paris, 1976) is one of the first attempts to define this chapter in the artist's life, but Cooper did not have the benefit of the many documents that have become available in recent years. For another account of Errazuriz's activities as a patron of the arts, see Philippe Jullian, "The Lady from Chile," *Apollo*, April 1969, 264–67. For the murals Picasso painted at Errazuriz's villa, see Galerie Gmurzynska, *Pablo Picasso: La Villa Mimoseraie*, Cologne, 1993.

2. Cecil Beaton, *The Glass of Fashion*, Garden City, 1954, 205.

3. Letter of August 3, 1918, from Picasso to Guillaume Apollinaire (Seckel and Caizergues, *Picasso/Apollinaire*, 172).

4. Zervos 3.231.

5. This drawing is published in the facsimile edition of the sketchbook that Picasso gave Errazuriz in thanks for her hospitality (Cooper, *Pablo Picasso pour Eugenia*, no. 21).

6. Letter of August 28, 1918, from Picasso to Jean Cocteau (Collection of Edouard Dermit).

7. Letter of August 16, 1918, from Picasso to Guillaume Apollinaire (Seckel and Caizergues, *Picasso/Apollinaire*, 176).

8. Receipt of January 12, 1918, from Paul Rosenberg to Picasso. The extant documents pertaining to Picasso and other artists handled by the Galerie Paul Rosenberg were donated to the Pierpont Morgan Library in New York by Paul's son, Alexandre.

9. Private collection, New York.

10. In a cartoonlike series of sketches that he drew in 1902, Picasso imagined that a trip he and the artist Sebastian Junyer took from Spain to Paris culminated in Durand-Ruel's buying Junyer's paintings for a lot of money (Mu-

seo Picasso, Barcelona). The two artists did travel together to Paris in October 1902, but the outcome was quite discouraging.

11. By focusing on Picasso's relationship with Paul Rosenberg, I do not intend to dismiss the important role Picasso's marriage to Olga Koklova played in his accommodation to high society. His relationship with Koklova (and other lovers), however, has been much more fully treated than his relationships with his dealers have. For Picasso and Koklova, see Pierre Daix, *Picasso: Life and Art*, New York, 1993, 163–67, and the discussion of this biographical approach to Picasso's career in John Richardson's *A Life of Picasso*, vol. 1 (1881–1906), New York, 1991, 3–11.

12. Letter of September 27, 1918, from Paul Rosenberg to Picasso. Rosenberg's correspondence with Picasso is preserved in the Picasso Archive of the Musée Picasso in Paris.

13. E. Tériade, "Nos enquêtes: Entretien avec Paul Rosenberg," *Cahiers d'art* (feuilles volantes), no. 9, 1927, 1–2.

14. For Hessel, see E. Tériade, "Nos enquêtes: Entretien avec Monsieur Jos. Hessel," *Cahiers d'art* (feuilles volantes), nos. 4–5, 1927, 1–2. Hessel was a regular business partner with Paul Rosenberg. The pair had backed Marie Laurencin since before 1912.

Sales figures, unless otherwise noted, are drawn from handwritten accounts in two notebooks preserved in the Picasso Archive of the Musée Picasso. Although not in Picasso's hand, they must have been made by a person close enough to be familiar with his business transactions (matters he generally kept confidential). Intimacy is also suggested by the fact that the notebooks remained in Picasso's possession until they were found in the inventory of his estate. I believe that the notebooks, which begin with the sales of late summer 1918, were kept by Olga Koklova, whom Picasso had married in July. As far as I know, my conjecture is shared by the staff of the Musée Picasso and by others who have examined the notebooks.

15. During 1913, the last full year before the war, Picasso appears to have earned 51,400 francs from his contract with Kahnweiler. The very high inflation that swept France during the war and for a few years afterwards, however, makes this amount difficult to compare with his 1918 receipts from Paul Rosenberg. Between 1914 and 1919, the French retail price index rose by approximately 200 percent, and the franc was substantially devalued. The exchange rate between the dollar and the French franc fluctuated widely during World War I and immediately after it. In early 1914, a dollar bought 5.18 francs, but by 1920 the dollar was worth 13.49 francs. Thus the dollar increased relative to the franc despite the inflation that both France and the United States experienced. The disparity between the two currencies continued until 1926, when the dollar stood at 31.44 francs. From there, it declined to 15.15 francs in 1935 before beginning an ascent that left it at 119 francs at the end of World War II.

16. Letter of June 10, 1919, from Paul Rosenberg to Picasso.

17. Ibid.

18. See Salmon's essays for *L'Europe nouvelle* of March 2, 1918, October 5, 1918, and February 15, 1919.

19. To cite a few examples of Salmon's celebratory rhetoric: "PICASSO est tout

seul entre le ciel et la terre, suivi de ceux dont ses pas ont tracé la route precédé de l'homme qu'il fut . . . PICASSO a tout inventé." Salmon reprinted his catalogue essay in *L'Europe nouvelle*, October 25, 1919.

20. J.-G. Lemoine, *L'intransigeant*, October 29, 1919, 2.

21. Georges Martin, "Dans l'air de Paris—Picasso," *L'intransigeant*, October 27, 1919, 2.

22. This sculpture may have been the source for a drawing of a crucifixion that is generally dated 1918 (Zervos 6.1331).

23. For Saincère's early support of Picasso, see Richardson, A *Life of Picasso*, 171–72. Saincère was cited by Berthe Weill as one of her first customers.

24. The "salon Picasso" is Zervos 3.427; the drawing including the birdcage is Zervos 3.380 (1918–19); and the drawing of his studio is M.P. 895 (March 15, 1920). All are in the collection of the Musée Picasso in Paris.

25. These clippings, supplied by an agency, Le Courrier de la Presse, are preserved in the Picasso Archive of the Musée Picasso.

26. Cocteau's letter is quoted in Francis Steegmuller, *Cocteau: A Biography*, New York, 1970, 201.

27. Picasso's drawing after Renoir's painting is Zervos 3.428. The Renoir is Dault, no. 34.

28. For a discussion of Picasso's sources for *The Lovers*, see Susan Grace Galassi, "Picasso's 'The Lovers' of 1919," *Arts Magazine*, February 1982, 76–82.

29. Renoir's three paintings are *Dance at Bougival*, *Dance in the City*, *Dance in the Country* (all 1882–83). Both the first and the last contain this type of foreground device.

30. See René Gimpel, *Diary of an Art Dealer, 1918–1939*, New York, 1966, 151 (entry of October 9, 1920).

31. Letter of July 29, 1919, from Paul Rosenberg to Picasso.

32. Picasso's portrait of Renoir is Zervos 3.413.

33. See "Renoir: A Symposium," *Art in America*, March 1986, 103–24; Arts Council of Great Britain, *Renoir*, London and Boston, 1985; and Barbara Erlich White, *Renoir: His Life, Art and Letters*, New York, 1984.

34. Guillaume Apollinaire, "New Arts: The Futurists," *Le petit bleu*, February 9, 1912; reprinted in *Apollinaire on Art: Essays and Reviews, 1902–1918*, ed. Leroy C. Breunig, New York, 1972, 204.

35. Jean Boggs, ed., *Picasso & Things*, Cleveland, 1992, 77. For my discussion of this painting in the context of the exhibition Boggs curated, see "Picasso in the Beaux Quartiers," *Art in America*, December 1992, 82–93, 61 and 63. Picasso made a sketch of a dancing couple related to the one in this painting on November 18, 1919 (dated "18 n. 19" on the verso, it is no. 867 in the collection of the Musée Picasso in Paris). The drawing of the "salon Picasso" is dated November 21, 1919.

36. Brigitte Léal, "Picasso's Stylistic 'Don Juanism': Still Life in the Dialectic between Cubism and Classicism," *Picasso & Things*, 30. See page 192 for Jean Boggs's comment regarding the figural images in *Studies* seeming "fresher."

37. Boggs, *Picasso & Things*, 192.

38. John House, "Renoir's World," in Arts Council of Great Britain, *Renoir*, 11 and 17.

39. Arsène Alexandre, "Renoir sans phrases," *Les arts*, March 1920; quoted in House, *Renoir*, 13. Most of these works have not survived, and few of the ones that have are available for reproduction. But see Ambroise Vollard, *Renoir*, Paris, 1918, pls. 172, 445, 552, 553, and 605. Renoir appears to have begun using his new technique about 1880 and to have continued until the end of his life. I would like to thank my former colleague at Christie's, John Steinert, for his help in locating the works.

40. In the March 1986 issue of *Art in America*, Robert Rosenblum calls attention to Picasso's interest in Renoir during 1919-22 and suggests a link between Renoir's canvases of studies and Picasso's *Studies* (113). Rosenblum's reference to this relationship is the only one I know, and he has told me that he accepts my argument regarding Picasso and Renoir. According to him and others, Renoir's late works were an important source for Picasso's Neoclassicism; Picasso's interest in these works is further demonstrated by the number of them that he bought, starting by 1918-19 (they are now in the Musée Picasso [T61-T67]).

41. This similarity is noted by Hélène Parmelin in "Picasso ou le collectionneur," *L'oeil*, September 1974, 6-9.

42. See Michel Hoog, *Les grandes baigneuses de Picasso*, Paris, 1988; Elizabeth Cowling and Jennifer Mundy, *On Classic Ground: Picasso, Léger, de Chirico and the New Classicism, 1910-1930*, New York, 1990; and Ulrich Weisner, *Picassos Klassizismus*, Bielefeld, 1988.

43. For Matisse's contracts with Bernheim-Jeune during 1917-26, see Alfred H. Barr, Jr., *Matisse: His Art and His Public*, New York, 1951, 554-55.

44. Réne Gimpel records these prices in *Diary of an Art Dealer*, 121 (entry for December 13, 1919).

45. Ibid., 124 (entry for January 1, 1920).

46. Letter of November 11, 1921, from André Lhote to Gabriel Frizeau (Getty Center for the Humanities).

47. The estimate of Picasso's income for 1920 is based on both the preserved receipts from Paul Rosenberg (Pierpont Morgan Library) and the notations in the notebook thought to have been kept by Olga Koklova (Musée Picasso). A receipt from Paul Rosenberg dated January 7, 1920, records the purchase of *Young Girl with a Hoop* and *Green Still Life*.

48. Letter of July 6, 1920, from Paul Rosenberg to Picasso.

49. See Judith Zilczer, *"The Noble Buyer": John Quinn, Patron of the Avant-Garde*, Hirshhorn Museum, Washington, D.C., 1978. Quinn's correspondence relating to his collecting activities is in the John Quinn Memorial Collection of the New York Public Library.

50. These paintings are cited in a New York review of the exhibition that Paul Rosenberg sent to Picasso on July 16, 1921.

51. This painting can be identified as having appeared in the exhibition on the basis of the citation in the exhibition catalogue, no. 39 (misdated 1914) and its presence in Paul Rosenberg's photo inventory at the time. *The Aficionado* is Daix and Rosselet, no. 500.

52. Malcolm Gee analyzes the contents of these sales in *Dealers, Critics, and Collectors of Modern Painting: Aspects of the Parisian Art Market between 1910 and 1930*, New York and London, 1981, Appendix F.

53. Ibid. Léonce Rosenberg expressed his optimism about the sales in a letter to Picasso of April 22, 1921 (Picasso Archive, Musée Picasso).

54. For a discussion of this confrontation, see Gee, *Dealers*, Appendix F, and Christian Derouet, "Juan Gris: A Correspondence Restored," in Christopher Green, *Juan Gris*, London, 1992.

55. Daniel-Henry Kahnweiler with Francis Crémieux, *My Galleries and Painters*, New York, 1971, 70.

56. This review, signed "M. C.," was sent to Picasso by Paul Rosenberg on July 16, 1921.

57. André Salmon, *L'Europe nouvelle*, June 4, 1921, 734.

58. Paul Rosenberg's correspondence with Pierre Reverdy is preserved in the Pierpont Morgan Library (gift of Alexandre Rosenberg). The painting Reverdy cites is *Two Bathers*, a pastel of October 24, 1920 (Musée Picasso, M.P. 944). In the October 15, 1925, issue of *La révolution surréaliste* it was reproduced with the title Reverdy used—*Adam and Eve*—even though it clearly portrays two women (15).

59. For a discussion of *Three Musicians*, see Theodore Reff, "Picasso's *Three Musicians*: Maskers, Artists and Friends," *Art in America*, December 1980, 124–42.

60. Letter of July 9, 1921, from Paul Rosenberg to Picasso.

61. Letter of July 13, 1920, from Paul Rosenberg to Picasso.

62. See Anne Distel, *Impressionism: The First Collectors*, New York, 1990, 28–29. For the Photo-Succession exhibitions, see chapter 1, note 61; for the Modern Gallery, chapter 2, note 37. Apparently no exhibitions of Picasso's work occurred in America between 1918 and 1923.

63. Letter of July 9, 1921, from Paul Rosenberg to Picasso.

64. Letter of July 16, 1921, from Paul Rosenberg to Picasso.

65. For Prince Argotinsky-Dolgoroukoff, see Richard Buckle, *Diaghilev*, New York, 1979, 30. His correspondence with Picasso is preserved in the Picasso Archive of the Musée Picasso.

66. The Brooklyn Museum held an exhibition of avant-garde art, organized by Katherine Dreier, in November–December 1926.

67. For the history of the Arts Club, see Arts Club of Chicago, *Portrait of an Era: Rue Winterbotham Carpenter and the Arts Club of Chicago 1916–1931*, 1986.

68. Cable from Wladimir Argotinsky-Dolgoroukoff, copied in a letter of October or November 1922 from Abram Poole to Robert Harshe, director of the Arts Club. The archives of the Arts Club, which include this letter, are in the Newberry Library in Chicago.

69. Letter of January 19, 1923, from Wladimir Argotinsky-Dolgoroukoff to Robert Harshe.

70. The Arts Club purchased *Head of a Woman* for $350; *Three Bathers with a Child* was purchased by a Mrs. Hyman for $220. The Arts Club kept $20 as its commission, instead of the 20 percent agreed upon with Wildenstein and Rosenberg. The entire exhibition of fifty-three drawings was insured for $13,000.

71. Letter of June 7, 1922, from Paul Rosenberg to John Quinn (John Quinn Memorial Collection, New York Public Library).

72. Letter of January 27, 1922, from John Quinn to Henri-Pierre Roché (John Quinn Memorial Collection, New York Public Library).
73. Letter of November 20, 1923, from Paul Rosenberg to Alice Roullier (Newberry Library).
74. The show was on view at Wildenstein's New York gallery from November 17 until approximately December 8, 1923. Among the paintings in the show were *Harlequin* (Centre Pompidou), *Seated Harlequin* (Kunstmuseum, Basel), and *Woman in a Blue Veil* (Los Angeles County Museum of Art), all priced at $6,500, and *The Lovers* (National Gallery, Washington, D.C.), priced at $5,000.
75. Letter of November 26, 1923, from Paul Rosenberg to Picasso.
76. Letters of November 3 and November 16, 1923, from Paul Rosenberg to Picasso.
77. Letters of November 26 and December 11, 1923, from Paul Rosenberg to Picasso.
78. Letter of December 11, 1923, from John Quinn to Henri-Pierre Roché. An extremely cultivated man, Roché was a friend of many avant-garde artists. See Carlton Lake and Linda Ashton, *Henri-Pierre Roché*, Austin, 1991.
79. Letter of December 6, 1923, from John Quinn to Henri-Pierre Roché.
80. Letter of December 6, 1923, from Gerald Kelly to the Arts Club of Chicago.
81. Cable of December 10, 1923, from Gerald Kelly to the Arts Club of Chicago.
82. Wildenstein & Co., *Exhibition of Recent Work by Picasso*, with prices handinscribed. Gerald Kelly sent the catalogue to the Arts Club with a letter of December 11, 1923.
83. Quinn purchased *Mother and Child by the Sea* (Art Institute of Chicago) and *The Source* (Moderna Museet, Stockholm) from Paul Rosenberg.
84. Letter of December 11, 1923, from Paul Rosenberg to Picasso.
85. Letter of December 20, 1923, from Paul Rosenberg to Picasso.
86. Henry McBride, *Dial*, January 1924, 102.
87. Forbes Watson, "A Note on Picasso," *The Arts*, December 1923, 332.
88. Among the paintings from the American exhibitions were two versions of *Harlequin, The Saltimbanques, The Lovers, Woman in a Blue Veil, The Reply, Mother and Child, Seated Woman*, and *Woman in a Turban*.
89. Letter of January 21, 1921, from Paul Rosenberg to Picasso.
90. Receipt of October 23, 1923, from Paul Rosenberg to Picasso. Rosenberg paid Picasso 125,873 francs and agreed to pay the remaining 118,000 francs on January 4, 1924. Picasso's accounts show that he actually paid it on January 18, 1924, and Jos. Hessel is recorded as a joint purchaser.
91. For Staechelin as a collector, see Hans-Joachim Müller, ed., *The Rudolf Staechelin Collection*, Basel, 1990, esp. the essay by Christian Geelhaar, "Best Buy Quality Has Always Been My Opinion," 151–73. For Swiss collections of Picasso's work during this period, see Geelhaar, *Picasso: Wegbereiter und Förderer seines Aufstiegs 1899–1939*, Zurich, 1993. René Gimpel cites the prices of these Picassos in his *Diary of an Art Dealer*, 256 (entry of April 9, 1924).
92. André Salmon, *La revue de France*, May 1, 1924, 159. Salmon cites review in *Café du commerce* that included the accusation that "Picasso's art was a monument of insincerity."

93. Maurice Raynal, *L'intransigeant*, April 15, 1924, 2.

94. The precise chronology of this shift will be difficult to determine until a new catalogue raisonné more clearly establishes the dates of the works of 1922–24. Among the particularly intriguing paintings of these years are two additional images of the harlequin: *Harlequin with Mirror* (1923, Thyssen-Bornemisza Collection) and *Seated Harlequin* (1924, National Gallery of Art, Washington, D.C.). In the first image, the self-conscious primping of the figure as he looks into a hand mirror and adjusts his bicorne hat seems an appropriate comment on the whole series of Neoclassical pictures of the previous year. Unlike these paintings, the *Seated Harlequin* is in a Cubist style; its thick impasto suggests many reworkings and possibly an initial rendering in a classicizing mode.

95. See Kenneth Silver's review of the exhibit *On Classic Ground: Picasso, Léger, de Chirico and the New Classicism, 1910–1930*, the catalogue by Cowling and Mundy, and the accompanying volume of essays (*Art in America*, March 1991, 45–53). See also Christopher Green's *Léger and the Avant-Garde*, New Haven and London, 1976, and *Cubism and Its Enemies*, New Haven and London, 1987; and Silver's *Esprit de Corps*, Princeton, 1989.

96. See Jean Cocteau, *Le rappel à l'ordre*, Paris, 1926.

97. "Picasso Speaks," *The Arts*, May 1923; reprinted in Alfred H. Barr, Jr., *Picasso: Fifty Years of His Art*, New York, 1946, 270–71.

98. This watercolor is Zervos 19.340. For a photograph that captures much the same effect, see Anne Baldassari, *Picasso Photographe, 1901–1916*, Paris, 1994, 80 (*Self-Portrait in an armoir mirror*, 1921).

CHAPTER 4

1. For a discussion of *Mercure* and the other productions included in the Soirées de Paris, see Douglas Cooper, *Picasso Theatre*, New York, 1967, 52–62. Man Ray took the photograph of Picasso, Koklova, and Errazuriz in Count Beaumont's house; the count had asked Man Ray to set up his camera in a spare room where he could photograph the guests in their costumes.

2. Receipt dated October 22, 1923, from Paul Rosenberg to Picasso (Pierpont Morgan Library). The three Cubist paintings were *Still Life with Fish* (winter 1922–23; Zervos 4.448); *Guitar* (1922–23; Zervos 4.441); and *Guitar* (winter 1922–23; Zervos 4.439).

3. Cooper, *Picasso Theatre*, 56, 58.

4. The *Seated Harlequin* now in the collection of the National Gallery of Art, Washington, D.C. (1924; Zervos 5.328), may be an example of this pairing of styles through similar subjects. Unlike in his 1923 rendering, Picasso chose a Cubist style. To the naked eye, the heavy impasto of the later painting evinces many alterations; radiography might reveal whether the painting began as a figure in a classicizing style.

5. The Surrealists printed an "Hommage à Picasso" in several newspapers, including the *Paris-Journal* (June 20, 1924) and *Le journal littéraire* (June 21, 1924). Picabia reprinted it in issue no. 18 of his journal, *391*, on the same page as his put-down (3).

6. See for example, Picabia's comment in a letter to Tristan Tzara of March

28, 1919, reproduced in Michel Sanouillet, *Dada à Paris*, Paris, 1965, 485. By the mid-1920s, derogatory characterizations of Picasso had reached avant-garde circles in America. In her catalogue essay for the Brooklyn Museum's 1926 exhibition *Modern Art*, Katherine Dreier describes Picasso as "a middle-aged gentleman who started life full of enthusiasm and helped to create the cubist movement, which, however, is far bigger than he. He is a master in his own way. Though a fighter in his youth, he settled down to retirement as far as the world of art goes, today painting his own individual pictures" (82). This view of Picasso, and particularly the emphasis on Cubism's not being limited to his work, probably reflects the opinions of Marcel Duchamp, who served as Dreier's mentor.

7. Louis Aragon, "Pour arrêter les bavardages," *Le journal littéraire*, June 21, 1924, 10.

8. Picasso's inscribed copy is preserved in the Dossier de Presse in the Picasso Archive of the Musée Picasso.

9. Aragon, "Pour arrêter les bavardages."

10. Musée national d'art moderne, *André Breton: La beauté convulsive*, Paris, 1991, 106. In November 1918, Breton had apparently used his friendship with Apollinaire to develop a passing acquaintance with Picasso; two of his letters to Aragon record a visit to the artist (93).

11. See Margit Rowell, "André Breton et Joan Miró," in *André Breton: La beauté convulsive*, 179–82.

12. The small notebook preserved in the Picasso Archive records the sale as occurring on February 20, 1924.

13. The small notebook in the Picasso Archive records the price as 30,000 francs, but in 1961 André Breton recalled that Doucet had paid 25,000 francs; see the remarkable "Elements pour une chronologie de l'histoire des *Demoiselles d'Avignon*" assembled by Judith Cousins and Hélène Seckel, in Hélène Seckel, *Les Demoiselles d'Avignon*, vol. 2, Paris, 1988, 591. Apparently, Doucet's records have not been preserved.

14. The small notebook in the Picasso Archive records this sale to Rosenberg (and Hessel) as having occurred on February 5, 1923.

15. See Judith Zilczer, *"The Noble Buyer": John Quinn, Patron of the Avant-Garde*, Hirshhorn Museum, Washington, D.C., 1978, 176.

16. See the financial records of Chester Dale's collection in the Archives of American Art, microfilm no. 3970.

17. See Seckel, *Les Demoiselles d'Avignon*, vol. 2, 570–79. For a discussion of the negotiations over the sale of the painting and Picasso's complaints about the price in later years, see 585–91.

18. Letter of November 6, 1923, from André Breton to Jacques Doucet, in Seckel, *Les Demoiselles d'Avignon*, vol. 2, 585.

19. See Seckel, *Les Demoiselles d'Avignon*, vol. 2, 650–51, for a discussion of this episode.

20. Ibid., 591.

21. Letter of November 2, 1922, from André Breton to Picasso (Picasso Archive, Musée Picasso); reprinted in *André Breton: La beauté convulsive*, 110.

22. André Breton, *Les pas perdus*, Paris, 1924, 158–59.

23. See Sanouillet, *Dada à Paris*, 381–87, for a discussion of these events.

24. Letter of September 18, 1923, from André Breton to Picasso (Picasso Archive, Musée Picasso); reprinted in *André Breton: La beauté convulsive*, 114.

25. See Michel Décaudin, "Autour du premier manifeste," in *Surrealismo*, ed. P. A. Janini, Rome, 1974, 29–74.

26. Charles Stuckey argues vigorously and persuasively that the term *surrealism* should not be capitalized. Breton and his colleagues consistently refused to capitalize it, so as to prevent their movement from being perceived as a restrictive school. Nonetheless, historians have generally capitalized it, as they have such movements as Fauvism, Cubism, and Futurism. With the hope that Stuckey will forgive my ahistoricism, I adopt the customary practice in order to help the reader distinguish between the Surrealist movement associated with André Breton and other forms of surrealism stemming from Apollinaire's original use of the term.

27. Preserved in the Dossier de Presse, Picasso Archive, Musée Picasso.

28. "La querelle du surréalisme," *Le journal littéraire*, September 6, 1924, 10.

29. Letter of June 9, 1925, from André Breton to Picasso (Picasso Archive, Musée Picasso); reprinted in *André Breton: La beauté convulsive*, 176.

30. Roland Penrose, *Picasso: His Life and Work*, New York, 1971, 257.

31. Robert Rosenblum, "Ten Images," *Picasso from the Musée Picasso, Paris*, Walker Art Center, Minneapolis, 1980, 57–59. See also the unpublished essay by Elizabeth Cowling, "Picasso's *Le Baiser* of 1925—A Reinterpretation," in the library of the Musée Picasso, Paris.

32. Elizabeth Cowling, " 'Proudly We Claim Him as One of Us': Breton, Picasso and the Surrealist Movement," *Art History*, March 1985, 87.

33. Letters of August 5 and September 5, 1924, from Paul Rosenberg to Picasso.

34. The sales were held in New York at the American Art Association on February 9–11, 1927. An earlier sale of seventy-two works had taken place at the Hôtel Drouot in Paris on October 28, 1926.

35. The *New York Times* reported the number of works Rosenberg had purchased (January 10, 1926), 10. The reference to the "innumerable paintings" in his inventory is in the letter of September 5, 1924, in which he announced Quinn's death.

36. According to the photo inventory of the Galerie Paul Rosenberg, 328 works entered the gallery between February 1923 and January 1925. Of these, more than two-thirds (approximately 229) were twentieth-century works.

37. Among the artists Rosenberg showed in the following decades were Graham Sutherland and Nicholas de Staël.

38. The small notebook in the Picasso Archive records the balance payment on January 18, 1924, and the purchase of the drawings on April 16. A receipt from Paul Rosenberg dates the sale April 14 (Picasso Archive, Musée Picasso). There are many such small discrepancies between the official receipts and the notations in the small notebook.

39. The small notebook in the Picasso Archive records this payment as "Vanity Fair journal American" on February 17, 1924.

40. The small notebook in the Picasso Archive records a payment of 20,500 francs from Kahnweiler on May 29, 1923. So far as I am aware, this was Picasso's first transaction with Kahnweiler since the beginning of the war.

The notebook also records the two sales of lithographs—the first on December 10, 1923, and the second on February 8, 1924.

41. Receipts preserved in the Pierpont Morgan Library; see also the small notebook in the Picasso Archive, Musée Picasso.

42. See, for example, Pierre Cabanne, *Le siècle de Picasso*, vol. 2, Paris, 1975, 112. In defense of his devotion to Picasso's prewar Cubism, Kahnweiler maintained this view as well (*My Galleries and Painters*, with Francis Crémieux, New York, 1971, 70).

43. Letter of August 16, 1927, from Paul Rosenberg to Picasso.

44. For the Baron and Baroness Gourgaud, see Malcolm Gee, *Dealers, Critics, and Collectors of Modern Painting: Aspects of the Parisian Art Market between 1910 and 1930*, New York and London, 1981, 183–85.

45. See Claude Fohlen, *La France de l'entre-deux-guerres*, Paris, 1966, 50–72.

46. Letter of July 7, 1925, from Paul Rosenberg to Picasso. Between approximately 1900 and 1920, Maurice Gangnat acquired more than 150 paintings by Renoir, as well as many others by Impressionist and Post-Impressionist artists; his collection was sold at the Hôtel Drouot in 1925. See Anne Distel, "Renoir's Collectors: The Patissier, the Priest, and the Prince," in Arts Council of Great Britain, *Renoir*, London, 1985, 25.

47. Among the most prominent Japanese collectors of Western art between the wars were Kojiro Matsukata and Baron Fukushima.

48. Paul Rosenberg's contracts with Matisse of July 16, 1936, and July 16, 1939, are in the Pierpont Morgan Library.

49. Letter of September 8, 1925, from Paul Rosenberg to Picasso.

50. Letters of September 16, 1925, October 7, 1926, and August 18, 1928, from Paul Rosenberg to Picasso.

51. This decline is documented in Cocteau's letters to Picasso and culminates in one dated October 25, 1926 (Picasso Archive, Musée Picasso).

52. Several writers have interpreted Picasso's marital difficulties as the primary motivation for this period of his art; see esp. Mary Matthews Gedo, *Picasso: Art as Autobiography*, Chicago, 1980, 125–68.

53. See William Rubin, *Picasso in the Collection of the Museum of Modern Art*, New York, 1972, 120–22.

54. *Woman with Sculpture* is Zervos 5.451; *The Drawing Lesson* is 5.421.

55. Christian Geelhaar notes the presence of *The Dance* in *Picasso: Wegbereiter und Förderer seines Aufsteigs 1899–1939*, Zurich, 1993, 151.

56. See Ronald Alley, *Picasso: The Three Dancers*, Newcastle upon Tyne, 1967, and Theodore Reff, "Picasso's *Three Musicians*: Maskers, Artists and Friends," *Art in America*, December 1980, 124–42.

57. Christian Zervos, "Oeuvres récentes de Picasso," *Cahiers d'art*, 1926, 89–92.

58. See Rosalind E. Krauss, "Life with Picasso: Sketchbook No. 92, 1926," in *Je suis le cahier: The Sketchbooks of Pablo Picasso*, ed. Arnold Glimcher and Marc Glimcher, New York, 1986, 115.

59. See Waldemar George, "L'Exposition Picasso," *L'amour de l'art*, Paris, 1926, 188–93.

60. The following discussion of Picasso's proposals for the monument to Apollinaire is based on my dissertation, *Pablo Picasso's Monument to Guillaume*

Apollinaire: Surrealism and Monumental Sculpture in France, 1918–1959, Columbia University, 1987, and an article, "La Materialisation d'un héritage littéraire: le monument à Apollinaire," *Que vlo-ve? Bulletin international des études sur Apollinaire*, 2nd series, no. 25 (January–March 1988), 14–21. For the most recent discussion of Picasso's sculpture, see *Picasso: Sculptor/Painter*, ed. Elizabeth Cowling and John Golding, London, 1994.

61. *SIC*, nos. 37, 38, and 39 (January and February 15, 1919), 1.
62. Philippe Soupault, *Profils perdus*, Paris, 1963, 7.
63. André Billy, "Chronique Apollinarienne: Le tombeau-fantôme," *Les marges*, October 1, 1935, 57.
64. Paul Léautaud, *Journal littéraire*, vol. 6, Paris, 1959, 164 (entry for December 14, 1927).
65. Apparently, the sketchbook was *carnet* 15, now in the collection of the Musée Picasso (dated July 17, 1927, to September 11, 1927), and the sculpture was *Metamorphosis* (Musée Picasso, no. 261 or 262).
66. John Golding, "Picasso and Surrealism," in *Picasso in Retrospect*, ed. Roland Penrose and John Golding, New York, 1973, 99–101.
67. For a history of the term *surrealism*, see Leroy C. Breunig, "Le sur-réalisme," *La revue des lettres modernes*, nos. 123–26 (1965), 25–27. *Les mamelles de Tirésias* was first performed on June 24, 1917. The quotation is from the last sentence of the play's preface.
68. The announcement appeared in *Action*, no. 6 (December 1920).
69. Roche Grey, "Guillaume Apollinaire," *L'esprit nouveau*, no. 26 (October 1924), n.p.
70. Recounted by Paul Léautaud, *Journal littéraire*, vol. 3, 378 (entry for October 6, 1920). Rachilde was married to Alfred Valette, the editor of the *Mercure de France* and a member of the monument committee.
71. "A la Mémoire de Guillaume Apollinaire," *Le Mercure de France*, December 1, 1928, 499–500.
72. Zervos 24.237.
73. Roger Vitrac, *Jacques Lipchitz*, Paris, 1927, 8. Although the title page lists the book's date of publication as 1927, Vitrac's essay is dated "February 1928."
74. André Breton, "Picasso dans son element," *Minotaure*, 1 (1933), 13.
75. André Billy, "Preface," in Marcel Adema and Michel Décaudin, *Apollinaire: Oeuvres poétiques*, Paris, 1959, 37.
76. I discuss this denouement in *Pablo Picasso's Monument to Guillaume Apollinaire: Surrealism and Monumental Sculpture in France, 1918–1959*, dissertation, Columbia University, 1987, 350–75.
77. E. Tériade, "Une visite à Picasso," *L'intransigeant*, November 27, 1928, 6.
78. *Woman in the Garden* is S.72(1) in the Musée Picasso inventory.
79. Letter of July 16, 1927, from Paul Rosenberg to Picasso.
80. Unfortunately, the records of Picasso's sales to Paul Rosenberg (as well as to other buyers) do not seem to be preserved for the period from late 1927 through 1939. Except for a few isolated sales, the transactions of October 17–19, 1927, appear to be the last documented sales until the Second World War and Picasso's return to Kahnweiler. Paul Rosenberg's photo inventory,

however, makes it possible to surmise a great deal about his commercial relations with Picasso during the late 1920s and the 1930s.

81. The exhibitions were as follows: Picasso, Braque, Derain, Matisse, Laurencin, and Léger, April–May 1929; Picasso, Braque, Léger, and Laurencin, March–April 1930; Picasso, Matisse, Braque, Laurencin, and Léger, January–February, 1931.

In June and July 1927, Rosenberg had presented an exhibition of one hundred drawings by Picasso at his gallery; the show also appeared that year at Wildenstein & Co. in New York. Although it is not possible to identify every drawing that appeared in these exhibitions, it is clear that most (probably all) dated from 1918 to 1926 and were rendered in classicizing styles. In December 1927, Rosenberg held a group show at his gallery that included Picasso, Braque, Léger, Matisse, Derain, and Laurencin.

In January 1928, the Galerie Pierre in Paris presented an exhibition of Picasso's work. Since joining Rosenberg's gallery in 1918, Picasso had never had a one-man show anywhere else in Paris. Although the organizer, Pierre Loeb, was not sufficiently established to seriously threaten Picasso's relationship with Rosenberg, the show probably does reflect Picasso's less cordial relations with his primary dealer. Loeb was closely associated with the Surrealists.

82. *Painter and Model* is Zervos 7.143; *The Studio* is 7.142.

83. See Gee, *Dealers*, 282.

84. Zilczer, "The Noble Buyer," 177.

85. "Interview with Sidney Janis conducted by Helen M. Franc," June 1967, 1–2 (Museum of Modern Art Archives).

CHAPTER 5

1. Guy Hickok, "He Keeps the Art Boys Guessing," *The Eagle Magazine* (New York), July 17, 1932, 7.

2. The exhibition ran from June 16 to July 30, 1932. For the list of lenders, see pages 75–77 of the catalogue, *Exposition Picasso*, Galeries Georges Petit.

3. The role of dealers in the organization of exhibitions presented by museums has been little investigated. Paul Rosenberg's representation of most of the leading French artists of the early twentieth century earned him a particularly significant role in these projects when museums, especially in America, began to turn serious attention to modern art. Nonetheless, I do not wish to leave the impression that Rosenberg was unusual in his ambition to gain museum retrospectives for artists.

4. Brassaï, quoted in Pierre Daix, *Picasso: Life and Art*, New York, 1993, 191.

5. Hickok, "He Keeps the Art Boys Guessing." Jacques-Emile Blanche described Picasso in the process of hanging the pictures; see "Rétrospective Picasso," *L'art vivant*, July 1932, 333–34.

6. *Three Generations of Twentieth-Century Art: The Sidney and Harriet Janis Collection of the Museum of Modern Art*, New York, 1972, 211.

7. Hickok, "He Keeps the Art Boys Guessing."

8. For a brief history of the Galeries Georges Petit, see Anne Distel, *Impressionism: The First Collectors*, New York, 1990, 36–40.

9. René Gimpel, *Diary of an Art Dealer, 1918–1939*, New York, 1966, 378 (entry for November 1, 1929).

10. E. Tériade, "Nos enquêtes: Entretien avec Paul Rosenberg," *Cahiers d'art* (feuilles volantes), no. 9, 1927, 1–2.

11. Gimpel, *Diary of an Art Dealer*, 376 (entry for October 25, 1929).

12. Typescript of autobiographical reminiscences dictated by Chester Dale in 1953 and corrected in 1959, Archives of American Art, microfilm reel no. 3969, frames 533–34.

13. Introduction, Galeries Georges Petit, *Cent ans de la peinture française*, June 15–30, 1936, n.p.

14. Ibid.

15. Dale, autobiographical reminiscences. For Dale's purchases, see "The Chester Dale Collection: Financial Material," Archives of American Art, microfilm reel no. 3970.

16. For photographs, see Jack Cowart, *Henri Matisse: The Early Years in Nice, 1916–1930*, Washington, D.C., and New York, 1986, 234.

17. "Chester Dale Collection: Financial Material."

18. Ibid.

19. E. A. Carmean, Jr., *Picasso: The Saltimbanques*, Washington, D.C., 1980, 77–83. In 1915, Thannhauser sold the painting to a Munich collector, Hertha von Koenig, apparently for approximately what he had paid at the Peau de l'Ours auction. By late 1930, Koenig's financial difficulties forced her to put the painting on the market. After the Berlin National Gallery declined to purchase it, the painting apparently came into the possession of a Swiss bank, as Chester Dale recounts. See Christian Geelhaar, *Picasso: Wegbereiter und Förderer seines Aufstiegs 1899–1939*, 74–78.

20. Dale, autobiographical reminiscences, frames 569–73, reel no. 3969.

21. The Galerie Percier, which opened in 1922, was similar to La Peau de l'Ours even though it operated as a commercial gallery. Backed by financial supporters and fellow collectors—André Lefevre, Raoul and Max Pellequer, and Alfred Richet—Level bought for the group, organized shows, and sold from inventory through the gallery (see Malcolm Gee, *Dealers, Critics, and Collectors of Modern Painting: Aspects of the Parisian Art Market between 1910 and 1930*, New York and London, 1981, 175–79). On March 3, 1927, Level held a very successful sale of his private collection at the Hôtel Drouot—once again catching the market near a peak.

22. *Portrait of Olga* and *After Le Nain* are now in the collection of the Musée Picasso in Paris; they are, respectively, M.P. 55 and 56.

23. Among the sculptures included, four works were dated "vers 1900," and the remaining three were of recent vintage, 1930–32. The Cubist reliefs still in his possession were excluded. The illustrated books similarly joined Picasso's early career with his current work. Three dated from 1903 to 1914 and three from 1931 to 1932 (one was still in preparation).

24. Daix, *Picasso: Life and Art*, 221.

25. Ibid., 223. See also Pierre Cabanne, *Le siècle de Picasso*, vol. 2, Paris, 1975, 257–63.

26. For a more detailed discussion of the Zurich exhibition, see Christian Geelhaar, *Picasso: Wegbereiter und Förderer seines Aufsteigs 1899–1939*, 188–96. The Petit and the Zurich exhibitions were the last Picasso retrospectives in Europe until the mid-1950s. In 1953, retrospectives were held at the Palazzo Reale in Milan and the Musée de Lyons. In 1955, an extremely important retrospective took place at the Musée des Arts Décoratifs in Paris.

27. For the history of the Museum of Modern Art and Alfred Barr's role in its establishment, see Russell Lynes, *Good Old Modern: An Intimate Portrait of the Museum of Modern Art*, New York, 1973, and Alice Goldfarb Marquis, *Alfred H. Barr, Jr.: Missionary for the Modern*, Chicago, 1989. See also the reminiscence by Margaret Scolari Barr, "Our Campaigns," *The New Criterion*, special issue 1987, 23–74. None of these works discuss Barr's plans for a Picasso exhibition in 1931 or 1932.

28. Barr's correspondence of this period is part of the Alfred H. Barr, Jr., Papers in the archives of the Museum of Modern Art.

29. Letter of August 20, 1931, from Alfred Barr to Jacques Mauny.

30. Letter of April 25, 1931, from Alfred Barr to Jacques Mauny.

31. Letter of July 1, 1931, from Alfred Barr to G. F. Reber.

32. Ibid.

33. Barr believed that his exhibition was better than the Petit's. In a letter to Matisse's daughter, Marguerite Duthuit, he cited the response of contemporary critics in support of his view: "All critics with whom I have spoken and who saw the Georges Petit Exhibition feel that our exhibition is very much superior in quality though not so large" (Exhibition file, Museum of Modern Art).

34. Alfred H. Barr, Jr., Papers, Box 17, Museum of Modern Art.

35. Barr's conception of Picasso's work was deeply indebted to the criticism of the writers associated with Surrealism, especially André Breton and Michel Leiris, as well as to more peripheral figures, such as Carl Einstein.

36. Letter of July 13, 1931, from Alfred Barr to G. F. Reber.

37. Letter of December 19, 1931, from Alfred Barr, to A. Conger Goodyear.

38. Letter of December 30, 1931, from A. Conger Goodyear to Alfred Barr.

39. Letter of January 15, 1932, from A. Conger Goodyear to Alfred Barr. This memorandum reports the decision that the Committee on Exhibitions had made on January 13.

40. Letter of January 26, 1932, from Alfred Barr to Picasso.

41. See Margaret Scolari Barr, "Our Campaigns," 28; Lynes, *Good Old Modern*, 102; and Marquis, *Alfred H. Barr, Jr.*, 103–05. None of these accounts mention the aborted Picasso exhibition as a factor in Barr's decline.

42. Margaret Scolari Barr, "Our Campaigns," 28–29. Since Alfred Barr did not arrive in Europe until September, he did not see the Petit exhibition; however, he did visit the Zurich show.

43. Letter of July 20, 1931, from Alfred Barr to Jacques Mauny.

44. Guy Hickok, "He Keeps the Art Boys Guessing."

45. Quoted in Gimpel, *Diary of an Art Dealer*, 418 (entry for November 26, 1933).

46. *Hartford Courant,* November 15, 1933.

47. Quoted in Eugene R. Gaddis, " 'The New Athens': Moments from an Era," in *Avery Memorial, Wadsworth Atheneum,* ed. Gaddis, Hartford, 1984, 39. Austin announced this goal in March 1928, six months after becoming director of the museum.

48. Gimpel, *Diary of an Art Dealer,* 352 (entry for December 3, 1928).

49. For Austin's career, see Gaddis, *Avery Memorial.* Gaddis is writing a biography of Austin. I very much appreciate his careful reading of my text on the Atheneum.

50. The sale occurred between April 8 and June 3, 1931 (Archives of the Wadsworth Atheneum).

51. James T. Soby, "A. Everett Austin, Jr., and Modern Art," in Wadsworth Atheneum, *A. Everett Austin, Jr.: A Director's Taste and Achievement,* Hartford, 1958, n.p.

52. Letter of November 3, 1931, from A. Everett Austin to Alfred Barr. Austin's correspondence is in the archives of the Wadsworth Atheneum.

53. Quoted in the *Hartford Courant,* November 15, 1933.

54. Letter of January 18, 1934, from Alfred Barr to A. Everett Austin. Quoted in Gaddis, " 'The New Athens,' " 39.

55. Henry-Russell Hitchcock, Foreword, *Avery Memorial,* 14.

56. Letter of November 25, 1933, from A. Everett Austin to William C. Bullit.

57. Letter of November 29, 1933, from Georges Wildenstein to Picasso (Picasso Archive, Musée Picasso).

58. In a letter of May 26, 1992, to the author, Daniel Wildenstein explained that the business association between the firms of Wildenstein and Rosenberg ended in 1932. The basis for the split lay in personal differences; the untangling of their commercial relations was not completed for several years. Wildenstein's departure may have caused Rosenberg to be particularly cautious about acquiring stock in the mid-1930s.

59. Letters of December 19 and December 23, 1933, from A. Everett Austin to Mrs. Chester Dale.

60. Cables of December 19 and December 23, 1933, from Paul Guillaume to A. Everett Austin.

61. *Hartford Times,* December 22, 1933 (Archives of the Wadsworth Atheneum).

62. Letter of December 18, 1933, from A. Everett Austin to Earle Horter; letter of December 18, 1933, from A. Everett Austin to F. Ohwald.

63. Undated letter from Earle Horter to James Thrall Soby (Archives of the Wadsworth Atheneum).

64. Letter of January 2, 1934, from Sidney Janowitz [Janis] to A. Everett Austin.

65. Letter of January 16, 1934, from Paul Rosenberg to A. Everett Austin.

66. Letter of January 17, 1934, from Paul Rosenberg to A. Everett Austin. According to the catalogue of the exhibition, two paintings of 1923, *Maternité* (no. 43; 6 by 8 in.) and *Jeux Familiaux* (no. 44; 6 by 4 in.), were lent by Picasso. The third painting is not identified in the catalogue.

67. Cables of January 22 and 23, 1934, from Paul Rosenberg to A. Everett Austin.

68. Letter of January 17, 1934, from Paul Rosenberg to A. Everett Austin.

69. For Gallatin, see Gail Stavitsky, *The Development, Institutionalization, and Impact of the A. E. Gallatin Collection of Modern Art*, dissertation, Institute of Fine Arts, New York University, 1990.

70. Letter of March 13, 1934, from A. Everett Austin to Paul Rosenberg.

71. Letter of March 14, 1934, from Paul Rosenberg to A. Everett Austin.

72. Henry McBride, "The Durand-Ruel Galleries Exhibit Best of Picasso, Braque and Matisse," *The Sun* (New York), March 17, 1934, 31.

73. *Sculptor, His Work, and His Model* is Zervos 8.120; *Sculpture and Boat on the Seashore* is 8.125.

74. *Plaster Torso* is in the collection of the São Paulo Museum of Art; *Artist and Model*, Scottish National Gallery; *Interior*, National Gallery of Art, Washington, D.C.

75. To meet the asking price of $20,000, Phillips traded Rosenberg *The Reader* by Daumier and *Banks of the Seine* by Sisley. Thanks to Charles S. Moffett for providing me with this information from the archives of the Phillips Collection.

76. Letter of March 18, 1934, from Paul Rosenberg to Picasso.

77. *Still Life with Biscuits* (1924) is Zervos 5.242; *Still Life with the Head of a Sheep* (1925) is 5.443.

78. Quoted in Dorothy Kosinski, "G. F. Reber: Collector of Cubism," *Burlington Magazine*, August 1991, 527. This article is my basic source for information on Reber's collecting.

79. Letter of July 13, 1934, from Alfred Barr to Stephen Clark.

80. Letter of July 18, 1934, from Stephen Clark to Alfred Barr.

81. Alfred H. Barr, Jr., *Modern Works of Art: Fifth Anniversary Exhibition*, New York, 1934, 15. The exhibition ran from November 20, 1934, through January 20, 1935.

82. Letter of September 9, 1936, from Alfred Barr to Albert Gallatin. Quoted in Stavitsky, *Development*, 310.

83. Alfred H. Barr, Jr., *Painting and Sculpture in the Museum of Modern Art, 1927–1967*, New York, 1977, 625. The museum will not reveal the price paid in 1949.

84. John Richardson, *A Life of Picasso*, vol. 1 (1881–1906), New York, 1991, 310.

85. The primary monographs are: André Level, *Picasso*, Paris, 1928; Maurice Raynal, *Picasso*, Paris, 1922; and Pierre Reverdy, *Pablo Picasso et son oeuvre*, Paris, 1924.

86. Daix, *Picasso: Life and Art*, 228.

87. André Breton, "Picasso dans son element," *Minotaure*, no. 1 (1933), 3–23.

88. Cabanne, *Le siècle de Picasso*, vol. 2, 266.

89. Jaime Sabartès, *Picasso: An Intimate Portrait*, New York, 1948, 105. Although Picasso's writings were little appreciated during his lifetime, they have recently been published in a lavish volume, *Picasso: Ecrits*, ed. Marie-Laure Bernadac and Christine Piot, Paris, 1989.

90. Letter of January 3, 1936, from Paul Rosenberg to Picasso.

91. William Rubin, ed., *Pablo Picasso: A Retrospective*, New York, 1980, 307.

92. Letter of January 3, 1936, from Paul Rosenberg to Picasso.

93. *Woman Reading* is Zervos 8.246. There was luxuriant nudity displayed in

many of the works, and Rosenberg apparently felt that Picasso sometimes went too far in exposing the body. Pierre Daix records that Picasso told Roland Penrose that "Rosenberg had not been at all pleased with the backside of a naked girl (Marie-Thérèse), and had shouted, 'I don't want any assholes in my gallery' " (*Picasso: Life and Art*, 236). Picasso may simply have been taking pleasure in portraying his dealer as censorious or Rosenberg may have been joking. Whatever the case, a painting that remained in Picasso's possession and is now in the collection of the Musée Picasso, *Nude in the Garden* (M.P. 148), might have prompted the remark.

94. Sabartès's account is on pages 121–26.
95. Sabartès, *Picasso*, 142.
96. Zervos 8.360 (private collection).
97. Letter of February 17, 1939, from Meric Callery to Alfred Barr. Correspondence related to the 1939–40 exhibition is in exhibition file 91, Museum of Modern Art. A version of the exhibition appeared in London at Rosenberg and Helft, March 1–April 1, 1939. Paul Rosenberg was a partner in the gallery.
98. Letter of March 20, 1939, from Alfred Barr to Meric Callery.
99. Marquis, *Alfred H. Barr, Jr.*, 163–64.
100. For an extensive analysis, see Judith Cousins and Hélène Seckel, "Elements pour une chronologie de l'histoire des *Demoiselles d'Avignon*," in Seckel, *Les Demoiselles d'Avignon*, vol. 2, Paris, 1988.
101. Barr, *Painting and Sculpture*, 626.
102. "PICASSIANA: Purchase and the 1939 Show," *Art News*, January 28, 1939, 15.
103. Letter of January 27, 1939, from Alfred Barr to Meric Callery.
104. Letter of February 17, 1939, from Meric Callery to Alfred Barr.
105. Letter of February 23, 1939, from Paul Rosenberg to Alfred Barr.
106. Draft letter of March 13, 1939, from Alfred Barr to Paul Rosenberg.
107. Letter of March 20, 1939, from Alfred Barr to Paul Rosenberg.
108. Letter of March 20, 1939, from Alfred Barr to Meric Callery.
109. Letter of March 28, 1939, from Paul Rosenberg to Alfred Barr.
110. Margaret Scolari Barr, "Our Campaigns," 55.
111. Ibid., 56; Letter of August 5, 1939, from Alfred Barr to Meric Callery.
112. Letter of July 1, 1939, from Alfred Barr to Meric Callery; letter of July 6, 1939, from Alfred Barr to Picasso; letter of July 18, 1939, from Paul Rosenberg to Alfred Barr.
113. Margaret Scolari Barr, "Our Campaigns," 56.
114. Letter of July 9, 1939, from Alfred Barr to Tom Mabry.
115. *Actor* (1904–05) is Zervos 1.291; *Two Nudes* (1906) is 1.366.
116. Letter of July 9, 1939, from Alfred Barr to Tom Mabry.
117. Letter of August 10, 1939, from Alfred Barr to Paul Rosenberg.
118. Rockefeller's cable to Picasso is preserved in the exhibition file. In an internal memorandum of August 18, 1939, Sarah Newmeyer, the head of publicity, wrote: "At least a cable will do no harm. Picasso has plenty of money to come over but he is lazy and, I believe, he does not care much for ocean journeys. Anyway there might be a chance if N. R. cabled him. I asked Alfred if he had invited Picasso and he said yes, he had, but that Picasso only shook his head, smiled and shrugged."

119. Alfred H. Barr, Jr., *Picasso: Forty Years of His Art*, New York, 1939, 6. Although, as Barr pointed out to Rosenberg (March 20, 1939), the Zurich exhibition contained approximately 460 items, it had only about the same number of paintings as the Petit retrospective.

120. This information is contained in the second edition of the catalogue, 21.

121. Ibid., 60. This conception of the *Demoiselles* reflects the views of the Surrealists as stated, for example, in André Breton's letter of November 6, 1923, to Jacques Doucet: "A single certainty: 'Les Demoiselles d'Avignon' because there we enter directly into Picasso's laboratory" (quoted in Seckel, *Les Demoiselles d'Avignon*, vol. 2, 585).

122. Barr, *Picasso: Forty Years of His Art*, 65.

123. Cable of December 5, 1939, from Alfred Barr to Picasso.

124. Edward Alden Jewell, "In the Realm of Art: Picasso," *New York Times*, November 19, 1939, 9; "The Biggest Picasso Show: 360 of Varied Works Are Put on Display in N.Y.," *Newsweek*, November 27, 1939, 39.

125. Brassaï, *Conversations avec Picasso*, Paris, 1964, 52.

CONCLUSION

1. René Gimpel, *Diary of an Art Dealer, 1918–1939*, New York, 1966, 23 (entry of May 14, 1918).

2. Una Johnson, *Ambroise Vollard, Editeur: Prints, Books, Bronzes*, New York, 1977, 139–43. Ninety-seven of the etchings and aquatints in the set were made between September 1930 and June 1936; the final three were made in 1937. According to Johnson, Vollard paid for the series by giving Picasso several paintings from his collection.

3. Letter of August 11, 1939, from Meric Callery to Alfred Barr (Exhibition file 91, Museum of Modern Art).

4. The contract is in the Pierpont Morgan Library (gift of Alexandre Rosenberg).

5. Letter of August 25, 1939, from Paul Rosenberg to Alfred Barr (Exhibition file 91, Museum of Modern Art).

6. After the war, Alexandre joined his father's gallery (as Rosenberg had predicted in his letter to Picasso of November 26, 1923) and directed it from Paul's death in 1959 until his own death in 1987. He was a founder and the first president of the Art Dealers Association.

7. Letter of September 10, 1939, from Meric Callery to Alfred Barr (Exhibition file 91, Museum of Modern Art). In the Picasso estate, there is a painting, dated by estate officials 1939–44, that appears to be a portrait of Vollard. It recalls Brassaï's well-known photographs of the dealer playing with a cat. Presumably Picasso painted the picture soon after Vollard's death. It is also possible that Picasso painted the portrait to celebrate the publication of Vollard's autobiography in 1938.

8. Letter of February 1, 1940, from Paul Rosenberg to Picasso.

9. I have received a fellowship from the National Endowment for the Humanities to study the Nazis' use of art during their occupation of France.

10. Presumably, Göring intended to trade the painting rather than keep it for display.

11. Pierre Assouline, *An Artful Life: A Biography of D.-H. Kahnweiler, 1884–1979*, New York, 1990, 318. Paul Rosenberg maintained his gallery in New York until his death in 1959, when Alexandre became director.

12. Françoise Gilot and Carlton Lake, *Life with Picasso*, New York, 1964, 286.

13. Ibid., 287. Immediately after World War II, Picasso dealt primarily with Louis Carré, who held exhibitions of Picasso's recent work at his gallery in 1945 and 1946.

INDEX